CLEMENT
GREENBERG

CLEMENT GREENBERG

A LIFE

FLORENCE RUBENFELD

University of Minnesota Press
Minneapolis

Published by the University of Minnesota Press
111 Third Avenue South, Suite 290
Minneapolis, MN 55401-2520
http://www.upress.umn.edu

ISBN 0-8166-4435-7

A Cataloging-in-Publication record for this book is available from the Library of
Congress.

Printed in the United States of America on acid-free paper

The University of Minnesota is an equal-opportunity educator and employer.

14 13 12 11 10 09 08 07 06 05 04 10 9 8 7 6 5 4 3 2 1

To
Vik, Deb, Jed
Amy, Sophia, Louisa

ACKNOWLEDGMENTS

Clement Greenberg was foremost among those whose cooperation made this book what it is. His lusty personality and pithy observations animate its every page. Closely following are those who generously consented to be interviewed, sometimes more than once, and whose composite recollections and analysis—of the period as well as the man—provided the basic material from which much of this portrait emerged: Lionel Abel; Pat Adams; Mrs. Lawrence Alloway (Sylvia Sleigh); Dore Ashton; Josh Baer; Elizabeth Baker; Darby Bannard; Peter Blake; Norman Bluhm; Leonard Bocour; Willard Boepple; Louise Bourgeois; Stanley Boxer; Paul Brach and Mirium Shapiro; Marcella Brenner; Howard Buchwald; Dan Budnik; Nick Carone; Mrs. Sandra Casper; David Cast; Leo Castelli; Herman Cherry; Jack Cowart; Susan Crile; Ron Davis; Dorothy Dehner; Friedal Dzubas; John Elderfield; Andre Emmerich; Vicente Esteban; Emanuel (Manny) Farber; Elizabeth Frank; Helen Frankenthaler; Jean Freas; Michael Fried; Bob Friedman; Eugene (Gene) Goossen; Janice (Jenny) Greenberg; Martin Greenberg; Sarah Greenberg; Grace Hartigan; Al Held; Joe Helman; Elizabeth Higdon; Irving Howe; Andrew Hudson; Harry Jackson; Carroll Janis; Rueben Kadish; Max Kozloff; Hilton Kramer; Rosalind Krauss; Irving Kristol; Donald Kuspit; James Lebrun; Alfred Leslie; Vincent Longo; Ira Lowe; Nancy Macdonald; Charles Millard; Conrad Marca-Relli; Porter McCray; Robert Miller; Kenworth Moffet; Eleanor Munro; Cornelia Noland; Kenneth Noland; Elaine O'Brian; Jules Olitski; Beverly Pepper; William Phillips; Norman Podhoretz; Jeffrey Potter; V. V. Rankine; Larry Rivers; Sonia Rosahn; Barbara Rose; Leatrice Rose; Nan Rosenthal; Lawrence Rubin; William Rubin; Ellen Russotto; Irving Sandler; Edwin Santiago; Richard Schiff; Mirium Shiell; Andrea Silverman; David Simpson; Candida Smith; Rebecca Smith and Peter Stevens; Michael Steiner; Rob Storr; Peter Stroud; Sidney Tillim; Diana Trilling; Maurice Tuchman; Karen Wilkin; James Wolfe. William Rubin and the late Irving Howe have to be singled out. The first for enriching and broadening the context of this study and the second for bringing forward information that might otherwise have been missed. Special thanks as well to Robert Storr for suggesting artists to be interviewed, and to Andrew

Hudson for his interest, encouragement, and willingness to share the fruits of his extraordinary files.

I am indebted to the many people who read and edited chapters of this book during its formative phase, not alone for the useful suggestions they provided, but for that sense of community so necessary to the work of an independent scholar. First among these is Leona Schecter, my agent and friend, for the countless hours she devoted as first editor for every page of this manuscript. Next, to Jerrold Schecter for advice and good counsel, and to both for their unstinting support, constant encouragement, and glorious dinners they provided during the entire decade this study consumed. My thanks as well to Sylvia and Walter Austerer; Amy Chua; Eleanor Heartney; Irene Lee; Jed Rubenfeld; Eloise Segal; the artists, writers, and curators of the Washington No Name Discussion Group and to individual members Carole Bolsey, Sharon Fishel, and Frank Getting who shared with me their personal experiences and conversations with Greenberg. And to Jerry Clapsaddle for the many books he called to my attention and sometimes provided, and for my photograph on the book jacket. For their technical and technological support I extend heartfelt appreciation to Washington artists Annette Polan and Dorothy Fall.

Thanks, too, to Mark Stephens, for commiserating and sharing information, most particularly about Willem de Kooning; to Elaine O'Brian, for insights gathered during her research on Harold Rosenberg; to Michael Wreszin, for generously providing me with material he unearthed while researching his biography of Dwight Macdonald; and to Irving Sandler, for confirming my hunches with regard to long-buried events in the fifties.

And last, but by no means least, my gratitude to the Washington Biography Seminar, whose encouragement and support were of inestimable value; and to its leader, Marc Pachter, special counselor to the secretary of the Smithsonian, whose perceptive counsel and rare insight into this particular subspecies of literary effort made this a more honest book than it would otherwise have been, I extend my heartfelt gratitude.

My frequent stays in New York were greatly enriched by the unfailing friendship and hospitality of Sylvia and Walter Austerer, Eloise Segal, Louis and Shelley Lauzar, Eleanor Heartney and Larry Litt, Jed Rubenfeld and Amy Chua, all of whom shared their homes, bolstered my spirits through the unavoidable disappointments, and listened as I reconstructed the nuances of just-completed interviews. My most particular gratitude, however, is extended to the late Harvey Segal, for the relish with which he instituted and conducted the regular debriefing sessions that followed, and illuminated, my every session with Greenberg.

To the many research librarians at the Library of Congress, the National

Gallery of Art, Washington, D.C., the Hirshhorn Museum and Sculpture Garden, the Archives of American Art, the Bennington College Library, the Wellesley College Library, I extend my appreciation, as well as to painter Lucy Baker, for her help with photographs.

My thanks to Scribner editor-in-chief, Nan Graham, for her sustained commitment to this book, to editors Hamilton Cain and Gillian Blake for their staunch efforts in its behalf, and to Carin Goldberg, for her terrific cover design. And last, but most crucial, my gratitude to Edward P. "Ned" Chase, the original editor of this book, whose substantive input during its formative stages, and continued input long after his departure from Scribner, was crucial.

CONTENTS

PREFACE

Among Washington, D.C., artists in the midseventies, when I became involved, Clement Greenberg was more than a legend: he was an obsession. Some twenty years earlier Washington had, for a brief period, been a cultural as well as a political center of power. Greenberg first singled out and encouraged the artists responsible for this flowering and then brought them to public attention. With confidence born of his conviction, Morris Louis and Kenneth Noland, along with Tom Downing and Howard Mehring, friends and students of Noland's, gave birth to a buoyant and lyrical style of painting known as the Washington Color School. Later exemplars were Gene Davis and Leon Berkowitz. Greenberg included the original four, plus Davis, in a major exhibition he organized in the midsixties. He praised Louis and Noland in print and arranged one-person shows for them in New York. From near total obscurity these two were catapulted to stratospheric heights.

When I came on the scene, Louis was dead, Noland no longer lived or painted in Washington, and Greenberg had ceased to be involved with the city's artists. Tragedy pervaded the legacy of those halcyon days. Like rejected siblings, the two artists Greenberg left behind were permanently scarred: one committed suicide; the other drank himself to an early death. Greenberg, the hero who put Washington on the art map, was now the villain, labeled a despot by artists, dealers, and curators. It was rumored that he told artists what and how to paint and consigned them to anonymity—destroyed them professionally—if they would not or could not comply.

When this book was conceived in the late eighties, a similar polarity defined Greenberg's national reputation. In Canada, artists whose studios he visited still felt like God had just walked through the door. In New York, he was the Devil incarnate, and artists made the sign of the cross when mentioning his name. He was accused of rampant cynicism, said to champion only those who did what they were told. In exchange, or so the story went, he made them famous and they made him rich by gifting him with paintings that he sold for skyrocketing sums. The same duality clung to his criticism. Some saw his voice as reasoned, nuanced, even flexible. They said he articulated basic standards, stayed close to the art he was writing

about, and revealed a clear capacity to be deeply moved by what he saw. Others resented an influential voice whose pronouncements issued forth like words from on high.

As a biographical subject Greenberg was as fascinating as he was intimidating. Two books were needed. First, an intellectual biography that traced his ideas and laid the groundwork for a reexamination of his important critical contribution. Second, a social biography that explored his career within the context of his life and times. It would examine the emotional and intellectual forces that shaped his character, personality, and intellect, the values he held dear, the animosity he provoked, and his own goals and aspirations.

The second, the book attempted here, was a mare's-nest. The firestorm that engulfed his reputation yielded more heat than light. The issues surrounding Greenberg's legacy involved questions of interpretation and issues of motivation. Did he disdain certain artists because their work failed to support his theories about the historical progression of modern art, or was he, as he maintained, prepared to like anything so long as he enjoyed it enough? Was he a rigid formalist, as his critics claimed (despite a written record to the contrary), or did these critics vent their rage on his so-called formalism in response to his success in bringing recognition to those he favored? Should each art object dictate the standards by which it will be measured, or is there a single standard by which all art is judged? Given the extent of Greenberg's influence and the subjective nature of criticism, how could one justify the symbolic destruction his opinions visited on so many artists?

Fearing Greenberg's reputed appetite for control, I elected to do an unauthorized biography, gambling that concern for his reputation would gain me the direct access I needed. Since much pertinent information had never been published, I set out to compile a selected oral history from those in the New York art and literary worlds with which he was involved between 1940 and the midseventies, the decades in which, for the first time in history, American art defined the mainstream of Western culture.

I met Greenberg for the first time in December 1988, shortly after signing a contract with Scribner. He lived alone in the Central Park West apartment that in the sixties had been the meeting place for an international "Who's Who" of art luminaries eager to "have a word with Clem." Celebration plans for his eightieth birthday (January 16) were under way and his phone rang constantly. He was frank enough to say that he was flattered by Scribner's interest in him and equally candid with regard to his feelings about an unauthorized biography by a writer he did not know. He said he did not "want a book on him" while he was alive and that he

planned to outlive his father (who died at the age of ninety-six). It took a second meeting to convince him that there was to be a book with or without his cooperation. Once he accepted this fact he made no effort to interfere. The sting of his tail was still potent enough for many of the people I contacted to call him before agreeing to meet with me. To each, I later learned, he expressed reservations about the project but nothing more.

I traveled to Los Angeles, San Francisco, and Boston to meet artists and curators and had telephone interviews with those in cities I did not visit. For several years I spent one week out of every month in New York City taping more than one hundred in-depth interviews with artists, curators, dealers, critics, and scholars, friendly as well as unfriendly, who had been major figures during this singular period of America's cultural history. I also sought out those possessing specialized information relevant to specific aspects of his life.

One afternoon during each visit was reserved for a meeting with Greenberg. He arose about eleven, I arrived around noon and stayed until five or six. The yield was some fifty hours on tape (the machine being periodically turned off for conversations he wanted off the record).

The shape of these encounters evolved gradually. Common ground had to be found between my curiosity and his irascibility; between my desire for information and his determination to deliver as little as possible without driving me away. Our sessions became a game, a game he designed and whose rules it was my task to discern. There was also, I now realize, an unstated precept at work, which I later stumbled on while reading "What Kind of a Day Did You Have," Saul Bellow's short story about Victor Wulpy, an archetypal New York Intellectual art critic. In the forties, Bellow and Greenberg were part of the group of writers known today as the New York Intellectuals, a group whose members often figured in Bellow's fiction. In his short story, Bellow's art critic observes to his wife that he has contempt for those with no "power stir," that in this life you get only as much "truth" as you have "the courage to approach." At any given meeting with Greenberg I got only as much truth as the current level of my information compelled him to yield.

Our meetings were exercises in mutual seduction. He was curious about the information I gathered and my interpretation of it, and was willing to barter for what he wanted, within limits. If my question was phrased with sufficient specificity, I was rewarded with an answer. If he was caught out in terms of giving a misleading or incomplete response in one area, he would make it up by illuminating another. He rarely lied but expressed what he said with great precision. Truth was like an onion. He peeled its layers one at a time and only when necessary.

He resisted direct questions. However, the same query phrased to reflect what someone said about him—I repeated critical comments without identifying the source—drew an immediate response.

Thus, when I interviewed artists, critics, curators, and dealers who knew him and had strong feelings about him, he was an invisible presence. Information contributed or hinted at by one person influenced the questions put to the next, and so on, in a chain that elicited the fullest response when it reached Greenberg.

He spoke modestly of his own accomplishments but exhibited what might be described as pride of place, a clear sense of where he ranked on the historical tablet of critics. This arrogant sense of himself was revealed more in brutal reactions to what others said in praise of him than in things he said in praise of himself. Even when complimented, his response could be devastating. Diana Trilling was the *Nation*'s literary critic during the forties when Greenberg was its art critic. She commented to me that in retrospect, and although she did not like him, "in terms of exerting influence on cultural movements," Greenberg had turned out to be the most important of the extraordinary group writing for the magazine during those years: James Agee on film; Margaret Marshall and Mary McCarthy on theater; Fred Dupee and Randall Jarrell on poetry. "For example," continued Trilling, "I did not change the course of the American novel or the course of literary criticism. Clem did that in the art world. He influenced artists, dealers, critics, academics." "That's some comparison," Greenberg said dryly.

After roughly two years of interviews, control problems over whose book this was became unavoidable. He wanted my assurance that I had come down on his side with reference to what he called "market involvement." I suggested that he could put the matter to rest definitively by allowing me to examine his financial records. He refused. Several days later, actually in the middle of the night, he called, threatened to sue if I wrote what he feared I would write, and said he was no longer interested in talking to me.

For the next two years there was no contact between us. Our meetings resumed in 1993 when, as a gesture of good will, he gave me access not to his financial books but to his "diaries," small, pocket-size notebooks in which he recorded his daily activities: where he went, whom or what he saw, what he worked on, whom he entertained or was entertained by, the restaurants at which he dined (he rarely ate at home), the clubs he frequented, personal comments, and so on. His health was failing, however, and our time together was running out.

Edward P. "Ned" Chase, at that time Scribner's senior editor, and the original editor of my book, brought closure to this saga. Ned, a presence in

the New York intellectual world for forty years, had made a major commit-
ment to this project.

As my relationship with Greenberg continued to founder, Ned, who
knows everybody and had been a close friend of Harold Rosenberg's,
wanted to size up the elderly Greenberg. He called and was invited for
drinks. They moved in similar circles, had many acquaintances in com-
mon, and talked for several hours. Preparing to leave, Ned responded to a
quizzical look on Greenberg's face, a look that bespoke his curiosity, and
concern, over how he was to be portrayed in the book Ned edited. Chase
offered Greenberg the fruits of his long experience. Shaking hands, he
observed, "You could do a lot worse than Rubenfeld."

Icarus in the Art World

|n his inimitable cross between a swagger and a snarl, Clement Greenberg, America's preeminent, and most controversial critic of modern art volunteered a brief character analysis:

> [The poet W. H.] Auden said I reminded him of something he read in the Talmud about people who have warm heads and cold hearts. That wasn't so complimentary but I thought it was accurate. Yeah, about me, it was accurate.

Greenberg and Auden both knew, of course, that in the Talmud the head was the repository of knowledge, the heart of wisdom. Recounting the anecdote was Greenberg's disarming shrug in the face of fate, a preemptive strike against those who would accuse him of worse.

Greenberg was always more, and less, than his challengers gave him credit for. *Art and Culture*, the slim volume of selected essays he published in 1961, secured his place on the same shelf with Roger Fry and Julius Meier-Graefe, the great English and German art critics of the first half of the twentieth century.[1]

Few critics, whatever heights they achieve within their particular discipline, influence the culture of their time. This Greenberg did. He masterminded the campaign that triggered the process that unseated Paris and made New York the art capital of the Western world. During a crucial period in this history, he set the standard against which American art criticism measured itself.

In 1939, when Greenberg wrote his first seminal essay, major movements in art were expected to originate in Europe, modern art was not yet part of the American liberal arts curriculum, and the New York School did not exist. It is sometimes said that Greenberg, single-handedly, brought fame to the American abstract expressionists, but the artists' talent did that. Neither can he take credit for the American public's acceptance of

modernism. That distinction goes to the Museum of Modern Art, in the person of Alfred Barr, its founding director. Greenberg's criticism paved the way for the revolution in taste that had to occur before the "wild" art of the New York School could be understood and appreciated. He created the intellectual foundation for a radical new art, a new way of seeing, that helped make that art accessible first to Europeans and then to Americans.

Like T. S. Eliot's, Greenberg's conception of the critic's job was both rigorous and demanding. For thirty years he established the level of discussion and served as the backboard off which the art conversation bounced. But where Eliot was revered for his efforts, Greenberg was reviled. Those who did not think he walked on water thought he was the Antichrist.

As an intellectual and a connoisseur, this towering and complex figure dominated the New York art world, enraging some with the power of his ideas and others with what seemed an uncanny ability to make his taste prevail. He had the courage of his convictions. He willingly stood alone against entrenched opinion. He possessed an almost Baudelairean sense of his age, was so much in tune with the painting and sculpture of his time that, for a brief moment, it was as if the path along which American art would unfold had been revealed to him in advance.

Greenberg's first forays into art criticism coincided with the efforts of a few Greenwich Village painters, known to one another through the Works Project Administration (WPA) but operating more or less independently to combine elements of cubism and surrealism, the twin poles of French modernism. The quasi-abstract products of this alchemical concoction touched something deep inside the writer who had, until then, been primarily a literary critic.

For close to a decade, alone among practicing critics, Greenberg was the voice of the "boiling kettle," the on-the-record and on-the-spot champion of a new and vibrant art others dismissed as raw, reckless, and ugly. Ten years later the handful of artists he singled out from among hundreds working in New York—Jackson Pollock, Robert Motherwell, David Smith, Willem de Kooning, Arshile Gorky—were hailed as creators of the first national art of genuine magnitude to originate in the United States.

By that time, however, Greenberg had moved on. In the fifties, as an affluent but anxious America worried about the Bomb and the Cold War, he backed a second group whose visual vocabulary appeared to constitute an even more extreme departure from the past: Hans Hofmann, Barnett Newman, Adolph Gottlieb, Mark Rothko, Clyfford Still. Between 1945 and 1970 Greenberg's choices, while neither unerring nor all-inclusive, constituted the core of what is today known as the New York School. A network of influential collectors, curators, and dealers circled in his orbit,

as did a phalanx of young critics dazzled by the order he brought to the intellectual chaos of modern art.

Every artwork, be it poetry, literature, or painting, is involved in an ongoing dialogue about the nature and function of art itself: What is beauty? What do we mean by truth? What is art's function? As New York became the center of the art world, Greenberg's ideas were the maypole around which that conversation danced.

By the midsixties he was Mr. Modernism, traveling the world as the State Department's cultural ambassador. From Saskatchewan in Canada to Capetown, South Africa; from Perth to Tokyo, Toronto, London, Rome, Berlin, and cities in between, the phrase "Clem says," signifying direct contact with the almighty maven of modern art and allegiance to his point of view, was repeated like a mantra by artists and critics alike.

Greenberg captured mass media attention and used it to spotlight a talented but unwashed few whose strange art isolated them in wartime New York as if they were in a stockade. He was one of three key elements without which this art could not have triumphed when it did, but like Prometheus, the gifts he bestowed cut both ways. Once the lid of anonymity was removed, miseries plagued the artists involved, as well as the critic who brought them to public attention.

Greenberg became a very large fish in a tiny pool. His appetite for art was Rabelaisian in size but narrow in scope. In thirty years of active art-world involvement he championed fewer than twenty artists, all of whom worked more or less abstract. Those he passed over accused him of wanting to prescribe the direction ambitious art had to take. To them, and to the critics who supported them, he was evil incarnate. "Clem . . . was the enemy and most critics who were not his progeny (and some who were) had it in for him."[2]

Greenberg flew too close to the sun and suffered the prescribed fate. The godlike certainty with which he issued pronouncements, as if he alone had the capacity to discriminate good from bad, infuriated many, but for a long time that taste was almost unerring. Sooner or later those he singled out were recognized and lionized, and those less favored hoarded their resentment as fuel for his funeral pyre.

The torch was a September 1974 article in *Art in America* titled "Changing the Work of David Smith." The David Smith affair is emblematic of Greenberg's visceral engagement with the art and artists of his time. Grand convictions played a role and egos affected the outcome.

Greenberg first recognized and wrote about Smith's incipient greatness in 1943 when the artist was all but unknown and the critic at the start of his career. In 1947, before Smith had a following, a market, or a bank of

critical support, Greenberg singled him out as one of only two American artists to deserve the term "major." In time a friendship formed between these larger-than-life personalities, and for many years the critic was a welcome visitor at Terminal Iron Works, Smith's Bolton Landing studio in upstate New York.[3] They made an unlikely pair. Smith, a six-foot-four-inch bear of a man, was moody, expansive, and spontaneous. The hallmark of the critic's temperament was self-control.

Smith became known as the heroic sculptor of steel, but his first love had been painting, and he painted some of his small early sculptures. Circa 1960 he conceived of uniting—via color—these historically disparate media, and a series of massive polychrome sculptures followed. Today, painted sculpture is widely accepted, but in 1960 most viewers found it almost heretical. While Greenberg did not object to painted sculpture per se, he thought Smith a poor colorist and advised him to stick with his strength. The artist persevered, however, and the friendship grew strained.

Some artists struggle to come up with new ideas, and some to keep up with those they have. Smith was among the latter. Some artists exhaust one idea before moving to another, and some, like Smith, pursue several directions simultaneously. While experimenting with painted sculpture, Smith also explored the light-reflecting qualities of worked steel. Some of those sculptures Greenberg continued to think great. Their professional reputations remained intertwined.

In spring 1964 Smith had a major exhibition at the University of Pennsylvania's Institute of Contemporary Art (ICA). In his catalog introduction, Greenberg praised Smith as the "best sculptor of his generation," meaning anywhere in the world, but described the painted pieces as "vexed."[4]

A year later, showing off a new and not yet mastered motorcycle, Smith took a bad spill and hurt his shoulder. That evening, filled with booze and painkillers, he was crushed to death behind the wheel of his panel truck as he drove from Ken Noland's studio in South Shaftsbury, Vermont, to an opening on the Bennington College campus, just a few miles away. Smith and his second wife, Jean Pond, were in the middle of an acrimonious divorce, and their daughters, Rebecca and Candida, were still in grade school. Not long before, Smith had hastily drawn up a will on the eve of a court appearance connected to the divorce. Greenberg, Ira Lowe, a Washington attorney, and painter Robert Motherwell were named as executors, charged with managing his estate until his daughters came of age, and painters Kenneth Noland and Helen Frankenthaler as "artistic consultants."

Nine years later, the now famous *Art in America* issue hit the stands, its

entire "Issues and Commentary" section occupied by what, to the uninitiated, seemed like a dispassionate discussion of the sanctity of a dead artist's work. Written by Rosalind Krauss, a former disciple of Greenberg's, it documented the changed appearance of some of Smith's sculptures. Greenberg was mentioned only once, as one of three executors, but insiders knew he made the aesthetic decisions, and they knew the resentment Krauss harbored against them. Indeed, some had been presented with the same material Krauss used but had declined to pursue the matter.

Smith's large painted pieces, weighing two thousand pounds and more, were made during the last years of his life. He knew they were too large to store in the "tomb" (his sealed, protected basement), and he was not anticipating a market for them anytime soon. He told Dan Budnik, his official photographer, that he was designing them to stand in the fields around his home. Budnik had been privy to Smith's ongoing search for materials capable of withstanding the elements. "It was a tremendous thing to observe," he recalled. "It was Smith's great vision. The sculptures never again looked as good as they did when they were all in the fields around the studio. They needed each other and they needed the sky reflected on them if they were stainless steel and they needed the fall colors and the snow in the winter. It was as close as you can get to nature in a way. It's something that will stay with me forever." Budnik had periodically photographed Smith's sculptures, and Smith and his assistant, Leon Pratt, at work in the studio. After Smith's death he continued this practice, in some instances taking close-up detail shots.

Sorting through his slides in 1971, Budnik noticed extreme changes in certain pieces: "It became clear that quite a few Smiths were no longer anything like the way the artist had left them." The photographer was then living in Colorado, but he came east from time to time and on his next trip visited Bolton Landing. It was summer and Jean Pond was there with Rebecca and Candida Smith. Pond saw Budnik when he came back to the house after completing his early-morning inspection and invited him in for coffee. Budnik told her that the surfaces of the painted pieces were deteriorating from exposure to the weather and she innocently responded, "Oh, that's what Clem wants to happen."

Budnik called Clem, who told him that the famous Greek sculptures had had their paint removed and were still great works of art. Clem said the sculptures were his responsibility and advised Budnik to stay out of it. Worried by the extent of the erosion, however, Budnik persisted: "I don't think Smith realized how severe those winters were. He used to brag about the fact that his sculptures had more paint on them than a Mercedes; that they would last a lot longer than a Mercedes. But in those winters even a Mer-

cedes wouldn't have lasted very long: rain turning to ice, fifty-mile-an-hour winds. Nothing could survive that way. But Smith didn't live to see those effects."[5]

Budnik put together before-and-after slides of the altered pieces and showed them to various critics and editors powerful enough to do something if they chose: Hilton Kramer, chief critic for the New York Times, Thomas B. Hess, the man who made Art News the leading art magazine in the country. These people knew Greenberg and, in some instances, shared his opinion about Smith's painted pieces. They were reluctant to get involved. Budnik was about to give up when, at a party one night, he met Elizabeth (Betsy) Baker, the newly appointed editor in chief of Art in America. Baker recognized Budnik's tale as the kind of hard-news story rare in the art world and agreed to do something with the photographs. She also realized that her chief problem would be finding a writer with the guts to challenge Greenberg. Baker knew that Krauss, a former acolyte, was out of favor. She asked Krauss to lunch, showed her Budnik's slides, and said, "You're the Smith expert. Will you write something?"[6]

Krauss was in an awkward position. Earlier in the sixties, while working on her doctorate in art history at Harvard University, she wrote reviews for Artforum and flew into New York once or twice a month to see shows. Greenberg was much admired at Harvard during those years, and Krauss arranged an introduction through a mutual friend. One of his opening gambits—"Spare me smart Jewish girls with typewriters"—proved prophetic.[7]

Greenberg and Krauss hit it off, and she became part of his inner circle: "Clem was always at home during the day. . . . Whenever I was in New York, I would go up to his apartment around four or five P.M. and have a drink, and Clem would tell me where it was at. . . . Clem was interested in discipleship. He liked to have young people around who looked up to him. He liked to speak in aphorisms and guide the people he trusted."[8]

If she was staying in New York overnight, she often joined Greenberg and some of the artists—Kenneth Noland, perhaps Michael Steiner, or Jules Olitski—on their nightly prowls: dinner followed by dancing at Dom, a nightclub they frequented on St. Mark's Place in the East Village. But by 1968, Krauss recalled, their relationship was growing problematic: "By 1970 it was over. . . . Part of the terms for any discipleship involve a fundamental obedience to the line of the master. . . . I was required to voice agreement and I got to the end of being able to do that . . . we had a big rift." The break was messy, prolonged, and ugly, and her resentment widely known. Still, when Baker approached her, Krauss hesitated.

Her reputation as a Smith expert derived from her association with

Greenberg. Not long before meeting her, he had been asked to recommend someone to prepare Smith's catalogue raisonné and had steered the plum to another of the graduate students in his circle. After meeting Krauss, however, he had a change of heart. Smith's catalogue raisonné was Krauss's dissertation project, and the grounds for her standing as a "Smith expert." Worried about the consequences if she wrote the essay, she asked Baker for time to think it over.

Years later, Krauss recalled how formidable Greenberg was and the reasons for her concern: "By 1959 or 1960 Clem was organizing exhibitions. People understood he had a relationship to the material that was very powerful. In the sixties and well into the seventies Clem exerted an enormous amount of power, and this had to do with the fact that many collectors were buying according to what was the direction of his taste. Museum directors and curators were following the same thing. He had a huge influence. There was a network of power firmly in place. . . . Curators and dealers, especially those who didn't have their own access to the scene, took his word as law."[9]

Aware that her debt to Greenberg as well as her bitterness were well-known, Krauss worried that anything she wrote would be seen as "a patricide." She felt, however, that his actions were questionable and that calling attention to them was the right thing to do: "Clem had made no secret of his belief that Smith's decision to paint sculpture was wrongheaded, aesthetically bad. . . . Clem really believed he had a better eye and better judgment than certain artists, and it was an open secret that he believed in the idea of studio criticism, where a critic spends time in an artist's studio, while the artist is at work, and makes suggestions."

Art was Greenberg's passion, but during the period when he wrote the criticism on which his reputation rests, he made his living as a literary editor, first at *Partisan Review* and then at *Commentary*. By 1960 there was talk that Greenberg did with artists what he did with writers. He looked at their work and offered comments. Soon there were whispered rumors about a critic who had the temerity to make suggestions to an artist.

In Western tradition painters and sculptors occupy, or used to occupy, a special status. They were instruments of the muses and their art was sacrosanct. Writers might work with editors, and performance artists create in tandem with choreographers and directors, but an unwritten code declared the work of painters and sculptors inviolate. You could think or write what you liked, but to suggest an "improvement" implied that the "editor" considered himself more important than the artist. Krauss knew the animosity felt toward Greenberg by artists whose work he did not regard sympathetically, and she knew they considered his studio edits the

price of the Faustian bargain he exacted in exchange for his support. What made her piece so explosive was that Greenberg was "caught" doing literally what he had long been rumored to do figuratively.

"Changing the Work of David Smith" was prefaced by an editorial note framing the issue in moral terms: "The photos on these pages were taken by the photographer Dan Budnik over a period of eleven years. An extraordinary documentation, they represent startling alterations of some works by David Smith. They raise important questions about the integrity of works of art and the responsibilities of the people who take care of them."

Krauss formulated her essay in terms of the questions posed by the reintroduction of painted or polychrome sculpture, opening with a description of the startling impact made by the massive, painted Greek gods pictured in Jean-Luc Godard's 1963 film *Contempt*. Reminding her readers of the visceral distaste with which these "blue-eyed figures with garish red mouths and mahogany hair" were greeted, she likened the powerful, even atavistic feelings they aroused to those that initially greeted Smith's sculptures.

When the artist began exploring the formal possibilities of "painted three-dimensional" sculpture, he knew he was breaking with a centuries-old European tradition, albeit a tradition based on a mistaken belief. By the time classical sculptures were rediscovered, their surfaces had been bleached of color by exposure to the elements. Krauss likened the aversion greeting Smith's polychrome pieces to the shock felt when archaeologists discovered that the Greeks, like all pagan cultures before them, routinely painted their gods and goddesses in brilliant and probably symbolic hues. She implied that the person or persons responsible for removing Smith's paint suffered from a similar antipathy.

Anticipating Greenberg's retort—that Smith had often agreed with him about aesthetic matters—Krauss cited the sculptor's response when, five years before his death, he learned that, at a collector's request, the dealer Leo Castelli ordered the color removed from a painted piece he owned.

In simultaneous letters to *Art News* and *Arts* magazine during the summer of 1960, Smith disowned the 17-by-44¾-inch sculpture: "I renounce it as my original work and brand it a ruin," he wrote. "My name cannot be attributed to it, and I shall exercise my legal rights against anyone making this misrepresentation. . . . I declare the sculpture's value to be only its weight of 60 lbs. of scrap steel."

Accompanied by four pages of before and after photographs, the *Art in America* article revealed changes in Smith's painted pieces. Krauss's carefully worded text emphasized that paint had been stripped from some and that others had been left outdoors for the wind and weather to do the job.

* * *

It is not uncommon for magazines to extend the courtesy of prior notice before publishing attacks on prominent members of the community, but Greenberg was not alerted. He was at his home in Norwich, in upstate New York, when the calls began to come: "Before I saw the story in *Art in America*, Robert Hughes and Hilton Kramer called up. And that was when it started out. I didn't collect myself in time."[10] Like Krauss, Kramer had been privy to—and often shared—Greenberg's opinions about Smith's painted pieces. Like Krauss, he knew that Smith's studio was too small to house the large works and that the artist intended them to remain out-doors. When Budnik first showed him the photographs, Kramer declined to act.[11] Once the story came out, however, the issued raised had to be addressed.

Kramer devoted three major columns to the subject in the pages of the *New York Times*. He quoted dealer David McKee, then affiliated with Marlborough Gallery, which represented the Smith estate: "I remember, all the time I was at Marlborough, Clem expressed the opinion that the Smiths would look better 'in their natural state.' " McKee confided to Kramer that Clem, as he was always called, told him he had allowed one sculpture to be stripped "and that . . . the piece looked great" as a result.[12] Hughes wrote about the scandal for *Time*. Interest extended far beyond the art world. Clem's daughter, Sarah, eleven at the time, said she first realized her father was "somebody special" when everybody at her school started talking about what he had done to the work of a dead artist.[13]

Ira Lowe and Robert Motherwell, Greenberg's coexecutors, disclaimed all responsibility. They issued a statement denying all knowledge of aesthetic decisions involving the estate and dissociated themselves from Greenberg's unconscionable activity: "Any change of any kind in any artist's work is inappropriate and should not be done."[14] Years later Lowe refused even to acknowledge that the executors discussed the incident among themselves after the storm broke.

The ruckus aroused by Krauss's piece was followed by a reaction of epic proportion. Not only Greenberg but those associated with him were engulfed. Critics and academics vied for the position of Greenberg killer, outdoing one another in excoriating the godlike arrogance of Clem's conduct as a critic. The feeding frenzy that ensued lasted so long it became institutionalized. "Clembashing" became a cottage industry. Entire careers were built on little more than trashing the straw man put forward to represent his views. Once unleashed, the hostility continued at fever pitch for decades. In 1989, Pulitzer Prize–winning author Elizabeth Frank opened her review of his collected essays by observing that "Clement Greenberg

has to be the most hated man in the New York art world."[15] No one accused her of overstating the case, and Greenberg himself quoted her with a certain perverse pride.

With the exception of William Rubin, chairman of the Department of Painting and Sculpture at the Museum of Modern Art, no art-world figure of substance spoke in his defense, and in accord with his motto, "Never complain, never explain," Greenberg remained silent.

History records one other example in which a critic, after the death of an artist whom he had championed, destroyed work he judged inferior. That precedent involved the great English critic John Ruskin, who as a young man stood against the combined vision of his colleagues to praise the atmospheric landscapes, "airy visions, painted with tinted steam," of J. M. W. Turner. Following Turner's death in 1851, opposition to these landscapes increased, and Ruskin, to protect the reputation of an artist he admired, as well as his own, broke into the artist's studio and burned paintings and drawings he deemed unworthy. When the subject of Smith's sculptures was raised, Greenberg immediately cited Ruskin as a precedent.

Where Ruskin acted surreptitiously, however, Greenberg was so secure in the rightness of his position that he called the attention of Smith's friends and family to the gradual changes created by wind and weather. And so great was the prestige he commanded that it was years before the Smith family questioned his judgment.[16]

Despite the dispassionate voice adopted, Krauss's personal feelings toward Clem came through in her subtle elision of two independent issues. In her catalogue raisonné she correctly identified the sculptures from which Greenberg later ordered paint removed as primed but unfinished. In *Art in America* she allowed readers to infer that paint had been stripped from finished pieces: "The serial shots on these two pages represent the stripping of paint from works on which Smith had carefully placed multiple layers of white paint over a yellow undercoat. . . . In committing (or permitting) these actions on Smith's work, the executors force us to confront extremely serious issues. The primary and most dramatic issue involved direct intervention to change work."

By finessing the difference between primer and finish paint Krauss painted a sharp black-and-white picture of the ethical issue. To this day, Greenberg's name is immediately associated with the removal of paint from Smith's finished sculptures. Greenberg's actions were not that clear-cut, however. Smith's practice was to complete the sculpted forms of pieces he planned to paint and then cover the metal with a protective coating consisting of multiple coats of primer until he decided how he

wanted to proceed. Primer peels, however. Even multiple coats of it flake off after a short period. It cannot be considered a permanent solution. Smith's executors had to make a decision with regard to the six or seven primed pieces left when the artist died. They had three choices: replace the primer with finish paint, i.e., treat the pieces as finished painted sculptures; remove the paint, cover the surface with a long-lasting protective coating, and treat them as finished steel sculptures; or maintain them as unfinished works by continually stripping and repriming them. It was a judgment call and Greenberg did what he thought best. His lofty refusal to respond to Krauss's essay, however, meant this information never entered the discussion.

Clem's only rejoinder came in the form of a postscript to a letter to the editor of *Art in America* some four years later.[17] Calling attention to Krauss's primer stratagem, he concentrated on the psychological heart of the matter, chiding her for "bad faith" and suggesting a lack of loyalty, a basic ambivalence in her feelings toward him. He accused Baker of colluding with Krauss to distort the known facts of the matter and, as a final thrust, quoted the Roman comic playwright Plautus to the effect that "*mulieres duas pejores esse quam unam*" (two women are worse than one).

In her riposte Krauss defended her original obfuscation, arguing that "primer is paint." She indirectly acknowledged that the issue was a judgment call rather than a breach of ethics and parried with a brief in favor of leaving unfinished works in the state in which they were found. In a neat jab of her own, she concluded by reminding her readers that the passage from Plautus quoted by Greenberg was a debased version of a line from Aristophanes. "Plautus," she wrote, "knew a vulgar line when he quoted one."[18]

Lost in this stylish fencing match was the more noteworthy issue Krauss had originally raised: "The second issue is negligence—lack of protection or lack of restoration of fragile paint surfaces, the loss of which will ultimately affect the sculptures just as basically as deliberate stripping. . . . For Smith's own vigorously gestural paint application, once lost, is not recoverable."

Years later, pushed to the wall, Greenberg was feisty and unrepentant. When told that Rebecca Smith Stevens, the older of Smith's daughters, remembered him pointing to sculptures standing in the fields—long after the *Art in America* piece had been published—and saying, "This is going to get better. This is going to be a good piece when the paint comes off," he said, "Okay. But I didn't take the paint off. I only took the primer off. . . . You can ask Helen Frankenthaler. She knows how David went along with me . . . when I suggested things. He didn't mind listening to me when he

was alive, so—so now he was dead! I didn't tell him what to do, but one of the Tank Totems I said, 'Leave the head off,' and he did that. And he did a series out of that."

Greenberg also insisted that he had no choice, the sculptures were too large to be stored in the house. When it was suggested that he could have built a structure to house them, as he did later, his response was not exactly guilt ridden: "Well, so I let that slip [sardonic laugh and short pause]. I didn't let it slip. David Smith did one good color piece, the Helmholtz one [*Helmholtzian Landscape*, 1946]. It was always provisional, his color." Asked if he had any regrets, he replied, "I did think in the end, well, maybe I should have just laid off instead of making his sculpture better."[19]

2

An Inauspicious Beginning

Clement Greenberg was born January 16, 1909, on Alexander Street in the Bronx. He was the first of three sons born to Dora Brodwin and Joseph Greenberg, Polish Jews of Lithuanian extraction who met in New York and married in 1907. He was followed by Sol in 1913, Martin in 1918, and a half sister Natalie, in 1928. Yiddish was his parents' first language, which Clem learned at the same time he learned English. He also learned something harder to define: There was a harsh duality at the core of his nature before he entered grade school.

Dora Greenberg and her sister, Lily Staff, married within a year of each other. Their first children—Clem and Sonia—were born only months apart. The families were close and, with sundry other relatives, often vacationed together at oceanfront resorts in Far Rockaway or in the Catskill Mountains in New York State, where the women and children stayed for the season and the men worked during the week and joined them on weekends. During the summer of 1914, when Clem and Sonia were five, the extended clan chose a hotel in the Catskills that was also a working farm. The farm animals provided one of Clem's few happy memories of his childhood: "There were cows, chickens, horses. I remember being put on top of a farm horse that was dragging a plow. . . . That was a big experience. . . . The animals would make me drunk, you know."

Sonia remembered Clem as a loner who refused to play with her or the other children. And she recalled the day she watched in horror, spying on him from a distance, while he tracked and killed a goose, battering it to death with the handle of a shovel. The incident was sufficiently traumatic for both to recall it vividly some seventy-five years later. His account differed from hers in only one detail: "I took an ax and went after him. . . . Geese can attack small children, you know. But I don't think that's why I went after him. It was cruel."[1]

Not many preschool children can imagine beating to death a living creature close to their own size. Few could conceive of such a plan, and fewer still have the anger, will, or determination to carry it through. The

love/hate paradox implicit in Clem's intense response to sensuous experience—the animals made him "drunk" with pleasure, and he bludgeoned one of them to death—prefigured an adult personality prone to similar paradoxes. Martin Greenberg, nine years Clem's junior, recounted a pertinent memory: "When I was a teenager, Sol and Clem and I would sometimes play ball or touch football . . . and sometimes Clem would become enraged. When Sol got mad at me, I knew he wouldn't hurt me a lot, but I didn't know that about Clem." Much later in his life girlfriends used words such as "cruel" and "sadistic" to describe him.

Dora and Joseph Greenberg were born in the 1880s in parts of Polish Lithuania then under Russian control. In 1881 the reform-minded tsar Alexander II had been assassinated and the famine that followed dominated their childhood experience as food shortages exacerbated ethnic differences. It was at that time that the word *pogrom*, Russian for "riot," came to refer specifically to bloody attacks on Jews by local townspeople or peasants, either with the connivance of the local government or without hindrance from its soldiers.

Urban Jews, such as the Brodwins, lived in villages called *shtetls*, located at the edge of the city. The children were not allowed to attend the city schools, and Clem's mother, like others in her shtetl, was educated at a *cheder*, a shtetl school. The Greenberg family lived in the country. They were *pachter*, moneylenders. "The Polish nobility were often terribly poor. They were always trying to court rich heiresses, so they needed money for a dowry and to maintain a carriage and horses," Clem explained. His father's family loaned money to impoverished Polish gentry in return for leases on their estates (taken out in the name of a local peasant since Jews were not permitted to control property) and operated the taverns or shops located there.

For a time the Greenbergs were sufficiently prosperous to remain untouched by the chaos, but after the death of Clem's grandmother Sarah, for whom his daughter was named, the family fortunes declined. Joseph, Clem's father, was forced to abandon his studies and leave home at the age of eleven. He went into the nearest town, Brest Litovsk, and got a job in a dry-goods store where, at night, he was allowed to sleep on one of the shelves. Many times the eleven-year-old worked all day and went to bed with an empty stomach. "My father was knocked down in the world," Clem explained, accounting for his parents' pessimistic attitude toward life.

The experiences of Clem's parents, which were not uncommon, politicized many Jews, Joseph and his brothers among them. They abandoned the rituals and traditions of Jewish life and became "atheistic socialists,"

Clem revealed. Eventually, a large number of Jews fled Russia and Poland, some as a result of persecution but many, especially the young, because there was no future for them. Dora's family made their way to New York in 1899 when she was eleven. At sixteen, following in the footsteps of his older brother Isadore (Isie), Joseph Greenberg crossed the border into Hungary and boarded a boat for England. "You couldn't stay in England though," said Martin Greenberg, picking up the narrative. "There wasn't any kind of opportunity. Some Jews went to South Africa, many to the U.S. In 1880, there were something like eighty thousand Jews in the United States; by 1910 there were roughly two million. The movement was one of the largest of its kind."[2]

The twenty-year-old Joseph, again preceded by Isie, landed in New York in 1904 and quickly found work as a buttonhole maker in a clothing factory. By the time Clem was born, Joseph had acquired a small "stationery" or "candy" store on the west side of upper Broadway. He sold writing supplies and penny candy and received the income from a lucrative paper route attached to it. Clem's first memory was standing on the counter of that store identifying comic-strip characters that his father pointed out in the newspaper. Joseph soon acquired other stores.

Sonia often heard the grown-ups talking about Joseph's business acumen, the way he picked up "stationers" that were going under, made them successful, and then sold them for a profit. Isie Greenberg, meanwhile, had settled in Norfolk, Virginia. By 1914, the women's wear business he started had grown too large for one person to handle. Isie asked Joseph to join him as a partner.

Clem was only five when his family moved to Norfolk, but the rich detail of his visual memory is impressive: "We took the train and then the ferry. I remember the dock in sunlight and the stevedores—black mostly. We lived in downtown Norfolk and I started school there." Norfolk, a big transhipping port, was booming because of the war. Clem remembered having his appendix removed and choosing his own books from the library; *Tom Swift* was a particular favorite. Joseph and Isie called themselves the OK Brothers and their store, OK Outfitters. Although the family stayed in Norfolk only six years, it was a significant period in the building of their fortunes. "My father had a clothing store and then he got another one" was Clem's laconic description. Sonia, whose father was a successful lace manufacturer and a Yiddish poet, supplied the details: "They ended up owning five stores, in Norfolk, Newport News, and Richmond. Uncle Joe used to do the buying. He had marvelous taste. Aunt Dora would sometimes come to town and stay with us, or they'd come together and stay at the McAlpin, a fine hotel. Uncle Joe was a man of prestige. He knew business. He knew

all the manufacturers. He used to get dresses—very often the same one—for Aunt Dora and my mother, and he got dresses for me too, beautiful stuff. . . . The boys' clothes were always the best. They had to be well dressed. There was no sloppiness about them. Clem, for example, was always immaculate."[3]

Dora doted on her firstborn. Sonia, who enjoyed listening as the women gossiped on the beach during the summer, recalled that after Sol and Marty were born, when Dora was absent, the talk often centered on the way she favored her oldest son: "Do you know she makes special malted milks for him in the morning and gives it to him in bed?" Sonia had seen this herself: "Aunt Dora had a malted milk machine in her kitchen. She had malt in the form of powder in a jar, and syrup. . . . Clem was her favorite, everything was for Clem. She didn't give Marty or Sol malteds in bed. Only Clem. My mother said, 'She's such a *meshuggeneh* mother. Can you imagine doing that for one kid and not for the others?' And I thought, 'She must love him better than anybody else.' "

Martin remembered his mother as cold and detached, but Clem described her as beautiful and believed she understood him in a way that his father did not. But Joseph was the dominant parent, as Clem's tactical analysis of his mother's position reveals: "In the stereotypical Jewish family the mother was the prime minister and the father the king. My mother wasn't a prime minister. My father did and dominated everything. . . . I was never close to him, though. He didn't know what to do with children. He couldn't abide children."

Joseph treated his sons scornfully. "If you didn't know something, it wasn't just a case that you didn't know it, you were a fool," Martin explained. "Knowing" was crucial because it affected the way you appeared to others. "Front," as Clem called it, was all-important to Joseph. Clem remembered with pleasure occasions when his father took him to the circus or a baseball game, but felt that he only did it for "show."

Joseph and Isie worked well together and OK Outfitters flourished, but after six years Joseph became restless. He sold his share of the business to Isie and moved his family to Brooklyn, where Clem was enrolled in PS 134. "I remember getting hooked on poetry. Alfred Noyes was my favorite: *Go down to Kew at Lilac Time, it's not so far from London, The Barrel Organ*, and *The Highwayman*." Somerset Maugham's *Of Human Bondage* made a big impression: "The hero's love affair, I suppose, was what attracted me. He was handicapped, like Maugham himself. I think Maugham had a clubbed foot, like Byron."

Joseph initially invested in five-story apartment houses on Ocean Parkway, but he soon entered into a partnership with a manufacturer of metal

casings—lipsticks, compacts, cosmetic containers. In retrospect, his sons interpreted the move back to Brooklyn as motivated by Joseph's need for status. No matter how many stores he owned or how prosperous he became, if he stayed in women's wear, he would never be anything more than a lowly shopkeeper. A successful manufacturer, on the other hand, commanded respect in the community.

The manufacturing plant thrived but Joseph remained discontent. There was little laughter, affection, or easy enjoyment in the Greenberg home. "We were better off than many," Martin observed, "but we were enveloped in my father's sense of fear. He was a man who worried all his life, who was afraid all his life . . . as though he didn't know where the next meal would come from." The boys were given mixed messages. As they grew older, they empathized with their father's fear and uncertainty about the future but were also conscious that the specter of imminent financial ruin was not realistic. "My father thought of us as poor Jews. And Clem felt very strongly about this," Martin explained. Clem understood it to mean that certain avenues were closed to him, that there were limits to what he could do or how far he could go. "It drove Clem crazy," said Martin.

Joseph blamed himself when things did not go his way and was no less demanding toward his sons. He was rarely sympathetic or compassionate. He wanted everything done his way and did not appreciate questions. "He was the expert on reality," Martin observed caustically. "His response to any kind of questioning was 'Och, my God, you don't understand the way the world is.' "

In the Greenberg house "prudence" was a primary virtue. As foreigners and underdogs, immigrant Jews learned to be alert to what others thought of them. Being prudent meant not calling attention to yourself. It meant prizing the ability to fade into the background. Dora and Joseph resolutely refused to reward any accomplishment other than the accumulation of money, which represented survival. If one of their children was proud of something he had done, he was told not to get above himself or life would slap him down. "Being an intellectual was the best thing you could be, but it was too good for the likes of us," Clem recalled. "We shouldn't shoot for that. But making a lot of money was pretty good too. We were supposed to earn our way the hard way, though. The guy pushing the clothes rack on Seventh Avenue was what we called a shipping clerk. That's what we were supposed to be—or at least the way we were supposed to start out."

Dora was sickly and desperately unhappy. "I'll never forget, Fanny Brice did a thing on radio about the Jews at Coney Island," Clem recalled. "There was such a protest that the tape had to be cut, but I heard the original. It hurt because it reminded me of my mother. The screaming and hol-

lering. God, it hurt. Because it was so true." Values were Dora's bailiwick, and the layered message she imparted affected Clem throughout his life. She imputed motives to him and then condemned him for feeling or thinking the way she imagined he did: "My mother was a fanatic for the truth. She overdid it. . . . The main thing was to be on the level. You weren't to tell lies. Not because it was wrong but because you would get caught out. It was imprudent. The emphasis was on being truthful in the sense of having no pretensions. . . . In the name of being truthful our ambitions were slapped down. If we wanted to be writers or something like that, then we put ourselves at the risk of being phonies. . . . She used truth aggressively too. She'd say this is true about you and then get angry at you for it."

Clem believed his mother had the better "character" but he identified with his father. As a young man he looked up to Joseph and once described him to a friend as "noble": "There was his energy and ability and he was a good provider." As Clem grew older, however, admiration gave way to resentment: "I don't want to go into my father for this book. I've been in rebellion all of my life. Rebellion against him." Although Sol and Martin both made peace with Joseph, or some semblance of it, Clem never did. In his late seventies he had recurrent nightmares in which he pounded the mattress, bellowing at the father who refused to accept him.[4]

Joseph and Dora worried about the big things and left the boys to fend for themselves on day-to-day matters. In his eighties Clem was still indignant about their lack of concern: "You know, Jewish parents are supposedly protective. Mine were and they weren't. I went into Manhattan by myself on the subway starting when I was twelve. I learned to swim by myself at the age of ten. Marty, the best athlete in the family, taught himself to swim at five in the surf at Far Rockaway. Nobody watched him. My parents didn't take me to a doctor, either. You got Ben-Gay or a hot-water bag or an ice bag. When I was twelve or thirteen, I had a bad headache for a long time. . . . The next year I got it again. I remember finally being taken to a doctor over on the other side of Gravesend Avenue in Brooklyn. I used to love diving in the surf and the headaches were from the water. The doctor said, 'He should wear earplugs in the water and give him an aspirin.' We'd never heard of aspirin before."

Sonia remembered Clem as a sad, "funny-looking kid" with big ears, a big nose, and "eyes so dark they looked almost black." He was never close to anyone in his family but had a few friends at school, among them "Danny" Fuchs, later a well-known novelist and screenwriter. Clem spent much of his time alone and drawing was one of his favorite pastimes. He recalled drawing "obsessively" from age four and a half on: "My uncle Harry, my father's half brother [different mother], liked to draw and he encouraged me."

Clem's drawings were part of Martin's earliest memories: "I remember him drawing torsos on yellow paper and in book margins. . . . He used Conté crayons and loved umber, a kind of terra-cotta color."

On the one hand Clem was a little prince, pampered, dressed immaculately, brought malted milks in bed; on the other, he was a "bad" boy, a disappointment to his parents. The reasons were not specific, such as doing badly in school: "My parents didn't take enough interest to know how I was doing in school. They criticized me for not being grown-up. . . . I didn't know for sure what they wanted, but I didn't want to be what I thought they wanted."

One thing they wanted was for him to be more financially enterprising, and this became the area in which he rebelled. While in college Clem worked one summer as a lawyer's clerk in the office of a family friend, and two as a waiter at Camp Mohaph, near Port Jervis, one hundred miles from New York City on narrow, winding roads, where Sonia's future husband, Otto Rosahn, was chief counselor. "By the time I went to college my father would reproach me for not working my way through, as if there was any need to," Clem observed scornfully.

The final misfortune in a miserable childhood came in 1925. Dora had suffered for some time from a painful and somewhat mysterious ailment diagnosed as a form of blood poisoning. She liked to sew and her family assumed she had pricked herself with an unclean needle. When Clem was fifteen, her condition worsened and she was in and out of the hospital several times. Dora was sufficiently anxious about her firstborn's well-being that, before entering the hospital for the last time, she enrolled him in Richard Lahey's life-drawing class at the Art Students League in Manhattan. From March to May, Clem took the subway into Manhattan two nights a week and attended classes. As his mother's condition worsened, however, he lost interest.

Clem was sixteen in 1925, the year Dora died. He claimed to have been more or less untouched by the event, but his behavior belied his words. Sonia recalled her shock when she realized Clem was wearing his mother's wedding ring: "A long time after Aunt Dora was buried, Clem wore that ring."

The severity of the loss was compounded when Sonia's mother, Lily, told the boys she blamed Joseph for their mother's death. Her words not only created a permanent rift between the families, they increased the tension between Clem and his father. Clem was not sure what his aunt Lily meant, but he thought it was Joseph's coldness toward Dora, his lack of demonstrated affection, she had in mind.

Joseph's aloof behavior toward his wife and children doubtless stemmed in part from the harshness of his childhood, but there was a more immedi-

ate factor. Although his sons never knew it, Joseph had become entangled in a classic love triangle soon after arriving in New York.

Years after Dora's death, Sonia's mother revealed to her that although her aunt Dora fell in love with her uncle Joe at their first meeting, it was she, Lily, whom Joseph loved. Only after Lily refused him did Joseph propose to Dora. "Uncle Joe wanted my mother, but when she decided to marry my dad, he married her sister," Sonia revealed. "My mother told me, 'Aunt Dora knew.' All her life my aunt Dora knew and I think it embittered her."

Dora apparently believed Joseph would come to love her, but it did not happen. "I didn't know this until I was a grown woman," Sonia disclosed. The knowledge clarified many things for her. Joseph had always been stingy with money and affection where Dora and the boys were concerned, but he bought Sonia "fabulous dolls and pretty dresses," and once he and Dora took her with them when the family went on holiday. Joseph occasionally invited Sonia out for lunch and once treated her to a ride around Central Park in a horse-drawn carriage. As a child Sonia assumed it was because her aunt and uncle never had a girl, but later she thought it was because she was her mother's daughter.

Immediately following Dora's death and Lily's accusation, Joseph transferred Clem from Erasmus Hall, a large public high school, to Marquand, a small private day school, also in Brooklyn. His instructions were that Clem was to complete his last two years in one. "My father was in a hurry to get me out of the house" was Clem's terse comment.

In those years the sons and daughters of most immigrant Jews went to City College in New York, which was free. A special few, such as Meyer Schapiro and Lionel Trilling, earned scholarships to Columbia University. Neither of these options was presented to Clem. In the fall of 1926, hair parted in the middle, wearing a raccoon coat and carrying a lacrosse stick, this son of "atheistic socialists" was shipped off to Syracuse University, where he promptly joined a fraternity.

Perhaps as a reaction to his mother's death and the events surrounding it, the man later regarded as the scourge of the New York art world was a somewhat unassertive college freshman: "I was timid, unenterprising. I just wanted to have fun. I didn't have much fun though. . . . I didn't have girlfriends in high school or in college. I was too backward. I had crushes but that's all." He did, however, have a gift for relationships and counted on friends to bolster him when in need. In high school and college he made fewer than half a dozen close friends, but they were people he could call on throughout his life.

Like many timid and introspective boys, Clem fantasized about being a sports hero, a big man on campus. He told his family that he was on the

Syracuse swim team,[5] and into his eighties he presented himself that way: "I was on my high school baseball team. . . . I was scattered in college in the beginning. I wasn't much interested in my studies, but I was on the swim team," he said in 1989. When pressed, however, shortly before his death, he admitted that he occasionally played baseball with friends in high school but was never on the school team. Moreover, he tried out for, but failed to make, the Syracuse swim team.[6]

He performed poorly during his freshman year and credited John Keats's "Ode to a Nightingale" with turning him around. Napping on the couch of his fraternity house one day, he woke with "a volume of romantic poetry on my lap. I read Keats's poem and I got hit by it. Now that's kind of melodramatic, but that was the turning point. I moved out of the fraternity house, studied English literature, learned German, and started to do well in my studies." He also read omnivorously. During summer holiday in his sophomore year he read *The Satyricon, The Iliad, The Odyssey,* and the plays of Sophocles, first in English and then in Greek, which he taught himself for the purpose. That same summer, while working as a counselor at Camp High Lake, near Honesdale, in northeastern Pennsylvania, he read *Don Quixote,* plays by Molière, the philosophy of Spinoza, and the poetry of T. S. Eliot.

Soon after Clem left for college Joseph married Fanny Greenberg, his spinster secretary and second cousin. A year later, Fanny gave birth to Clem's half sister Natalie. Joseph's manufacturing business prospered, but again he was unhappy. He and his partner had different ideas about how to proceed. "Mr. K had big ideas and my father was more cautious," Martin disclosed. Joseph was a deeply antisocial man, but he was acutely conscious of the suspicion with which foreigners, especially Jews, were viewed and went out of his way to be friendly, scrupulous, and aboveboard in his business dealings. "The gentiles would accuse the Jews of cheating them, so my father was superconscientious," Martin explained. In 1929, while Clem was still at Syracuse, Joseph concluded that his differences with his partner could not be resolved to his satisfaction. He and Mr. K agreed that one would buy the other out. Ever alert about appearing aggressive or "pushy," Joseph allowed Mr. K to go first. If he could come up with the money in thirty days, the business was his. "My father never thought he could do it. Mr. K always spent everything he got," Martin continued, "but on the last day someone loaned him the money."

Joseph sold out just as the Depression began and turned to real estate as a stopgap measure. The economy soon worsened, however, and he could not find a business in which it made sense to invest. "Gentile businessmen didn't want any part of real estate," Martin recounted. "It was too marginal and difficult. That's how the Jews got in." Real estate had little prestige,

and the comedown must have been humiliating for the status-conscious Joseph. "My father built up his holdings very painfully, doing everything he could by himself," Martin continued. "Sol and I didn't help because it was too painful. My father couldn't explain anything and he blamed us for not knowing what he wanted. If we did something wrong, he flagellated us with his tongue. There were big explosions of rage."

During the Depression, Mr. K filed for bankruptcy protection several times but managed to hang on to the factory. When the United States declared war on Japan and Germany, he retooled the plant to manufacture bullet shells and other casings. He "made it big" and Joseph never forgave himself. "It confirmed my father's sense of discouragement. He never got over it," Martin observed. For the remainder of his life Joseph blamed himself for the cautiousness that cost him his big chance. Clem agreed: "My father was very able but he was a piker. He made a million but he should have made ten."[7]

In June 1930, Clem was graduated with honors from Syracuse: "I made Phi Beta Kappa. Before, whenever I accomplished anything, my father would say, 'If I had your advantages, I could do that too.' But when I made Phi Beta Kappa, my father made a fuss about that. Phi Beta Kappa was something tangible. There the key was. He went and showed it all around." Clem returned to his family's three-bedroom apartment on Riverside Drive in Manhattan. Sol and Martin were still at home, and Natalie had to be moved out of her room to make a place for him. Aimless and unmotivated, Clem slept late, went to the movies, and discovered art's capacity to thrill him. He spent a great deal of time in museums and found that he could be deeply moved by the experience. He discovered he had a powerful visual memory and a capacity for fine discriminations. He thought about a job but did not exactly look for one. He argued with his father, behaved unforgivably toward the stepmother he loathed, but was fitfully attentive to his baby sister. For his brothers he had little but criticism. Martin remembered the interval as one of "awful and constant condemnation."

After five months in this crowded setting, Joseph moved his family to a seven-room house at 539 Ocean Parkway in Brooklyn. There Clem perfected his German and brushed up on the French and Italian he had studied in college. He gave his brothers unsolicited advice and distanced himself if they did not accept it.[8] He worked briefly for his father as well as for a credit clearinghouse, a Manhattan title company, and the *Brooklyn Eagle*. From the latter three, he was fired in short order but with compliments for his performance.[9]

He drew constantly and continued his reading. In the months after

graduation he read Dante and the German Leo Frobenius. He learned Portuguese so he could read Camões in the original, and he started work on a novel called *Sweet*. He tried his hand at short stories and a play, but was unable to get anything published. The situation at home remained strained. Conversation took place only at the dinner table, where Joseph and Clem argued, usually about politics.[10] Museums were free and paintings took him out himself. He visited the Metropolitan Museum of Art, the Museum of Modern Art, and the Brooklyn Museum several times a week.

Clem's influence on Martin, his youngest brother, was profound: "Clem. was the big brother. He brought books into the family, and books, with what they represented of Clem, became the center of my life. I remember [Joyce's] *Ulysses* on the top of his bureau. It was the famous first edition, illegal then, only licensed after a trial. Clem was responsible for the start of culture in my family, and my father certainly had respect for that. But my father always had a certain kind of jealousy about it too." The constant tension took its toll. Although famous now for his energy and vitality, during those years Clem was engulfed by a lethargy severe enough that he was sent to a doctor. One of Martin's most vivid impressions was walking into Clem's room at eleven in the morning: "The air would be kind of cold and stale. It never felt right. Probably it was depression."

Clem believed his childhood had placed limits on him, put a ceiling on how far he could go. His family interpreted this quite literally. "Clem held it against my father that he hadn't educated himself when he came here," Martin explained. Although Dora spoke unaccented English by the time Clem was born, Joseph, like the celluloid Jews of *Hester Street*, spoke the language with a heavy accent. "My father thought Clem looked down on him for having a Yiddish accent," Martin went on. "Several times he said to me, 'Clem is ashamed of me. He's ashamed because of my accent.'"

Clem's response to his unhappy childhood was creative. He made himself into everything his parents had told him he could not be. Psychologists use the term *reaction formation* to describe a personality unconsciously shaped to avoid revealing—to the self as well as others—aspects it deems unworthy. In Clem's case it produced a person highly critical of himself and quick to condemn others. At one level the fearlessness with which he challenged accepted opinion and the apodictic conviction of his authorial voice can both be interpreted as a denial of the parts of himself that left his parents unsatisfied; the boy who was ever alert to, but defiant of, the way others perceived him. On an equally unconscious level, the unparalleled animosity he incurred might be seen as a self-fulfilling prophecy, a bringing down upon himself the punishment his mother predicted for imprudent Jews who fly too high.

$$3$$

Metamorphosis

After two and one-half years, Joseph Greenberg devised a plan to get his firstborn son out of the house. In 1933 he started a wholesale neck-tie business with stores in cities from St. Louis to San Francisco. Clem was the top manager, a kind of traveling salesman. He spent several months in each city overseeing the start-up operation and drumming up new business. He threw himself into the enterprise wholeheartedly and soon knew more about neckties than one might have thought there was to know. St. Louis was his first stop. The store thrived and Joseph was proud of his son.

But the Depression deepened and Clem's enthusiasm waned. It is unclear which came first, but the business went downhill. Clem learned that he loved traveling and exploring new places, particularly bars and museums, and that he had a penchant for making friends, especially with women, and for falling in love. In San Francisco he met Edwina "Toady" Ewing, a twenty-six-year-old divorced librarian and a well-bred WASP who counted Abraham Lincoln among her ancestors.[1] Although Clem often complained about his father's lack of concern for him, his oddly heedless behavior at this juncture of his life suggests a young man with lit-tle concept of what it meant to assume responsibility for himself.

Despite the fact that the necktie business had been in extremis for months, Clem married Toady after a three-week love affair. Two weeks later both the business and his income were things of the past. Joseph offered bus fare if Clem and Toady wanted to settle in New York, but nei-ther housing nor financial support. Clem and Toady moved in with Mrs. Ewing, who lived south of San Francisco in beautiful Carmel, then a small, arty community with dirt paths and pine forests. Clem got a job with a local newspaper but was again fired after a week. "I was incompetent. I was too screwed up. I wasn't grown up yet" was his explanation. He next tried his hand at short stories and accumulated a tidy packet of rejection letters.

At that time, young men of an intellectual bent aspired to be artists, most specifically poets. Clem had written poetry for years, and he now submitted a poem to *New Masses*, where it was accepted for publication. Toady, mean-

while, was six months pregnant and Mrs. Ewing their sole source of support. Her patience with a son-in-law who could not keep a job was fast running out. The situation worsened and Clem accepted his father's offer of bus money and returned to Brooklyn, another large apartment on Ocean Parkway in which the Greenberg family then lived. The idea was that he would find a job and an apartment and Toady would move east.

They wrote one another daily. For Knight Publications Clem translated *The Brown Network: The Activities of the Nazis in Foreign Countries* from German into English and was one of three translators for *Goya: A Portrait of the Artist as a Man.*[2] He got part-time work assisting some teachers in their effort to write a textbook and tried his hand at short stories, two of which were published in *Esquire*. (He was ashamed of them, used a pseudonym, and insisted he could not recall the titles.) Meanwhile he read Sophocles and Aeschylus in the original Greek (with the aid of a dictionary), read the Old English version of *Beowulf, Martin Chuzzlewit,* and everything he could find on Pancho Villa.

On September 24, 1935, "Sacramento 1935," his only published poem, appeared in *New Masses*. Almost immediately, it was denounced as a plagiarism; a slightly revised version of a poem by Mary de Lorimer Welch that was published in *The New Republic* two years earlier.[3] For several weeks, letters went back and forth in a publication widely read by his family and their friends. Clem denied the accusation but could not explain the correspondences between the poems. Worse yet, Welch lived in Carmel, where everyone knew everyone else, at least by sight.

Clem staked out the moral high ground: "This is too close to be a coincidence. Something else is involved here, and I'll be damned if I know what. . . . Either there are mystical correspondences between people or else I'm an out-and-out plagiarist. Well, I know what I am."[4] The similarities were undeniable, however. In "The Harvest" Welch wrote, "The stem is rotten on the root / And the seed on the stem; / Store away the meager yield . . ." "Sacramento 1935" read as follows: "The stem is rotten on the root / And the seed on the stem. / Go store away the meager yield . . ."

Reconstructing the situation, Clem concluded that he must have been "hit" by the poem when he first read it and copied it into his notebook, where he came on it again two years later. Assuming it was his own, he reworked it slightly, sent it to his brother Sol for suggestions, and then to *New Masses*.

This, apparently, was the last straw for Mrs. Ewing. When his son Daniel (Danny) was born, Clem wanted desperately to be with him. On the strength of his two published stories Joseph Greenberg bought his oldest son a typewriter and promised him $25 a week, a sum it was still possible to

subsist on, so long as he kept writing. Clem returned to California where it quickly became apparent that Mrs. Ewing wanted no part of him and Toady, who did not like being a mother, had found others to divert her. After a brief stay he pledged himself to contribute to their support and returned to New York and his father's apartment. He succeeded in earning enough from his writing to send his son expensive gifts on occasion and Toady infrequent checks for $50 but nothing more. In 1936, Clem and Toady divorced and she soon married for a third time, although this union, too, lasted less than a year. Mrs. Ewing remained Danny's prime caretaker and sole financial support.

Guilty and unhappy, Clem tried to find work. He had learned to ride horses at Camp High Lake and now rode almost daily in the park near his father's home, grateful for the release it provided. Finally he succeeded in acquiring, and holding on to, a full-time job with the U.S. government, first as a clerk in the Manhattan office of the United States Civil Service Commission and then with the Veterans Administration.

Meanwhile, Clem's cousin Sonia had married. She and her husband, Otto Rosahn, lived in Greenwich Village where they were "at home" to their friends on Sunday afternoons. Periodically Clem took the train into Manhattan and attended one of these gatherings. They were very casual, Sonia later explained: "No one had any money, but a huge bag of popcorn cost fifteen cents and cider only twenty-nine cents, so that's what I served." Sonia collected antiques and knew May Tabak and her husband, Harold Rosenberg, because May had an antique shop, "really a junk store," in the Village. May and Harold sometimes attended Sonia's "at homes," and at one of these, Sonia introduced Clem to the bearded, six-foot-four-inch Harold, who looked like a Sumerian prince and would later become the *New Yorker*'s powerful art critic. Through Harold, Clem met Lionel Abel, on his way to becoming a well-known playwright and literary critic. The three usually met at Harold and May's Brooklyn apartment and soon became close friends.

Harold, too, wrote poetry, some of which had already been published. It was his proudest accomplishment and he told Sonia he wanted to be introduced as a poet.[5] Clem's new friends were already known in intellectual circles. Abel, who admired the surrealists, was famous for an escapade at the Cafe Royale. Bored with the company one night, he held a lit cigarette to his thick, oily, black hair, allowing it to smolder until the place filled with smoke and, no doubt, a terrible smell.[6]

The three friends had much in common. All were sons of Jewish immigrants politicized by their experiences in Eastern Europe, and all had, to some extent, absorbed their parents' political views, along with their feel-

ings of alienation. All three felt like outsiders in their native land. WASP values and culture dominated America, and although this country proved a land of opportunity for immigrant Jews, for a long time their manners, dress, and speech set them apart. Clem served as his family's expert on the "world." During his high school years he would go into the city and report to his younger brothers about "the way things were out there." He told them what kind of clothes to wear, how to behave toward girls, how one was supposed to act in social situations.[7]

Many Jewish immigrants identified themselves, not as Americans but as socialists. Clem, Rosenberg, and Abel were brilliant, idealistic, and radical. They dreamed of a cosmopolitan society in which superficial differences did not label one an outcast. They were in thrall to the concept of social revolution, and a society in which acceptance was based not on how one looked or spoke but on what one had to contribute. All three considered themselves Marxists.

They were getting to know one another just as news of the Moscow Trials (1936–38) and the purges that followed began filtering through the Soviet propaganda screen. Rosenberg and Abel had been communists or fellow travelers in the early thirties. Like Clem, they may not have joined the Party, but it commanded their sympathies. They shared what they thought were its goals, and they published in its magazines. Until then Clem had no active involvement in politics, although he had read Marx, loved Bertolt Brecht, and his sympathies were leftist. For all three, Leon Trotsky was the primary subject of the day. They knew little about him or what he actually stood for. The instinct was that any enemy of Stalin's deserved the benefit of the doubt. Trotsky was the founder of the Red Army. With Vladimir Ilyich Lenin he had organized the October Revolution of 1917. After Lenin's death, however, a struggle for power ensued between Trotsky, a visionary and an inspirational speaker who had been the voice of the Revolution, and Stalin, a consummate political strategist. In 1929, Trotsky was exiled from Russia on charges of treason against the Soviet state. During the Moscow Trials he was tried in absentia and sentenced to death.[8]

Disillusioned by Stalin's betrayal of the ideals they thought the Russian Revolution stood for, a group of leftist intellectuals in New York, including the novelist James T. Farrell (of *Studs Lonigan* fame) and Dwight Macdonald, already well known as a journalist, organized a commission to provide Trotsky with a platform from which to argue his case. For eight mesmerizing days in 1937, in Coyoacán, Mexico, the Dewey Commission—headed by the philosopher John Dewey—interrogated him. Trotsky, a cultured and educated man, emerged from the ordeal a compelling, even electrifying fig-

ure. Saul Bellow captured the New Yorkers' feelings about him when, in *The Adventures of Augie March*, he had his protagonist, traveling in Mexico, describe a chance encounter with the "great man": "I was excited by this famous figure, and I believe what it was about him that stirred me up was the instant impression he gave . . . of navigation by the great stars, of the highest considerations, of being fit to speak the most important human words and universal terms."[9]

Lionel Abel recalled long, impassioned conversations in which he, Clem, and Harold wrestled with such questions as whether loyalty to the teachings of Marx meant automatic support for Stalinist Russia and whether loyalty to Marxist ideals entailed putting the issue of art's autonomy, an issue close to their hearts, on hold. Did art, for instance, have value in its own right or did it acquire value by way of the social and/or political function it fulfilled? Should literature be slanted politically for the sake of society or should one be indifferent in writing to social questions and concerned only with aesthetic issues? Unlike Stalin, Trotsky was educated, well read, and highly articulate. His erudite manner suggested a sensitivity to such issues.

The three friends talked about why the 1920s were better than the 1930s. No James Joyce came forward in the thirties, no Ernest Hemingway. No William Faulkner, Hart Crane, or F. Scott Fitzgerald. Poets of real stature—T. S. Eliot, Ezra Pound, e. e. cummings—had come up during the twenties. By contrast, "the thirties seemed rather barren," Abel recalled, and they wondered why.[10]

In this stimulating environment Clem came into his own. At the end of 1937, he left the Veterans Administration for a more lucrative position with the U.S. Customs Service, Port of New York, in the Appraisers Division of the Department of Wines and Liquors. With the princely income of $1,800 a year, he moved out of his father's house and out of Brooklyn. Apartments were scarce in Manhattan, and he lived briefly in a sublet on West Seventeenth Street, then found a place of his own on Minetta Street in Greenwich Village.

It was the era of small-circulation, privately funded "little magazines," each of which represented a distinct point of view, usually literary or political in nature. In 1937, as Clem was settling into Greenwich Village, *Partisan Review*, a magazine Rosenberg and Abel had written for in an earlier incarnation, was reborn amidst a cacophony of invective powerful enough to scare off all but an intrepid few.

The countless articles that have been written about Greenberg's ideas, his criticism, the arrogance of his authorial voice, usually read as if he had

emerged full-blown from the head of Zeus. But many of the values and convictions embodied in his writing, as well as the critical theory of modernism articulated, were shared by the writers and editors of the renascent *Partisan Review*. PR was a unique phenomenon, a "little" magazine—its circulation never exceeded eight thousand—whose impact on American cultural life during the forties and fifties was immense. Hilton Kramer observed:

> For certain writers and intellectuals of my generation . . . drawn to PR in the late forties and early fifties . . . it was more than a magazine, it was an essential part of our education, as much a part of that education as the books we read, the visits we made to the museums, the concerts we attended, and the records we bought. It gave us an entrée to modern cultural life—to its gravity and complexity and combative character—that few of our teachers could match [and those few were likely to be readers of or contributors to PR]. It conferred upon every subject it encompassed—art, literature, politics, history, and current affairs—an air of intellectual urgency that made us, as readers, feel implicated and called upon to respond. If later on, we began to question the perfect confidence that PR seemed to bring to its pronouncements on every issue, and to understand the unacknowledged contradictions that lay concealed beneath its style of apodictic authority—well, that too was an essential part of our education.[11]

The scholarly interest the PR crowd continues to elicit is so great that a recent issue of *New York* magazine (January 30, 1995) referred to them as "the most eulogized circle of thinkers, writers, and talkers in our literary history." Clem became a central figure among that brilliant company, and the amalgam of political and cultural convictions it represented shaped, and were shaped by, him.

PR was founded in 1934 as the literary organ of the John Reed Club, the writers' arm of the American Communist Party, at a time when support for "proletarian," which is to say antibourgeois, literature was the Party line. Philip Rahv and William Phillips, later described by Clem as "two of the smartest men in America," were among the founding editors and quickly became the magazine's dominant voice. Both were dedicated to the idea of social revolution and saw proletarian literature as a way to make the experience and humanity of working men and women accessible to the ruling

classes. But both were also dedicated to modern literature, to the writings of Joyce and Eliot and those who explored the effects of modern society on the human spirit.

In the midthirties, with the German army massed at the border of the USSR, a desperate Stalin needed the support of bourgeois liberals, especially American liberals. The network of antibourgeois John Reed Clubs was summarily disbanded, replaced by the Popular Front and the League of American Writers, geared to bourgeois antifascists and the writers who spoke to and for them.

PR's initial phase lasted only two years. Its editors, particularly Phillips and Rahv, objected to the literature the Party now favored and to the values it represented. Events in Moscow, the editors announced, had moved so rapidly it was necessary to rethink the magazine's position. The editors went their separate ways. Phillips and Rahv stayed in touch, however, and began toying with the idea of "liberating" the magazine from Party control and beginning again as a politically independent publication. Recognizing the risks involved, and concerned for their personal safety, they resolved to move forward only if others joined them.

In downtown Manhattan, in the neighborhoods below Fourteenth Street, one did not defy the Communist Party lightly in those days. Kramer, now the curmudgeonly editor in chief of the neoconservative *New Criterion*, recalled just how powerful the Party was. The *PR* crowd got "quite a workout" about what it meant to go against prevailing opinion, Kramer observed: "In the radical left-wing world the Communist Party really dominated. It didn't just dominate opinion, it controlled jobs, decisions as to which publishers published which books, which magazines hired which writers, how people lived their personal lives. I mean who married whom, what schools their children went to, and so on."[12]

When rumors began circulating that *PR* might be reborn as an anti-Stalinist publication, former colleagues pleaded with Phillips and Rahv to proceed with caution, arguing that they, too, disapproved of the Moscow Trials but that information about the purges remained inconclusive, and the cause of social revolution remained the greater good. A cause, they argued, that would be doomed by a split among American intellectuals.

In the fall of 1937, *PR* was reborn. In addition to Rahv and Phillips, the editors included Frederick W. Dupee, former literary editor of *New Masses;* Dwight Macdonald, now a well-known Trotskyist; abstract painter George L. K. Morris; and Mary McCarthy, then at the start of her career and living with Rahv. Morris had been at Yale with Macdonald and Dupee. He had a private income and agreed to underwrite the projected annual budget of $1,500.

One by one, a small number of writers, disenchanted with Stalin but not with Marx, had moved away from the Communist Party during those years. Some gravitated toward *PR*, whose political views and taste for modern literature they shared. James Burnham, Elliot Cohen, later the founding editor of *Commentary*, Max Eastman, James T. Farrell, Sidney Hook, Reinhold Niebuhr, Meyer Schapiro, Lionel and Diana Trilling, Edmund Wilson, and Hannah Arendt (who arrived in New York later but immediately gained status as a member) were among them. A somewhat younger group that included Abel, Rosenberg, Saul Bellow, the Italian critic Nicola Chiaramonte, Paul Goodman, Elizabeth Hardwick, Richard Hofstadter, Alfred Kazin, Bernard Malamud, Arthur Schlesinger Jr., William Barrett, James Baldwin, and Ralph Ellison, clustered around at the same table.

PR's announced goal was "to free revolutionary literature from domination by the immediate strategy of a political party."[13] But its first issue emphasized highbrow or modernist literature, at odds with the bourgeois posture of the Party. It included poetry by Wallace Stevens and James Agee, Delmore Schwartz's famous story "In Dreams Begin Responsibilities," an essay on Flaubert by Edmund Wilson, a review of Kafka's fiction by Dupee, reviews by Sidney Hook, Lionel Trilling, Arthur Mizener, and William Troy, and an essay by Lionel Abel. *PR* presented itself as an independent entity that was anti-Stalinist, or anti–large-C Communist, but pro-Marx and as committed to modern art, principally literature, as it was to radical politics.

Macdonald was the only editor to join the Trotskyist Party, but the magazine took a Trotskyist position on the war in Europe and invited Trotsky to publish in its pages. The *PR* crowd quickly became known as Trotskyists to their friends and Trotskyites to those less kindly disposed—a distinction Delmore Schwartz neatly captured when he said that "a Trotskyist is to a Trotskyite something like a socialist to a socialite."

In the fall of 1937, Clem's political involvement amounted to attending a few large, public meetings, although, through Rosenberg and Abel, he was intellectually involved with the issues. Abel noted that they were all "radicals" on political issues and that Clem's basic views were the same as those of his friends.

PR did not represent the only splinter group among the radical left-wing, but its editors and writers comprised a disproportionate number of intellectual heavyweights. Worried that *PR* might tip the balance of power within the radical community, the Party unloosed its biggest guns. A virtual torrent of abuse, what Alan M. Wald, in *The New York Intellectuals: The Rise and Decline of the Anti-Stalinist Left from the 1930s to the 1980s*, termed a "fusillade of invective," was heaped upon these "traitors and

turncoats." *New Masses* and the *Daily Worker* greeted *PR*'s rebirth with headlines shrieking "Falsely Labeled Goods" and "A Literary Snake Sheds Its Skin for Trotsky." V. J. Jerome, the Communist Party's "commissar of culture," raved splenetically in the *Daily Worker* (October 1937) that Rahv, F. W. Dupee, James T. Farrell, and Lionel Abel were "of the same ilk that murdered Kirov" (the popular Leningrad Party leader who was actually killed during the Spanish Civil War by his girlfriend's husband, but whose death Stalin managed to pin on Trotsky).[14] The same ilk that "turned the guns on the backs of Loyalist civilians in Spain" and were "caught in plots with the Gestapo and the Japanese militarists to dismember the Soviet Union."[15] The *PR* crowd became anathema, scorned by former friends, and an embarrassment to their families.

Many years later, commenting on the qualities Clem shared with the original Partisans, Kramer described Trotskyism as "a great school for developing, if not . . . total independence of mind, certainly a moral stamina for resisting the accepted way of thinking. The tendency to say, 'I don't care whether other people think it's right or not. I think it's right.' "

In 1937 Clem watched these events from afar. He was lonely and worried about his son, although that was the extent of his involvement in the boy's life. His salary at Customs covered his own expenses, but believing Toady's mother to be well off, he was not inclined to give up what few luxuries he enjoyed to contribute to his son's support. He read, drew, and in the late thirties painted with a brush for the first time, a process he found exhilarating. Although he still considered poetry the pinnacle of artistic achievement, he began to have fantasies about making a career as a painter[16] and became curious about the New York avant-garde. In the midthirties Harold Rosenberg had worked as an artist's assistant at the Works Project Administration (WPA). Before leaving New York for Washington, D.C., at the end of 1937, where he served as national arts editor for the WPA's *American Guides* series, Harold introduced Clem to his former boss, the painter Lee Krasner, then a student at the Hans Hofmann School on Eighth Street in Greenwich Village. Through Krasner, Clem met Igor Pantukhov and enrolled in his life-drawing class at the WPA. Krasner introduced Clem to her friends at the Hofmann School and to Hofmann's ideas, and Clem attended three of the six public lectures the master gave during the 1938–39 school year. When Clem began writing art criticism, he frequently credited Hofmann's ideas—about Matisse, cubism, the space in modern painting—with influencing his own.

Years later Clem wrote "The Late Thirties in New York" (*Art News*, summer 1957), describing that tiny avant-garde community: "Eighth

Street, between 6th and 4th Avenues, was the center of New York art life that I became acquainted with. . . . Worldly success seemed so remote as to be beside the point and you did not even secretly envy those who had it. . . . When I thought of taking up painting as seriously as I had once half-hoped to do . . . the highest reward I imagined was a private reputation of the kind Gorky and de Kooning then had, a reputation which did not seem to alleviate their poverty in the least."[17]

When Clem originally thought about making a career in art, it was as an artist, not a critic. His proclivities as a critic, however, may have precipitated the sudden end of his friendship with Harold Rosenberg. Harold died in 1978. His account of these events has never been told. In Clem's version, Harold's behavior toward him changed suddenly from warm and encouraging to sarcastic and biting shortly before he left New York. Clem attributed Harold's hostility to nasty remarks Clem had made about a new painting he saw in Harold's apartment. Not realizing his friend was the artist, Clem expounded at some length on its many flaws.

Clem worked for the Customs department, but his chief preoccupation during these years appeared to be women. He still wrote stories and poetry, but did not publish. In 1939 he was introduced to Dwight Macdonald, and it was then that his career as a writer began. Clem's education had been in literature, and he resolved to try his hand at literary criticism. He wrote a review of Bertolt Brecht's opera *A Penny for the Poor,* that appeared in the winter 1939 issue of *Partisan Review,* the same issue in which the third in Macdonald's series of essays on Soviet cinema was printed. Macdonald had been impressed with Clem's piece on Brecht and borrowed some of the ideas. (Philip Rahv later told Clem that the other *PR* editors had objected to the lack of attribution.)

Macdonald commented that Russian peasants seemed willing to like whatever Stalin put before them, a docility he attributed to their lack of previous cultural exposure. Clem fired off a remarkably assured letter of response. Making no mention of "borrowed" ideas, he took issue with that remark: "It must be pointed out that in the West, if not everywhere else as well, the ruling class has always to some extent imposed a crude version of its own cultural bias upon those it ruled, if only in the matter of seeking diversions such as popular music or magazine fiction. There is a constant seepage from top to bottom and Kitsch (a wonderful German word that covers all this crap) is the common sewer."[18] The real question, said Clem, was not why this was true in the Soviet Union but why it was no longer the case in the West. Macdonald was more than impressed. He suggested Clem expand that idea into an essay for *PR.* "Until then I had been making desultory efforts to write, but now I began in earnest, in my office-time

leisure—of which I had plenty—and fairly soon I began to get printed" was Clem's laconic summation of the near total transformation of his life that followed.[19]

Given Clem's life experience to that point, his confidence seems inexplicable. While Rosenberg, Abel, and Macdonald fought the good fight on the political front, Clem slept late, went to the movies, and advised his brothers on how to behave with girls. His chief accomplishment seems to have been making life so miserable for those around him that his father started a business just to get him out of the house. He did make Phi Beta Kappa and, as he approached his thirtieth birthday, had some translations and two short stories to his credit. Lying to his family about his position on the Syracuse swim team, however, suggests he was not altogether pleased with who or what he was. And abandoning his pregnant wife because her mother was unwilling to go on supporting him cannot have been an ego-enhancing experience nor, presumably, could being publicly exposed as a plagiarist. Wherever it came from, however, his confidence served him well.

Clem had reached a turning point in his life and he seemed to know it. He dashed off a first draft of "Avant-Garde and Kitsch," submitted it to *PR*, and with money borrowed from his father on the strength of his Brecht review, took a two-month leave of absence from the Customs Service. Despite the war and the danger it presented for sea travel, he sailed out of New York on the *Île de France*, April 20, 1939, and returned on June 6. His private assessment of his place among world-class intellectuals can be gleaned from the list of people he arranged to meet.

In Paris he prevailed on *Time/Life* correspondent Sherry Mangan, his traveling companion on the *Île de France*, to arrange introductions for him to Jean Arp, Hans Bellmer, Paul Eluard, Georges Hugnet, Jean-Paul Sartre, and Virgil Thompson. His meeting with Sartre is illuminating. Sartre's first novel, *La Nausée*, had been published not long before and Clem had been "struck" by it: "It was new, original, and I'd never heard of him before . . . I had to dig him up. He wasn't famous yet." When they got together, Sartre "didn't talk a hell of a lot . . . but he was very polite and friendly. We got into an argument about the merits of John Dos Passos. I didn't think so much of him and Sartre did. We agreed about Faulkner, and I said Faulkner was more important than Dos Passos."[20]

Before Clem sailed, Macdonald had proposed that he interview Ignazio Silone, the Italian antifascist then living in exile in Zurich, for *Partisan Review*. Clem recalled the encounter with pleasure: "We had to talk in my pidgin French; I could make out in Italy in gas stations and restaurants, but I couldn't have a conversation." Silone "tested" him, Clem recalled: "He

was staying in . . . a small mansion, a town house. I was left alone in the library for about fifteen, twenty minutes, and I thought I understood why. They wanted to make sure I wasn't somebody who was up to mischief. Don't forget, he was in exile there as an anti-Fascist, so he had to be careful." They went out to lunch and Silone asked if Clem had any objections to eating in a restaurant owned by fascists, to which Clem responded, "I've never yet made any sacrifices in the fight against Fascism and I'm not going to make any now. Let's go."[21] The meeting went well and the two kept in touch.

Clem was dazzled by what he saw and did and sent postcards to friends, relatives, and the editors of *Partisan Review,* among them Mary McCarthy. As Clem's stature increased, McCarthy regaled dinner parties with satirized versions of these missives: "Oh my God. It's so beautiful. . . . Did you know they have water in the streets of Venice?" Or, "In Rome, I discovered the Spanish Steps and I discovered that place that is called the Sistine Chapel."[22]

Clem returned to New York to find that "Avant-Garde and Kitsch" had been returned. His argument was too vague, his assertions too grand, sweeping, and unsubstantiated, said *PR*'s editors. Macdonald offered to help him rewrite it, but working with the more experienced man proved something of an ordeal. Macdonald was celebrated for the authority, wit, and acerbity of his authorial voice. Clem was so intimidated that his mind went blank in Macdonald's presence:[23] "Dwight could write. He sure could write. . . . And I couldn't. . . . My not knowing how to write was in part neurotic . . . because in grade school and in high school I'd get prizes for my writing." But with Dwight, "I got too self-conscious . . . I got too self-conscious about everything then. Yeah, painting and everything else." One Saturday morning Clem tore up everything they had done together and, in one sitting, rewrote the essay from scratch.[24]

Tracing the connection between industrialism, commercialism, modern art and popular culture, "Kitsch" opened with the penetrating observation that for the first time in the history of Western civilization and possibly in the history of the civilized world, a single society had given birth to two separate cultures. In addition to that which percolated down from above there was now "Kitsch," bubbling up from below. Using painting, poetry, and music to make his point, Clem examined high art and popular culture as two sides of the same cultural coin. Both, he said, had emerged in response to the social upheaval brought about by the Industrial Revolution and, to a lesser extent, the Enlightenment. The former created jobs and led to urbanization, as vast populations migrated from country to city in

search of economic security and a better life. With the passage of time, the working class commanded an aggregate income large enough to demand cultural diversions in line with its own taste. That shift in economic power began the erosion of the upper or leisure class's social influence, most particularly on taste and values. Clem saw the avant-garde as a temporary holding action, a unique effort to maintain standards, prevent stagnation, and keep culture "moving" until the West adjusted to a technological revolution whose repercussions we still could not imagine. He anticipated that a Marxist paradigm would ultimately replace the class structure of the West, but could not say when or what form it would take. Clem did not introduce the German word *kitsch* into the English language, but his essay put it in circulation among intellectuals and defined its American meaning as effortlessly consumed cultural "junk": "slick magazines, Norman Rockwell covers, poems by Eddie Guest."

The invitation to write an original essay had come to Clem so easily that his initial response was quite casual. The care with which the final piece was crafted suggested a different order of ambition. "Avant-Garde and Kitsch" (fall 1939) addressed itself to the space between two major discussions then under way in intellectual circles. The first involved the meaning of abstraction and examined the mystery of modern art's unfamiliar forms within an art-historical context. The key figures were Alfred H. Barr Jr., the founding director of the Museum of Modern Art, and Meyer Schapiro, professor of art history at Columbia University, and arguably the most spellbinding lecturer on impressionism ever to mount a podium. The second discussion, the question of art's autonomy, took place within a political context that centered on the function of art. Leon Trotsky, André Breton, and Philip Rahv were the major figures.

Clem entered the discussion of abstraction in New York soon after it got under way. In the first decade of the twentieth century, cubism and abstraction produced paintings whose imagery bore little or no relationship to objects in the external world. War and social upheaval overwhelmed Europe shortly thereafter, and in 1936, when Barr organized *Cubism and Abstract Art* for the Museum of Modern Art, the discussion of this event was still in its infancy. Barr's show was the most comprehensive of its kind ever mounted and one of the most controversial. Advanced European art had been known in America since the Armory Show of 1913, but it remained an arcane and exotic subject and many were not sure it was art. When Barr organized his show twenty years later, the U.S. Customs Service impounded nineteen sculptures because they "did not show

natural objects in their 'true proportions' and therefore were not admissible ... as art."[25] Barr's show was seen as such an indignity that the *New York Times*, moved to editorial comment, dismissed it as "a bit of childish chicanery that requires more attention from the social psychologist than from the art critic."[26]

Anticipating the hostile reaction, Barr created a diagram for the catalog cover tracing modern art's evolution. He attempted to reassure viewers by explaining that the shift from representational to nonrepresentational imagery stemmed from the well-known human tendency to become "bored" when repeating a task already mastered. Renaissance artists had perfected the ability to portray the three-dimensional figure in space on a two-dimensional surface. The invention of the camera obviated any practical need for painting as a historical record. In Barr's view, representational art was involved with the world of the artist while abstract art was essentially independent of the surrounding culture, a straightforward effort to concentrate on, and experiment with, formal issues.

Schapiro, a political independent and a classical Marxist, had written stirringly about the Russian Revolution in the early thirties, encouraging artists to participate in the important issues of their day. By 1936, like others around *PR*, Schapiro had reevaluated that position in light of Stalin's efforts to compel artists to serve the propaganda interests of the state. In "The Nature of Abstract Art" (*Marxist Quarterly*, January/February 1939), Schapiro dismissed as fiction Barr's view that abstraction was basically representational art from which the trees and figures had been removed. All art, he wrote, has its roots in the culture that produces it. By definition, art communicates prevailing values.

Eight months later, "Avant-Garde and Kitsch" brilliantly sketched the cultural and social context that gave rise to abstract art and the philosophical necessity to which it responded:

A society, as it becomes less and less able, in the course of its development, to justify the inevitability of its particular forms, breaks up the accepted notions upon which artists and writers must depend in large part for communication with their audiences. It becomes difficult to assume anything. All the verities involved by religion, authority, tradition, style, are thrown into question, and the writer or artist is no longer able to estimate the response of his audience to the symbols and references with which he works. In the past such a state had usually resolved itself into a motionless Alexandrianism, an academicism in which the really important issues are left untouched

because they involve controversy, and in which creative activity dwindles to virtuosity in the small details of form, all larger questions being decided by the precedent of the old masters. . . .[27]

Hence it developed that the true and most important function of the avant-garde was not to "experiment," but to find a path along which it would be possible to keep culture *moving* in the midst of ideological confusion and violence.[28] (Emphasis in original.)

The second exchange into which "Kitsch" was inserted, the question of art's autonomy, was in some ways a corollary of the first. In 1937, *PR* published Trotsky's "Art and Politics in Our Epoch." In autumn of the following year, his "Manifesto: Towards a Free Revolutionary Art" appeared in the same pages. (Although signed by Diego Rivera and André Breton, the piece was written by Breton and Trotsky.) In the first essay, Trotsky argued that Stalin's policy would prove ineffectual because art powerful enough to stir an audience for a cause could only be made by an artist true to his "own inner self." A painting or sculpture whose subject was a political cause in which the artist did not believe would move no one. In the "Manifesto," Trotsky and Breton reiterated that position but concluded that, given the nature of the time, "truly independent creation cannot but be Revolutionary by its very nature."[29]

In 1939, Rahv responded. "Twilight of the Thirties" took issue with both Trotsky and Stalin. Contending that art's autonomy was a central tenet of modernism, Rahv asserted that "art's value derived not from its relation to society, but from the nature of the *experience* it provided." No one, Rahv claimed, could say what form "truly independent creation" *had* to take. Artists could only be true to their own "inner self" if they were free to *make* art that opposed the policies of the state or art that ignored the state.[30]

Greenberg, drawing on the antifascist Frankfurt School—Theodore Adorno, Georg Lukacs, Walter Benjamin—broadened the context of the discussion. The urbanization of the lower classes that followed the Industrial Revolution, he said, gave rise to a new social force and a culture curiously at odds with itself. "Avant-Garde and Kitsch" opened brilliantly on that note:

One and the same civilization produces simultaneously two such different things as a poem by T. S. Eliot and a Tin Pan Alley song, or a painting by Braque and a *Saturday Evening Post* cover. All four are on the order of culture, and ostensibly, parts of the same culture and products of the same society. Here, however, their connection seems

to end. A poem by Eliot and a poem by Eddie Guest—what perspective of culture is large enough to enable us to situate them in an enlightening relation to each other?[31]

"Kitsch" was nothing like the work of a beginner. The strength of the voice, the large perspective, the originality of the insights, suggested great authority. The goal of modernism, Clem wrote, was to keep cultural standards alive until a paradigm emerged broad enough to encompass both aspects of our culture. He was optimistic about society's ultimate ability to perfect itself, but pessimistic with regard to the immediate future.

T. S. Eliot and James Joyce described the consequences for the human spirit of life lived in a society in which money was the only agreed-upon measure of value. Joyce's "The Dead," for example, evoked emptiness and alluded to the unexplored life; Eliot's "The Waste Land" explored the aftermath of life in a culture in which the deepest human feelings were untouched. Clem articulated the social circumstances that made these concerns inevitable and related them to the condition of art in the industrialized world.

Clem has frequently been belittled for the oxymoronic union of beliefs revealed in "Kitsch"—on the one hand, praise for the elitist tradition of "high" art, represented by the avant-garde; on the other, praise for Marx and the prospect of a better world through workers' revolution. But this paradoxical union of values dominated postwar American intellectual life. In the words of sociologist Daniel Bell, "They [the *PR* crowd] encapsulated, in the most surprising way, two of the complex features which summed up American cultural life in th[at] thirty-five-year period [from 1930 to 1965]—the union of political radicalism and cultural modernism."[32]

Many years later the *New York Times* described *Partisan Review* as "the best literary magazine in the country," the one whose "cultural importance" would be "hard to overestimate."[33] It was the literary community's widespread support for *PR*'s "oxymoronic" union of elitism and idealism that led the *Times* to make that observation. "Avant-Garde and Kitsch" was a seminal essay, not because it invented that union, but because it was the first to articulate it.

PR's editors took the thrust of Clem's essay so much for granted that neither they nor he recognized how original it was. The praise that rolled in took them all by surprise. Ironically, the man the art world reviled as the avatar of high art was celebrated in the intellectual world for initiating a new approach to mass culture. In the introduction to *Nothing but a Fine-Tooth Comb*, Prof. David T. Bazelon, himself a member of the *PR* crowd,

CLEMENT GREENBERG

noted that " 'Avant-Garde and Kitsch' was the major piece bringing the two strands [of high and popular culture] together . . . possibly the most important essay on the subject . . . after [D. H.] Lawrence's analysis of [Edgar Allan] Poe."[34]

The late Irving Howe remembered the furor "Kitsch" aroused. Howe was a good friend of Clem's brother Martin and, like him, resented Clem's imperious manner. He nonetheless emphasized that as much attention as "Kitsch" received, it deserved more. Much of Dwight Macdonald's important work on mass culture in the forties was based on Clem's ideas, said Howe: "In the era before the war, there was a great interest in the criticism of mass culture. No one talks about this today, possibly because no one quite knows what to say about it. At that time we had a pretty simple but effective kind of critical view on the subject, and Clem's piece was a major initiating point for that work."

"Avant-Garde and Kitsch" catapulted Clem from the anonymity of the U.S. Customs Service to center stage among the stellar group known today as *the* New York Intellectuals, "that brilliant, quarrelsome bunch that made its reputation in the thirties, forties, and fifties writing for journals with circulations in the low four figures," said *New York* magazine in 1995 of the coterie that "so captivates today's academic specialists that dozens of books and Ph.D. theses about them" are still churned out regularly.

Years later Clem purported to hate the way "Kitsch" was written. He said his argument was full of holes that no one picked up on. Nonetheless, the piece was reprinted in the new British journal *Horizon* just six months later, where it put Clem's name in circulation among highbrows on both sides of the Atlantic.

Like all landmark essays, "Kitsch" raised as many questions as it answered. To account for the trend toward "purity" in fiction and poetry, as well as the visual arts, Clem suggested that in this period of social upheaval "the poet or artist turns in upon the medium of his own craft," replacing the constraints provided by the world of "extroverted common experience" with the "invention and arrangement of spaces, surfaces, shapes, colors, etc." He did not attempt to account, in aesthetic terms, for why these explorations took the form they did.

Exploring that issue further, he wrote "Towards a Newer Laocoön," but his thesis was so large and controversial that it was nine months before *PR* (July-August 1940) agreed to publish it. The overwhelming response to "Kitsch," whose importance the *PR* staff intentionally undervalued, ultimately persuaded them to print "Laocoön," but this essay was not well received. According to Greek legend, the priest Laocoön warned the Tro-

jans against Greeks bearing gifts, and in so doing incurred the wrath of the gods. He and his two sons were crushed to death by serpents of Athena in some versions of the myth and by Apollo in others. The event was commemorated by a famous second-century B.C. sculpture, *The Laocoön Group*. Greenberg's title, although an apt metaphor for what fate had in store for him, referred not to the legend, however, but to two earlier essays: Gotthold Ephraim Lessing's "Laocoön," written in the 1760s, and Irving Babbitt's "The New Laocoön: An Essay on the Confusion of the Arts" (1910). The "confusion" to which both referred was the tendency of less popular arts to imitate the form of communication employed by the most popular: the inclination on the part of nineteenth-century painting and sculpture, for example, to imitate literature by telling a story. Clem's "A Newer Laocoön" proved the springboard for a twenty-year investigation into why modern art had moved away from that model to adopt a form of communication that was closer to classical music.

What compelled painting to become abstract? he asked. "The imperative comes from history, from the age in conjunction with a particular moment reached in a particular tradition of art." These forces, he said, hold artists in a "vise." Those artists "who are dissatisfied with abstract art," who feel "it is too decorative or too arid and inhuman, and desire a return to representation" a return to a narrative component in plastic art, have no choice but to "surrender to images from a stale past." In other words, abstract art, far from being devoid of content as Barr suggested, was the only means whereby our current art could communicate that content. Later, artists and critics who preferred representation interpreted Clem's theoretical conjectures as an attempt to dictate the direction good contemporary art *had* to take. In 1940, however, Clem had no thought of writing art criticism. He spoke theoretically of a circumstance he neither created nor controlled. Observing that not only painting but the best modern poetry and literature had grown increasingly abstract, he concluded that reductive and unsatisfactory as we might find it, "we can only dispose of abstract art by assimilating it, by fighting our way through it," fighting our way through the cultural circumstances that created it. Where to? The destination was unknown. The only thing he could say with assurance was that "the imitation of nature" was no more God-given "than the desire of certain partisans of abstract art to legislate it into permanency."

Art, like religion, communicates "by working on" the emotions as well as the mind. Its content is beyond words, ineffable. By the mid-1800s, Clem hypothesized, the ideas underlying Western society were in flux and conventional subject matter had lost its power to communicate on a profound level. With abstract art, he wrote, "there is nothing to identify, con-

nect, or think about, but [there is] everything to feel."[35] Although he felt the best art of our time was abstract or tended in that direction, he argued that one style was neither better nor worse than the other. The best art of any time was not abstract or representational, he said, but that which "released" the feelings of the age.[36]

One month after "Laocoön" appeared, Clem wrote a political piece whose consequences he never lived down. Where "Kitsch" was smooth, organized, carefully thought through, and beautifully controlled, "An American View" was puffed up and overblown (to use two of his preferred adjectives), its supporting arguments painfully out of touch with the reality of events.

Clem grew up in a socialist household. Everyone his family knew was a socialist. As a small boy he thought *socialist* meant *Jewish.* But where Phillips, Rahv, Irving Howe, and others joined organizations, wrote articles, made speeches, and sharpened their thinking in clashes with those they hoped to convert, Clem seemed to believe in the inevitability of socialism the way Alfred Kazin believed in the Messiah: "Someday it will come but in the meantime it has nothing to do with daily life."

By the fall of 1940, however, Clem was seeing a great deal of Dwight Macdonald, an ardent Trotskyist. German tanks had rolled across much of Europe, Paris was occupied, Great Britain under siege, and Trotsky dead, assassinated by Stalin's henchmen. Clem's politics had become more radical. Trotskyist New Yorkers were in a quandary. They disliked Stalin as much as Hitler and they did not trust Franklin Delano Roosevelt. They feared, as Alan Wald put it in *The New York Intellectuals,* that American participation "would not be to defend democracy or to fight fascism on principle but to attain domination of the world's economy."[37]

In the late thirties, *PR* had taken an essentially Trotskyist position, arguing that capitalism, not Hitler, was the real enemy and urging its readers to support a position of United States neutrality in the European war. The reasoning was that war between Germany and the United States, because it pitted two capitalist countries against each other, diverted essential skills and resources from the real task, which was workers' revolution.

By 1940, however, Rahv and Phillips had become concerned with the lack of movement in revolutionary circles, while others, such as Macdonald, remained staunch Trotskyists. In "What Is Living and What Is Dead?" (PR, May-June 1940), Rahv argued that there was a "crisis" in Marxism severe enough to make intellectuals reconsider their position. Although Marx had been correct with regard to the inadequacies of bourgeois society, his solution—the rise of a working class willing and capable of recon-

structing it—showed no signs of becoming a reality. The term *New York Intellectual,* in fact, was coined at that time by members of the Trotskyist Party as a caustic euphemism for highbrows who liked putting their toes in the water but refused total immersion. Macdonald was livid and complained bitterly to Clem, by now his close friend. He wanted to resign or to force Rahv and Phillips out.

Clem agreed and "An American View" (*Horizon,* September 1940) was the result. Clem asserted that the shift in power Marx predicted, while not yet visible, was under way. It could be inferred, from the extraordinary ease with which Hitler conquered France and seemed to be having his way with Great Britain. "The masses in Britain and France are not satisfied enough with the *status quo* to die for it," he wrote. For this reason, he argued, Western countries were not in a position to wage war, whatever their leaders' preference might be. The time had come for those who controlled the capital to choose. They could knowingly sell out Western freedom by keeping money and control in their own hands, or they could deliver economic power into the hands of the workers. If the West did the right thing, Clem assured his readers, German workers would desert Hitler and the war would immediately end: "A socialist revolution in the West would send an answering thrill through German workers. It would come with idealism and sincerity; it would invite the world to join it in fraternity and love— yes, *love.*"[38] (Emphasis in original.)

Clem's position was so extreme that Cyril Connolly, coeditor of *Horizon,* took the unusual step of appending an unsigned editorial statement in which he observed that the ideas above, though "extremely popular among left-wing groups in Great Britain," were on this occasion presented in such "simple" and "extreme" form, it was apparent that, put into practice, the direction proposed "would lead to disaster."[39]

The editorial division between Macdonald and Rahv and Phillips was vast. Macdonald needed support. In editorial meetings he urged that the number of editors be increased and Rahv and Phillips agreed to the addition of one person. In October, Clem was invited to become a *PR* editor, but initially demurred on the grounds that he had a full-time job and no wish to be part of an editorial war. Moreover, he preferred writing poetry and painting to reading and editing other people's manuscripts. Unfortunately, the value he placed on his poetry was not shared by others. Although he submitted poems to many magazines, all were rejected.

Macdonald was persuasive, however, and in December 1940, Clem became an editor, filling the position vacated by Mary McCarthy when she left Rahv to marry Edmund Wilson. No money was involved. He contin-

ued working full-time at Customs, and to do his own writing during his office-time "leisure." Nights and weekends he devoted to editorial chores.

Clem was self-conscious and insecure, but even at this early date he was capable of arousing a kind of animosity that went beyond professional differences of opinion. Nicolas Calas, an expatriate Greek academic, now a New York critic, had been intrigued by "Kitsch." When he called, Clem invited him to come for a drink. Calas was so put off by that encounter that in the second issue of the poetry magazine *View* (October 1940), he not only disparaged Clem's ideas but his talent as a painter, a talent he had had occasion to observe only as a guest in his apartment. One of Clem's first acts as a *PR* editor was a response to Calas. He wrote "Renaissance of the Little Mag: Review of *Accent, Diogenes, Experimental Review, Vice Versa,* and *View*" (*PR*, January-February 1941). He was already sophisticated enough to hold the editor's—not the writer's—feet to the fire. He never mentioned Calas directly but hit back at the magazine. Many of *View*'s editors were gay, and Clem exaggerated and satirized the magazine's somewhat mincing, literary style: "Nantes is too lovely—the Balzac period stopped and Stendhal began," he wrote. Everyone understood that Calas was the target, however, and the Greenberg/Calas contretemps culminated in a fistfight.

Meanwhile, relations among *PR*'s editors deteriorated. Policy was usually hammered out in editorial sessions with consensus required for major pieces, but in May, Greenberg and Macdonald collaborated on a piece urging U.S. neutrality in the war against Hitler and "pushed it through."[40]

In the late thirties *PR*'s position was so radical that, where many Americans considered Franklin Roosevelt an antibusiness "extremist," the *PR* crowd viewed him as a kind of Daddy Warbucks. In "10 Propositions on the War," (*PR*, July-August 1941), Greenberg and Macdonald reiterated the line Clem had advanced in his *Horizon* piece. They predicted that if Roosevelt insisted on going to war, the alienated working classes would refuse to fight. To compel obedience the president would be obliged to impose some form of domestic fascism. Win or lose, they predicted, participation in the war would cost America its democracy.

In the very next issue Rahv counterattacked with "10 Propositions and 8 Errors" (September 1941). Despite the fervent hopes of his fellow Marxists, he wrote, a workers' revolution was not "just around the corner" and imperialism was not "tottering on the edge of the abyss." This, unfortunately, was wishful thinking, said Rahv. American workers had, so far, demonstrated neither the will nor the ability to assume responsibility for running the country. In fact, he continued, "life is running so low in the revolutionary movement" that it is no longer possible to "lull ourselves

with illusions . . . about the abilities of workers to fulfill . . . Marxist prophecies."

The split among the six editors was four to two in favor of U.S. participation in the war. Half a century later, the Macdonald-Greenberg position seems inhuman but at the time *PR* writers were split almost fifty-fifty. Mary McCarthy, Edmund Wilson, Meyer Schapiro, Irving Howe, and James T. Farrell were among those opposed to U.S. involvement. Rahv and Phillips were in a bind. They could not risk a split with Macdonald. Morris was the magazine's sole support and he was Macdonald's close friend. The editors agreed to paper over their differences. Following the bombing of Pearl Harbor *PR* announced that, because of internal divisions, the magazine would espouse "no editorial line on the war."

This political moratorium, soon after Clem joined the staff, led to an increased focus on literary and cultural criticism at a propitious time. The forties, as the poet Randall Jarrell observed, were the beginning of the epoch during which "criticism . . . was probably the most vital intellectual activity in America."[41] Rooted in Rimbaud's idea that art had the capacity to "change life," the criticism of art acquired great prestige: "The idea that wrong critical judgments do not really matter means that the literature [or art] in question does not really matter, that it lacks the power to shape the spirit of the age, to mold and extend consciousness, to heighten a sense of reality which would otherwise be dulled."[42]

Today art no longer aspires to such heights and the job of the critic has lost its sacred edge. But after the war, when Clem did his most important work, membership in the *PR* crowd was important, not because it guaranteed respect or consideration, but because it meant your opinions counted in the most important conversation. A great critic was one who pointed out strengths and weaknesses, offered comparative judgments, and kept that conversation moving. The objective was to stake out extreme positions backed up by reasoned, persuasive arguments, to make yourself a backboard off which ideas could bounce.

This world and these ideas shaped Clem's career. It was a world he entered while in the throes of a love affair with a woman he described as the "great passion" of his life. Jean Connolly, née Bakewell, was a Pittsburgh-born, Baltimore-raised heiress with a substantial independent income. Like the young Americans in Henry James's novels, she had gone to Europe in the twenties to study art and land an upper-class, preferably titled husband. In 1929, at age seventeen, she married Cyril Connolly, the brilliant, sharp-tongued coeditor of *Horizon*, and a man whose impact on British intellectual life was such that the question "What does Cyril think?" remained

valid "for forty years and more."[43] Through Cyril, Jean became part of an exclusive circle that included W. H. Auden, the novelist Christopher Isherwood, and the poet Stephen Spender.

Neither Jean nor Cyril was monogamous. They remained married, but by the late thirties Jean lived in France and Cyril in England. In 1939, war seemed imminent, and Jean, along with several traveling companions, left Paris for London. Cyril was involved with someone else and they lived separately. After several months Jean returned to the United States, but Cyril chose to remain in England. Peter Watson, part of Jean's entourage, was "looking for something to do during the war." He offered to stay in England and underwrite a literary magazine. *Horizon*, and Connolly's career as an editor, was the result.[44]

Jean and her remaining companions settled in a somewhat seedy "castle" in the Los Angeles hills that was owned by her aunt. Christopher Isherwood visited her there, and in his curious kiss-and-tell memoir, *Down There on a Visit*, in which all important figures have fictitious names, he described "Ruthie" the woman who introduced Clem to the concept of a social life and instilled in him a fear and a lust for bohemia.[45] "Ruthie's face is chalk white, with huge vermilion lips daubed upon it," wrote Isherwood. "She is a big girl altogether; big hips, big bottom, big legs. I've seldom seen anyone look so placid, so wide open to visitors, so sleepy-slow. Her great gentle cow eyes have sculptured lids which make me think of an Asian bas-relief—the carving of some giant goddess. She wears a black silk dress with black lace which would do just as well for evening (this is lunch); maybe she hasn't taken it off since last night. It is cut low—very low; it could almost be a nightgown. My God, I believe it is! Anyhow, she has a fur coat to go over it if necessary. It is somewhat smeared with cigarette ash."[46]

Cyril and Clem had never met but there had been contact between them. When Jean decided to abandon California for New York City, Cyril gave her Clem's address, and soon after arriving she banged on his door—not everyone had telephones in those days.

Shortly after they met, Clem borrowed his father's car and they spent two days together in a country hotel, after which he drove her to Massachusetts, where she was to stay with W. H. Auden and his lover, the American poet Chester Kallman. Clem stayed just long enough to be introduced: "I met Auden with Chester in the summer of 1940 and then I knew him off and on. I admired him a great deal, but down at the bottom, I didn't like him."[47]

That same summer, Harold Lazarus, the college friend Clem credited with "helping turn me away from rah-rah life and all that," vacationed in Mex-

ico. There he met Margaret Marshall, the cultural or back-of-the-book editor of the *Nation*. Lazarus sent her some of Clem's poetry, but she was not interested. Later she met Clem at a party given by Dwight Macdonald. Marshall told Clem to call and perhaps do a book review. Clem was offended. But the *Nation* paid more for reviews and articles than *PR* and he needed money to keep up with Jean and to send his son.

It was a fortuitous encounter. In February 1941, Greenberg reviewed Carl Thurston's *The Structure of Art* for the *Nation*. The remarkable opening sentence seems, among other things, to have been crafted to grab the most demanding editor's attention: "This book might serve as a text on the typical biases of the American mind: its positivism, its unwillingness to speculate, its eagerness for quick results, and its optimism."[48] Clem and Marshall discovered they had similar views on art and politics. They became close friends. Marshall gave Clem his start as an art critic and it was to her that he dedicated *Art and Culture,* the slim volume of selected essays on which he expected his future reputation to rest. Soon Clem's "stuff," as he called it, appeared in the *Nation* as often as it did in *PR*. On April 19, 1941, Marshall printed Clem's first art review, a critique of gallery exhibitions by Joan Miró, Fernand Léger, and Wassily Kandinsky.

The following month Clem wrote an "Art Chronicle" on Paul Klee for *PR* (May-June 1941), and it is with some surprise we note that at this early date in his career he singled out two of the formal elements close to the bone of his critical practice in the sixties: color as form and color as the vehicle for what was then an unusual kind of illusory space:

> I do not think that Klee's color has the range of his line. Its register is limited, relatively, to tints: light, tender, aqueous, thin, it seldom inheres within definite contours, is seldom thick or solid. . . . It is color that intensifies and fades like light itself, translucent, vaporous, porous. Such coloration achieves a kind of depth, but not one in which "real" events are probable. . . . Lines wander across areas of hue like melodies across their chords; surfaces palpitate, figures and signs appear and disappear. It is an atmosphere without dimensions. This is the brilliance of Klee's art.[49]

"Kitsch" had been a big "hit," Clem recalled, but neither "Laocoön" nor his art reviews attracted favorable attention. He told a friend that nobody seemed to like reading about the "technical aspects" of art. For the remainder of the year, however, with the support of William Phillips at *PR* and Marshall at the *Nation*, he was able to move back and forth in his writing between modern literature, poetry, painting, and sculpture, examining

ideas generated by one discipline to see if they were equally valid in another. His range was impressive. He reviewed George Zabriskie's *The Mind's Geography; Currier and Ives* by Harry T. Peters; Saul Bellow's first novel, *Dangling Man; Great American Paintings* by John Walker and Macgill James; *Metapolitics* by Peter Viereck (titling it "Venusberg to Nuremberg"); and *The Philosophy of Literary Form* by Kenneth Burke. Clem wrote about the Victorian novel and primitive painting, and "An Inquiry on Dialectic Materialism." He reviewed books of poetry by Robinson Jeffers, Randall Jarrell, R. P. Blackmur, and Stephen Spender. Clem believed that a great literary magazine had to continuously search out new talent. Toward that end, in his capacity as *PR* editor, he published a selection of mostly unsolicited poetry.

He also believed that one of a critic's jobs was to educate taste. He struggled to find critical language nuanced enough to do justice to the art he wrote about. Identifying Anna Seghers as "the most talented German novelist to appear since Thomas Mann," he went on to observe, "The difficulty is to puzzle out why, Seghers being as good a writer as she is, her novels are not really first rate."

To answer his own question he was obliged to articulate the standards by which he judged art, or more precisely, by which he believed art should be judged. Although Greenberg would later be accused of praising only art that confirmed his theory, at this early date he indicated an awareness of the problems entailed should an artist create from such a position: "The task of art is to impose the greatest possible organic unity upon the greatest diversity," he began, but that is only the beginning, as "any piece of kitsch can have that." The key is "the resistance of the material unified. How far does the artist strain toward completeness (toward expressing the full and incompatible nature of his deepest feelings) before applying the controls of his art? "The material Seghers attempts to shape," Greenberg continued, "is diverse, vivid, resistant to any simple logic, and pregnant with the half and double meanings of authentic experience." Her problem, he concluded, was that she insisted on a preconceived outcome: "It is all weighted toward a significance and a moral derived from an incomplete— insofar as it is only political—view, which infects everything with its obligatory optimism."[50]

In the midthirties, Clem, Rosenberg, and Abel talked about the decline of current literature. Shortly after Clem began writing literary criticism for *Partisan Review,* his disappointment with the subject was as evident as his impressive command. Reviewing a volume called *New Poems: 1940* for the *Nation* (June 1941), he commented that English poetry, once so glorious,

had become "loud, orotund . . . declamatory," depending for emotion upon the sensed presence "of a moment in history great with threats."[51]

His disappointment with literature's current scale and reach were undisguised. Of *Selected Poems* by John Wheelwright (*Nation*, August 1941), he observed, "He has left us a body of work which is something to be reckoned with, but there is little into which we can sink our teeth."[52] On another occasion: "Randall Jarrell has the talents, the sensitivity, the wisdom and almost everything else that the good fairy can give. . . . But like Fred Astaire, another very gifted American, he seems to have a blank personality. He is swallowed up by his gifts. His writing, critical and poetic, for all its brilliance, lacks a core."[53]

Reviewing a new volume of Marianne Moore's poetry, he spelled out his concerns in the kind of plainspoken English that relies on the quality of ideas rather than four-syllable words: "There is a certain thinness, a certain frailty, which Miss Moore's poetry has in common with that of W. C. Williams, e. e. cummings . . . and even Ezra Pound and Wallace Stevens. It is small-scale poetry, lacking resonance . . . belonging to an outlook that has to break things into small pieces in order to see them. . . . Its makers have neither inherited nor acquired enough cultural capital to expand beyond the confines of their immediate experience and of a narrowly professional conception of poetry." As with Anna Seghers, Clem's objection to Miss Moore's poetry was not that it lacked virtue but that it lacked the magnitude required for greatness: "Perhaps Miss Moore yields to her limitations too easily, but within them her poetry is perfect. Literally that. It delights even when it irritates."[54]

Philip Rahv liked to say that Clem turned to art criticism because the competition was too tough in the literary field. But disappointment with contemporary literature was clearly a factor. Clem turned his back on the literary criticism serious people took seriously and, in the process, influenced the course of American art history and modern art criticism.

4

The New York Intellectuals

In March 1942, Clem was a *PR* editor with a full-time job at Customs, when he accepted the invitation of Margaret Marshall, cultural editor of the *Nation,* to be the magazine's official art critic. It was a curious move for many reasons, not least among them the fact that art criticism was not then considered a discussion relevant to important issues. "Little" magazines prided themselves on their cultural coverage and regularly reviewed books, poetry readings, theater, music, and film. But exhibitions of contemporary visual art were largely ignored.

Today "Avant-Garde and Kitsch" reads like a call for, or a prophecy with regard to, American abstract expressionism, and it is often assumed that Clem had that small group of artists in mind when he accepted Marshall's offer. But Clem had lost contact with Krasner, and with the American avant-garde, after becoming a *PR* editor. He had various motives for accepting Margaret Marshall's offer, but expectations with regard to that small group were not among them.

Clem accepted the job as the *Nation's* art critic because he was disappointed with current literature, excited by School of Paris painting, and needed money. *Partisan Review* paid its editors nothing and its writers very little, and Clem was in danger of losing his job at Customs. His association with *PR* had aroused suspicions concerning his loyalty, and a special agent from the Customs department had been assigned to question him. He felt the handwriting was on the wall. The *Nation* paid as much as $15 for a 350-word review. Toady had married for a fourth time but Danny was still with her mother, who resented Clem's continued failure to contribute to his son's support. Meanwhile, Clem was besotted with Jean Connolly and a lifestyle unlike anything he had ever known.

Jean maintained her own apartment, but she and Clem essentially lived together. She was the center of a small group of international literati, all of whom seemed to camp out in his small living room. They dined with Auden, Isherwood, John Farrelly, Edmund Wilson, Mary McCarthy, and Margaret Marshall, among others. Jean introduced Clem to European

expatriates living in New York during the war, the circle Peggy Guggenheim describes in her memoir, *Out of This Century*. He met the surrealist painters sitting out the war in New York and Elena Yurevitch, a beautiful Russian princess with a Balkan title and a sculptor father.

Clem had a gargantuan appetite for life, but Jean and her friends had independent incomes and the leisure to devote their lives to the pleasures of mind and body. The split at *PR* following "10 Propositions" had not healed, and Clem was in danger of losing not only his income but his intellectual base. Rahv was spreading the story that Clem might appear to be a serious intellectual but he was really a social climber and a snob.[1] Clem tendered his resignation, but Phillips and Rahv were concerned that "it would be seen as a political statement" and asked him to stay.[2] He remained at Customs for five months after becoming the *Nation*'s art critic, so he was essentially carrying three full-time jobs in addition to his consuming personal life. The physical strain took its toll. He consulted a physician who recommended he quit at least one job and take a month's vacation, but neither suggestion was feasible.

Jean loved painting and sculpture as much as she did poetry, and often made gallery rounds with him. He no doubt tested ideas on her. At this time Clem first speculated about the effects of an artist's character on his art.[3] He believed that quality in art bespoke a certain kind of virtue in its creator. To affect the viewer at a profound level, he wrote, art had to be persuasive, which it could not be unless the feeling it communicated was genuine, i.e., honest, neither falsified, sentimentalized, nor overblown.[4]

In "Laocoön," Clem observed that the best art of our time was abstract or tended in that direction. A year later, he indicated his acute consciousness of just how difficult a task that was given such reduced means: "When the abstract artist grows tired, he becomes an interior decorator. . . . We demand of a picture what we do of literature and music; dramatic interest, interior movement; we want a picture to be a little drama, something, even if only a landscape or still life, in which the eye can fix and involve itself. It is the task of the abstract artist to satisfy this requirement with the limited means at his disposal."[5]

Hofmann's lectures had made Clem sensitive to abstraction's consequences for art, most particularly for easel painting, the traditional "window-in-the-wall" composition with its illusion of three-dimensional space and the figures that occupy it. The world was in the middle of a great war. Clem reasoned that if abstraction was the direction in which the best Western art currently moved, and if sociocultural causes were the driving force behind that tendency, signs of the struggle should be visible in the work of American artists as well as Europeans. In May 1942, two months after becoming

the *Nation*'s art critic, he reviewed a show of the AAA (American Abstract Artists), which included Ibram Lassaw, Georgio Cavallon, Stuart Davis, George L. K. Morris, and I. Rice Pereira, among others. His excitement was palpable, as was his ambition for American art. "New possibilities are being plumbed that burst the confines of the set easel picture and sculpted piece." Despite "the absence of any great successes there is a beginning," he wrote "and *beginnings* can be found almost nowhere else in contemporary American art."[6]

All abstraction did not move him equally. Clem reviewed the Russian suprematist exhibition at the Museum of Modern Art but found little to please him in the work of Kazimir Malevich, Alexander Rodchenko, or Mikhail Larionov: "All have documentary value but are meager in aesthetic results."[7] Although sometimes harsh in his judgments the critic put his neck on the line, offering nuanced analyses of what he saw as the problem, and was no gentler with critics than with artists. His review of Jerome Mellquist's *The Emergence of an American Art* (*New Republic*, June 15, 1942), was a guns-blazing, take-no-prisoners assault: "Mr. Mellquist writes badly, without strictness or distinction, with injected color, cooked-up drama and panting breath. . . . Like most people without ideas, he takes too much for granted, failing to question his theme for the distinctions and connections which, after judgments of value, give the most excitement to discussion of art."[8]

Following his own advice, Clem compared Corot to a symbolist poet, exploring the ways his formal elements fused with his content to achieve art's deeper purpose: "Corot does not try to create a specific world but rather to awaken in the spectator limitless associations, muting the contrasts of light and dark lest things become too definite."[9] In a review of the Cézanne exhibit at the Paul Rosenberg Gallery (*Nation*, December 12, 1942),[10] he wryly commented on the difficulties a gifted artist creates for himself: "It is . . . the misfortune of a great artist to set standards in his very best work from which one cannot escape in judging the rest."[11]

Clem had hoped to avoid the draft because of his age—thirty-five—and by cynically claiming Danny as a dependent, but Toady's mother, not surprisingly, declined to cooperate. That same month he was classified 1A and resigned from the Customs Service and from *PR*. While awaiting induction, he visited the landmark exhibition *American and French Painters*, where he saw the work of Jackson Pollock for the first time. The show was organized by the flamboyant Polish-born, Russian-educated émigré painter John Graham, at McMillen, Inc. Gallery. Graham was an important figure on the New York scene. He traveled frequently between

New York and Paris, had close ties in the art communities of both, and carried news from one to the other. He was an early admirer of Willem de Kooning and the first to recognize Jackson Pollock's talent. Graham understood the scope of this American painting and its importance. His show placed American artists—Stuart Davis, Willem de Kooning, Virginia Diaz, Pat Collins, Lee Krasner, Walt Kuhn, Jackson Pollock (Krasner and Pollock met for the first time on this occasion), and H. Leavitt Purdy—side by side with such French masters as Picasso, Braque, Matisse, and Modigliani.[12]

This was the first time Clem had seen Krasner's work in two years. A few days later, walking on East Eighth Street in the Village, he ran into her and her companion, a scowling young man in a fedora, whom she introduced as Jackson Pollock. They were on their way to the studio of an artist whose work they had heard about but never seen and invited Clem to come along. Years later, Clem attributed his habit of conducting a running commentary when visiting an artists' studio to this experience. Pollock and Krasner slowly and carefully examined everything in the studio while the anxious artist looked on. They said nothing. Nothing at all. Clem said he empathized with the artist's excruciating discomfort and vowed never to subject anyone to that kind of emotional torture.[13]

Clem's book reviews appeared in the *Nation* through May, but as of February 1943 he was Pvt. Clement Greenberg of the U.S. Army Air Force. He endured basic training uneventfully at a camp in Miami Beach, Florida, and in April was shipped to south-central Oklahoma just outside the town of Tishomingo. A German prisoner-of-war camp was located a mile from his base, and he immortalized the town and the camp by dashing off "Goose-Step in Tishomingo" (*Nation*, May 1943) in a single four-hour sitting. His opening paragraph graphically conveys not just the German response to captivity but his own: "Tishomingo, Alfalfa Bill Murray's hometown, in south central and darkest Oklahoma, was chosen with good reason as the location of a prison camp. God help the fugitive who tries to hide himself in the unsubstantial foliage of its gullies or to slip past the squinting eyes of the Bible-pounding natives."[14]

Clem's strongest memory of Oklahoma was learning to touch-type in a school to which the army sent him. In June he was shipped to Kellogg Field in Battle Creek, Michigan. Anticipating a desk job, he discovered he was about to be sent to the front lines. Nervous and depressed, he asked Jeannie, whom he had not seen for six months, to visit. She made excuses, as she had done since he left New York. Clem's depression worsened. Toward the end of July Jean came for a weekend. He attributed what happened next to feelings of isolation and alienation induced in him by sharing a bar-

racks with forty men, none of whom had interests similar to his own. But shortly after Jean's return to New York, she wrote him a Dear John letter explaining that she and Lawrence Vail, Peggy Guggenheim's first husband, were in love and planned to move to Mexico where they would marry once her divorce from Connolly was final.[15] Whether from Jean's rejection, the prospect of the front lines, or the isolation he described, Clem sank into a near suicidal despair that he described in a ten-page handwritten letter to Dwight Macdonald (August 1943):

> I fell into a state of the deepest depression which lasted for an awful 13 days and then one morning I broke down, disobeyed orders, and shook all over. I was given a five day furlough and when I came back was sent to the hospital where they kept me a week and returned me to duty with the recommendation that I be transferred somewhere my qualifications could be used properly. . . . "Maladjustment" was the verdict. . . . I hate the neatly packaged terms of psychiatry: "maladjustment" doesn't quite take care of my case. I'd say that there were certain essential demands I *make on life which the Army can't satisfy.* . . . All in all, I was offered no inducement to go on living.[16] (Emphasis in original.)

Months later, Clem reviewed *War Diary* by Jean Malaquais and alluded to the problems confronting a dissident obliged to serve a cause in which he does not believe: "An intellectual with subversive notions, you are put into mobile confinement together with a conglomeration of males under the assumption that the purpose of the confinement transcends all personal considerations. If the assumption is not acted on, brute force admonishes. Since you are cynical about the end being served by the confinement, you find that everything that happens to you and that you do in your official capacity as an inmate is irrelevant when not repugnant."[17]

Despite his letter to Macdonald and the autobiographical reference above, Clem's history suggests that losing Jean played a larger role in his breakdown than he was willing to credit. She was everything he wanted in a woman. Connolly even kept Clem's seat warm at the *Nation* while he was in the army, writing the art reviews and art notes that had been his responsibility. She lost her apartment and moved in with her friend Peggy Guggenheim, who had also abandoned Europe because of the war. In New York, Guggenheim, an ardent collector, opened Art of This Century, a remarkable gallery dedicated to advanced painting and sculpture. Jean reviewed Peggy's new 1943 group show and actually wrote about Jackson Pollock before Clem did. (Peggy remained fond of Vail, who was the father

of her children, and wished them both well. In their small circle, exchanging partners was not uncommon.)

Pollock, in fact, entered art-world mythology as the result of an infamous act he committed at the going-away party Guggenheim threw for Connolly and Vail. Guggenheim had commissioned Pollock to make a mural for the entrance hall of her apartment on the condition that it would be in place in time for her party. Pollock planned to install it that day. His measurements had been off by several inches, however, and the piece did not fit. Frantic, he started to drink. Guggenheim enlisted the aid of Marcel Duchamp and the sculptor/playwright David Hare. By evening the mural was hung and looked terrific, but Pollock was drunk and humiliated. He resented Connolly's soigné friends who made him feel stupid and out of place. Toward midnight he wove his way across the crowded living room, pulled down his pants, and in plain view of the assembled guests, peed in the marble fireplace.[18]

But we digress. Clem insisted that Jean's throwing him over had nothing to do with his breakdown: "I wasn't depressed over Jean. I was depressed by the army. I felt trapped." But Clem had a history of extreme reaction when abandoned by important women in his life. It took years for him to get over his mother's death, a tragedy many young people interpret as punishment for some imagined wrongdoing. In the fifties and again a decade later, ruptured relations with women Clem loved precipitated reactions as severe as those he endured when Jean ended their affair.

In September 1943, after eight months of military service, Clem was honorably discharged for medical reasons and returned to New York, where the editorial imbroglio at *Partisan Review* had ended with Macdonald's departure. The parting was bitter. While Clem battled depression during the summer of 1943, civil war raged in *PR*'s offices. Finally, Macdonald proposed that Phillips and Rahv try to find a backer. If they succeeded by fall, he would go peaceably, leaving the magazine to them. If they were unsuccessful, it would be his turn to try.[19] Macdonald underestimated his fellow Partisans. They came up with an angel, the wife of a high-ranking military officer who insisted on anonymity. Macdonald and his wife, Nancy, conducted a sit-in at the *PR* offices, refusing to vacate the premises until Rahv and Phillips turned over the mailing list, which Macdonald used to start *Politics*, his own lively and opinionated journal.[20] After the war, *PR* entered its most illustrious phase, but Macdonald was never again part of the circle. Rahv, no doubt, would have liked Clem to suffer a similar fate, but most of the magazine's writers forgave him for his part in the editorial spat. He was young, inexperienced, and loyal to the man who had given him his start, they said. Clem's name would never again appear

on the *Partisan Review* masthead, but that did not trouble him. He needed a paying job to support himself and his son, which he was now determined to do.

Still in a state of nervous depression, Clem attempted to resume his life as an art critic. One month after his return, MOMA exhibited a recent acquisition, Mondrian's *New York Boogie Woogie*. Clem wrote about it for the *Nation* (October 9, 1943). His inability to concentrate was evident but so too was his lack of an art history background. One year before Mondrian's death, Clem, who put himself forward as an authority on abstract painting, betrayed a total ignorance of the color theories of one of the style's leading exemplars. Right or wrong, however, he advanced his argument with enviable clarity and construction: "The simplest way almost of accounting for a great work of art is to say that it is a thing possessing simultaneously the maximum of diversity and the maximum of unity possible to that diversity. For lack of the first . . . Mondrian's *New York Boogie Woogie* . . . is something less than a masterpiece."

Had he stopped there, people might have disagreed but that would have been the end of it. Clem went on. To his credit, the following week "Reconsideration of Mondrian's *New York Boogie Woogie*" appeared: "My memory played tricks when I discussed last week the new Mondrian at the Museum of Modern Art. The painting had no orange, purple, or impure colors [and] . . . the picture improves tremendously on second view."[21]

Gossip spread quickly through the art and literary worlds about a critic presumptuous enough to take as his area of expertise a subject about which he was so patently uninformed. Fifty years later the Mondrian debacle lived on, a measure of the art world's fixation with Greenberg. It is cited by some as proof that his highly vaunted "eye" was more myth than reality, by others as an early example of his art politics—his need to fit Mondrian into the canon. At the time, however, the canon did not yet exist.

Clem drowned his depression in work. For sheer quantity, not to mention diversity and quality, his output during this period was remarkable. Reviewing *The World of Sholom Aleichem* by Maurice Samuel, he called Aleichem "the Jewish Dickens." He critiqued exhibitions by Giorgio De Chirico, Vincent van Gogh, Marc Chagall, Lyonel Feininger, Charles Burchfield, and Milton Avery. He praised Pollock's first one-man show at Art of This Century. Pollock's art was so radical and disturbing that even his fellow artists found the effect overpowering. Painter Morris Kantor, Pollock's friend since their WPA days together, wrote in Guggenheim's guest book: "This isn't painting! He just blew his top . . . burst a blood vessel."[22] Another wrote: "I had to leave. Either the guy is just too sick . . . I just couldn't take it."[23] The eminent curator James Johnson Sweeney had writ-

ten a brief forward to the catalog in which he spoke of Pollock's talent and "vitality" but also of his lack of "self-discipline."

Clem's review (*Nation*, November 27, 1943) was evenhanded. His puzzlement was evident but so too was his interest: "There are . . . surprise and fulfillment in Jackson Pollock's not so abstract abstractions." Judging the smaller works the most fully realized, Clem observed, with that note of absolute authority as widely envied later, as it was ridiculed, that the larger pieces, "although the least consummated," were the "most original and ambitious." The "mud" still "abounds" in Pollock's color, he continued, and "being young and full of energy, he takes offers he can't fill . . . [but Pollock] has gone through the influences of Miró, Picasso, Mexican paintings, and what not, and has come out on the other side at the age of thirty-one, painting mostly with his own brush. . . . In his search for style he is liable to lapse into an influence, but if the times are propitious, it won't be for long."[24] Clem later recalled that although his first impression of Pollock's art had been favorable, not until he saw the mural in the entrance hall of Guggenheim's apartment was he really "hit": "I wasn't bowled over at first. I didn't realize what I'd seen till later."[25]

The relationship of form and content was much on Clem's mind during those years. He tackled it in literature, specifically in an essay on the Victorian novel. Speaking of Trollope's *The American Senator* (*PR*, spring 1944), Clem observed that "the more robust Victorian novelists . . . let their scenes and creatures get out of hand." They let content shape form. Like Dickens, Clem continued, Trollope was "always ready to sacrifice the planned shape of a work . . . to the resistances and deflections he met in the writing of it." In other words, an insistent character, by captivating its creator and "snatch[ing] more than its allotted space," could lead its author into unanticipated realms. Clem speculated that when Trollope gave the "Senator" his head, his novel "ascended into a realm" its author had not planned to enter. Greenberg might be expected to have condemned that elevation of content over form, but he did not. Clem wrote that Trollope explored an Americanism "that turned out to be a kind of moral imperialism" and created "one of the most interesting novels in English."[26]

His next essay, "Abstract Art" (*Nation*, April 15, 1944), reexamined what he saw as Western art's current inability to achieve profound statements in a realistic genre: "Unable to represent the exterior world suggestively enough, pictorial art is driven to express as directly as possible only what goes on inside the self—or at most the ineluctable *modes* by which that which is outside the self is perceived."[27] Clem has often been accused of trying to tell artists how or what to make, but on this occasion he

rehearsed the argument Rahv made earlier, in a political context. He said, in effect, that compelling an artist to move in a direction he did not feel is an exercise in futility: "Art is under no categorical imperative to correspond point by point to the underlying tendencies of its age. Artists will do whatever they can get away with, and what they can get away with is not to be determined beforehand. Good landscapes, still lifes, and torsos will be turned out. Yet it seems to me—and the conclusion is forced by observation not by preference—that the most ambitious and effective pictorial art of these times is abstract or goes in that direction."[28]

While Clem wrestled with these ideas, a small group of Village artists were experimenting with surrealist techniques such as "automatic writing" to tap into the unconscious. They were attracted to abstraction but found the cubist-based geometrical forms of the AAA too inexpressive. They were in search of abstract forms capable of carrying a heavier emotional charge. Blindfolded, or with eyes closed, the artist concentrated on the feelings aroused by the process, freeing his hand to sketch or "doodle" marks. Building on that affective foundation, this small group of Village artists strove to invent forms that fused with feelings, the object being to elicit in the viewer the evocative power of the creative experience itself. Combining cubist structure with surrealist techniques, they arrived at an original and uniquely American art.

Someone once said Clem was in the delivery room when abstract expressionism or "American-type" painting was born. He began to write about American art just as these artists moved toward their mature styles. No major style in Western art had ever originated outside Europe. Some in New York predicted that Europe's half century of war and upheaval meant that America's day was coming, but in 1944, when Clem observed that Pollock, Robert Motherwell, William Baziotes, "and only a comparatively few others" represented "the future of American painting,"[29] he alone was betting that these were the artists who make it dawn.

The images they produced, while initially off-putting, had a punch that he felt and described but could not explain. Reviewing Baziotes's first show at Art of This Century, Clem wrote: "Baziotes . . . is unadulterated talent. . . . Two or three of his larger oils may become masterpieces . . . once they stop disturbing us by their nervousness, by their unexampled color—off-shades in the interval between red and blue, red and yellow, yellow and green, all depth, involution, and glow—and by their originality."[30]

Robert Motherwell's first show, also at Art of This Century, marked one of the few times Clem attempted to describe specific feelings aroused in him by a work of art. The result was intriguing enough to make one wish

for more: "The big smoky collage *Joy of Living*—which seems to me to hint at the joy of danger and terror, of the threats to living—is not half as achieved as the perfect and Picasso-ish *Jeune Fille*, yet it points to Motherwell's only direction: that is, the direction he must go to realize his talent— of which he has plenty. . . . Only let him stop watching himself, stop thinking instead of painting himself through."[31]

Clem was disappointed in the "inflated pastel and gouache" that Pollock showed in Guggenheim's *Spring Salon* that year, but wrote that despite its "shortcomings," and lack of "pressure," it warranted attention. He lavished praise on Guggenheim for the immeasurable service she performed in discovering and bringing forward remarkably gifted young Americans whose talents had hitherto been unremarked: "All credit is due Peggy Guggenheim for her enterprise in showing new and unrecognized artists at her Art of This Century Gallery. But even more to her credit is her acumen" (*Nation*, November 1944). Howard Putzel, Guggenheim's assistant, was the real discoverer of these artists, and Clem regretted that he had never praised him in print, commenting that "Putzel deserves more credit than he has ever gotten."[32]

For the next six years, art was Clem's obsession although he did not write about it exclusively. He looked at and wrote about everything, including photography's potential as a fine-art medium, long before it was fashionable to think of it in those terms. He wrote about Currier and Ives and the cartoons of William Steig and James Thurber. And he usually found something fresh and interesting to say. He traced the "liberties" cartoonists took with the "human form," for example, to "the breakdown of the Renaissance conception of . . . personality and industrialism's mutilation of man."[33] He articulated the message to which we as viewers unconsciously responded. Thurber confronts us with the "frustration and boredom" of middle-class America, Clem observed, "its inability to be spontaneous except when drunk, its impersonal energy, and its desperate, sociable aggressiveness."[34] Rarely superficial, he paid cartoonists the respect of taking them seriously, railing against the trivialization of the human spirit, for instance, that was implicit in Thurber's humor: "It is part of our reaction to neurotics and neurosis—which in our time seem the only things capable of compromising human beings in their very essence, as sin once could."[35]

Art could raise Clem's spirits, but his view of life in America's urban society was as bleak as Thurber's: "Not so long ago it was still possible to conceive of an attainable way of life possessing dignity and interest." Today "we can scarcely even dream of one."[36]

* * *

What makes a great critic? In the nineteenth century Walter Pater said, "What is important . . . is not that the critic . . . possess a correct abstract definition of beauty . . . but a certain kind of temperament, the power of being deeply moved."[37] Contrary to reputation, this quality distinguished Clem's writing in the forties and fifties. *The Truants*, William Barrett's memoir of his adventures among the *PR* crowd, contains this interesting observation: "The other two art experts in our immediate circle were Harold Rosenberg and Meyer Schapiro, and I doubt that they had the capacity for visual immediacy that Clem did. I went once to the Museum of Modern Art with Meyer Schapiro, who was an erudite and brilliant scholar in the history of art, and the experience was exhilarating; but there came a moment when I could not help thinking: if only the man would stop talking for a bit . . . I had the feeling that the work of art was noticed only as a springboard to his discourse. But Clem could be stopped in his tracks by the sheer visual impact of a painting, and let it work on him in silence."[38]

So influential was "Avant-Garde and Kitsch" that Clem was soon forgiven his political missteps. Among the New York Intellectuals, position in the pecking order could be assessed with a fair degree of accuracy by the number and the prestige of the symposia to which one was invited to contribute. As passionate about art as Clem was, the literary world was home. Six months after his army discharge, symposia invitations were again pouring in. An early version of T. S. Eliot's *Notes on a Definition of Culture* appeared as an essay in *Partisan Review* (spring 1944). Clem, along with the poet R. P. Blackmur, William Phillips, and I. A. Richards, were asked to respond in *PR*'s summer number. Rahv invited Clem to contribute to a symposium he organized for *Contemporary Jewish Record* (*CJR*) that explored the current situation of the Jewish-American writer. Clem's difficulties in getting published were over. He wrote regularly for *Partisan Review* and the *Nation*, and on occasion for *Politics, Horizon, Dyn*, the *New Republic*, and *CJR*.

He wrote with such seeming ease and fluidity that it was commonly assumed (with not a little envy) that no great effort was involved. His early essays on art vibrate with the passion of direct experience. He struggled to find language and forms with which to convey precise subtleties of response and nuanced pleasures. He rewrote constantly, endlessly searching for the elusive key that would reveal what it was that made a particular work of art "work" or not work. Clem routinely shied away from putting words to what he called art's "ineffable" experience, but in the forties he tried to commu-

nicate it nonverbally, crafting his critical essays in the same way he might craft a poem. In a review of Mark Tobey's paintings, he directed the viewer's eye to the vibrating space activated by the artist's signature white lines, as the visual gateway through which its abstract content entered the central nervous system. Coursing beneath the detached, disinterested prose was a rhythmic drumbeat that expanded to encompass the feeling he wished to convey: "Tobey's great innovation is . . . the calligraphic, tightly meshed interlacing of white lines which build up to a vertical, rectangular mass reaching almost to the edges of the frame; these cause the picture surface to vibrate in depth—or better, toward the spectator."[39]

From Marx and modernism Clem took his belief in the inevitability of progress. From the criticism of T. S. Eliot he took both his understanding of modern art as a continuation rather than a break with the past, and his definition of the critic's function. From Hans Hofmann's lectures he took the formal logic of cubism, in which "color and line" are to be "detached" from former associations "and made to express or suggest what is inconceivable to anything but the eye's imagination."[40] His openings were invariably meaty and provocative: "T. S. Eliot has done a good deal to expose the superficialities accompanying the popularization of liberal ideas, but he has done so by attacking habits of feeling rather than ideas as such."[41] Or, "There remains something indescribably racy and sudden for all its familiarity by now, in the way Cézanne's crisp blue line can separate the contour of an object from its mass."[42]

Clem wrote economically, his prose lean, "incisive, brash, uningratiating . . . free of fat as well as sugar."[43] He expressed complex ideas in language that was plain, though by no means simple or even straightforward.

His critical voice was fully formed by the time he wrote his first art review: its authority; the moral high ground it staked out; the implicit theoretical structure from which everything within seemed naturally to flow; the rigor of what was included and what excluded. Greenberg's values and aesthetic standards as well as the fearlessness with which he staked out his positions were more shared than shaped by the group into which "Avant-Garde and Kitsch" propelled him. But the group's coherence empowered each by reaffirming these traits.

The term "PR crowd" is confusing. The magazine's relationship with its writers was never exclusive. Indeed, many were more closely associated with *Commentary, Dissent,* or *Politics.* The term is apt, however, because *PR* was "the vibrant center" of their intellectual life, as Irving Howe noted. *PR* established value. No young writer could hope to be taken seriously without first having been honored by Phillips and Rahv with an invitation to write something for the magazine.

During the war the family's ranks were swelled by younger writers such as sociologist Daniel Bell (to whom we are indebted for our genealogical chart), Leslie Fielder, Nathan Glazier, Gertrude Himmelfarb, Howe, Murray Kempton, Irving Kristol, Melvin Lasky, C. Wright Mills, Robert Warshow, and David T. Bazelon.

They were not America's first group of intellectuals, but they were its first intelligentsia, defined as such by their unique combination of Marx and modernism and by their socioeconomic composition: roughly 40 percent were the well-educated offspring of upper-middle-class families who had been politicized by the Depression; the majority were the educated progeny of uneducated Jewish immigrants.

Isolated by their ideas from the majority of capitalist America as well as the organized left, they were intellectual pariahs who "got stuck with one another against the rest of the world whether they liked it or not (and most did not)."[44] They were one another's prime audience and most devastating critics. Irreverent in their attitudes toward "bourgeois" society, formidably intelligent, shamelessly competitive, they became "preoccupied with one another to the point of obsession . . . and as intense in their attachments and hostilities as only a family is capable of being."[45] Howe described them as a "gang of intellectual freebooters whose relations with one another more closely resembled the jungle of Hobbes than a commune of Kropotkin." Each Partisan, he went on, seemed to constitute a faction. "A writer like Harold Rosenberg or Lionel Abel presented himself as a sort of freelance guerrilla ready to take on all comers."[46]

Yet even among this contentious assembly Clem stood out as a "hard man with a strong mind . . . not exactly deficient in aggression,"[47] according to Howe, who also described him as "the best editor I ever had."[48] For this group, alienation was a defining condition, a map word. It shaped the lens through which they saw the world. The late Anatole Broyard, literary critic for the *New York Times*, was a Greenwich Village intellectual, although not a member of their circle. He and poet Delmore Schwartz, a *PR* editor during the midforties, occasionally strolled the streets of the Village together. Broyard, a black man passing as white, was sensitive to the nuances of alienation. He commented that Schwartz was often surprised and even impressed by observations that seemed ordinary to him: "Delmore seemed to see American life only in the abstract, as a Platonic essence. Sometimes he saw it as vaudeville, but he always saw it *through* something else. He imposed a form, intellectual or esthetic, on it, as if he couldn't bear to look at it directly."[49]

The *PR* voice, widely imitated in New York literary circles, reflected that sense of isolation and despair. "Hypercritical," "learned," "referential,"

"disinterested," the voice was "despairingly moral," wrote Norman Pod-
horetz, "as of one who has nothing to gain and nothing to lose in relation to
social, political, and even cultural questions."[50] The flip side, Podhoretz con-
tinued, was an implicit arrogance—the elitist conviction that "others [out-
side the group] need not be addressed in one's writing except to attack" and
that "integrity and standards were only possible among 'us.' "[51]

Their writing had an "aura of tournament," of the "writer as gymnast
with one eye on other rings."[52] They "celebrated the idea of the intellectual
as antispecialist, the writer whose specialty was not to have one." Ordinary
readers often felt excluded as the "beauties," not to mention the intricacies
of the polemic sped past them. It was an outsider style for insiders, for an
audience with shared a priori assumptions. Discourse was focused, lucid,
penetrating, aggressive. As a group they had a forceful style, a remarkable
command of the English language, and a watchful agility that made them
quick on their polemical feet. They also had a characteristic mind-set.
Clem, as Hilton Kramer noted, "was clearly willing and probably even
eager, certainly had no fear of, taking a position that most other people
would want to resist, that went contrary to whatever was the accepted
view of the time."[53] Partisans functioned as individuals and joined forces
around specific issuses. Friendships survived only so long as agreement
existed. Clem came on the scene later than the founding fathers, but his
ascent was so rapid, and his "dissenting tone . . . quick to reject what was
meretricious in contemporary culture" so similar to that of the others that,
early on, one outsider dubbed him "Lionel Schapiro," meaning he was
indistinguishable from the rest.[54]

In the art world Clem was admired for his ability to put forward and
defend unpopular positions, but he was no match for those around *PR* and
quick to admit it: "Phillips and Rahv could put me down and they could
outtalk me, and how." The *PR* crowd shared a particular brand of satirical,
almost Perelmanesque humor, Groucho Marx in tone. It was wry, caustic,
and self-deprecating. Here, too, Clem was at a disadvantage: his style was
drier, harsher, less spontaneous than that of the others. It played off unex-
pected juxtapositions and multilayered meanings. By comparison, he
seemed heavy, pompous. Where Lionel Abel might rely on a witty rejoin-
der or Harold Rosenberg dazzle his challenger with high-wire mental gym-
nastics, Clem earned early notoriety as someone who "goes around socking
people."[55]

Drunken fistfights among artists were not uncommon in certain circles,
but among intellectuals, even radical Marxist intellectuals, hand-to-hand
combat excited a lot of talk. William Phillips recalled: "Clem got into fist-
fights with a lot of people during the forties. I remember once he and I were

on a pier and two sailors came up to us. Before I knew what was going on, Clem knocked one of them down. I said, 'What happened?' He said they made an anti-Semitic remark. And then, I don't know, we started wrestling the other guy down and that was the end of that. He was quick with his fists, that's for sure."

Clem's version, drawing on his phenomenal memory for visual detail, heightens the drama and reveals much about what made him such a good writer: "It wasn't on a pier, it was in a train station. . . . There were these two sailors, one in white and one in blue. The one in white was drunk. And he left his companion and came over to us and pushed us apart and I objected. He grabbed me—behaving like a tough guy. And so by reflex, I went and hit him . . . overhand. Will noticed this and mentioned it to me afterwards. The sailor fell down but he got up and staggered towards me and there was blood trickling from the corner of his mouth. I didn't like that. Then Will got in between us. And then the sailor's companion grabbed him. And that was it."

Minimizing the significance of these brawls, Clem attributed his reputation for bellicosity to an overblown account of an altercation he had with painter/writer Manny Farber, at that time art critic for the *New Republic*:

I had a reputation for pugilism because of a thing with Manny Farber that happened in the forties. Delmore [Schwartz] called me up and told me, "Manny said you stole the stuff about big paintings from him." I was writing about size in abstract expressionist paintings. Manny was writing art criticism for the *New Republic* and movie criticism for the *Nation*. He was a better movie critic than Jim Agee, but . . . anyway, I think I called Manny and said, "What the hell is the idea?" He stuck to his guns. So I said a couple of dirty words and that was it. He called me back and said he wanted to come over. So he came over. I was living in a room and a half in my father's house [building], on Bank Street. Manny said, "Yeah, I think you did crib from me." And I said something, bad language again, and he sort of took a swing at me and I swung back. He knocked my typewriter over. I must have then tapped him lightly and he quit. He just quit. He was so neurotic. He could've beaten me up. He made his living as a carpenter then. He had big hands. He just quit. And then he went and sat on the stairs outside my rooms. And I reproached him for the typewriter. It wasn't much and that was that. And then he told the story all around town. I didn't tell anybody except maybe William Phillips. And then the story went around that I worked out in gyms and all that. And I didn't.

Ruminating about the onset of his combativeness, Clem associated it with feelings of helplessness. He recalled his friend Martin Abelov's comment that at college Clem was "a scared kid": "I sure was. Then one day I woke up and discovered I could hit people, and then I wasn't scared anymore." Although Clem appeared confident, his arrogance concealed a self-doubt that had to be hidden at all costs, especially from himself. He made provocative statements and reacted defensively when people responded in kind. He sometimes got flooded with feelings that he could not put into words and went for the quick kill—literally as well as figuratively. Often, he seems to have struck when words failed him.

One night at Lionel Abel's apartment in the Village, someone referred to a comment made by the French philosopher Jean Wahl, a good friend of Abel's. Clem said Wahl was an anti-Semite. Abel, furious, told Clem to leave his house. Clem suggested his host come downstairs and settle the matter then and there. Although recovering from a lung ailment and in frail condition, Abel agreed, and once outside Clem knocked him around. Dwight Macdonald phoned Clem in disbelief when the well-known Italian critic Nick Chiaramonte told him he had been to see Abel, who was in bed, and that his face was bruised "from several blows." Macdonald asked Clem if he had really struck first, and Clem said Abel had given him no choice, he'd insulted him.[56]

Chiaramonte wrote Clem a letter taking him to task for picking on a man thinner and weaker than himself. Macdonald wrote saying, "I don't see how it will be possible for me in the future to have any personal relations with you."[57] Clem ignored Chiaramonte but responded angrily to Macdonald, saying the fault lay entirely with Abel: "The only reason he got struck was because he accepted my invitation to come downstairs." But even this rather pitiable excuse was buried in the vicious assault he leveled at Macdonald: "Curiously enough, Abel and I were in agreement on the subject of you, *Politics* [Macdonald's magazine], and Hamilton Fish. Nor were we abusive. We just concluded you are a fool." Clem went on, shamelessly bullying the man who'd given him his start: "Don't go spreading the absurd story that I once hit [W. H.] Auden. It was [Nicolas] Calas and he struck the first blow. And don't harp on my habit of fighting . . . with weaker people."[58] The bully routine paid off. Macdonald apologized and Clem graciously accepted. The relationship was never the same, but they remained on speaking terms.

In his letter exchange with Macdonald, Clem insisted that he was not combative by nature and that "the three fights I've got into in our circles have all been with Surrealists, or ex-would-be Surrealists, who make a practice of courting violence by abuse."[59] In other words, he wrote criti-

cally about them and their work ("Surrealist Painting," *Nation,* August 12 and 19, 1944) and they said unkind things to and about him.

Years later, when Abel had reestablished relations with Clem, he gleefully used Clem's fight with a surrealist to characterize the *PR* crowd's humor and style. At a party one night Clem had been approached by the painter Max Ernst, another of Peggy Guggenheim's former husbands. In "Surrealist Painting," Clem had singled out Ernst as belonging to the branch of surrealism responsible for the "vulgarization" of modern art and described his "volcanic landscapes" as "exceptionally well manufactured scenic postal cards."[60] On another occasion he had remarked that Ernst was a "better sculptor" than he was a painter (a position largely accepted today).[61]

At the party, the conversation between Clem and Ernst quickly degenerated. Ernst overturned a loaded ashtray on Clem's head crowning him "King of the Critics," and Clem "hauled off and punched him in the eye—gave him a black eye," continued Abel. "I wasn't at that party but I remember running into Rahv and Phillips and they told me about it. I criticized Clem. I said, 'Well, Max Ernst is so much older than Clem is and physically is no match for him. Why didn't Clem just say something witty? Why'd he have to punch him?' 'Oh,' they said, 'you're such a romantic. What if he couldn't think of anything witty to say?' "[62]

Two other reactions to this story illustrate the legendary weight assigned Clem's adventures even at this early date. The fight with Ernst aroused so much jocularity among the *PR* crowd that Hannah Arendt, the German philosopher whose heavyweight intellectual status Clem acknowledged with a trenchant "no flies on her," felt obliged to come to his defense. Arendt insisted Clem's behavior was justified because "he struck in the name of principle" (the critic's responsibility to record honestly what he thought). She argued that the trouble with intellectuals was that "everything became a matter of talk, talk, talk." Invoking Camus's "virile ideal," Arendt said Clem deserved praise, not ridicule, for what he had done: "This young man has some sense of manliness and honor."[63]

William Rubin, former director of the Department of Painting and Sculpture at the Museum of Modern Art (MOMA) and a longtime—or onetime—friend of Clem's, used the Ernst story to illustrate the critic's penchant for shaping his personal style to communicate values he did, or wished to be seen to, embody.

Speaking of Clem's response when Ernst crowned him "King of the Critics," Rubin said, "That was his *geste,* as the French call it. Clem just hauled off and punched him in the jaw. And there it was. Ernst was probably shocked beyond belief when, instead of a witty response, he got a sock in

the jaw. It was the difference between French and American painting in the late forties and fifties, between the very elegant work of a painter like [Georges] Mathieu and that done by Jackson Pollock, between [Pierre] Soulages and Franz Kline. It's the difference between haute cuisine and meat and potatoes. Clem always overemphasizes the meat-and-potatoes thing because that's his posture."[64]

5

Highbrow and Jewishness: Twin Poles of Identity

All philosophy is the confession of its author," Nietzsche wrote, "a kind of involuntary unconscious memoir" that chronicles the "relative positions of the innermost drives of his nature."[1] The brash, life-affirming energy and enthusiasm with which Clem greeted American-type painting represented one pole of his identity; his work on Jewishness, a term that referred not to religion, but to the effects of Jewish identity on self-esteem, the other.

Anglo-Saxon values dominated America when Clem was growing up. Anti-Semitism, widespread in Europe for centuries, increased significantly in the United States during the thirties.[2] Clem experienced little of it directly, but even as a boy he remembered being conscious that he and his family were "different," a condition he attributed not to his parent's immigrant ways but to their status as Jews. "In Jewish tradition they call the Torah the fence . . . the fence of the law," he said. The concept of the Torah as a fence separating Jews from non-Jews, however, can be interpreted in different ways. Clem saw it as a fence that penned him in, separating him from the larger world to which he wished to belong.

His generation of Jewish writers, the remarkable group whose competitive zest and mordant humor flavored the *PR* stew, belonged neither to the East European tradition of their parents nor to the America symbolized by the dream. Like men without a country—and they were predominantly male—they belonged nowhere. Some responded with anger toward the country at large, or toward fate, but Clem blamed his parents. He believed his childhood had imposed a ceiling on what he could achieve. But he also believed that within those limits it was up to him. He seemed to view his budding self as a tabula rasa on which all remaining marks were subject to his control. He expected that he could pick and choose the "identity" he wanted from the cultural smorgasbord that was Manhattan: "You had to go out, outside the Jewish community, and make yourself into yourself.

That's why I went at first. I'd take the subway and go into New York and see the crowds of gentiles—and it was liberating."

Freudian ideas had not yet permeated society during the twenties and thirties, and it did not at first occur to this generation that their attitudes and values—toward politics, literature, intellectual accomplishment—had been projected through the prism of their Jewish identity and shaped or mis-shaped by the process. "Standing at the synagogue door, heart in, head out," in Irving Kristol's famous phrase, that generation of writers—who did not so much invent as give voice to a Jewish-American culture—initially con-ceived of themselves neither as Americans nor as Jews but as "novitiates of the Republic of Letters, a world of whose concrete physical existence" they had less doubt "than about the existence of the Midwest." This Repub-lic "included everyone who had ever been instrumental in shaping Western civilization: Herodotus and St. Augustine, D. H. Lawrence and Yeats," wrote Norman Podhoretz, whose generation was younger than Clem's but had similar aspirations.[3]

They set sail for a cosmopolitan, literary society more European than American in tenor. Like many children of immigrants, upward mobility and class distinctions played a critical, albeit unconscious, role in shaping their aspirations. Confusing their status as immigrants with their status as Jews, they nonetheless understood that recognition or "success" (meaning reputation and a modest income) would remove at least some of the stigma that caused people to look down on them and their families. "Again and again," Clem wrote, "Jewish writers describe escapes or better, flights, from the restriction or squalor of the Brooklyns and Bronxes to the wide open world (presumably Manhattan) which rewards the successful fugitive with space, importance, and wealth."[4]

So enraptured were they by the pursuit of this assimilationist dream that they blinded themselves to Hitler's intentions. While it is true that the full extent of the Holocaust became evident only after the war, evidence of Hitler's direction was visible by the end of the thirties. In 1939, however, when the German passenger liner *St. Louis*, carrying 937 Jewish refugees, was turned away from U.S. shores, the *Partisan Review* crowd made no protest. Trotskyists, they dismissed early reports of concentration camps and mass killings as disinformation, designed by enemies of the Revolution to distract attention from the socialist cause. When the realization hit them that but for an accident of geography they too "might also now be bars of soap," as Irving Howe so eloquently put it, that a single drop of Jew-ish blood made you a Jew, and nothing but a Jew, forevermore, they seemed unable to absorb it. It was as though, traveling full steam ahead, they ran into a brick wall and their minds wouldn't clear. "Among writers and critics

usually quick to analyze and philosophize, there developed a curious tongue-tiedness on the question of the Nazis and the destruction of European Jews," wrote historian Alexander Bloom.[5]

This state of mind was later associated with the concept of Jewish "self-hatred," a term coined by Theodore Lessing, a German Jew, and put into American circulation by his countryman the expatriate sociologist Kurt Lewin ("Self-Hatred Among Jews," *Contemporary Jewish Record* [CJR], 1941). Lewin wrote that in sociology it is recognized that people tend to internalize the picture of themselves reflected by the external world. Individuals belonging to groups with low value tend to have low self-esteem. This heightens the tendency of the Jew who finds his identity too much of a psychological handicap "to cut himself loose from things Jewish. . . . Being unable to cut himself entirely loose from his connections and his Jewish past, the hatred turns upon himself."[6]

Although the idea of Jewish self-hatred was not publicly addressed by the New York Intellectuals until several years later, Lewin's piece was read and discussed. The concept surfaced indirectly in a 1944 symposium, "Under Forty: American Literature and the Younger Generation of American Jews" (CJR, February 1944), organized and edited by *Partisan Review* chieftain Philip Rahv in his capacity as the magazine's part-time editor. Assembling an outstanding group of eleven young writers—Lionel Trilling, Alfred Kazin, Delmore Schwartz, Isaac Rosenfeld, Howard Fast, Muriel Rukeyser, Louis Kronenberger, and Clem among them—Rahv's theme was ostensibly a literary one: whether any difference existed between American writers of Jewish descent, who had only recently become "full participants in the cultural life of the country," and their "Christian colleagues." The secondary theme was to what extent the writer's position as artist or citizen had been altered "by the revival of anti-Semitism as a powerful force in the political history of our time." Implicit, given that it was 1944 and the invited participants all assimilationist-minded intellectuals, was a more loaded question: whether assimilation could still be considered an honorable or even a realistic goal for Jewish writers.

Clem's remarkably candid response suggests just how private "family" discussions in *Contemporary Jewish Record* were presumed to be. Responding to Rahv's question as to whether the writer had formed any conscious attitude toward his Jewish heritage, or merely reflected it in a "passive, haphazard, and largely unconscious fashion," Clem focused on the impossibility of total assimilation:

> This writer has no more of a conscious position toward his Jewish heritage than the average American Jew—which is to say, hardly any.

Perhaps he has even less than that. His father and mother repudiated a good deal of the Jewish heritage for him in advance by becoming freethinking socialists who maintained only their Yiddish, certain vestiges of folk life in the Pale, and an insistence upon specifying themselves as Jews, i.e., to change one's name because it is too Jewish is shameful. Nevertheless the reflection in my writing of the Jewish heritage—is *heritage* the right word?—though it may be passive and unconscious, is certainly not haphazard. *I believe that a quality of Jewishness is present in every word I write, as it is in almost every word of every other contemporary American Jewish writer.* It may be said that this quality derives from a heritage and not from a racial psychology, but it is very informal, being transmitted mostly through mother's milk and the habits and talk of the family. (Emphasis added.)

Clem also argued that an intrinsic difference, based on the inescapability of childhood experience, existed between Jewish children of immigrants and non-Jews. He believed that "for reasons of security" Jewish parents had severely curtailed the experiences to which the children were exposed: "No people on earth are more correct, more staid, more provincial, more commonplace, more inexperienced; none observe more strictly the letter of every code that is respectable; no people do so completely and habitually what is expected of them: doctor, lawyer, dentist, businessman, school teacher, etc., etc. (The fault is not theirs but that is immaterial for the moment.)" The limits on their experience curtailed the range of subject matter that Jewish writers could address, Clem wrote, giving voice to the strength of his feelings with this unforgettable image: "The Jewish writer is forced to write, if he is serious, the way the pelican feeds its young, striking his own breast to draw the blood of his theme."[7]

The autobiographical focus of Jewish writers—Bellow and Roth, to name only two—validates Clem's observation. We are all victims of our childhood, but the benefits he ascribed to his own are of particular interest given his recent brush with bohemia: "The Jewish writer's . . . assets lie mostly in an area (heritage) that has a direct relation to himself but only an indirect one to his writing. The Jew has at least a way of life, a code of behavior, a felt if not conscious standard to which he conforms and which protects him from the ravages of bohemianism. . . . The trouble is, as I have indicated, that this code is too utterly middle-class to inform the Jewish writer's attitude to what he writes about."[8]

Clem's resentment was widely shared by others in the symposium, although not his analysis. Alfred Kazin asked angrily: "Who is the American Jew? What does he believe . . . that separates him at all from [Ameri-

can] national habits of acquisitiveness, showiness and ignorant brag . . . what a stupendous moral pity, historically, that the Fascist cutthroats should have their eyes on him . . . when he asks for so little—only to be safe in all the Babbitt warrens." Lionel Trilling accounted for his instinct toward assimilation by noting that out of modern Jewish religion "there has not come a single voice with the note of authority—of philosophical, or poetic, or even rhetorical, let alone of religious, authority," to hold or sustain the Jewish writer.

That same year, 1944, Harold Rosenberg reviewed Hollywood journalist Ben Hecht's book A Guide for the Bedeviled (Contemporary Jewish Record). By 1944, Hecht estimated the number of dead Jews at roughly 3 million. Hannah Arendt, who later wrote about the "banality" of evil, responded with "Organized Guilt and Universal Responsibility" (Jewish Frontier), in which she rationalized the difficulty of Jewish intellectuals trying to digest that information. "Systematic mass murder . . . strains not only the imagination of human beings, but also the framework and categories of our political thought. There is no political method for dealing with mass crimes. . . . [The] human need for justice can find no satisfactory reply to the total mobilization of a people for that purpose."[9] Dwight Macdonald discussed what we now call the Holocaust as "a phenomenon unique in history" but argued against the popular notion that all Germans were equally guilty (Politics).[10] By war's end, still unable to consider the question in its largest frame, "one which began with the figure six million," as Irving Howe later wrote, the PR crowd chose to reduce it to its smallest terms and examine the impact of Jewish identity on themselves.[11] But even then they hesitated, trapped by what Howe would call "our dirty little secret."[12]

They were caught in a classic double bind, damned if they acknowledged the full extent of the Holocaust on their own sense of identity, and damned if they did not. Even after the reality had become inescapable intellectually, they went on denying it emotionally. The problem, or one of them, was that to accept the Holocaust meant disavowing membership in the Republic of Letters. It meant, or so they thought, exclusion from that elevated, ongoing conversation through which history bestows meaning on itself. It meant acknowledging the terrible truth: that the modern writers who were their "culture heroes," the same who comprised the living membership of the Great "Republic," to whose membership they aspired, reflected in their writing the widespread anti-Semitism that had given birth to Hitler.

Through fancy psychic footwork, Clem and his friends had earlier suc-

ceeded in distancing themselves from Eliot's "Jew," squatting on the "windowsill." Now the "one drop" rule made that impossible. They were trapped. If they publicly protested anti-Semitic statements, they widened the gulf between themselves and those whose company they wished to join. If they adopted a broader perspective, which is what they tried to do, they were hamstrung with respect to the larger issue, the exploration of Jewish identity in a post-Holocaust world. This damned if they do and damned if they don't scenario was not written about explicitly until the nineties when Howe addressed it publicly for the first time.

In June 1944, ten months after his army discharge, Clem was named managing editor of *Contemporary Jewish Record*. He was given complete editorial freedom and proved a talented chief editor with a discerning eye for new talent. Bernard Malamud and Hannah Arendt were two he published early in their careers. He used this position to try to blast the "dirty little secret" into the open. The American Jewish Committee had concluded that the time was right for a broad-based magazine that appealed to a wider Jewish audience. They launched *Commentary*, into which *CJR* was folded. Elliot Cohen, earlier the "presiding genius" (as Lionel Trilling, with a bow to Trollope, called him) of *Menorah Journal*, was named editor in chief, and Clem was given the number two position, that of associate editor. In the final issue of *CJR* (June 1945) Clem published historian Edward N. Saveth's "Henry Adams' Norman Ancestors," openly referring to Adams's anti-Semitism.

The strength of the taboo can be gleaned from the eerie silence that greeted Saveth's piece, but the depth and complexity of the feelings stirred were evident in the violent exchange the piece precipitated between Clem and Lionel Trilling. Trilling's much discussed short story "Of This Time, Of That Place" had recently appeared in *PR*. In it Trilling unflinchingly examined the conflicting feelings of a former radical who, following a promotion to full professor, suddenly recognized in himself an appetite for establishment acceptance, a previously unrecognized sympathy for the values held by the group to which he wished to belong.

Trilling and Greenberg met at a party given by Margaret Marshall, the *Nation*'s cultural editor, some six months after Saveth's piece appeared and promptly got into an argument. Blows were averted only by the intervention of cooler heads. Years later Greenberg said that Trilling took him to task for the Saveth piece, saying that Adams was "many things besides an anti-Semite and that I shouldn't have run it."[13] Trilling wrote that Greenberg accused him of suffering from "Jewish self-hatred."[14] William Dean

Howells once joked that "anyone can make an enemy, the problem is to keep him." Clem managed. His relationship with Trilling never recovered.

The uneasy quiet surrounding the subject of anti-Semitism was finally shattered by a non-Jew. After the Nazi defeat Jean-Paul Sartre wrote a short book called *Réflexions sur la question juive*. The English-language translation ran serially in *Partisan Review* and *Commentary* in 1946 and 1947. Sartre's book addressed the problem that had turned many Frenchmen into collaborators during the occupation and was pitting Frenchman against Frenchman as French Jews returned to their homes. "Sartre wrote with evident good will and even after Auschwitz that was no small matter," noted Howe.[15] At the same time, his book was replete with the unexamined assumptions common to prejudiced thinking. It was 1949 before Harold Rosenberg undertook a full analysis and response, but the book's flaws had the immediate benefit of generating discussion where there had been none before.

Sartre argued that anti-Semitism was a waste of effort, that left alone Jews would become just like everyone else. Jews were different, he said, because anti-Semitism had forced them outside the shared history of Western culture and obliged them to cultivate pursuits disdained by others, such as banker or moneylender. Clem could never tolerate the Jew-as-victim scenario. In his "Introduction to *The Great Wall of China*" (*Commentary*, October 1946), his first essay on Franz Kafka, the "Jew who wrote in German," he took up Sartre's question, though he never mentioned him by name.[16]

We therefore digress to introduce Kafka and the important place he occupied in the Greenberg oeuvre. Kafka came to American attention in the late thirties when *Partisan Review* published one of his short stories in translation. In 1942, Clem translated "Josephine the Songstress: or, the Mice Nation" for the magazine and during the next six years translated several of Kafka's short stories and essays for Schocken Books, Kafka's American publisher. Clem's *Commentary* piece was the introduction to Schocken's first volume of Kafka's collected works (1948).[17]

For Jewish writers in the awkward position of having only non-Jewish and frequently anti-Semitic exemplars, the discovery of a profound and moving author who was also a Jew was a signal event. The opening lines of Clem's essay capture his excitement: "The revolutionary and hypnotic effect of the works of Frank Kafka . . . upon the literary avant-garde of the world has been without parallel. Where Joyce, Proust, and Mann write finis to a whole age of fiction, Kafka seems to initiate a new one single-handed, pointing a way beyond most of the cardinal assumptions upon

which Western fiction has rested until now. Kafka's writings represent, moreover, perhaps the first time that an essentially and uniquely Jewish notion of reality, expressed hitherto nowhere but in religious forms, has found a secular voice."[18]

Kafka's anxious protagonists, "sealed off . . . governed by unknowable powers," were a metaphor not only for the condition of the Jew in modern society but for modern man, at the mercy of vast impersonal forces who controlled the Bomb and could at any moment wreak havoc on the planet.

Podhoretz once said that to be a great critic one needs an artist who "can unlock the floodgates of your mind and, releasing everything you already know, think, or feel, free you to make as much sense of your experience as you have the imagination and intelligence to do." Kafka did this for Clem. He became the vehicle through which Clem explored "Jewishness."

Qualifying Sartre's position, Clem argued that Jews had a history as a people but that this history unfolded outside the mainstream of international events. He reminded his readers that until the second half of the nineteenth century, Jewish culture had been exclusively religious, dominated by the all-encompassing rules of halakah, the department of the Torah concerned with postbiblical law. Clem interpreted Kafka's Great Wall of China as a metaphor for the "fence" of the Torah. The Wall divided as well as protected. Those inside were sealed off from the cultural and technological evolution of history.

The combination of the self-imposed "fence" of the Torah with anti-Semitism rendered Jews the object rather than the subject of history. By setting themselves apart as God's children, they defined themselves as separate, different. Kafka's "Jewish notion of reality," Clem wrote, materialized as his protagonists struggled in vain to reestablish routines whose only apparent function was to symbolize order and safety. Clem likened the claustrophobic reality of traditional Jewish life, governed by halakah, to that experienced by Kafka's protagonists: "Kafka's static, treadmill . . . world bears many resemblances to the one presented in the Halachic . . . that department of the writings of the sages which deals with the Law."

Clem developed an elaborate theory to account for the circumstances in his parents' life that led to what he considered their abject conformity to middle-class rules of behavior. He interpreted this conformity as a longing for the security of halakah, which for two thousand years had given meaning and purpose to daily life by prescribing rules that covered every "jot and tittle" of existence, from what to do if your ox steps in a hole on your neighbor's property to a husband's obligations toward his wife, parents, children. Jews had become so dependent on a code prescribed from on high that

when forced to abandon their traditions, they latched on to a secular code, essentially a blind adherence to middle-class morality, to replace it.

One side of Clem's nature was characterized by extraordinary stamina and vitality, the other, a more passive side, he associated with the "immobility" and conformity of his childhood. It is interesting to note that Sartre also experienced his past as a kind of passivity. In his first novel, La Nausée, the book that made Clem seek him out in Paris, the French writer prefigured existentialism by having his hero, Roquentin, abandon the historical biography on which he had been working with these words: "The true nature of the present stood revealed. It was what exists, and everything that was not present did not exist. . . . For me the past was only a retreat: it was another way of living, a . . . passivity."[19]

Clem loathed the passive tendencies in his nature. He willed himself to resist the internalized pull of the fence, but he never got over the fear that he would unconsciously succumb. A painter close to him for forty years volunteered, in a different context, that "fighting against feeling helpless was always a big part of Clem."[20] His concerns, as he embarked on a life without rules, revealed themselves in his pseudonymous review of Out of This Century, Peggy Guggenheim's memoir about life among the bohemians (Commentary, September 1946). Clem admired what Guggenheim had done for American art and they were good friends. He cringed, however, at what she revealed about her defenselessness and dependency, with which he seems to have identified to some extent: "As a Jew I am disturbed in a particular way by this account of the life of another Jew. Is this how naked and helpless we Jews become once we abandon our 'system' completely and surrender ourselves to a world so utterly Gentile? . . ."[21]

Clem set out, quite deliberately, to create his own behavioral code. He was so outspoken about the effort that it assumed hilarious proportions among PR gossipmongers. Many, such as Rahv and Delmore Schwartz, made fun of him, but others respected the effort. In The Truants, William Barrett remarked, "I happened . . . to admire him for his deliberate concern with his own personal integrity, his efforts to establish a kind of moral code for himself, however corny and quaint this might seem to some people in the circle."[22]

Clem's effort to shape himself into the kind of person he wanted to be included a desire to be well-rounded. The man the art world dubbed the avatar of high culture found someone to teach him to jitterbug and thereafter prided himself on being up-to-date about the latest dance steps. He loved jazz and developed a lifelong passion for popular music and for movies, which he attended three or four times a week. Baseball was another of his passions. He, Delmore Schwartz, and William Phillips went

to games together, hotly disputing the merits of their respective teams on the train to Ebbet's Field. A mania their fellows found vastly amusing. Abel recalled raucous dissecting sessions in which the psychological and philosophical implications of the trio's team preferences were analyzed. "Delmore admired the Giants," Abel explained. "He liked the subtleties of baseball—bunting and things like that. Clem only liked home runs so Clem admired the Yankees." One day Delmore, in a snit because his team was losing, dubbed Clem the Yankee lover, mockingly conflating his choice of baseball teams with his preference for well-bred WASP women. The mot spread like a kerosene fire.

Concurrent with all this was the war's end. Contemporary French painting reappeared in New York museums and galleries soon after VE day in May 1945. Everyone rushed to see what was new and exciting. In June 1946 there was a Rouault show at MOMA and an exhibition of School of Paris paintings at the Matisse Gallery. Most, including Clem, concluded that "the School of Paris remains . . . the creative fountainhead of modern art."[23]

Clem wrote about the positivism and materiality of French painting and how "its essence lay in . . . immediate sensation," not because artists chose to give up the natural world but because the "age and milieu" made it too difficult for Picasso, the most prominent example, "to devote himself ambitiously to anything but the 'physical.' " Again and again Clem's writing, in the careful shadings of its discriminations, demonstrated his remarkably acute intelligence. Speaking of Paul Gauguin, whom he considered a "genius" but something less than a "great" artist, he observed that "Gauguin was misled, as many a later artist has been, into thinking that certain resemblances between his own and primitive art meant an affinity of intention and consciousness."[24]

Clem routinely distinguished between a great artist, for example, and a great painter. In 1946 he described the German painter Max Beckmann as "a great artist . . . one of the last to handle the human figure and the portrait on the level of ambitious, original art," but not a great painter.[25] In his lexicon it was the primary job of the critic to make rank order discriminations, and he rarely shrank from the task.

In the midforties Clem explored a great many ideas in print. He wrote about the relationship between character and art quality: How true was the artist to himself, to what he felt? He reviewed the MOMA's 1946 Chagall retrospective, noting that the Russian artist "went too far in emphasizing the uniqueness of his personality and did not know at what point to humble himself."[26] The same month, speaking of Matisse's postcubist still lifes, Clem made this interesting observation: "Their controlled sensuality,

their careful sumptuousness, prove that the flesh is as capable of virtue as the soul and can enjoy itself with equal rigor."

Clem returned again and again to the fundamental question of why modern art took the form it did: "After 1920 the School of Paris's positivism, which had been carried by the essentially optimistic assumption that infinite prospects of 'technical' advance lay before it, began to lose faith in itself. . . . Mondrian seemed the handwriting on the wall." Artists such as Matisse and Picasso "appear to have felt that unless painting proceeded, at least during our time, in its exploration of the physical, it would stop advancing altogether—that to return to the literary would be to retreat and repeat."[27] His positions were not inflexible and he seemed willing simply to record certain observations. A few weeks after his comments on Picasso's emphasis on the "physical" quality of painting, he observed that "if Dubuffet's art consolidates itself on the level indicated by these three pictures [at the Matisse Gallery] . . . then easel painting with *explicit* subject matter will have won a new lease on life."[28] (Emphasis in original.)

Clem was not particularly well liked among the PR crowd but he was not a controversial figure. Most of the criticism directed at him focused on the outlandish art he so vociferously championed. He wrote favorably about American artists whom most dealers, curators, and critics considered undisciplined, raw, and lacking in refinement. In May 1946, he predicted that Arshile Gorky would soon "acquire the integral arrogance that his talent entitles him to . . . and . . . will begin to paint pictures so original that they will look ugly at first."[29]

By this time his expressed discontent with American art institutions and the work they chose to showcase was attracting comment. Of the 1946 Georgia O'Keeffe retrospective at MOMA he wrote, "That an institution as influential as the Museum of Modern Art should dignify this arty manifestation with a large-scale retrospective is a bad sign."[30]

The mid- to late forties were formative years for Greenberg personally as well as professionally. They were the years when he made the transition from Brooklyn to Manhattan; from first son of Jewish immigrant parents fearful and out of place in America to highbrow cultural critic questioning that country's values. He moved to a room-and-a-half-with-no-view at 90 Bank Street, a building owned by his father just off Hudson near the White Horse Tavern, where Dylan Thomas died. Cornelia Reis, then married to painter Kenneth Noland, recalled that "it was your classic intellectual pad . . . sort of bare with the requisite Barcelona chair, tattered little Oriental rugs scattered around, and books and bookcases everywhere."[31] Clem had little pictures and objects hanging on the walls, and there were always one

or two of his own canvases. Painter Harry Jackson recalled, "Clem was so proud, he seemed to wear that apartment."[32]

From 90 Bank it was an easy walk to the artists' studios on Eighth and Tenth Streets, the jazz clubs he enjoyed, and the famed Cedar Street Tavern, already frequented by the artists he admired.

At 90 Bank Street he learned to entertain, and to arrange a social life for himself. Once or twice a week he invited one person or several for drinks, often followed by dinner at a nearby restaurant that featured the kind of meat-and-potatoes menu he preferred. Adolph Gottlieb; William Phillips and his wife, Edna; the writer Paul Goodman; Sidney Phillips, the publisher of Dial Press, and his wife, Gert; the de Koonings; and Lee Krasner were among his guests.

The space was small but he composed his guest lists with care. Hilton Kramer remembered one party in the fifties: "Clem introduced me to the widow of [the deceased German art critic] Julius Meier-Graefe, and it was amazing to me that she would be still alive and living in New York. . . . I think that at the same party I met Hans Hofmann. There weren't many people, it was a small apartment, but it was very convivial." Clem was a stickler for form. Two years before his death he irritably recalled the time in the early fifties he invited Bill and Elaine de Kooning for drinks and they showed up with an entourage.

Clem was then in his midthirties, five feet eleven inches tall, with an impressive forehead exaggerated by a domed head, bald for as long as anyone could remember. He had a beaked nose, large liquid-brown eyes, full sensual lips, and long, shapely fingers usually locked around an unfiltered Camel in the standard toke position. He spoke carefully, his words issuing from the front of his mouth, as if his teeth stood guard, not against the release of some ill-considered opinion but against exposing a part of himself he might not choose to reveal. He had a slight drawl, a vestige of his boyhood days in Norfolk, and dropped the final consonant from most gerunds: "After toilin' with Dwight for all that time . . ." The vocabulary and phrasing were out of Oxbridge, by way of Eliot or maybe Auden, but the delivery was downtown New York and the style brash and colorful. He juxtaposed trenchant contradictions with blunt character appraisals: "De Koonin' was a barbarian like his wife, Elaine, whom I rather liked." His face was mobile, expressive, ugly but appealing, like a Yiddish bulldog. A hapless visitor might be greeted with snarling, lip-curling scorn or bathed in a warmth with the intensity of a high-powered sunlamp. He was not much for small talk. Introduced to the Jewish painter Larry Rivers by Delmore Schwartz, Clem bypassed pleasantries in favor of "What was your name before you changed it?"

* * *

As 1946 progressed, Clem found himself thinking the unthinkable, i.e., that some of the young Americans Peggy Guggenheim showed were actually ahead of their French counterparts, that is, more advanced in terms of their capacity to absorb and reflect what he saw as the spirit of the age. For the first time he entertained the idea that New York, not Paris, might be the postwar art capital.

John Bernard Myers, man-about-the-art-world and editor of *View,* the surrealist poetry magazine, met Clem at a party in the Village and shortly thereafter bumped into him on the corner of Park Avenue and Thirty-fourth Street. Myers admired avant-garde painting and sculpture and had confided to Clem his dream of one day directing a gallery. Clem was interested in recruiting talent to the cause of vanguard American art. They repaired to the Vanderbilt Bar to talk. Myers was a tall, well-built, impish, and elegant young man in his twenties. Clem's opening comment so startled him that he recorded it in his journal (March 1946) and thirty-five years later included it in his memoir, *Tracking the Marvelous.* "Y'know," commented Clem, "Paris has been limping along as the world center of art since 1936." "How is that possible? What would happen? Where would the center be?" sputtered the astonished Myers. Clem's response: "The place where the money is, New York."[33]

In 1946, de Kooning's first one-man show was still two years in the future, Clyfford Still's a year away. Mark Rothko and Bradley Walker Tomlin painted abstract, but it would be another year before they or their peers moved toward abstract expressionism, a term coined for German modernists such as Kandinsky and not yet even applied to New Yorkers.[34] Early in 1947, still hedging his bets, Clem began making comparisons in print. In February, reviewing an exhibition of French painting, he observed, "French art still has vitality" but American art has "more originality and more honesty." On another occasion, he acknowledged the refinement of French painting but hinted that it was no longer enough. French art "culminate[s] in charm," he wrote, but "we," when "we do culminate, shall have force."[35]

The prestige Clem had accrued as the author of a landmark essay benefited the art he favored. The educated, elite readers of the little magazines in which his essays and reviews appeared might not share his taste, but if he said something was important, many made a point of seeing it. Clem was by then persuaded that among the handful of young Americans he had been watching for four years—Baziotes, Hofmann, Gorky, Pollock, Motherwell, and Smith, among them—two produced art with the breadth Nietzsche had in mind when he wrote, "Balance, largeness, precision,

enlightenment, contempt for nature in all its particularity—that is the great and absent art of our age."

Clem feared that the isolation in which these artists worked was so extreme that the tiny seedling they cultivated would wither before bearing fruit. The art establishment's lack of interest meant the conventional route to recognition—handsomely installed exhibitions in prestigious galleries and museums, illustrated catalogs with scholarly essays by recognized authorities, favorable reviews in the *New York Times*—was closed to them. Clem decided to gamble what reputation he had on a long shot, an art that looked like nothing the world had ever seen before, an art whose surface and finish opposed aesthetic values that for centuries had been deemed sacred.

6

Breaking the Ice

The American art establishment was still very small when Clem concluded that some of the young Americans discovered by Peggy Guggenheim were on a par with their French counterparts: Alfred Barr, the founding director of the Museum of Modern Art; James Thrall Soby, who succeeded Barr; Meyer Schapiro at Columbia University; Robert Goldwater, professor of art at New York University's Institute of Fine Arts; and a handful of others. These men had been taught that new directions in art had always originated in Europe. The unspoken assumption was that they always would. Aware of the Americans Guggenheim showed, they did not share Clem's view of their talents.

Concerned that American art could not long survive the vacuum of its current isolation, Clem first tried bullying the establishment into seeing things his way. He had already perfected the famous *über* voice—judgmental, authoritative, issuing from above and outside—and maintained a constant drumbeat, mercilessly hectoring Fifty-seventh Street and the Museum of Modern Art for poor judgment and undue cautiousness. When these measures failed to produce the desired effect, he conceived a daring plan to do an end run around the powers-that-be and capture mass media attention for the artists he believed in.

Between October 1947 and March 1948, he wrote three major essays— "The Present Prospects of American Painting and Sculpture" (*Horizon*, October 1947), "The Situation at the Moment" (*Partisan Review*, January 1948), and "The Decline of Cubism" (*Partisan Review*, March 1948)—each making more extreme claims for the significance of what he saw as the first national art of real magnitude to emerge in the New World.

The care with which "The Present Prospects of American Painting and Sculpture" was crafted indicates the all-or-nothing stakes for which he played. The piece had to be irksome enough to get a rise out of the New York establishment, sexy enough to bait the media, and doleful enough about the American situation to tantalize Europeans without threatening them. There was a certain poetry in the placement. *Horizon*, Cyril Con-

nolly's magazine, was sometimes referred to as the British counterpart of *Partisan Review. Horizon* had reprinted "Avant-Garde and Kitsch" six months after it appeared in *PR* and had introduced Clem's name in European intellectual circles.

"Present Prospects" was a brazen polemic couched as a disinterested report on the sorry state of American culture. In prose that came as close to purple as he ever got, Clem dwelt in excruciating detail on the impoverishing ennui of a society reduced to its lowest common denominator.

The "middlebrow" phenomenon was just emerging as a topic of intellectual discussion. Clem praised America's "effort at mass education," but expressed concern for the future of high art in a society dedicated to the "wiping out of cultural distinctions between the more and less cultivated." He told how American middlebrows, deficient in "eccentricity" or "the distortions of personal bias," lacked the necessary depth to appreciate great art. He castigated the philistines (among whom he specifically included the art establishment of the nation) for the cultural sludge spreading through the wasteland of our cities. He cautioned against the relativity in judgment that "render[ed] standards of art and thought provisional." He railed against nouveau know-nothings who aspired to culture on the assumption that "like personal hygiene" it went "with a high standard of living."[1] Sad to say, he told his European readers, these people comprised the only art market America had. And he went further, intimating that the implications of this state of affairs was not solely a matter for U.S. concern. After the two world wars, Europe was morally and emotionally demoralized, its economy in a shambles. (It was in 1947 that the Marshall Plan was introduced.) America was about to become the vital center of the West in more ways than one.

His prime focus, and the implication was that it should be theirs as well, was the frail tendril he saw poking through America's hitherto barren art soil: "The fate of American art does not depend on the encouragement bestowed or withheld by 57th Street and the Museum of Modern Art. The morale of that section of New York's Bohemia which is inhabited by striving young artists has declined in the last twenty years, but the level of its intelligence has risen."

Beneath his "dispassionate" prose pulsed a song of "outcast genius" and "tortured" souls, the living, breathing counterparts of celluloid antiheroes like Marlon Brando or James Dean.[2] In racy but harrowing terms Clem sketched a portrait of these hot-blooded, independent Americans, heir to the romantic individualism of the cowboy and the lonely frontier but carrying, deep within, the genes of their aristocratic forebears, the artists who gave birth to the European tradition.

He singled out two fully mature Americans and "seven or eight . . . tentatives" already standing in the wings. He described Jackson Pollock as "a Gothic, morbid and extreme disciple of Picasso's cubism and Miró's post-cubism" who "attempt[ed] to cope with urban life" by "dwell[ing] entirely in the lonely jungle of immediate sensations." Pollock, he told the world, was the most powerful painter in contemporary America. Clem singled out the "constructivist" sculptor David Smith, describing him as "broader" than Pollock, capable of substituting "virile elegance" for "unadulterated emotional force." Both, wrote the esteemed author of "Avant-Garde and Kitsch," "produce. . . art capable of withstanding the test of international scrutiny" and both "justify the term major."[3] He concluded with a vivid portrayal of the circumstances confronting these valiant few and their supporters, concluding with this autobiographical passage: "The artists . . . all . . . exist from hand to mouth. Their only hope a small circle of [highbrow] fanatics, art-fixated misfits . . . as isolated in the United States as if they were living in Paleolithic Europe. The isolation is inconceivable, crushing, unbroken, damning. . . . What can fifty do against a hundred and forty million?"[4]

Published in *Partisan Review* Clem's essay would have been bleak but "in the family." The mass media would no doubt have ignored it. Hanging America's dirty linen on *Horizon*'s party line, however, was something else. What he set in motion was beyond his wildest dreams. European intellectuals read the piece avidly for its confirmation of views they already held about America's cultural deficiencies and responded with amusement to the charge that the art establishment of the nation was in middlebrow hands.

Greenberg angled for the mass media and he reeled them in. Two months later, *Time*, in a single-column piece entitled "The Best?" asked sarcastically, "Is any good art being made in America? . . . Manhattan critic Clement Greenberg singled out Jackson Pollock, who painted this!" Followed by a black-and-white reproduction, roughly the size of a postage stamp, of what looked like a meaningless mass of streaks and smears. Still, *Time* spelled the names right and broadcast the message. It was a start.

Three months after "Present Prospects," the second essay of Clem's trilogy, "The Situation at the Moment" (*PR*, January 1948), opened on a grim note: "To define the exact status of contemporary American art in relation to the history of art past and present demands a certain mercilessness and pessimism. . . . Our most effective course is to confront the situation as it is, and if it is still bad, to acknowledge the badness, trusting in truth as the premise for any improvement." By including American art within the majestic folds of "art past and present," however, he gave it a place within the metadialogue surrounding Western culture. The good news was that

the extreme isolation endured by the Americans may have been a cloud with a silver lining. Like Kafka's alienated heroes, these artists had unparalleled experience with the central problem of modern life in its most unvarnished form: "Isolation, or rather alienation . . . is the condition under which the true reality of our age is experienced. And the experience of this true reality is indispensable to any ambitious art."

"The Decline of Cubism" (PR, March 1948) was still more extreme: "One has the impression—but only the impression—that the immediate future of Western art, if it is to have an immediate future, depends on what is done in this country. As dark as the situation still is for us, American painting in its most advanced aspects—that is, American abstract painting—has in the last several years shown here and there a capacity for fresh content that does not seem to be matched either in France or Great Britain." The future was in the hands of these Americans not because their art was technically superior, nor because it offered more pleasure to the eye, but because it alone had the capacity to release the pent-up feelings of the age: "The great art style of any period is that which relates itself to the true insights of its time. . . . The conclusion forces itself, much to our own surprise, that the main premises of Western art have at last migrated to the United States, along with the center of gravity of industrial production and political power."

This migration had not solved the sociocultural problems faced by the West, but it did permit some hope that high art, and therefore high culture, could survive that preserved the standards of the past. For the mass media, this was heady stuff. A New York critic with impressive elitist credentials was exposing, layer by layer, the deeply buried content in unintelligible art by uncelebrated Americans. Content he deemed vital to the continued health and well-being of Western civilization.

If Clem imagined that a grateful art community would make him its hero, he was wrong. If he hoped to change the situation by gaining entrée to the establishment, and as unlikely as that may seem, he apparently did harbor such fantasies, he miscalculated.

Louise Bourgeois, the well-known French-born sculptor, and her husband, Robert Goldwater, the eminent art historian, were well-placed members of that respected community. During the mid- to late forties Clem was a close friend of the Goldwater family. Robert "had aspirations to be a writer," according to his wife. He was impressed by the seeming ease and authority of Clem's prose: "Robert considered that Clem was a real writer. He did not use jargon. His writing was clear, educational, and straightforward." Clem was flattered by Goldwater's attention. He looked up to

Robert and "picked his brain," according to Bourgeois, and Robert was in turn flattered to have so accomplished an admirer. Clem soon occupied a privileged position in the Goldwater household. He was the *"enfant gâté,"* the "fair-haired child," said Bourgeois. His relations with the family were so *"intime"* that he frequently dined alone with Robert, Louise, and their two sons. If Goldwater had another engagement, Clem and Louise would sometimes have lunch or coffee together. "Personally, he was very nice," she later mused. "And if you fed him, I mean if he came for dinner, he loved the food and was sweet."

Alfred Barr, a key member of the establishment was a close friend of the Goldwaters'. In 1927, at the age of twenty-four, Barr had been tapped as the founding director of the Museum of Modern Art. In short order he had made it the premier institution of its kind in this country and, as war enveloped Europe, in the world.

Barr was modernism's most influential advocate, although he had doubts about the aesthetic value of abstraction. The second exhibition he organized at MOMA (1929) was billed as a representative cross section of American painting. Abstraction had been known in Europe for twenty years and was well represented by American painters, but Barr excluded it from his show.[5] He organized *Cubism and Abstract Art* in 1936, but his focus was on abstraction as a historical phenomenon, not on its aesthetic merits. In the late thirties Barr turned down a request from the organization American Abstract Artists (AAA) to hold one of their annuals at the museum, implying that they were following a blind alley.[6]

Clem's differences with Barr were differences of philosophy as well as of discrimination. They liked many of the same artists but Clem believed the task of a museum of modern art was to educate and elevate taste by showing only the best of the most advanced art of the time. He believed Barr focused too carefully on presenting a historically balanced picture. Beginning in 1942, he made it his job to hold MOMA's feet to the fire. In 1943 he called his readers' attention to the "extreme sensitivity of MOMA to the trade winds on Fifty-seventh Street [the heart of the art market]," indirectly accusing Barr of allowing his trustees to influence exhibition policy.[7] That same year, referring to MOMA's recent acquisition of works by Roberto Matta and André Masson, Clem wrote, "The museum shows taste in that when it buys the work of inferior artists it at least chooses their best work . . . but this does not atone for its masochistic fondness for the social and other epigones of the School of Paris."[8]

Barr was widely admired as a connoisseur, but in 1944 Clem ripped into the museum for its failure to evidence this quality with sufficient rigor. His attack centered on MOMA's ostensible failure to endorse the same high

standards for contemporary art that the Metropolitan Museum employed in relation to old masters. The subtext of his protest was MOMA's insistent pluralism, its willingness to show inferior art by surrealists and German expressionists while ignoring the superior accomplishments of talented Americans. But when the museum finally mounted *Fourteen Americans,* Clem damned the effort with faint praise (*Nation,* November 23, 1946). The MOMA was simply too inclusive, he said, not "prejudiced" enough to "select and back specific tendencies." The "function of a museum of *modern* art is to discriminate," he thundered. "The extreme eclecticism now prevailing in art is unhealthy, and it should be counteracted, even at the risk of dogmatism and intolerance. Inevitably the museum makes enemies. Let it make them for good reasons."[9]

Presumably Barr saw no reason to assume this Johnny-come-lately was a better judge of modern painting than he. Moreover, Barr had a host of testy and opinionated trustees to answer to. By the midforties the museum's bad press—mainstream publications flagellated the exhibitions as too radical while Clem battered them as too cautious—had brought the trustees' wrath down on Barr's head. The last thing he needed was a high-minded critic beating the drums for American artists he was disposed to ignore and disparaging those he exhibited, purchased, and advised his trustees to collect. During the war Barr was stripped of the directorship but allowed to remain in a lesser capacity. His prestige remained such, however, that all decisions regarding exhibitions routinely went through him.

Robert Goldwater was certain that if Barr and Greenberg got to know one another, relations would improve, but Bourgeois knew it could never be:

> Many times Robert said, "Why don't we get the two men together?" but it was not possible. If Barr would have seen Clem sitting at the table, he would have said, "Well, I'm very sorry, Louise and Robert, but I have to be at home because my daughter has a birthday party," or some such thing. He would not have had dinner with him. He would not talk to him. For instance, sometimes in a symposium, when there is a discussion and so on, you have to talk to each other. But there are ways of not doing that. And Alfred would not be put on the spot. Alfred did not want to deal with certain issues: what he liked, for example, and what he disliked. Alfred was in a position. Not only was he the founding director of the museum, but he controlled acquisitions and placed work in private collections. He made collections. Alfred was afraid of Clem. He was afraid of tensions and he felt safer in not arguing with him.[10]

When Clem inevitably realized that the MOMA was not about to reward him for his efforts, he seemed anguished and confused. He complained bitterly to Bourgeois that the museum never offered him a job or asked his advice. "His ambition became completely twisted inside when he thought of the Museum of Modern Art," Bourgeois maintained. "It was not a man talking. It was a child. . . . He was personally jealous of Barr." Bourgeois described Clem as openly envious of Barr's position. "Why him and not me?" he asked her.

Clem next pinned his hopes on James Johnson Sweeney, a writer and curator who shared his interest in what the English called American-type painting. Clem often spoke to Bourgeois "about the importance of being received at the house of Sweeney," and she, a frequent guest there, was sympathetic: "To be received at the house of Sweeney would have been quite something. It would have conferred insider status, regardless of the MOMA or Alfred Barr." Moreover, Bourgeois observed, Sweeney was Irish and supported the left politically. He participated in the Artists' Congress of 1936 and was on *PR*'s Advisory Board. Unbeknownst to Clem, though common knowledge around *Partisan Review*, Sweeney was scornful of Clem's ideas and contemptuous of his tendency to handicap artists as if they were horses in a race. He disapproved, too, of the "ex cathedra" style in which Clem delivered his opinions.[11] The coveted invitation never materialized, and Clem, angry and hurt, again asked Bourgeois, "What makes them so special? Why them and not me?"

The last blow was his rejection by the academy. Greenberg was the only American critic building on the ideas of such men as Roger Fry. The Institute of Fine Arts, widely recognized for the quality of its scholarship, should presumably have found his work of some interest. But he was never invited to lecture or even to attend one of the Institute's Friday-afternoon teas. The reason, according to Bourgeois, was the one that first circulated after his Mondrian review. He did not have the requisite academic credentials. It was said that he did not know enough.

So the establishment found his ideas unpersuasive and his taste execrable. But the hope he generated in the artists, and the mass media attention they received as a result of his essays, had their own momentum. Clem's claims for his contribution were modest. He phrased them in terms of changes that occurred in the work of artists who today are well known:

I can't talk about how much influence I've had on artists. I don't know. More is attributed, much was attributed to me for being supportive. . . . I know in '47 a painter like Bradley Walker Tomlin went

toward abstract expressionism; he'd been an abstract artist before. Jim Brooks, Philip Guston. For some reason '47, '48, there was a swing. New recruits. Rothko earlier painted quasi-abstract, and he came under the influence of Cliff Still, I think in '47 when Still had his first one-man show at Peggy Guggenheim's gallery. I know that Baziotes came under Still's influence. At that point Rothko became more decisively abstract. . . . In a detached way Hofmann played a part, although none of the abstract expressionist painters had attended his school. Some went for a couple of lectures as I did, or some, like Gorky, went over to Hofmann's school for company when classes were letting out.

In October 1948, seven months after Clem's trilogy, *Life* convened a Round Table on Modern Art (which met at the Museum of Modern Art). Fifteen "distinguished" critics and connoisseurs were invited to "clarify the strange art of today." Although known to Americans since the Armory Show of 1913, modern art was little understood and widely ridiculed. The round table addressed the question why modern art, which did not come to grips with "the great obvious truths" of human life and which the layman found "ugly," "strange," and "difficult to understand," constituted "the dominant trend . . . of our time."[12] For the first time, Pollock was included among the pantheon of important artists to be discussed and Clem was among the "distinguished" scholars, whose numbers included Sir Leigh Ashton, director of the Victoria and Albert Museum in London; Francis Henry Taylor, director of the Metropolitan Museum of Art; Charles Sawyer, dean of the Yale School of Fine Arts; James Thrall Soby, director of the Department of Painting and Sculpture, Museum of Modern Art; and Meyer Schapiro, professor of art history, Columbia University.

A wide-ranging colloquy ensued, excerpts of which appeared in *Life* (December 20, 1948). Four years after the war the discussion of modern art was just beginning. The panelists could not even agree as to the value of Picasso's *Girl Before a Mirror*, now considered a masterpiece. Schapiro held the table "spellbound" with his brilliant and spontaneous exposition. He explained that Picasso distorted and fragmented the human figure only after concluding that traditional portraits, which depicted the subject from the perspective of the viewer, had lost the power to move us. Picasso, Schapiro explained, portrayed his nubile young woman as simultaneously contemplated by herself, her lover, and the viewer. By this means "the vision of another's body" once more became the "intensely rousing and mysterious process" it had been in the hands of Titian or Rubens.

* * *

Alfred Frankfurter, editor and publisher of *Art News*, noted that in the past, like all things human, the arts were "implicated in the problem of good and evil; esthetics were implicated in ethics." That being no longer the case, modern artists found themselves obliged to create art that stood alone in human experience. Clem observed that the point to remember was that art never functioned in a vacuum. Modern artists immersed themselves in experience rather than the material world that surrounded them because society was in a state of flux. Familiar forms no longer communicated as they once had done. Like it or not—and Clem made plain that he did not—this was the situation of our age: "I think it one of the tragedies of our time that great painting has to do without recognizable subject matter."

The round table legitimized Greenberg as an authority but his elevation did not sit well with American art professionals. Clem pressed on. In 1948, he advanced two of the artists he originally classified among the tentatives to "major" status.

Clem had reviewed Arshile Gorky's 1946 show at the Julien Levy Gallery (*Nation*, May 1946), and judged him an artist of great promise who had not yet found his own voice: "Gorky's art does not yet constitute an eruption into the mainstream of contemporary art, as I think Jackson Pollock's does. . . . His self-confidence still fails to extend to invention."[13] In 1948, however, Clem felt Gorky had come into his own. He wrote of the "largeness" of Gorky's art, terming it the most "luscious, elegant, mellifluous grand style painting I have seen." Clem pronounced Gorky "the equal of any painter of his own generation anywhere."[14]

De Kooning, as is well known, set high standards for himself. He would often work for weeks on a painting, decide it was not good enough, scrape the canvas clean, and start over. Although a mature painter by the mid-thirties, his first one-person show (Charles Egan Gallery) did not take place until 1948 (a year after Greenberg's "Present Prospects"). After seeing that show, Clem's exhilaration was boundless. He described de Kooning's art as "large, serious, and magnificent." "Decidedly," he continued, "the past year has been a remarkably good one for American art. . . . Now, as if suddenly . . . we are introduced to one of the four or five greatest painters in the country."[15]

In June 1949, Clem again lambasted American galleries for their steadfast promotion of European artists and studied indifference to their own: "It is possible that the more powerful organs of American public opinion will

after a time awake to the fact that our new painting and sculpture consti-
tute the most original and vigorous art in the world today." It is possible
that "national pride will overcome ingrained philistinism and induce our
journalists to boast of what they neither understand nor enjoy." But blind
recognition, although better than no recognition, was not a situation he
thought healthy: "It would be very embarrassing . . . if the Luce magazines
. . . boarded the train before the powers on Fifty-seventh Street did. That
would show bad business policy on the part of those powers, and business
policy is the only excuse they can still offer for their obtuseness."[16]

In March of 1949 Robert Goldwater was named editor of the *Magazine of
Art*. One of his first acts was to organize a symposium called "The State of
American Art." Among the sixteen contributors were Barr; James Thrall
Soby; Lloyd Goodrich, director of the Whitney Museum of Art; Douglas
MacAgy, director of the San Francisco Museum of Art; H. W. Janson,
author of the *History of Art*, the most widely read art history text in Amer-
ica; and Greenberg. The consensus among the contributors was that
movement and vitality existed in American art but, excepting Clem, all
agreed that the best painting of our time still originated in Paris.

Clem held his ground: "There is, in my opinion, a definitely American
trend in contemporary art, one that promises to become an original contri-
bution to the mainstream and not merely a local inflection of something
developing abroad."[17] The American invention was the continuation "in
abstract painting and sculpture of the line laid down by Klee, Arp, Miró,
Giacometti and the example of the early Kandinsky," but it was married to
an "expressionist ingredient . . . that relate[d] more to German than
French art" although it embraced "cubist discipline . . . an armature upon
which to body forth emotions whose extremes threaten either to pulverize
or dissolve plastic structure."[18] The Americans he named were a diverse
group, including Gorky, Pollock, de Kooning, David Smith, Theodore
Roszak, Adolph Gottlieb, Robert Motherwell, Robert de Niro, and Sey-
mour Lipton. And he pulled no punches. "I would even hazard the opin-
ion," he continued, that three or four of these artists are not only on par
with, but "actually *ahead* of the French artists who are their contempo-
raries in age" (emphasis added).[19] In closing he took a nasty swipe at the
well-known English critic Sir Herbert Read, who had recently observed
that abstract and naturalistic art were "compatible" in the "same age and
even in the same person." Despite Clem's preference for realistic art, he
believed the "naturalistic art of our time is unredeemable . . . as it requires
only taste to discover."[20]

Barr had had enough. He backed cubism and impressionism when they

were objects of scorn and derision. During the war, through MOMA, he had done more for modern art than all European institutions together. He was the country's leading modernist and, as we know, had doubts about the future of abstraction. For the same symposium, naming no names, Barr gave voice to his exasperation: "When one kind of art or another is dogmatically assumed to be the only funicular up Parnassus, those who love art or spiritual freedom cannot remain neutral."[21]

Five months later, on August 6, 1949, the MOMA's James Thrall Soby, writing in *Saturday Review*, restated the establishment position: "We [in America] have produced in painting and sculpture no figure big enough to hold the eyes of the world on himself and also inevitably, on those of lesser stature around him. . . . We await our first in painting and sculpture, certain that he will appear and others like him."[22] Two days later, Soby's words were history. *Life* hit the newsstands with a feature story on Pollock and a banner headline that read: "JACKSON POLLOCK—Is He the Greatest Living Painter in the United States?" Despite its de rigueur sarcasm, the magazine answered with a qualified affirmative.

Why Pollock? "Recently," said *Life*, "a formidably highbrow New York critic hailed the brooding, puzzled-looking man shown above as a major artist of our time and a fine candidate to become 'the greatest American painter of the twentieth century.'" Greenberg was never mentioned by name but he did not have to be. Only one critic was making such a claim, and everyone in the art world who counted knew who he was.

The two-page spread included a full-figure photo of the brooding artist, dressed in jeans and cowboy boots, a cigarette dangling from the side of his mouth, standing in front of *Summertime*, a lush, lyrical "drip" abstraction.

Pollock was not the first modern artist to be featured in the magazine. In fact, he wrestled for some time over whether to accept the magazine's offer of a feature story. The French painter Jean Dubuffet had been spotlighted in *Life* just six months earlier—and not treated kindly. But something about his photographed image and his art seemed to touch *Life*'s editors as well as the public at large. The response was overwhelming.

Europe treated its artists as demigods. It had an old and respected fine-arts tradition. In the United States, resourcefulness and independence of mind, symbolized by Daniel Boone and his coonskin cap, had always been valued over a poetic soul. "Effete Eastern snobs" was the category to which most Americans assigned artists. But Pollock defied the image. He hailed from Cody, Wyoming, and looked the part of the lonesome cowboy. Mail streamed into the Pollock home on Fireplace Road, in Springs, East Hampton Township, Long Island. Pollock attracted so much attention that

almost overnight he became a celebrity, "notorious if not famous," as Greenberg sardonically commented.[23]

Clem was on a roll. The spotlight was shining on "that section of New York's Bohemia . . . below 34th Street [where] . . . the fate of American art [was being] . . . decided,"[24] and he was the man who had put it there. A few months earlier, Alfred Barr had taken MOMA curator Peter Blake to task for praising Pollock in an exhibition catalog. "I don't think Pollock's work is something we should be supporting," Barr admonished, but three months after *Life's* feature he accompanied Mrs. John D. Rockefeller to the Betty Parsons Gallery for the opening of Pollock's November show and helped select a painting for her collection.[25]

In 1949, maybe fifty people in the world outside the artists themselves admired abstract expressionist art. Opening-night crowds usually consisted of the artist's family, friendly painters and sculptors, and one or two interested outsiders. This night de Kooning and Milton Resnick arrived late at the Betty Parsons Gallery. They found it packed with people they had never seen before. Paint-spattered jeans were the usual attire for such occasions, but here were men dressed in suits and ties and women in fashionable dresses. They were "all walking around, shaking hands" with one another, observed the stunned Resnick. "What's going on, Bill?" he asked. "Look around," came de Kooning's famous reply, "these are the big shots. Jackson has finally broken the ice."[26]

Among big-name collectors expressing interest in avant-garde American painting for the first time were the Burton Tremaines, financier Roy Neuberger and Mrs. Neuberger, Edgar Kaufmann Jr., owner of the famous Frank Lloyd Wright house Falling Waters, and Happy and Valentine Macy. Five months later Barr invited Pollock, de Kooning, and Gorky to join three other artists representing the United States at the twenty-fifth Venice Biennale in June 1950.

"Avant-Garde and Kitsch" examined modern art as a reaction to sociocultural changes set in motion by the Industrial Revolution and, to a lesser extent, the Enlightenment. "The Present Prospects of American Painting and Sculpture" identified one of the main threats posed by these social changes for high art as we knew it. For this reason, Clem's art-world visibility in the late forties was matched by prestige in the English-speaking literary world. His imprecations about middlebrows redounded to his credit precisely because they reflected a situation about which many intellectuals were concerned. When Clem wrote that "it becomes increasingly difficult to tell who is serious and who is not,"[27] intellectuals in England as well as

America knew exactly what he meant. The same year Clem wrote "Present Prospects" (1947), his friend William Phillips outlined the American situation bluntly for readers of *Horizon:* "Culturally what we have is a democratic free-for-all in which every individual, being as good as every other one, has the right to question any form of intellectual authority."[28]

Clem attributed the middlebrow explosion to the widespread affluence of postwar America. He was not the first to articulate the middlebrow issue, but his dramatic exploration of its consequences attracted considerable attention. His 1948 diatribe against middlebrows in the Goldwater symposium had an almost biblical ring: "Middlebrow culture attacks distinctions as such and insinuates itself everywhere, devaluating the precious, infecting the healthy, corrupting the honest and stultifying the wise."[29] However, the consequences of these mutations were not all bad. Jobs opened up for intellectuals, even Jewish intellectuals.

The *PR* crowd became less radical. The fervor earlier reserved for Marxist polemics was channeled into culture, and taste came to be seen as a concrete asset. Being innate, taste was neither arbitrary nor a question of connoisseurship. Having taste signified inherent superiority, a mark of moral distinction, wrote Norman Podhoretz in *Making It*, a widely maligned book of inestimable sociological value. "Taste came to exercise a curious tyranny over the souls of educated Americans, leaving them with the uneasy conviction that by the fruits of their aesthetic sensibilities would they be known as saved (superior) or damned (crude and philistine)—known, that is, as much to themselves as others."[30] It became a substitute for politics as the area for testing virtue.[31]

Taste, associated with "sensibility," separated critics from the masses. Critics knew if something was good because their superior sensibility allowed them to make that judgment. That's why they were critics. Some people had the ability to make fine distinctions and discriminations and some did not. This sounds arbitrary, but it was the job of the writer to demonstrate the facts persuasively. The critic was not handing down law, but saying, in effect, "This is so, is it not?" The critic appealed to the reader's own experience of the work. "If the critic was on target, it would strike the reader as true or illuminating," wrote Podhoretz. "If not, or so the thinking went, the writer could look for another line of work." Of course, most critics didn't deal with new work. For those who did, disagreement was to be expected and the writer gambled that future judgments would confirm his taste.[32]

These were the years during which *PR* became an influential voice in New York's literary world, precisely for the combination of liberal politics

and highbrow attitudes it espoused. An event announced by Russell Lynes, editor of *Harper's*, author of *The Tastemakers*, and the official historian of the Museum of Modern Art, with appropriate fanfare in his widely read essay "Highbrow, Middlebrow, Lowbrow"(*Harper's*, 1948). Lynes mockingly doffed his cap to Partisans as exemplars of an unprecedented social phenomenon: "It isn't wealth or family that makes prestige these days. . . . It's taste and high thinking. What we see growing around us is a sort of social stratification in which the highbrows are the elite, the middlebrows are the bourgeoisie, and the lowbrows are the *hoi polloi*." Although the latter group was traditionally regarded as the problem, Lynes explained that that assumption was erroneous: "In general the lowbrow attitude toward the arts is live and let live . . . lowbrows are not Philistines. One has to know enough about the arts to argue about them with the highbrows to be a Philistine."[33] Identifying the characteristics of a highbrow, Lynes could have been describing Clem, whom he in fact singled out, along with William Phillips, as a quintessential example of the species:

> 1. A highbrow . . . is the kind of person who looks at a sausage and thinks of Picasso. It is this association of culture with every aspect of daily life . . . that distinguishes the highbrow from the middlebrow or lowbrow.[34]
> 2. A highbrow makes a profession of being a highbrow and lives by his calling. The highbrow is primarily a critic and not an artist—a taster, not a cook.[35]
> 3. The militant highbrow has no patience with his enemies. He is a serious man who will not tolerate frivolity where the arts are concerned. It is part of his function . . . to protect the arts from the culture mongers, and he spits venom at those he suspects of selling the Muses short.[36]
> 4. When an artist is taken up by the highbrow and made much of, he may become, whether he likes it or not, a vested interest, and his reputation will be every bit as carefully guarded by the highbrows as a hundred shares of Standard Oil of New Jersey by the middlebrows. *In a sense, it is this determination of par that is the particular contribution of the highbrow.*" (Emphasis added.)

Lynes's tongue-in-cheek obeisance celebrated *Partisan Review* as the Olympus from which the new elite looked down on everyone else and made known their arrival as a full-fledged presence on the New York literary scene. Clem, the recognized embodiment of the highbrow, was so much

talked about that the joke among the Greenberg family was that "his stuff was so popular it must be kitsch."[37] And when W. H. Auden satirized the PR crowd in verse, they knew they had really arrived:

> Our intellectual marines,
> Landing in Little Magazines,
> Capture a trend.

More on the Jewish Question

During the years Clem wrestled the gods of modernist art to clear a path for American abstraction, he wrestled with the Jewish self-hatred he recognized in himself and others. But given the response provoked by his 1945 publication of Saveth's piece on Henry Adams, he kept his thoughts on the subject to himself.

In 1946 he reviewed *Thieves in the Night*, Arthur Koestler's pro-Zionist novel, in which the hero, a tall, handsome, half-Jewish terrorist who puts his neck on the line for a Jewish state, is contrasted with a stereotypical European Jew, fearful, hesitant, and opposed to action. Clem criticized Koestler first, for supporting a post-Holocaust stance that was not only aggressive but militaristic. Second, for tacitly accepting the European view that Jews, by going meekly to the gas chambers instead of taking some Germans with them, confirmed the world's low opinion of them. "It is possible, I want to suggest, to adopt standards of evaluation other than those of Western Europe,"[1] wrote Clem.

But it was 1949 before the *PR* crowd engaged the issue of Jewish identity in a post-Holocaust world. That year the first Bollingen Prize for Literature was awarded to Ezra Pound for *Pisan Cantos*, rated the best book of poetry published in 1948. The judges, Fellows in American Letters of the Library of Congress, comprised the literary establishment of the country: T. S. Eliot, W. H. Auden, Allen Tate, Katherine Anne Porter, Robert Lowell, Robert Penn Warren, John Berryman, and Karl Shapiro. Pound had been Eliot's mentor; "The Waste Land" was dedicated to him. Together, these two expatriate Americans revitalized the language of modern poetry and led a revolution in English literary taste. Pound had been generous to many young writers coming up behind him, including Hemingway and Fitzgerald. He was also a Fascist. Fascism, as Irving Howe pointed out, was one of the organizing themes of *Pisan Cantos*.[2]

Pound spent the war years in Italy where he made frequent radio broadcasts in support of the Fascist cause: "Every sane act you commit," he told his listeners in 1942, "is committed in homage to Mussolini and Hitler."

On other occasions he blamed the war on industrialists in general and Jewish industrialists in particular. His suggestions were explicit: "Don't start a pogrom—an old-style killing of small Jews. That system is no good whatever. Of course, if some man had a stroke of genius, and could start a pogrom up at the top, there might be something to say for it."[3]

In *Pisan Cantos*, Pound described the war as a horror. Gentiles, he said, were sent to their slaughter for Jewish profit. Pound was not the only respected writer whose books contained anti-Semitic content, but he was unique in what Alfred Kazin called his "witchlike instinct for the hate buried in the age."[4] At the time of the award, to spare the government the embarrassment of jailing a famous poet as a traitor, Pound was confined in St. Elizabeth's Hospital for the mentally ill in Washington, D.C.

The judges, aware that Pound's Fascist sympathies would make his book a controversial choice, accompanied the announcement of the prize with a statement intended to cut the ground from beneath the feet of potential challengers: "To permit other considerations than that of aesthetic achievement to sway the decision," they wrote, "would destroy the significance of the award and would in principle deny the validity of that objective perception of value on which any civilized society must rest."[5]

Despite this caveat, the prize ignited a firestorm of protest. Pound's poetry was difficult and confusing. The mainstream press objected to the prize's being given to a Nazi sympathizer, and an "obscurantist" Nazi sympathizer at that. But the shock and outrage felt by Jewish intellectuals was more personal. The judges were academics closer in their predilections to New Criticism, a mode of literary analysis in which the text is examined as separate from the author's intentions or the reader's response, than to the political, contextual approach practiced by the New Yorkers. But both groups published in the same little magazines and participated in the same symposia. Eliot, in fact, had been dubbed the *PR* crowd's "culture hero" by Delmore Schwartz because he articulated their sentiments about the modern world. With the exception of Shapiro, who voted against the award, the judges were non-Jews.

Partisans were shocked that writers they looked up to could display such blatant, and blind, insensitivity. Moreover, the prize to Pound could not be justified on the grounds that it was for lifetime achievement. The award was "for the best book of poetry in 1948." In New York, lines were drawn. Howe said, "Very well, they might feel as they wished about their crank genius. But to render him public honor a few years after word of the Holocaust reached us was unbearable."[6] Two issues comprised the nub of the argument. First, the judges' assumption that aesthetic values superseded

all others, and second, that "aesthetic achievement" based on "objective perceptions of value" could be separated from subject matter that was morally repugnant.

William Barrett, a non-Jew, wrote an editorial in *Partisan Review* attacking the second. Barrett asked how far it was possible, in a lyric poem, "for technical embellishments to transform vicious and ugly matter into beautiful poetry." Yes, said the New Yorkers, Pound should be free to write what he pleased, but his repellent ideas did not have to be dignified with public honor. Feelings ran strong and dissension went on for months.

The judges, stung by the charges of anti-Semitism, accused their Jewish colleagues of trying to impose censorship. Auden announced that if he thought Pound's poetry would foster anti-Semitism, he would be "in favor of censoring it." But, he added, given that "aesthetic autonomy was the higher principle," he would first award it the prize.[7] At the height of the tumult the elegant Allen Tate challenged Barrett to a duel because "courage and honor are not subjects of literary controversy, but occasions for action." (Barrett sidestepped, to the vast disappointment of his fellow Partisans.)[8]

In April, *PR* organized a symposium on the continuing controversy, and Auden, Robert Gorham Davis, George Orwell, Karl Shapiro, Allen Tate, Greenberg, and Irving Howe contributed. Auden, who famously wrote, "We must love one another or die," and whose lover Chester Kallman was a Jew, made one of those English observations whose blunt truthfulness Americans find offensive: "Anti-Semitism is, unfortunately, not only a feeling which all gentiles at times feel, but also, and this is what matters, a feeling of which the majority of them are not ashamed."[9] In other words, the judges might not agree with all of Pound's statements, but they were not unsympathetic to the underlying attitude.

Greenberg, often categorized as a strict formalist, called the attention of Jewish intellectuals to their own complicity in what had happened. Although the question of T. S. Eliot's anti-Semitism was not fully explored until the nineties, Clem argued that the *PR* crowd's decision to overlook anti-Semitic content in writers they admired had made it possible for those conferring high public honor on a Fascist sympathizer to act without shame. Dismissing the formal framework within which the judges hoped to confine discussion, he began by saying that "life includes and is more important than art and it judges things by their consequences. . . . As a Jew, I myself cannot help being offended by the matter of Pound's latest poetry; and since 1943 things like that make me feel *physically* afraid too."[10]

Indicating his belief that the prize could be contested on the basis of quality, he chose instead to challenge the award on grounds he considered

more important. His widely quoted response demolished question one, the assumption that aesthetic values superseded all others.

Aesthetic autonomy, on its face, means simply that the experience communicated by art is valid in and of itself, that art has no obligation to be socially or politically involved. It was a phrase employed by the Trotskyist *PR* crowd in the late thirties and early forties to oppose Stalin's claims about art's obligations to the state. Even then, however, the phrase had a resonant undercurrent. Modern literature, which was abstract and difficult, had been the *PR* crowd's line in the sand when they split with the Communist Party, most of whose members preferred naturalistic literature. To Partisans a taste for modern art signified superior perception but something else as well: superior character. In the postwar years, as political urgency subsided, this unstated meaning came closer to the surface. In the larger culture, highbrows, defined as those who knew and loved modern art, were looked up to for their taste but also for the elevated values they represented.

In his contribution to the *PR* symposium on the Pound award, Clem argued that the term *aesthetic autonomy* had become a respectable umbrella under which Jews as well as non-Jews felt free to substitute literary values for moral and ethical ones:[11]

> I do not quarrel with the esthetic verdict [of the Bollingen judges], but I question its primacy in the affair at hand, a primacy that hints at absolute acceptance of the autonomy not only of art but of every separate field of human activity. Does not hierarchy of values obtain among them? Would Mr. Eliot, for instance, approve of this for "Christian society"?

> I am sick of the art-adoration that prevails among cultured people, more in our time than in any other: that art-silliness which condones almost any moral or intellectual failing on the artist's part as long as he is or seems a successful artist. It is still justifiable to demand that he be a successful human being before anything else. . . . As it is, psychopathy has become endemic among artists and writers, in whose company the moral idiot is tolerated as perhaps nowhere else in society.[12]

The Pound award forced the *PR* crowd's dirty little secret out into the open. Jewishness came into its own as a cultural issue as deserving of examination and criticism as mass culture, modern literature, or Soviet cinema. The debate was conducted with "the same range of reference, the same candor, and the same resonance that typified the highbrow *PR* style."[13]

Anti-Semitism, which was beyond their control, was never the issue. The focus was the effects of "Jewishness," or minority identity, on self-esteem, and the conversation was addressed not only to the family but to the larger Jewish community and interested gentiles.

PR was a political/literary magazine many of whose writers were Jewish. *Commentary* was a curious hybrid: an anomaly among little magazines because it was Jewish, and an anomaly among Jewish magazines because it included two or three articles each month that had no relationship at all to Jewish affairs. *Commentary* was the primary platform for the discussion of "Jewishness," which came to the fore in the midst of the larger Jewish community's acrimonious, factionalized battle over the question of an independent state of Israel. Nonreligious Jews, like those at *Commentary*, and Orthodox Jews were anti-Zionists, opposed for different reasons to the formation of a separate country for Jews. Conservative Jews, irreverently termed "true believers" or "rabbis" by the *PR* crowd, favored such a state. To counter the clout wielded by the little magazines, the true believers adopted a no-holds-barred attitude. They accused anti-Zionists of suffering from Jewish self-hatred. The idea was that positive Jews embraced their religion and wanted what was best for their people, while negative Jews—especially atheists and assimilationists—were anti-Zionist because they were ashamed of what they were.

Both positions had merit. After the Holocaust, Zionists were persuaded that Jews could never live safely in the Christian world and, given the one-drop rule, could not assimilate, even if they wanted to. Zionists saw a separate state as the only hope. In 1950, an article by a Zionist rabbi referred to *Commentary* editors as "uprooted intellectuals," implying they wanted to deny their ties to the Jewish community. In other words, he accused them of suffering from Jewish self-hatred. Clem responded with "Self-Hatred and Jewish Chauvinism: Some Reflections on Positive Jewishness" (*Commentary*, November 1950), turning the self-hatred charge back on the Zionists. Maintaining that assimilationists did not have a monopoly on the category, he wrote, "Reluctantly . . . I have become persuaded that self-hatred in one form or another is almost universal among Jews—or at least more prevalent than is commonly thought or admitted—and that it is not confined on the whole to [negative] Jews like myself."[14]

Furthermore, he said, the Zionist position rested on a demeaning premise: "The mind has a tendency, deep down, to look on a calamity of that order [the Holocaust] as a punishment that must have been deserved. The mind . . . fears . . . that we were punished for being unable to take the risk of defending ourselves."[15] Zionists, he maintained, want to show the world that "Jews can fight," but their inclination, while under-

standable, accepts a view foisted on them by a dominant culture intent on discovering a reason why the same thing could never happen to them. By buying into that myth, Clem argued, Zionists do the same thing gentiles do. They identify with the victimizer rather than the victim.

Acknowledging that Jewish self-respect craved action, Clem issued a far-sighted warning against the dangers of the separatist course. Concerned that future problems vis-à-vis the Palestinians had been built into the agreement with the British, he was bothered by the idea that Jewish nationalism might prove little better than the German variety: "Self-pity turned a good many Germans into swine and it can do the same to others, regardless of how much their self-pity is justified."[16]

Podhoretz later observed that the modus operandi of the PR crowd was itself a perfect reflection of the self-hatred they analyzed so dispassionately:

Although the family paid no heed to virtually anyone outside it save kissing cousins, it had no mercy whatever on anyone inside it. To be adopted into the family was a mark of great distinction: it meant you were good enough, that you *existed* as a writer and intellectual. But once adopted, you could expect to be spoken of by many (not all) of your relations in the most terrifyingly cruel terms. They would rarely have a good word to say for anything you wrote, though they would at least always read it, and they would attribute the basest motives to your every action. Transposed into a different key, it was the Jewish self-hatred that has always been the other side of the coin of Jewish self-love and which found its classic formulation in Groucho Marx's immortal crack: "I wouldn't join a club that would have me for a member."[17]

Clem once said that the Jewish joke was reality's revenge upon the Jewish consciousness. Self-deprecating humor was one of the ways Jews traditionally vented the painful feelings we discuss.[18] But conversing about self-hatred in the abstract, Clem observed, was not particularly useful. The problem had to be focused on directly in the individual Jew and discussed in personal, not communal, terms: "For self-hatred," he observed, "is as intimate a thing as love."[19]

Clem did not fear for the physical safety of U.S. Jews, but he did feel that any group excluded from the country's top position paid too high a cost in self-esteem. In the last years of his life he believed that rather than accept the stigma of second-class citizenship—"There are lots of Jews in government but we're never the president"—Jews should intermarry until they disappeared completely, "like the Assyrians or the Phoenicians."[20]

* * *

Shortly after the Bollingen Prize was announced, the same month Pollock "broke the ice," Clem resigned as the *Nation*'s art critic and from the regular practice of art criticism. His longer essays on art, along with reviews of major museum shows, continued to appear in *Partisan Review,* and for another year or two he went on reviewing art books for the *New York Times,* but never again did he undertake week-to-week responsibility for reporting, interpreting, encouraging, and judging contemporary American art.

He had been on the art ramparts for seven years, working two or three full-time jobs. Burnout may have been one factor in his decision, but at that moment his overriding consideration was political. Clem believed the threat posed by Stalin was more serious than many Americans realized, and he had grave misgivings about the *Nation*'s foreign-policy commentary.

By 1949, the Cold War was heating up. The term *liberal* had become a catchall category for a group with substantive differences. *PR* and *Commentary* described themselves as liberal, for example, but were strongly anti-Stalinist. The *Nation* defined itself as liberal and for most of the forties reflected both Stalinist and anti-Stalinist views. Diana Trilling characterized Freda Kirchwey, the *Nation*'s owner and editor in chief, by saying, "Freda was a Communist but she was also a sort of civil libertarian. She really believed that everyone didn't have to share her views. She hired Margaret Marshall, an ardent anti-Stalinist, as literary editor. She hired [Julio Alvarez] del Vayo, later discovered to be a Party member and possibly a Communist agent, to do a column on foreign affairs. Freda managed to maintain some balance through most of the forties, but then she came totally under del Vayo's spell, and a great split developed between the front [political] and the back [cultural] parts of the book."[21]

Clem was a significant back-of-the-book figure. His publicity boosted public awareness of the magazine and influenced circulation. His resignation would have been damaging in any case, but had he publicly separated himself for political reasons the attention would have made his friend Margaret Marshall's position difficult. He and Marshall were so close in their views that any statement he made would reflect on her. The deepening friction between Stalinists and anti-Stalinists at the magazine, generated by del Vayo's increasingly strident columns, made Marshall's position difficult. Out of deference to her, Clem initially made no formal statement. Despite his silence, the literary world understood his departure as the first outright act of opposition on the part of a prominent figure.

A year later del Vayo had become so blatantly Stalinist that Marshall released Clem to speak his mind. In early 1951, in a letter to the editor of the *Nation,* Clem protested del Vayo's pro-Stalinist bias. Kirchwey, object-

ing to various of his points, returned the letter with a note explaining why it could not be published. Clem revised and resubmitted the letter. Again it was returned, this time with a note warning that if his "false, defamatory and scurrilous" charges were published elsewhere, the *Nation* would sue him as well as the publication in which they appeared.

On March 19, 1951, alerted in advance of Kirchwey's threat, the *New Leader,* a more conservative "liberal" venue, published Clem's letter with considerable hoopla, including photographs of del Vayo and Kirchwey. The letter was prefaced by an editorial statement explaining that the magazine had chosen to get involved "because the reputation and name of the author demand that he be heard." True to her word, Kirchwey immediately filed a $200,000 suit against Clem and the *New Leader.* In truth, she could hardly have done otherwise. Clem had not minced words, and since the advent of Sen. Joseph McCarthy, the accusations he leveled could prove severely damaging: "I find it shocking that any part of your—and our—magazine should consistently act as a vehicle through which the interests of a particular state power are expressed. . . . The operation of J. Alvarez del Vayo's column along a line which invariably parallels that of Soviet propaganda is something that I protest both as a reader and as a contributor. He represents the point of view of the Soviet Union with a regularity that is quite out of place in a liberal journal."

The resulting brouhaha went on for months in the letters column of the *New Leader.* The *Nation* was criticized not only for del Vayo's columns but for Kirchwey's refusal to publish letters critical of his position. As the voice of the anti-Stalinist left, *Partisan Review* inveighed against Kirchwey's failure to air Greenberg's charges: "It looks very much like an attempt to shut off political discussion . . . when it touches the most sensitive spot." Copies of unpublished letters previously submitted to the *Nation* poured into the *New Leader* offices and were printed. Former contributors such as Richard Rovere, Arthur Schlesinger Jr., and F. W. Dupee supported Clem's position. The *Nation* was under siege and on the defensive. When Reinhold Niebuhr requested that his name be removed from the list of contributing editors, readers' queries as to a possible linkage went unanswered.[22]

Clem became a big figure. Podhoretz worked briefly at *Commentary* in 1953. Clem's letter and the *Nation's* suit were still a major subject of discussion: "Within our small circle the lawsuit was a very big deal. We were all fiercely anti-Stalinist. That was taken for granted. No question. Clem was something of a hero. He wasn't the largest presence in the New York intellectual community, but he was large enough."[23]

In a bizarre and ironic turn of events, Clem, an on-the-record Trotsky-ist, had his letter approvingly read into the *Congressional Record* by none

other than Congressman George A. Dondero, the Jesse Helms of his day, well known for the imprecations he thundered against modern art and its "pinko," "commie" ties.

In the fall of 1950, Clem joined the American Committee for Cultural Freedom (ACCF), a subsidiary of the Paris-based anti-Stalinist Congress for Cultural Freedom. In 1952, the question of whether McCarthy or Stalin posed the greater threat to the American way of life emerged as a serious issue. Clem was a member of the ACCF executive committee. A large segment of the organization believed McCarthy the greater threat and fought to release an organization statement to that effect. Given the threat posed by Stalin, however, others asked, "Might not Senator McCarthy perform a useful service?" Clem, along with Lionel Trilling, William Phillips, Daniel Bell, and others were among those who thought Stalin the greater threat. They opposed a motion to declare that "the main job" of the organization was to fight the danger represented by the senator from Wisconsin. The battle was bloody. The anti-Stalin group won and those on the losing side resigned in a block. Clem, too, resigned shortly thereafter, feeling that the organization no longer reflected his views: "They didn't listen to me. They didn't care what I thought."[24]

Ironically, Clem soon found himself the darling of far right groups whose members thought modern art an incarnation of the devil, meaning Karl Marx. One night toward the end of the decade, after completing a lecture to one of these groups, a women rose during the question period to ask a leading exponent of cubism if he would really hang a Picasso in his house.[25]

8

Influences on
Greenberg's Criticism

A maelstrom of controversy surrounded Greenberg for close to fifty years. Its development was a product of his feisty temperament, provocative stance, and uniquely powerful position as American art came to define the mainstream.

During the twenty years during which Clem produced the body of his criticism, the cadre of New York Intellectuals, the group he called his "center," served as his mental audience, the one to whom his writing was addressed. His tightly reasoned essays built on precepts well known within this circle and it was unnecessary to restate or rehash earlier arguments or to explain allusions. Later, when his reading audience broadened, his mental audience did not. In the sixties his habit of tightening and refining issues as if his readers had total recall for his past production combined with the growth and development of the art world, to encourage misreadings of his work. In many respects, Clem was his own worst enemy.

He issued theoretical edicts with the high-handedness of a Borgia and presented questioners with a moving target. "You can't argue with Clem in some ways," commented critic/painter Sidney Tillim. "If you say something like 'Then your position is . . . ,' before you finish the sentence Clem will say, 'I don't have a position. My position is that I don't have a position.' "[1]

He had the ability to co-opt words and stamp them with his own idiosyncratic definitions. His mother's maxim about lies being imprudent stayed with him, and as his position made him a larger and larger target, he developed a positive genius for using language with great precision, crafting sentences with multileveled meanings so that the reader or listener got as much truth as they could discern. The impression grew that Greenberg deliberately dissembled to disguise the unpalatable ramifications of his positions. In fact, however, he was no more forthcoming with regard to unobjectionable issues in his personal life.

With a light touch and a style just brazen enough to make you laugh in

spite of yourself, he would defend what initially appeared to be deliberately misleading statements. For example, he spoke reverently about "my wife Jenny" and the idyllic marriage they had shared for almost thirty years. This, I later learned, at a time when they were long divorced and she lived in Los Angeles with another man while he lived, off and on, with a young art historian teaching at Duke. Confronted with what appeared to be a blatant lie, his response was "Ach. So? You're so square!"

The implication was that the legal union understood by the term *marriage* was superficial. His provocative rejoinder, casually dismissing the weight of custom and spoken vows, illustrates his penchant for making words mean what he wanted them to mean. Clem was closemouthed about his influences, and little was known about the intellectual turf he mined. But his proclivity for redefining common terms, and his success in persuading the art crowd to adopt his usage, however, made it difficult for him to protest when his positions were oversimplified or misrepresented. A later chapter examines the complexity of his psyche. Here, we explore his sources in an effort to reconstruct his aesthetic origins and clarify bedrock beliefs.

Clem studied neither art nor aesthetics in college. He hoped to be a poet and majored in literature. In the early forties he discovered and frequently cited the work of the eighteenth-century German philosopher Immanuel Kant. So persistently did the great metaphysician figure in his conversation that it aroused considerable comment in *PR* editorial circles. Delmore Schwartz, several of whose stories Clem had returned for more work, needled Greenberg for "philosophy mongering," suggesting he was engaged in the "unauthentic rattling around of big terminology."[2] Kant, however, confirmed Greenberg's understanding of why nonobjective art could be as powerful as any other kind.

Devoid of subject matter, abstraction was often said to lack "content" or affective meaning. Kant was the first philosopher to observe that subject matter and content were separate entities. In *Critique of Judgment* (1790) he noted that "in all judgments by which we describe anything as beautiful we tolerate no one else being of a different opinion, and in taking up this position we do not rest our judgment upon concepts but only on our feeling."[3] Kant, of course, was speaking of representational art, but he was far ahead of his time. Until the twentieth century, judgments of quality were assumed to be intimately bound to subject matter. Kant was the first to say that the subject matter of a painting was independent of its *value*; that aesthetic value manifested itself in form but revealed itself in the feeling response of the educated viewer. This issue went to the heart of the discus-

sion about abstract art, but in the forties, Clem was the only one talking about it in those terms. By invoking Kant, Clem shifted the New York discussion of abstraction from politics to metaphysics. At that time, for example, as Lionel Abel observed, Meyer Schapiro would have said, "How can you talk about Goya's painting of July 23rd if you don't talk about the subject matter?" (Schapiro came around later on.) It is for that reason that Clem is referred to in books about Kant, but Schapiro and Harold Rosenberg are not.[4]

Greenberg did not set out to sketch the framework for a theory of modern culture or to figure out the way abstraction worked. He seems to have proceeded organically in response to personal needs, intellectual curiosity, and chance. His essays appeared in a host of different journals and were not available in collected form until the late eighties, when editor John O'Brian, with Greenberg's cooperation, published the first of four volumes, *Clement Greenberg: The Collected Essays and Criticism* (University of Chicago Press).

Asked which critics he most admired, Clem responded, "F. R. Leavis was a great literary critic. Eliot, of course. Eliot was responsible for a lot in Leavis, but Leavis maybe in some ways [was] better in the long pull." By the late thirties, if not earlier, Clem knew the poetry and criticism of Eliot, had read Matthew Arnold and Leavis, and was familiar with *Scrutiny*, the influential literary magazine Leavis and his wife published. During the forties and fifties, Clem was part of the *PR* crowd's competition with the Southern Agrarians for the hearts and minds of the American literary elite. The leftist New Yorkers, ideological and alienated, identified with the intelligentsia of France and Russia. The Southerners, well-established stock, were politically conservative ivory tower poets and critics, centered around various universities and the *Kenyon Review*.

The New York Intellectuals' "believing skepticism"[5] came to exert an almost hegemonic influence over American cultural life from the end of World War II until the social revolution of the sixties. But the Southerners gave birth to New Criticism, the mode of literary analysis that dominated university English departments for several decades and was a precursor to such linguistic philosophies as structuralism and poststructuralism.

The positions of these two remarkable groups were hammered out and honed to a sharp edge by years of on-the-spot combat with one another in the pages of the "little" magazines for which they wrote. Both groups claimed descent from Leavis and Eliot, but like water eddying around a rock, these ideas diverged into different streams after hitting the U.S. coast. The New Yorkers focused on substantive content. They resonated

to Eliot's and Leavis's concerns about the effects of modern life on the human spirit and to their conviction that in our time art's function was to keep that spirit alive in the face of a world engulfed by change and turmoil. As I. A. Richards, another Cambridge critic put it, poetry "is capable of saving us; it is a perfectly possible means of overcoming chaos."[6]

The New Critics picked up on the formal aspects of Eliot's and Leavis's ideas. They struggled to find objective elements on which to base judgments of value. Science was the post-Enlightenment god—even the writings of Karl Marx were known as scientific revolutionary socialism. Both groups felt obliged to ground the basically subjective enterprise of criticism on "objective" criteria but the New Critics made that search a primary concern.

Leavis was a key figure in revolutionizing the study of literature at Cambridge. He presided over the shift from an aristocratic, classics-oriented tradition to what came to be called "English," a study of the contempory novel including Jane Austen and Henry James, among others. Students studying literature were trained to be connoisseurs. Those studying English, as Oxford tutor Terry Eagleton wrote, confronted "the most fundamental questions of human existence—what it meant to be a person, to engage in significant relationships with others, to live from the vital center of the most essential values."[7] English students were steeped in liberal humanism, concentrating on the unique value of the individual and what Eagleton called the "creative realm of the interpersonal."[8] Although regarded among academics as less elevated than literature, English spoke to the spirit of the time. Eagleton reports that in the early 1920s at Cambridge, "it was very unclear why the contemporary novel was worth studying at all [but] by the early 1930s it had become a question of why it was worth wasting your time on anything else."[9]

Leavis, closely associated with such ideas as "practical criticism" and "close reading," fearlessly asserted the radical position that value was not to be determined solely by historical consensus, that it could be deduced from the study of formal relationships: the words on the page; the order the whole imposed on the sum of its parts; success in resolving conflicting tensions. In theory, Leavis avoided the formalist label by insisting that the unity of a work of art and its "reverent openness before life" were parts of a single process. In his criticism, Eliot, too, was sometimes less interested in what a literary work actually said than in "qualities of language, styles of feeling, the relations of images and experience."[10]

The formal aspects of Leavis's and Eliot's approach was reified by the New Critics, for whom the text became an object in itself.[11] Lip service was paid to content, but the belief grew, at least among the New Yorkers, that

the New Critics believed objective determinations of value could be arrived at by studying "nuances of language, patterns of form, strategies of rhetoric, refinements of tone."[12]

The Southerners thought the New Yorkers anguished too much over meaning and frittered away their mental energies arguing conceptual subtleties that could never be resolved. Howe described a lunch he once had with the poet Richard Blackmur and Meyer Schapiro at the end of which an exasperated Schapiro exclaimed, "Mr. Blackmur, when you use your mind, you do not use it up!"[13]

New Critics emphasized the technical and formal qualities of modern poetry. By means of "close reading" they searched for objective meaning in formal structure, untainted by the author's intentions or the reader's response, based instead on the tensions, paradoxes, and ambivalences of the text. In this way, Pound's anti-Semitic and anti-American subject matter could be put to one side and the value of his poetry determined by a disinterested reconciliation of opposing impulses.[14]

Both groups contended with similar aesthetic issues, but their political and sympathetic differences led to divergent emphases. The readers of little magazines were familiar with the teams as well as the players, and nuances of position were understood.

Because Clem wrote about abstract art he concentrated on the formal elements, which is to say the visible elements. To those who would say about abstraction that less is not more, he once replied that what is often forgotten by those who think abstract art lacks "content" is that art is made by human beings who, as Karen Wilkin phrased it, bring all their "baggage" and "*mishegoss*" (Yiddish for "craziness") with them and is looked at by others who bring the same.[15]

Clem identified himself as a positivist, and in the art world, it was assumed that he too dismissed what he could not quantify and based value judgments exclusively on the relationships of formal elements. But sensation and experience were always his bottom line. He insisted that abstraction by its nature had little to do with ideas and everything to do with feeling. Sensations being ineffable, however, the critic could only point to the formal elements that provided the gateway to the experience.

Moreover, similar sensations can evoke different responses. Viewers contemplating a work of art that induced feelings of disorientation, for example, might respond as if the artist's intent was a sinister desire to pull the rug from beneath their inner feet. Those for whom feelings of disorientation were less threatening, might respond as if to an intellectual challenge. The initial sensation was the same but the response aroused was

not. In a sense Clem's critical view was close to that of Eliot when he wrote, "The work of art cannot be interpreted; there is nothing to interpret."[16] Clem, right or wrong, refused to interpret works of art because he believed there was nothing useful to be said.

Most people today respond with incredulity to the idea that T. S. Eliot was the "culture hero" for a group of intellectual Jewish Trotskyists. Nevertheless, and despite the fact that no one named Greenberg or Schapiro was likely to be welcome in Eliot's "City of God," or that his poetry associated Jews with the moral and social squalor of modern life—"The rats are underneath the piles, the Jew is underneath the lot"[17]—Eliot gave inspirational voice to the *PR* crowd's fears for the postindustrial world. His formative impact on their thinking was such that they could not deny him. Howe referred to this quandary when he wrote: "Eliot wrote poetry . . . [that] seemed thrilling in its apprehensions of the spirit of the time, poetry vibrant with images of alienation, moral dislocation, and historical breakdown. . . . If his vocabulary came to draw upon unacceptable doctrine, his sensibility remained intensely familiar."[18] Leslie Fiedler put it this way: "The Jewish intellectual of my generation cannot disown him [Eliot] without disowning an integral part of himself. He has been a profounder influence on a good many of us than the Baal Shem Tov or the author of Job."[19]

Clem concentrated on formal elements such as line, color, shape, and the disposition of lights and darks. He talked about "experience" and "sensation," but never defined them. He sounded like the New Critics, and, in the art world, it was widely assumed that he shared their views. On several occasions, however, he made plain his objections. In "T. S. Eliot: A Book Review" (*Nation*, 1950), he wrote:

> This is not to deny that . . . exegesis and "close" reading have brought certain benefits. Only they [the benefits] have proved to have surprisingly, or disappointingly, little bearing on that order of fact to which I previously referred in praising Eliot's own criticism; the kind of fact which is decisive for literature insofar as it is art.
>
> Art happens. . . . [It is] a matter of self evidence and feeling, and of the inferences of feeling, rather than of intellection or information, and the reality of art is disclosed only in experience, not in reflection upon experience.[20]

Clem subscribed to the view that the critic's function was to isolate the formal facts that elicited "the irreducible elements" that encounter:

Aesthetic judgments cannot be proved or demonstrated; their supporting evidence can be pointed to, but can never compel our assent the way the evidence for logical or empirical propositions can. Yet in choosing the kind of evidence [facts] to point to in order to support his judgments, the literary or art critic is—at least ideally— just as much under the obligation to be relevant [to his evidence, his experience] as the scientist is.[21]

Despite Clem's differences with the Southerners, he handled the tricky question of the means by which personal and social meaning are translated into aesthetic terms in a similar manner, he put it to one side. Because abstract art was his subject, he often sounded more like the New Critics than the New Yorkers, but he could assume that readers of little magazines understood the differences between their positions.

Later, when these pieces were read by a younger art-world audience, the distinctions were less clear. When the New Critics said that a poem was not to be grasped through references to the world of familiar experience, that it inhabited a realm of its own, for instance, they expressed a preference for value judgments based on formal elements. When Greenberg said, "Let painting confine itself to the disposition pure and simple of color and line, and not intrigue us by associations with things we can experience more authentically elsewhere," he was taken to mean the same. But his observation was rooted in the social context that generated modern art. Clem believed the fragmentation of modern times resulted from a situation in which "society does not circulate an adequate notion of the human personality to which they [artists] can refer."[22]

When he wrote "there is nothing left in nature for plastic art to explore,"[23] it was interpreted to mean that the challenge was gone from representational art because, on a technical level, the illusion had been mastered and photography invented. But Clem attributed the exhaustion of nature as a subject for great art to the lack of a shared paradigm. Reviewing an exhibition of the painter Morris Graves, he commented on the problems that confronted a nature painter in the modern world: "Nature worship can furnish but scanty and rather irrelevant material in these times—when the main and inescapable problem is urban life."[24]

By the same token, a sculpted portrait that no longer reflected a shared view of what it meant to be human, but only the artist's private view of an individual, was, by definition, less powerful. Not because it was a *portrait* but because—as art—its power to *affect* the viewer had been diminished.

Further complicating the matter, with the passage of time, identical lan-

guage took on different meaning. When Partisans said "art for art's sake," they originally meant "not for Stalin's sake." Later, it came to mean art for the sake of the experience it provided. Although rarely alluded to, the language of aesthetic discussion was evolving. In 1925 George Moore, whose moral philosophy had a powerful influence on Bloomsbury, the group to which Virginia Wolfe and Lytton Strachey belonged, wrote the *Anthology of Pure Poetry* in which "pure" denoted "no hint of subjectivity," a meaning still current in discussions of modern art.

Ten years later, however, the poet Wallace Stevens wrote a letter to a friend in which he explained "pure" poetry as a response to the positivism and anti-Romanticism of the modern world. Today, said Stevens, "nominal" subject matter—"a duck on a pond, say, or the wind on a winter night"—did not rouse the reader the way they had once done. A poet wishing to elicit "poetic" sensation had to go beneath the "nominal" surface and communicate his meaning by means of the feelings aroused by sounds and resonance of language.[25] Abstract art used line, color, and the resonances they aroused to do the same.

Clem used "pure," which he began to put in quotes, to refer to art that, avoiding ideas, ideology, and the conflicts of the twentieth century, went "beneath the surface," evoking universal or archetypal feelings independent of cultural differences. Exploring modern art's move toward abstraction, he noted that each art focused on its own medium and concentrated on form: "Ideas came to mean subject matter in general. (Subject matter as opposed to content: in the sense that every work of art must have content, but that subject matter is something the artist does or does not have in mind. . . .)"[26] The emphasis was to be on the physical, the sensorial.

The ambiguity implicit in this method of communication intrigued him from the beginning. In "Towards a Newer Laocoön" (*Partisan Review,* July-August, 1940), he examined it with relation to poetry offering this singular summation: "To deliver poetry from the subject and to give full play to its true *affective* power it is necessary to free words from logic. . . . The poem still offers possibilities of meaning—but only possibilities. Should any part of them be too precisely realized, the poem would lose the greatest part of its efficacy, which is to agitate the consciousness with infinite possibilities by approaching the brink of meaning and yet never falling over it."[27]

Reviewing Willem de Kooning's first one-person show in 1948, he mused about the painter's deliberate lack of clarity. Calling de Kooning "one of the four or five most important painters in the country," Clem's precise description of de Kooning's process has stood the test of time: "The indeterminateness or ambiguity that characterizes some of de Kooning's

pictures is caused, I believe, by his effort to suppress his facility. There is a deliberate renunciation of will in so far as it makes itself felt as skill, and there is also a refusal to work with ideas that are too clear."[28]

Two years later, in "T. S. Eliot: A Book Review," he returned to the subject, this time in relation to Eliot's poetry: "Experience has shown us by now that the drift and shape of an 'obscure' poem or novel can be grasped for the purposes of art without being 'worked out.' Part of the triumph of modernist poetry is, indeed, to have demonstrated the great extent to which verse can do without *explicit* meaning and yet not sacrifice anything essential to its effect as art."[29]

Greenberg wrote poetry all his life and wrote about it with great sensitivity. His immediate response to abstract painting may well have stemmed from an intuitive grasp of the similarities between the language of "pure" poetry and that of "pure" painting. He was able to translate what he'd learned about "listening" for "poetic" as opposed to explicit meaning in "pure" poetry to the sensorial experience provided by abstract or "pure" painting. Looking past his ranking of the critics in question, he makes an interesting historical observation: "It is . . . not so surprising that the great age of positivism should have produced the supreme literary critic. And that it should also have produced the art criticism of Roger Fry and even Clive Bell's excessive simplifications. The notion of significant form was very much in the English air around 1914, and I cannot help thinking that this attempt to isolate the essential factor in the experience of visual art had some effect on the young Eliot."[30]

Clem once observed that in abstract art "feeling is all." Although often castigated as a "formalist," one who ignores content and focuses only on the visible elements of a painting or sculpture, he was quick to forgive technical weaknesses if the emotive power of the art was strong enough. In his review of the German painter Max Beckmann's 1946 show at the Buchholz Gallery, he commented, "The power of Beckmann's emotion, the tenacity with which he insists on the distortions that correspond most exactly to that emotion . . . suffices to overcome his lack of technical 'feel' and to translate his art to the heights."[31]

Clem labored over his essays. His diaries are filled with notations about revising or "reworking" major pieces and with terse announcements when, after weeks, or in some cases months, of effort, he ripped the whole thing to shreds and started over. In the forties the demands he made on his critical language were those of a poet. He concentrated on formal construction, communicating the rest by means of the rhythms coursing beneath the prose. His effort too was to "agitate the consciousness with infinite possibilities," in that way to communicate the ineffable.

* * *

Once Clem gave up the regular practice of art criticism, this difficult and painstaking effort to express, via the techniques of poetry, the feelings aroused in him by visual art all but disappeared from his writing. When *Art and Culture* appeared (Beacon Press, 1961), the effort to communicate on a that plane had been edited out of the revised essays. Until the collected Greenberg appeared, this part of his criticism was essentially lost from view. Questioned about the shift, Clem grunted, "Yeah, I was so busy bein' cool." He continued to insist that experience was the key to aesthetic judgments, but since he never described a particular experience, most in the art world concluded this was nothing more than lip service.

When Clem began writing about cubism and abstraction, no one had done for modern painting and sculpture what Eliot had done for modern literature. Eliot created a language with which to write about the subject and identified the standards by which it could be judged. The problem Greenberg confronted was similar. The Italian critic Bruno Alfieri's (*L'Arte Moderna*) 1950 review of a Jackson Pollock show gave expression to the quandary: "Jackson Pollock's paintings represent absolutely nothing: no facts, no ideas, no geometrical forms." Consequently, wrote Alfieri, they are "impervious to traditional criticism."

When Clem said Kant "confirmed my experience, that was the only help I ever got,"[32] his statement about the eighteenth-century metaphysician may have been heartfelt, but it was not the whole story. Kant confirmed but did not shape Greenberg's thinking. Clem was an assiduous reader of books on criticism, often reviewing new volumes for one publication or another. But his praise for most art writers (a term he preferred to *critic*) was conditional. He commended Bernard Berenson as a connoisseur of Italian Renaissance painting but found him to have a "radical and peevish miscomprehension of the art of his own age." He found Lionello Venturi a good historian but deficient in his account of how one actually "looks" at paintings.

It was Eliot who served as the model for the structuring principles of Greenberg's criticism: the standards to which he adhered; the job description he attempted to fulfill; even the scale of his ambition. Clem never credited Eliot specifically as a critical influence—possibly because of his anti-Semitism—but his personal debt to the poet was handsomely, if somewhat grudgingly, paid: "As frivolous as he [Eliot] can be in political and social questions, he is a kind of moral hero when it comes to literature, and for this more than anything else I know about him I pay him a homage that is more personal than calling him great."[33]

* * *

In the early years of the twentieth century, Eliot redefined the standards by which literature, including poetry, was judged. In the forties, Clem did the same for "advanced" American painting and sculpture. A dream recorded in his journal in the early eighties suggests that Clem's identification with Eliot was not entirely unconscious. In his dream, Clem arrived late at a large party and "spotted Eliot across the room surrounded by a large crowd of men." But after working his way across the crowded room he found, "I was looking at myself." [34]

Eliot was born in St. Louis in 1888 and studied at Harvard, the Sorbonne, and Oxford. In 1914, he established residence in England where he eventually became a citizen. Milton and Dryden were then the country's most respected poets and modern literature had few admirers. In 1919, Eliot began writing criticism, and in 1922, with the help of Ezra Pound, he became the editor of *Criterion*, a literary quarterly. "The Waste Land" appeared in its first issue. *Criterion* quickly became the center of a remarkable group of young writers that included Bloomsbury but also the young Cyril Connolly, Auden, Isherwood, and their crowd.

Modern poetry, unfamiliar and abstract, had little audience. To establish a taste for it Eliot was obliged to cut the intellectual ground from beneath the feet of those who favored Milton and Dryden. Skillfully, he resurrected long-forgotten seventeenth-century poets to make his points.

Milton and Dryden, Eliot argued, wrote poetry that was essentially cerebral, communicating by means of the head alone. It suffered the disadvantage of any insight delivered or arrived at by means of one sense alone: its meaning could never be wholly assimilated. Clem did something similar in 1953, when painterly American abstraction could not be given away in New York while the same genre of French painting enjoyed a vogue. In *Art Digest*'s symposium, "Is the French Avant-Garde Overrated?" he began the slow process of chipping away the conceptual underpinnings of French superiority:

> There is a crucial difference between the French and the American versions of Abstract Expressionism despite their seeming convergence of aims. In Paris they finish and unify the abstract picture in a way that makes it more agreeable to standard taste. . . . The result is softer, suaver, and more conventionally imposing than would seem to be the "idea" or inherent tendency of the new kind of abstract painting. If "abstract expressionism" embodies a vision all its own, that vision is tamed in Paris—not, as the French themselves may think, disciplined. [35]

Eliot believed that a "dissociation of sensibility" had occurred sometime in the 1600s from which literature had never fully recovered. The revolution in taste that he inspired called for poetry capable of communicating with the whole of one's being.[36] Eliot cited John Donne's "Death, be not proud" and "Go and catch a falling star." He mentioned George Chapman, sometimes thought to be the rival poet in Shakespeare's "Sonnets," and Jean Racine, popular in the fashionable literary world of Louis XIV for dramas in which the characters were governed more by passion than by will. These poets Eliot praised for deliberately seeking language that communicated thought and passion simultaneously. Greenberg's early essays overflow with similarly explicit objections to artists whose work does not appeal to enough of the senses. In 1943, reviewing the *Whitney Annual,* Clem complained that the artists were "competent," but disappointing: "No matter how well these artists paint and model, they do not *affect* us enough" (emphasis in original).[37]

Eliot praised Chapman for his "direct sensuous apprehension of thought into feeling"[38] and Donne for whom "thought . . . was an experience [that] modified . . . sensibility."[39] Eliot believed that the meaning communicated by good poetry lay as much in the feelings, associations, and sensations aroused by the sound of its language as in the literal meaning of the words. Or as Clem approvingly rephrased it: "The prime fact about a work of . . . art is not what it *means* but what it *does*—how it works, how successfully it works, as art."[40] In other words, the "prime" fact about a work of art is the experiential impact it produces.

In his catalog essay for the Canadian exhibition *Three American Painters: Louis, Noland, Olitski* (Mackenzie Art Gallery, Regina, Saskatchewan), Clem wrote that formal elements such as "color," "verticality," "concentricity," and the interlocking of all three "do not appear in paintings for their own sakes. They are there, first and foremost, for the sake of feeling, and as vehicles and expressions of feeling. And if these paintings fail as vehicles and expressions of feeling, they fail entirely."[41]

Deriding those poets who "triumph with a dazzling disregard of the soul," Eliot spelled out the depths to which an artist should delve: "Those who object to the 'artificiality' of Milton or Dryden sometimes tell us to 'look into our hearts and write,' but that is not enough . . . [it] is not deep enough; Racine and Donne looked into a good deal more than the heart. One must look into the cerebral cortex, the nervous system and the digestive tract."[42]

Modernists believed that art could change society. Eliot believed that to play its part, the language of literature—rich, complex, sensuous, and particular—must "concretely enact" felt experience. He concluded that modern literature, like religion, communicated principally by means of emotion,

by eliciting affective experience. Eliot sought a sensory poetic language that made "direct communication with the nerves." He searched for words and images that worked like "a network of tentacular roots reaching down to the deepest terrors and desires."[43]

Early on, Clem railed against those who objected to the American avant-garde, decrying easily assimilated work that communicated within safe boundaries: "Every fresh and productive impulse in painting since Manet, and perhaps before, has repudiated received notions of finish and unity, and manhandled into art what until then seemed intractable, too raw and accidental, to be brought within the scope of aesthetic purpose."[44]

Given the difficulty readers had in understanding modern literature, Eliot saw it as the task of the modern critic to educate taste by delineating quality. Eliot theorized that the best art of any age would align itself with a historical mainstream that it was the critic's job to discern.

In *The Function of Criticism* (1923), Eliot began by saying that art is an end in itself, but that "criticism . . . must always profess an end in view," i.e., "the elucidation of works of art and the correction of taste." Clem believed curators had the same obligation. He berated MOMA for its insistent plu-ralism, its determination to be "inclusive." In 1947, reviewing the museum's Ben Shahn retrospective, he wrote: "Ben Shahn's gift, though indisputable, is rarely effective beyond a surface felicity."[45]

A second controversial pillar of Greenbergian modernism—the age-old question of whether the great man shapes history or the other way round—was also addressed by Eliot. Granting the kinship with Marx's concept of historical inevitability, overtones of Eliot can still be seen in the way Greenberg weighted the issue on the side of history. In "Tradition and the Individual Talent," Eliot wrote: "I thought of literature then, as I do now, of the literature of the world, of the literature of Europe, of the litera-ture of a single country, not as a collection of the writings of individuals, but as 'organic wholes,' as systems in relation to which, individual works of literary art, and the works of individual artists, have their significance. There is accordingly something outside the artist to which he owes alle-giance, a devotion to which he must surrender and sacrifice himself in order to earn and to obtain his unique positions."[46]

When Clem said, in effect, that abstraction was the historical wave of our time, his phrasing evoked Marx more than Eliot, but when he argued that it was not individual artists but great styles or schools or movements that were important, Eliot was his model.

Eliot wrote that "no poet, no artist of any art, has his complete meaning alone."[47] Greenberg, speaking of the decline of the plastic arts during the

seventeenth and eighteenth centuries, said, "Good artists, it is true, continue to appear . . . but not good *schools* of art."[48]

Eliot dramatically redrew the line of modern literary descent: Milton, Shelley, and *Hamlet* were out; John Donne, Gerard Manley Hopkins, and *Coriolanus* were in. When Clem traced the lineage of great modern art from Manet through Cézanne to Picasso and Braque, his choices were equally idiosyncratic. Courbet, Mondrian, Léger, and Matisse were in; Corot, van Gogh, Gauguin, Duchamp, the surrealists, and the German expressionists were out.

The third principle Clem shared with Eliot—the objectivity of taste—made Clem the center of controversy for close to half a century. Clem never suggested that his or anyone else's taste was unerring. He said that the critic had an obligation to honestly report his experience, which was all he had to go on, and to accept the fact that, like everyone else, his taste was filtered through the "baggage" and *"mishegoss"* he brought with him. But he did believe in the long-term objectivity of taste: "In effect . . . the objectivity of taste is probatively demonstrated in and through the presence of consensus over *time*."[49]

> How do you in your own time identify the bearers of the best taste? It's not all that necessary. In time past the best taste could have been diffused through a whole social class, or a whole tribe. In later times it may or may not have been the possession of a coterie—like the *cognoscenti* in and around the Vatican in the 1500s, or the circles in which Baudelaire mixed in the mid-19th century. But it would be wrong on the whole to try to pin the best taste of a given period to specific individuals. I would say it works more like an atmosphere, circulating and making itself felt in the subtle, untraceable ways that belong to an atmosphere.[50]

Eliot believed critical value judgments, i.e., taste, could transcend the purely personal by means of a principle known as disinterested response, to the physiological response of one's body in the presence of great art. In the forties, subjective attributes such as taste seemed concrete to those around *PR*, and as we know, science was revered. All soft sciences aspired to be hard. The New York Intellectuals, good positivists all, deemed it unseemly to offer the reader personal opinion. Dispassionate critical judgments, predicated on the philosophical position that what one person "knows" or experiences is potentially available to all, had status as universal truths because—and this is key—they were based on involuntary physiological response.

A. E. Housman captured the idea when asked to define poetry: "I

replied that I could no more define poetry than a terrier can define a rat, but that I thought we both recognized the object by the symptoms which it provoked in us."[51]

The "symptoms" that accompanied the inner whir and stir of unconscious association extended from making the hair on the back of your neck stand up, the spontaneous "lift" or "surge" of feeling familiar to art lovers everywhere. Long before Joseph Campbell's unfortunate television appearances, when he was still at the height of his powers, he wrote, "Art is not, like science, a logic of references but a release from references . . . a presentation of forms, images, or ideas in such a way that they will communicate, not primarily a thought or even a feeling, but an impact."[52]

Eliot's poetry actualized this concept. Clem rewrote his early essays again and again, searching for exactly the right word to communicate the feeling aroused in him by a work of art. Asked if it was fair to say he transposed Eliot's ideas about literary criticism into the criticism of painting and sculpture, Clem responded that *transposed* was not the right word. Clem translated Eliot's ideas about modern literary criticism into language suitable for the criticism of modern painting and sculpture. Asked if Eliot's attitude toward quality was similar to his own, Greenberg responded, "I admire his taste. It's not his attitude though, it's his reactions . . . but he knew better than to try and explain them. . . . I agreed with Eliot's value judgments, with Eliot's taste, often, often, often."[53]

In light of this, the endless diatribes attacking Greenberg as a rigid formalist have to be reexamined. He adamantly denied that attention to the medium in and of itself was sufficient to create good art. His attitude bore a certain similarity to what Eliot called the "objective correlative." Clem believed that good art emerged when content, the unconscious, emotional, intuitive aspects of a work of art, and form, the "controlled" visible elements that embodied it, were perfectly fused: "Yeah, controlled by taste, intuition. That's all the artist's got, his own taste and his intuition."[54]

For Greenberg, content was to form as feeling was to Beethoven's Ninth Symphony. The existence of one without the other was unthinkable. "If a work of art works," Clem said, "it's got content. It wouldn't work without content. Whether it's Molière or whether it's Giotto."[55]

Today, much of the art in our galleries and museums is conceptual and/or political. The amplitude of feeling that was Greenberg's measure of value has been supplanted by something less lofty. Greenberg remains central to the discussion because a part of us yearns for grand-style art of similar magnitude.

9

He Wouldn't Join a Club That Would Have Him for a Member

Clement Greenberg enjoyed two great runs in his lifetime: one in the art world, the other among the New York Intellectuals. Each culminated in a backlash powerful enough to drive ordinary mortals to their beds. In the art world, the resentment that began in 1947 with the publication of "Present Prospects," was exacerbated by Pollock's success. In the seventies it exploded with a pent-up fury so potent that in the catalog for the Solomon R. Guggenheim Museum's *Abstraction in the Twentieth Century* (February–May 1996),[1] intended as a full-scale reexamination of the subject, abstraction's foremost critical exponent in the latter half of the twentieth century, is dismissed as an "elitist" and a "formalist," his work on the subject damned by omission. The how and why of such an exclusion constitute the heart of Greenberg's life story.

Prior to the 1940s American art was provincial, which is to say it reflected, rather than defined, the center or mainstream of its day. Greenberg was the first critic to recognize that Pollock, Motherwell, Gorky, de Kooning, and one or two others had created a new and distinctly American style that reflected the dominant values of the postwar West.

To bring this group accomplishment to public attention, Clem was obliged to single out individuals. When he wrote "The Present Prospects of American Painting and Sculpture" (*Horizon*) and named Jackson Pollock its best painter, he opened a Pandora's box. Pollock ascended to hitherto unimaginable heights, and his peers felt they had been left in the dust. "When Greenberg is on a favorite, everyone else goes down the drain," sculptor Philip Pavia griped.[2] "Jackson's promotion was our demotion," said painter Paul Brach. "The myth of the great artist somehow diminished the rest of us. He was the sun and we were the black hole."[3] Clem was "the great poo-bah," hated because he had done for them exactly what they wanted but had not done it quite the right way.[4] He elevated the

wrong artist, they said. The crown he placed on Pollock's head rightfully belonged to Willem de Kooning, whose first one-person show was still a year away.

At issue was something deeper than competition. America had never enjoyed a fine-art tradition in the way that Europe did. The United States, was populated by the underprivileged of many countries. Its citizens prized material advantage and personal freedom. U.S. artists never occupied the privileged position accorded their European compatriots. They had, however, always been the acknowledged experts on art. When, as in the case of Pollock versus de Kooning, a critic's opinion prevailed over that of artists, the resentment had many factors.

The forties saw the dawning of the "age of the critic." Modern fiction, poetry, painting, and sculpture were cryptic, recondite, confusing. Their unfamiliar language required interpretation. Clem's essay "Present Prospects" (*Horizon*, 1947) and Russell Lynes's "Highbrow, Middlebrow, Lowbrow" (*Harper's*, 1948) appeared at almost the same time. Lynes dubbed *Partisan Review* the Parnassus of highbrow criticism and identified Greenberg as a quintessential example of that rarified species.

By highlighting the sociological aspects of Clem's essay, Lynes's piece augmented its mass media appeal. The combination of highbrow chic, upper-class nose pulling, and heroic artists whose paintings looked like "a snarl of tar and confetti"[5] proved irresistible. *Time*, *Life*, and *Newsweek* all focused on Pollock, whose notoriety unleashed pressures with which the vanguard had never before had to contend. Their harmonious world splintered and they blamed Clem.

In 1948, Robert Motherwell, William Baziotes, and Mark Rothko started a school called the Subjects of the Artists, its clumsy title intended to convey a pro-subject-matter bias that was anti-abstract and anti-Greenberg.[6] Reeling from the turmoil of recent events, the artists craved a place of their own where they could meet and talk in private. In the fall of 1949, shortly after *Life*'s piece on Pollock, roughly twenty avant-garde artists, including de Kooning, Franz Kline, Milton Resnick, Philip Pavia, Conrad Marca-Relli, and Giorgio Cavallon, contributed $10 each and rented a loft at 39 East Eighth Street, near University Place, where some of them had their studios. That loft metamorphosed into the legendary Artists' Club, the place Lionel Abel, who lived in Paris after the war, described as "the only avant-garde scene in New York." Friday-night lectures and discussions, often featuring prominent intellectuals such as Abel and Hannah Arendt, lured uptown folk down to the more freewheeling environs of Greenwich Village. Meanwhile, the anti-Greenberg sentiment present at the time the Club was founded grew stronger.

When "The Present Prospects of American Painting and Sculpture" appeared, magazines devoted to American vanguard art did not yet exist. Clem's platforms were the "little" magazines written by and for producers of ideas. In 1948, his former mentor, Robert Goldwater, now editor in chief of the *Magazine of Art,* ran a series of essays on selected members of the vanguard. In 1949, Thomas B. Hess, another proponent of the new American painting, became executive editor of *Art News.* Competing critical opinions emerged. Soon after joining the *Art News* staff, Hess rose during a meeting at the Club and declared Willem de Kooning the best painter in the group. "Hess was playing a power game," concluded painter Conrad Marca-Relli, a friend of Pollock's. Hess was "pushing de Kooning and trying to get rid of Jackson in the number one spot."[7] If, in the process, Hess supplanted Greenberg as chief kingmaker, that too would be acceptable.

Clem did not initially react as if to a threat. He had stood alone for a decade. He understood that to get the recognition it deserved "advanced" American art needed attention. The more the better. And attention it got; 1950 was a watershed year in its history.

On January 1, 1950, four months after *Life's* feature and two months after Pollock "broke the ice," a front-page piece in the Sunday *New York Times* heralded the news that the Metropolitan Museum of Art, after years of "token activity," had drafted a new policy on contempory American art. The plan included an acquisition fund to fill in gaps in the museum's collection and a biennial exhibition with $8,500 in prize money, the first of which would take place the following December.[8]

That same month, Betty Parsons gave Barnett Newman his first one-person show, unintentionally revealing substantive divisions among the New York vanguard. Built like a truck driver, sporting a military-style mustache, Newman was articulate, high-minded, and at least as arrogant and overbearing as Clem. He had been an adviser to Parsons in the forties and was a popular lecturer at the Subjects of the Artists School, where his wit and erudition were much admired. But his fellows had never seen his work.

Ironically, the *New York Times's* conservative critic, Aline Louchheim, praised Newman's large, "flat" abstract paintings while his advanced fellows considered them extreme and questioned his motives. Pollock and de Kooning painted more or less abstract but vestiges of the natural world animated their art. Newman's paintings retained nothing of that world; not Mondrian's geometric grid, not even the brushstrokes that betrayed the presence of a human hand. All of these artists believed the communication of authentic feeling was art's primary goal, but now Newman's friends accused him of disavowing that high purpose. Many dismissed the show, saying Newman was a careerist, interested only in ideas, only in taking the

"next . . . step" in art.[9] Bill de Kooning and Philip Guston were so unnerved they left the show and repaired to a nearby bar. After a long drink and an equally long silence, de Kooning declared, "Well, now we don't have to think about that anymore."[10]

Tom Hess, writing for *Art News* (March 1950), captured the anger and resentment: "Barnett Newman . . . one of Greenwich Village's best known homespun aestheticians, recently presented some of the products of his meditations. . . . Newman is out to shock, but he is not out to shock the bourgeoisie—that has already been done. He likes to shock other artists."[11]

They were a small, isolated group in a hostile world, however, and they still had more in common with one another than with anyone else. Newman tried to explain that for him the flat fields of sensuous color, interrupted by nothing more than thin "zips" or stripes of light shooting through hazy, atmospheric space, embodied the creative forces present when vast upheavals take place. The A-bomb was on everyone's mind, but Newman looked beyond current survival. Without the big bang, he noted, human life might never have existed. Without the Industrial Revolution, none of them would be painters living in Greenwich Village.

The following year, at Parsons's insistence, Newman had a second show. Pollock, one of the few who responded positively to his art, helped him install it. The two had been friends since 1947 when Newman introduced Pollock to Betty Parsons, his dealer, after Peggy Guggenheim closed her gallery and returned to Europe. This time Hess dubbed Newman a "genial theoretician" (*Art News*, summer 1951). The implication, as Irving Sandler noted, was that they were painted ideas, "not really paintings."[12]

Meanwhile, news of the New York painting revolution spread through artists' communities around the country. Fueled by the GI Bill, ambitious young artists streamed into New York City. Eager to meet "Bill" and "Jack" and be where the action was, they settled in Greenwich Village, made their way to the Cedar Street Tavern, and signed up for courses at the Hans Hofmann School and/or the Subjects of the Artists School.

In 1950 few dealers were enthusiastic about vanguard art, although some felt an obligation to support their own. In April 1950, Sam Kootz, of the gallery by the same name, organized a memorial exhibition to honor the painter Arshile Gorky, who committed suicide the year before. Grace Borgenicht, who had not yet opened her gallery, told the following story to illustrate how little the work was valued even by those who appeared to support it: "When Sam Kootz did his posthumous show for Gorky, there were all these big, beautiful paintings for only three hundred dollars. Clem advised me to buy one and I wanted to, but every time I said anything to Sam, he told me I was crazy, so I didn't."[13]

Later that same month Kootz presented *Talent 1950*, a group show of new talent, selected by Clem and Meyer Schapiro, that concentrated on recent arrivals. The critics spent two weekends visiting studios. Franz Kline, not yet famous, was on their list. During their visit to his studio, the fabled incident occurred from which the artist's black-and-white calligraphic abstractions were said to emerge.

Clem and Schapiro were familiar with Kline's art and knew they wanted him in their show, but when they got to his studio, nothing seemed quite right. The artist then worked in color, but Clem spotted two black-and-white drawings tucked away in a far corner of the loft. He and Schapiro were both excited by them and Clem commented to Kline that his strength was not in color but in black and white. (Six months later, Kline showed black-and-white abstractions at the Charles Egan Gallery, and Clem wrote an advertising blurb calling him the "most striking new painter in the last three years."[14])

Talent 1950 opened on April 25.[15] Almost nothing sold but among the twenty-three artists included were Elaine de Kooning, Friedel Dzubas, Robert Goodnough, Grace Hartigan, Harry Jackson, Franz Kline (older than the others but not yet exhibited), and Al Leslie, the hot, young action or gesture painters of the fifties.

That month the Metropolitan Museum announced the list of jurors for *American Painting 1900–1950*, the first of its newly announced biennial exhibitions. It was immediately evident to vanguard artists that an anti-abstract bias had been built into the selection process. Despite their differences, still "fifty against one hundred and fifty million," they united against the outside enemy. Eighteen painters and twelve sculptors—Adolph Gottlieb, Barnett Newman, Mark Rothko, Clyfford Still, Robert Motherwell, William Baziotes, Willem de Kooning, Ad Reinhardt, David Smith, Ibram Lassaw, Herbert Ferber, and Theodore Roszak among them—composed an open letter to Roland L. Redmond, president of the Metropolitan Museum of Art, that accused director Francis Henry Taylor's highly touted new policy toward modern art of treating the subject with "contempt." The museum's choice of jurors nullified "any hope that a just proportion of advanced art will be included." Rather than "submit" work to a jury biased against abstraction, they had chosen to boycott "the monster national exhibition next December." Pollock lived on Long Island, in the small community of Springs, part of East Hampton Township. He was working on a mural commission when the letter was drafted and could not take time off to travel into the city to sign the letter, but knowing they needed his name to attract attention, he sent a telegram of support. Newman, using know-how acquired a few years earlier when he ran for mayor of New

York on the Anarchist ticket, hand-carried both to the city editor of the *New York Times.*[16]

This was not the first time American artists had protested the policy of a major New York museum. A few years earlier the Federation of Modern Painters and Sculptors wrote an open letter protesting the Museum of Modern Art's policy of excluding American abstract art. The museum's director, James Thrall Soby, responded with a high-handed letter, self-addressed postcard enclosed, to seventy members of the organization asking whether they had approved the letter in advance. The postcard did not require a signature, but the act of requesting the information was intimidating. Clem wrote that "aside from the questionable taste" the museum evidenced, its procedures called to mind "the Stalinist telephone-pressure campaigns of a few years ago."[17]

The Met was no more accommodating than the Modern, but a lull in world news and Pollock's notoriety resulted in front-page coverage for the artists' letter. "Painters Boycott Metropolitan: Charge 'Hostility to Advanced Art,'" screamed the front page of the Sunday *New York Times* (May 21, 1950). The following day, they made the op-ed page of the *Herald Tribune,* albeit in an unsympathetic piece by Emily Genauer, who labeled them "The Irascible Eighteen."[18] The letter and press coverage had no impact on the Metropolitan's exhibition, but it piqued public interest in the rebels and their cause.

That month Clem attended a reception at the Seligman & Co. Gallery where he met Helen Frankenthaler, a recent graduate of Bennington College in Vermont. Frankenthaler had been asked to organize an exhibition of paintings by Bennington alumni: "I took up a collection at Bennington and had an open bar. I invited Clem, Robert Coates from the *New Yorker,* everybody. When Clem arrived, I took him around. I remember, he singled out my painting *Woman on a Horse* as one he particularly did not like."[19] Tall, talented, witty, well-born, and very attractive, Helen had been serious about painting since her high school days at Dalton, a progressive private school in Manhattan, where her teacher was the well-known Mexican muralist Rufino Tamayo. Unlike the Greenbergs, who hailed from Eastern Europe, the Frankenthalers were German Jews, "upper class to the nines,"[20] as her dealer John Myers later put it.

East European Jews were forbidden to own property or attend university. They came to the United States as pushcart peddlers and buttonhole makers. German Jews, prior to Hitler, were assimilated members of a sophisticated culture. Class differences between German and East European Jews continued for several generations after they arrived in America. Clem's father's education ceased when he was eleven. His first American

job was in a tailor shop. Helen's father was a judge in the Superior Court of New York. Her affluent family occupied a near royal position in the hierarchy of Jewish American society.[21] But art was Helen's passion and Clem was the preeminent critic of the advanced American variety. Although she was twenty-one to his forty-one, Helen followed up their meeting with a phone call and he invited her to his apartment for drinks. Clem was already involved with two other women—the artist Susie Mitchell and the lay analyst Lillian Blumberg—but he was interested.

As 1950 progressed, major events followed one another with dizzying speed. In June, just weeks after Clem and Helen met, the American avant-garde made its European debut at the twenty-fifth Venice Biennale. John Marin's land and seascapes were the featured exhibit, occupying half the available space. The remainder was divided into room-size shows for six artists. Three—de Kooning, Gorky, and Pollock—chosen by Alfred Barr, and three—Hyman Bloom, Lee Gatch, and Rico Lebrun—by Alfred M. Frankfurter, chief editor and publisher of *Art News*.

European artists returned to the American Pavilion again and again, intrigued by the energy, scale, and optimism they saw in the vanguard trio.[22] The Italian painter Giorgio Morandi, walking through the exhibition for the first time, exclaimed at his first sight of Pollock, "Ah, ah . . . This vitality, this energy. This is new!"[23] European critics, however, were less impressed. So dismissive was their treatment of the Americans that Aline B. Louchheim wrote about it for the *New York Times*.[24]

On July 10, Clem boarded the train for Black Mountain College, the now legendary avant-garde institution near Asheville, North Carolina, where he was to teach that summer. By then he and Helen were seeing one another three or four times a week. On his recommendation she had enrolled in the Hans Hofmann School in Provincetown at the tip of Cape Cod. Fellow students remember her running to meet the mailman every day in hopes of finding a letter. Clem too was lonesome. His friends Theodoros Stamos and Paul Goodman were teaching at Black Mountain that summer as were John Cage and Robert Rauschenberg, but Clem's diary entry for the day after his arrival consisted of a single word: "GLOOM." For the next two days the word was "DREARY." A week later he learned of Jean Connolly's untimely death and went on a binge that lasted for nearly a week.

That summer Clem taught two courses: "The Development of Modern Painting and Sculpture from Their Origins to the Present Time" and a seminar in art criticism organized around Kant's *Critique of Judgment*. In the first he talked about cubism as the seminal style of twentieth-century art. In the second, he discussed Jackson Pollock, among others. Kenneth

Noland, whose career Greenberg would be associated with for the next forty years, was in that class.

Noland had graduated from Black Mountain in June 1949 and spent the following year in Paris studying at the studio of the School of Paris painter Ossip Zadkine. Noland's work was so promising Zadkine arranged a solo exhibition to introduce him to the Parisian art audience. Noland, like most of his friends, had always considered de Kooning a "real" artist and Pollock something of a joke. The latter's formal unconventionality— dripping and pouring paint—was so extreme that many other artists thought his work a scam, a clever ruse to attract critical attention.

The artistic effectiveness of these same innovations, on the other hand, had persuaded Clem that Pollock was an artist of remarkable gifts. In class, Clem analyzed his radical techniques in terms of the formal problems confronted. Pollock took the canvas off the easel, enlarged it, and dropped it to the floor, Clem explained, because he wanted to find a process capable of bypassing the glib fluency of his hand. The innovation circumvented his natural inclination to stand back and rework each passage, a method Pollock thought gave his art a "fussy," "overdone" quality, undermining the sense of immediacy he wanted to achieve.

Painfully inarticulate, Pollock was governed by powerful emotions he could only express through paint. He went outside the traditional vocabulary because he could not find what he needed within, Clem explained. It was this remarkable ability to devise effective new formal solutions to aesthetic problems that had persuaded Clem that, despite de Kooning's genius, Pollock would prove the more historically important artist.

Greenberg was a critic first and foremost. He never allowed the feelings of others to shape what he wrote or said. Black Mountain was a small community. The de Koonings were also teaching there that summer. In fact, it was Bill de Kooning who recommended Clem for the job. One can imagine his response when Clem's comments were passed along.

Although the human figure never disappeared from de Kooning's drawings, in the late forties his paintings were abstract. The summer he and Clem were at Black Mountain, he began work on *Woman I*, the first of his famous series. At first the ferocity of the image emerging from his own subconscious frightened him, and he put the picture aside. De Kooning was also concerned about the role of the human figure in modern painting, whether it was still possible to make an original statement in a figurative form.

As year's end approached, he was invited to participate in a series of talks organized by the Museum of Modern Art, and published the follow-

ing year in the form of a symposium titled *What Abstract Art Means to Me.* De Kooning used the occasion to attack a position associated primarily with Greenberg. The Dutch-born painter praised "inclusive" art—art that countenanced figures, representational objects, deep perspectival space, or anything else the artist chose to put in—and derided "exclusive" art, more precisely the idea that modern art, to be great, had to abstain from the use of certain forms.[25] De Kooning ridiculed "aesthetician artists" who "wanted to 'abstract' the art from art." He mocked artists (presumably referring to Newman) who were interested in making "the next step" rather than in providing an art we "intensely and largely" feel.[26]

De Kooning never mentioned Greenberg by name, but the artists in his audience knew to whom he referred. Clem had earlier written that the history of modern art revealed a steady progression from the deep space of Renaissance painting toward "flatness," that effectively obliterated the illusory space into which realistic images once fit. Citing the work of Manet and Cézanne, as well as the analytic cubism of Picasso and Braque, Clem had argued that, for sociocultural reasons, the plump apples and voluptuous peaches had been squeezed off the table and out of the picture. De Kooning's words amounted to a proclamation: he would stand for what he believed and buck the flatness trend and the critic who espoused it.

On November 25, 1950, about the time de Kooning spoke at the Museum of Modern Art, Clem, the chief advocate of advanced American art, took up the cudgels on its behalf, challenging the European critics who had given it short shrift at the Venice Biennale. Turning the tables, he critiqued the critics who critiqued the art. "The European View of American Art" (*Nation*) challenged the reflexive disdain of some, such as Great Britain's Douglas Cooper—who judged John Marin's work "convulsive and sometimes inept" and Jackson Pollock's as "merely silly"—saying their comments stemmed not from critical acumen but from the blasé assumption that Americans were, and always would be, cultural barbarians. Shifting his focus to another British art writer, David Sylvester, who had had the temerity to review the Biennale for the *Nation* (September 9, 1950), Clem skewered the piece as yet another example of critical flabbiness:

> What surprises me . . . in both cases is . . . the sign of a lack of critical competence. . . . Mr. Sylvester's remark about "the tradition of ham-fisted, paint-curdling illustration which stems from Albert Pinkham Ryder and Max Weber" makes one wonder whether he ever saw a picture by either artist. If he did it must have been a very fleeting glance. And the glance he threw at Gorky must have been just as

quick, for to connect Gorky, who was second to no painter of our time in sheer finesse, with anything "ham-fisted" and "paint-curdling" reveals a failure, not to appreciate Gorky, but to see him—that is, to make elementary use of one's eyes.[27]

Sylvester countered politely (in the same issue) by observing that Greenberg's admiration for the Americans no doubt stemmed from his lack of acquaintance with "something akin" to their work, only "very much better," produced by young Europeans. Clem's riposte, figuratively speaking, was a succinct and elegant kick in the teeth:

> When I claim that Gorky, de Kooning, and Pollock have turned out some of the strongest art produced anywhere since 1940, it may be that I am insufficiently acquainted with the latest work done abroad. But it is with the masterpieces of Matisse, Picasso, Klee, and Miró in mind that I say that some of their work warrants a place of major importance in the art of our century.[28]

During the summer and fall of 1950, as these events played out, photographer Hans Namuth was making his famous film of Jackson Pollock at work. In December, *American Painting 1900–1950* opened at the Metropolitan Museum of Art. The January 15, 1951, issue of *Life* included color pictures of the gala opening. On the very next page, however, *Life* printed photographer Nina Leen's dramatic black-and-white portrait of the boycotters, Pollock in the center. The composition was formal. The men—only one woman was included—were dressed in suits and ties, their demeanor serious, judgmental. The crackling intensity of Leen's image fairly burst the confines of its page. That picture riveted reader attention. The follow-up was not dramatic. The establishment did not immediately conclude they had been in error, nor did collectors suddenly emerge to support the boycotters. But Leen's shot transformed "The Irascibles" from a group of disaffected radicals into an acknowledged vanguard, America's Salon des Refusés.[29]

Clem had championed the New York vanguard since 1943. Now, just as his courage and discernment began to pay off, he pulled the rug from beneath his own feet. He had given up the regular practice of art criticism at the end of 1949. In 1950 he told Helen Frankenthaler that there was nothing more for him to write about since he "had written what he had written." He had discerned a subtle shift as yet unobserved by others. The appear-

ance was little changed but formally the artists had pulled back. They were taking fewer chances.

Clem feared that de Kooning's "inclusiveness" talk at MOMA would reinforce the trend toward caution—away from the risk-taking formal advances that had put them on the map. Clem respected de Kooning's talent. He later wrote that if American art "became a factor in the mainstream of Western art," de Kooning's "genius" would have played a large role. He knew de Kooning was looked up to by his fellow artists. He worried that the course recommended by the Dutch painter was the opposite of that which had thus far advanced the American position.

In January 1951, just weeks after de Kooning's talk at MOMA, the same month *The Irascibles* appeared in *Life,* Clem spoke at the annual convention of the College Art Association (CAA), America's foremost organization of art professionals. Members from all over the country converged on the National Gallery of Art, in Washington, D.C.,[30] to attend meetings, renew acquaintances, check out the job market, and hear Clement Greenberg, the chief advocate for advanced American painting, talk about the revolution taking place in New York City. What they heard, however, was an irritable discourse on how that glorious moment may already have come and gone.

Clem tended to become defensive and overstate positions he knew would be unpopular. Dore Ashton, later a self-described member of the "anti-Greenberg camp," recalled her shock when, at age eighteen, she sat in that auditorium and heard "the greatest exponent of the new American painting" speak "scornfully" about New York abstraction: "Clem has a suite of expressions that are unmistakable," she said by way of explaining how his words were intensified by the snarling and contemptuous manner of their delivery.[31]

Clem believed that the future of Western culture rode on advanced American art. He knew that in ordinary circumstances periods of consolidation follow periods of innovation in art. The problem was timing. As he saw it, American art stood on the threshold of a historic breakthrough. It could not afford to rest on its laurels. If it was not to prove a flash-in-the-art-history pan, the vanguard had to build on the accomplishments of Pollock, de Kooning, and Gorky.

Pollock was being talked about everywhere. In January, the same month Clem spoke at CAA, Namuth's still photographs of the artist "in action" appeared in *Portfolio* magazine. In March, two of Pollock's paintings served as backdrops for a fashion shot by Cecil Beaton in *Vogue.* In May, painter/writer Robert Goodnough's piece "Pollock Paints a Picture" appeared in *Art News*

accompanied by Namuth's pictures. That same year Peggy Guggenheim sent nineteen Pollocks from her private collection on a tour of Amsterdam, Zurich, and Brussels. The Museum of Modern Art's Department of Circulating Exhibitions chose two drip paintings for a three-year, twenty-five-city tour of the United States and offered Pollock a room of his own in the museum's 15 Americans show the following April. Illustrations of his work appeared in Life, Time, and Harper's Bazaar, and he was offered a one-person show in Paris. The sheer quantity of attention attracted attention. But curiously, the publicity did not translate into sales.

Today it is difficult to believe that all of this happened independent of a market for Pollock's work, or of anything more than modest hopes for the growth of one. One painting sold from his 1950 show and only two in 1951. "Back then you couldn't give the art away," recalled Grace Borgenicht, who opened her gallery in 1951, in the same Fifty-seventh Street building occupied by Charles Egan, de Kooning's dealer. "Charles didn't like to hang around the gallery," Borgenicht recalled. "He would leave the door open and go out to Schrafft's Bar on Fifty-eighth Street. Everybody knew where to find him. De Kooning drawings sold for three hundred dollars apiece then and Charles left them stacked on the floor. No one stole them or even wanted them."[32]

By 1950, the solidarity that had carried the avant-garde group through dark years of isolation was shattered. It is usually said that two main camps emerged: one around de Kooning, the other with a Greenberg/Pollock axis. But that was largely myth. The Namuth film had taken a heavy psychic toll on Pollock. Scenes had to be repeated and shots adjusted to take advantage of the natural light Namuth preferred. Pollock, whose concentration was so all-encompassing he seemed to enter a trancelike state when painting, was expected to start, stop, and begin again on demand. Toward the end of November, on the last day of shooting, his frustration erupted. After spending the whole of a cold, blustery day outdoors, gloveless, wearing only a cotton shirt, dutifully following Namuth's orders, he was sullen and truculent. From 1946 to 1950, perhaps his peak years as an artist, Pollock seemed to be winning his struggle with alcohol. (He drank beer but stayed away from hard liquor.) As the light began to fade that November day, Namuth declared the movie finished. Pollock headed straight for the kitchen cabinet in which a bottle of bourbon was kept for guests. He filled a water goblet, then another and another. He was still drunk three days later when his show opened at Parsons. "Even as the fans crowded the Parsons Gallery to see the grand visions of summer," wrote two of his biographers, Steven Naifeh and Gregory White Smith, "Pollock was stumbling through the dark, familiar streets of the Village, haranguing strangers and

howling at the moon."[33] The vanguard splintered but most lined up behind de Kooning's banner.

Clem and Helen were by then an item. His social schedule was full, his diary crammed with drinks and/or dinner plans with artists, dealers, and curators. He saw the *Commentary* crowd and friends such as William Phillips, his companion of choice for baseball games. They often spent weekends with the Phillipses at their country house near Hackettstown, New Jersey. Sidney Phillips, publisher of the Dial Press, was a close friend with whom Clem also spent lazy country weekends. They visited Bennington College, Helen's alma mater, and she introduced him to Paul Feeley, the head of the art department, and to his wife, also named Helen. Clem and Helen maintained separate apartments but saw one another almost daily. In the literary world, her youth, appearance, pedigree, and lively intelligence gave Clem a certain social cachet. Even Philip Rahv, who had earlier spread the word that Clem was a snob, became an eager member of his circle. Clem gave Helen entrée, at a high level, into the art and literary worlds of New York. Although the sentiment at the Artists' Club was predominantly anti-Greenberg, no one could afford to offend the powerful critic and he was often invited to parties and to participate in panel discussions. He and Helen often attended Friday-night lectures at the Club (the artists would never name it), after which everyone proceeded to the Cedar Street Tavern.

Clem loved being surrounded by people younger than himself. He and Helen often socialized with artists of her generation. Grace Hartigan, a statuesque young artist whose large abstract paintings Clem admired, was Helen's good friend and the two made quite a pair, recalled Dore Ashton, who envisaged them jointly: "I thought of them as 'La Grand Girl' because they were tall and they had this grandeur and bearing, really splendid creatures."[34] Clem and Helen often double-dated with Hartigan and her current beau. "We would go to a bar called Ed Winston's Tropical Gardens and dance," Grace recalled. "Helen did a painting of it for her first show. She and Clem were terrific dancers. Helen would give cocktail parties because she had a nice, uptown apartment with a pool and lots of space that she shared with Gaby Rodgers, the actress. Pollock would come, Al Leslie, Larry Rivers, and lots of the younger artists."[35]

The couple spent time with the tall, handsome, "cowboy" artist Harry Jackson and his second wife, the dancer Joan Hunt. Harry loved the American West. He wore cowboy boots and later created sculptures with a Western theme that John Wayne collected and Ronald Reagan gave as gifts to visiting heads of state. In the early fifties, some of Harry's paintings

had Western themes but others were large and abstract, influenced by Pol-lock, whose friend he was. "We [Helen, Clem, Harry, and Joan] often went to a nightclub on East Eighth Street, close to the Artists' Club," Harry reminisced. "Clem loved to dance and he was a lot of fun to go out with."

Harry had the impression of a "master/disciple relationship" between Clem and Helen. "With Helen, Clem was a father figure. He was a profes-sor. He was a Pygmalion, showing her about life. . . . Clem was a remarkably presumptuous man. He'd tell you who to marry, how to cook your break-fast, and how to raise your children. He did that not with me, but with Helen. He even wanted to conduct her attitudes toward sex. Helen is a self-determining kind of person with a good idea about how she wants to conduct her life, but Clem knew her when she was very young and he tried to play Svengali." Another friend, Cornelia Noland, saw the relationship differently: "They were Clem/Helen—just totally a couple. . . . She was very young but was no shrinking violet even then. She deferred to him and he taught her about life and art and aesthetics, but he trusted her judg-ment, particularly when they were looking at new work. . . . There was this electricity between them. I think a lot of it was sex. They just had every-thing in common. Even after she married Bob Motherwell, I'd think, 'Wait, this is wrong.'"[36]

In the bohemia of the downtown art world Clem and Helen cut a regal swath—too regal for some. Dore Ashton recalled a New Year's Eve party she threw in her third-floor walk-up during the halcyon days of the early fifties: "Lots of artists were there and we had a phonograph. I was dancing a tango—my favorite—with a Latin American painter. I saw Helen and Clem come in. She just looked at him and it was clear they didn't like the music, so they just walked over and took the record off. . . . Well, I'm a well-brought-up Jewish girl so I let it pass. But I didn't forget."[37]

Clem's son, Danny, reentered his life during these years. In 1945, when Danny was ten, he and his maternal grandmother had lived with Clem in a rented house in Greenwich Village. By then the boy had a history of school expulsions and a deep-seated aversion to his father. Clem enrolled him in private schools but he never remained very long. After roughly a year, Danny and his grandmother had returned to California.

In 1949, Edwina, a librarian by training, moved from southern Califor-nia to Washington, D.C., where she accepted a position at the Library of Congress. With her came her mother and Danny, now fourteen and a handful. His mother no doubt hoped proximity to Clem would prove ben-eficial. Danny often spent weekends with his father in New York. Clem

rarely organized excursions or activities to suit his interests, but he always included his son in his own plans. Danny accompanied his father to cocktail parties, dinners, openings, bars. Beginning in 1950, Clem and Helen visited Danny in Washington once or twice a year.

Clem was a bully. Conflict resolution was not one of his skills. He never learned, even after years of psychotherapy, that beating up on people psychologically might not be the most effective technique for getting them to do what he wanted. He behaved with Danny the way he behaved with relatives and girlfriends. He wanted Danny to be perfect and he carped and criticized in an effort to make him so. Clem had always resented his own father's coldness and stinginess toward him. He was financially generous with his son until the boy was well into his thirties. Emotionally, however, he was as distant and demanding toward Danny as Joseph had been toward him.

Over the next few years, de Kooning's *Woman* series became the most talked about paintings in New York, and de Kooning the most influential artist of his generation. If Clem's intent at CAA had been to stimulate discussion about the dangers conservatism posed for advanced American art, he failed. In 1951 he turned his attention to basic issues such as cubism and School of Paris painters, trying to understand what it was that made for great art. He produced a series of remarkable essays. In "Cézanne and the Unity of Modern Art" (May-June 1951), for example, he observed that art functions "as an emblem both of . . . originality and . . . mastery," but that the forms through which it accomplishes this vary with time and place: "That fullest, triumphant unity which crowns the painter's work, which arrives when the ends are tightly locked to the means, when all parts fall into place and require and create one another so that they flow inexorably into a whole, when one can, as it were, experience the picture like a single sound made by many voices and instruments that reverberates without changing, that presents an enclosed and instantaneous yet infinite variety . . ."[38]

But as the art that he had championed so vociferously entered the promised land, he essentially wandered in the desert.

10

Making Enemies and
Keeping Them

Clem became a pariah, but not always for the reasons commonly assumed. When the avant-garde split in 1951, its two main camps were divided by artistic as well as other issues. The de Kooning group, the larger of the two, prided itself on carrying forward the tradition of cubism, represented by Picasso's synthetic period. They identified their art as "inclusive," meaning it included the human figure and a space deep enough to accommodate it. They conserved the expressionist advances of the forties but did not press forward. They viewed the Greenberg/Pollock camp as "radical" because of the extremes to which it pushed the formal envelope, but relations between the camps remained fluid. The artists continued to mingle at the Club and at parties, but as 1951 progressed, "everyone knew what was happening. Everyone knew to which camp they belonged," painter Paul Brach recalled.[1]

At the time Greenberg castigated America's avant-garde for consolidating rather than innovating, the art in question was so advanced it was virtually incomprehensible, even to other artists. The retrenchment Clem observed, that later became evident to others, was as invisible to most of his CAA audience as it was to many of the artists. Why it happened when it did is still unclear. Perhaps it was a reaction to the possibility of success. Alternatively, it was McCarthy time in America and the country as a whole had become more conservative.

While the cause of the retrenchment was unknown, the response to Pollock's notoriety was not. Those who believed de Kooning the better artist, felt he had been robbed. This large and diverse group included the realistic painter Fairfield Porter and his followers, as well as abstract painters such as Franz Kline, Milton Resnick, Al Held, and Norman Bluhm. The Greenberg/Pollock camp, on the other hand, never boasted more than a handful. Friedel Dzubas, Adolph Gottlieb, Barnett Newman (who later changed camps so often it was joked about), David Smith, and

a very young Helen Frankenthaler comprised the regulars, with Paul Feeley and Paul Jenkins as peripheral members. This camp admired Pollock but also de Kooning.

Art was Clem's obsession, but he earned his living as an editor. His problem as a critic was to find art that possessed the power to open the floodgates of his mind and release what was pent-up within. His hopes for the future of American painting included artists from both camps as well as some who were allied with neither. In 1953 he listed Gorky, Gottlieb, Hofmann, Kline, de Kooning, Motherwell, Newman, Pollock, and Rothko among America's finest.

Clem was always in search of new talent. Some among the second-generation abstract expressionists attracted his attention. He had included them in *Talent 1950*, the show he and Meyer Schapiro organized for the Kootz Gallery, and he still recommended them on the infrequent occasions when a collector asked his advice. This younger generation constituted a swing group between the major camps. Harry Jackson and Grace Hartigan were "accepting Pollock's influence," and Clem thought their "all-over" abstractions showed promise. They hung out at the Cedar Street Tavern with "Franz" (Kline) and "Bill" (de Kooning) but also went dancing with Clem and Helen and to the weekly swim parties Helen gave around the pool in her apartment building. Although many of them never knew it, Clem was instrumental in getting them their first New York gallery. Jean Connolly had introduced Clem to the collector Dwight Dillon Ripley, scion of the eminent Dillon clan, and the two stayed in touch. A week before Clem's talk at the College Art Association Convention, Ripley and John Myers, the former editor of *View,* came to Clem's apartment to consult with him about a noncommercial gallery that Ripley would finance as a silent backer and Myers would run. The result was the Tibor de Nagy Gallery, named for Myers's close friend, the gallery's business manager. Myers asked Clem and the Pollocks to recommend young artists for his "stable," and Clem gave him the *Talent 1950* list. When Tibor de Nagy opened in November 1951, Helen and most of those on Clem's list had been asked to join—Elaine de Kooning, Kline, Rivers, Hartigan, and Jackson among them.[2] Myers sometimes included Clem's paintings in his group shows.

Clem developed what Frankenthaler described as a studio dialogue with some of these artists. When they met socially, he talked to them about their art, and he dropped by their studios once or twice a year to encourage them, Hartigan recalled.[3] Hartigan's chief complaint about these visits was their lack of substantive content. Clem "grunted" when he liked something and that was it, she explained. If she wanted art talk, she had to look

elsewhere: "I mean, I liked rah-rah and I liked grunt grunt, but I was hungry for more imaginative conversation. . . . I had met de Kooning, who was fabulously articulate and intricate in his conversation so . . . I'm pretty bright, you know . . . so I gravitated to the Cedar Tavern."[4]

Hartigan and Harry Jackson admired Pollock and at this time were trying to build on his achievement. The difficulty, Hartigan recalled, was that Pollock's drips and pours were so distinctive "whatever we did just looked imitative." Discouraged, Harry talked about going to Europe to study the old masters (which he later did), and Hartigan began accompanying Larry Rivers on his visits to the Metropolitan Museum of Art: "I felt that to understand the past I had to paint it, and so I started to do these free studies—Rubens, Goya, the masters." Hartigan gave up on Pollock and on abstraction and turned for inspiration to de Kooning, whose "mark" was something "you could build your own sentences with," as painter Al Held commented.

Second-generation abstract expressionists came of age after the ice was broken. Their experience was vastly different from that of the pioneers. The second group was written about and exhibited soon after arriving in New York. In 1951, they were included in the artist-organized *Ninth Street Show,* the first time the New York School showed together. They took all of this in stride, naturally attributing the recognition they received to their own remarkable talents. Where the first generation felt humble in relation to the great modern masters who preceded them, the second felt second to none. For example, Clem visited Hartigan's studio in March 1952. When he saw the direction her work had taken, his response was not what she had anticipated. To her it seemed as if one minute he thought she was great and the next that she had lost it. She had interpreted his interest as a sign, not that she had potential, but as recognition that she had the makings of a master. When his lack of enthusiasm penetrated, her outrage was unbounded. Aware of what Clem's support had done for Pollock, she, no doubt, had entertained fantasies about what it would do for her. Hartigan recalled her feelings as the extent of her loss became clear: "You have someone like Clem who has a great deal of power . . . and he doesn't love you anymore, it's upsetting. . . . I was furious and screamed at him that day in my studio, and when he left, I remember breaking some cups and saucers or glasses or whatever—hurling them after him when it was too late to hit him."[5] Reliving the incident many years later, she described what upset her: "Clem told me to stop doing it. He didn't say, 'You'll get over it.' He said, 'Don't do it, stop doing that, that's not what you do. You have to stay avant-garde.' "[6] Clem never mentioned the figure but Hartigan

assumed that it was the figure to which he objected. She spread the word that he rejected her new work because it was not abstract.

Frankenthaler, who was good friends with some of the younger artists, remarked that the "studio dialogue [with Clem] went awry and mutual admiration ceased."[7] By July all pretense of politeness had disappeared from the younger group's behavior toward him. In a letter to Harry Jackson, with whom he was still on good terms, Clem described an unpleasant situation to which he, Helen, and the Pollocks had been subjected by what he called the Tibor de Nagy group: "Two weekends ago, Helen and I visited the Pollocks and did the social rounds in Easthampton. . . . The Tibor de Nagy group was there in full force . . . John [Myers], Larry [Rivers], Jane Freilicher, and Grace [Hartigan]. They weren't too friendly to Helen, the Pollocks or me when we called on them. . . . I'll never be forgiven for implying that Grace and Larry were, possibly, not great artists."[8]

Clem was a master at circulating his own opinions. He let it be known that earlier he thought some of the group showed promise but that he now realized that promise would not be fulfilled. And such was the extent of the resentment against Clem that his disapprobation was not always without reward. Sometime later, Hartigan denounced Clem at a Friday-night meeting of the Club. Alfred Barr and Dorothy Miller were in the audience. They sought Hartigan out and scheduled a date to visit her studio. "She had quite a run for a time," Clem observed sardonically.[9]

By fall of 1952, Clem and Helen no longer felt welcome at the Club or the Cedar Street Tavern. In his 1989 monograph, *Helen Frankenthaler,* MOMA curator John Elderfield wrote, "The downtown group . . . made Greenberg less than welcome along with anyone who kept company with him. His relations with artists like Al Leslie, Larry Rivers, Michael Goldberg, Milton Resnick, Norman Bluhm deteriorated to that of animosity and belligerency."[10] The younger group hopped on the de Kooning bandwagon, where the feistiness of their combative attitude toward Clem endeared them to their elders. Hartigan and some of her friends had earlier attended Club events as guests of members. Now they were invited to join and soon were exhibiting at the same level as their elders.

Friedel Dzubas, a second-generation artist close to Greenberg, described the shift toward de Kooning. "In the early fifties Pollock was thought to paint good pictures and bad pictures," but "the attitude was that Bill could not paint a bad picture. Everything he did was sacred. There was a kind of suffocating academy created right there. Everyone accepted it, Alfred Leslie, Grace Hartigan, Mike Goldberg. . . . The role of Greenberg was strongly interwoven with the scene . . . very quickly his standing within that

group deteriorated from being the earliest and most profound spokesman for what was going on in America to an attitude of animosity and belligerency. . . . He became the enemy . . . a very feared, very respected enemy—but certainly the enemy."[11]

At a particular moment said Frankenthaler, "Hartigan, Leslie, and Harry Jackson's style changed abruptly from abstract to figurative painting. De Kooning, involved in his *Woman* series, was a strong influence. A division seem to evolve: on one hand, a small army of satellite painters who followed de Kooning (both the man and the aesthetic) and his demonstrations of paint stroke. . . . The trail of the brush mark itself became the signature, more or less, of the de Kooning faction and its satellites."[12]

Years later Clem insisted that he was too busy with events in the literary world to pay much attention to what was happening with these artists, but as the hostility toward him increased, his diary reflected a certain lassitude. Frequent mentions of doctor's visits and shots—"to gain energy"—appear for the first time.[13]

Grace Hartigan and Harry Jackson said Clem abandoned them when they rejected abstraction in favor of figuration. Larry Rivers, who had always included the figure, concluded Clem withdrew support from him because of an unpleasant incident between them at a party one night. The artists naturally chose to attribute Clem's rejection to something other than the quality of their art, or his judgment of it. Interpreting his behavior as an effort to pressure them to paint abstract, they said he was only interested in confirming his theory that abstraction was the style that characterized the best art of their time.

Greenberg, the critic of abstraction, allegedly rejected figuration and the artists who favored it. To this day he is said to have brutally criticized Pollock's return to the figure and to have rejected post-1950 de Kooning for the same reason. But the evidence does not always support this claim.

Although de Kooning painted *Woman I* in 1950, his *Woman* series was first exhibited in 1953. Pollock returned to the figure in 1951; the paintings were first exhibited at the Betty Parsons Gallery in November of that year. Forty years later a remarkable consensus existed, among those in a position to know, as to Clem's reaction.

Barbara Rose organized *Krasner-Pollock: A Working Relationship* at Guild Hall in East Hampton (1981). Later, as absentee curator of contemporary art at the Houston Museum of Fine Art, Rose organized the Lee Krasner retrospective shown at MOMA in 1983, a year before the artist's death. Rose and Krasner spent a great deal of time together working on the catalogs for these shows. Rose stated emphatically, "Lee blamed Clem's criticism" for the breakdown that culminated in Pollock's accidental death.[14]

The following story was so widely known that Rose accepted and repeated it as fact: "I heard many people, including Lee Krasner, talk about the dev-astating effect Clem's criticism had on Pollock. . . . Several people read Clem's critique of Pollock's 1951 black-and-white show where he says Pol-lock has lost it. Clem was devastatingly critical of Pollock's return to the figure. Clem wanted Pollock to stay abstract."[15]

Hartigan's memory was similar: "Pollock was way out on the edge. What he was doing [dripping and pouring] was so far out that when he finished a painting, he'd ask Lee, not is this good, but is this a painting? There were only two people in the world whose comments Pollock listened to, Lee and Clem. . . . It was a tragedy that Clem couldn't let him grow [meaning experiment with figuration]."[16] Harry Jackson stated unequivocally, "Clem and Pollock were at swords' points. Clem was attempting to direct Pol-lock's artistic career. Pollock at that time was going back toward figuration . . . and it was very clear that Clem certainly didn't like the idea."[17]

In reality, Clem thought the 1951 show was one of the twin peaks of Pol-lock's career. After resigning from the *Nation,* Clem continued reviewing shows for *PR* but he did not write about the New York vanguard. He was so impressed with Pollock's 1951 show that he ended his two-year morato-rium just to review it. "Art Chronicle: Feeling Is All" appeared in *Partisan Review* (January 1952).[18] Below is a representative segment of his com-ments, measuring roughly one-third the whole:

> Contrary to the impression of some of his friends, this writer does not take Pollock's art uncritically. . . . But the weight of the evidence convinces me—after this last show more than ever—that Pollock is in a class by himself. . . . His most recent show, at Parsons', reveals a turn but not a sharp change of direction . . . his new pictures hint . . . at the innumerable unplayed cards in the artist's hand. And also at the large future still left to easel painting. . . . Some recognizable images appear—figures, heads, and animal forms. . . . The outcome is a new and loftier triumph.
>
> If Pollock were a Frenchman, people would already be calling him "maître" and speculating in his pictures. Here in this country the museum directors, the collectors, and the newspaper critics will go on for a long time . . . refusing to believe that we [in America] have at last produced the best painter of a whole generation.[19]

Isaac Bashevis Singer said that truth is a "crown of feathers," but how is one to make sense of a consensus in total opposition to the written record? Were Hartigan, Harry Jackson, and Lee Krasner ignorant of Clem's piece?

Were they outright liars? Conceivably Harry Jackson missed Clem's *Partisan Review* piece, but was he so isolated that talk of this glowing tribute never reached him?

Clem's review preceded his last visit to Hartigan's studio by two months. It came at a time when he was on friendly terms with all three. On the evening of November 26, 1951, he noted in his diary that he attended Pollock's opening and afterward had drinks with Helen, Hartigan, and her friend "Walt." Two days later the notation read: "7:30, Grace and Walt's." Hartigan could not have been unaware of Clem's reaction to Pollock's show and neither could Krasner. She and Pollock had dinner with Clem and Helen on December 1 and again in January, after the review appeared.

"Feeling Is All" was an unlikely title for a critic putatively concerned only with formal issues. But Clem viewed Pollock's black-and-white show as a prime example of the artist's ability to devise innovative formal techniques whose function it was to increase the affective charge delivered by his paintings. Clem's essay, which included reviews of selected current exhibitions as well as some that had taken place during his hiatus, contrasted Pollock's dedication to the authentic expression of feeling with what he saw as an antithetical trend among de Kooning's followers. All young artists go through a period of reflecting the influence of those they admire, but de Kooning's admirers were becoming immediately recognizable by their wholesale appropriation of the famous de Kooning mark—the trail left by a loaded brush dragged across the picture plane.

When "Feeling Is All" appeared, this inclination was still in its infancy and Clem did not identify the artists involved. Instead, employing a variation of *PR*'s allusive style, he presented his remarks in such a way that his meaning was apparent only to the intended audience. Reviewing *Henri Matisse*, the retrospective exhibition organized by Alfred Barr that was then at the Museum of Modern Art, he praised the French master's patience and wrote glowingly of his refusal to "proceed" by means of "borrowed styles." Clem recounted Matisse's decade-long search for his own "voice," for artistic "independence." To paint successfully with another's voice, he wrote, Matisse would have had to feel the way they did, "which he did not": "We cannot be too often reminded how decisive honesty is in art. . . . It will not guarantee success—the artist has to have something to be honest with and about—but it is not entirely separate from the procedure of talent. Honesty and talent elicit each other. Without talent honesty is left incomplete. . . . Without honesty talent is . . . left in a void."

In the same essay, Clem praised artists from both camps. He commended Franz Kline's second show at the Egan Gallery: "Kline . . . has stripped his art in order to make sure of it—not so much for the public as

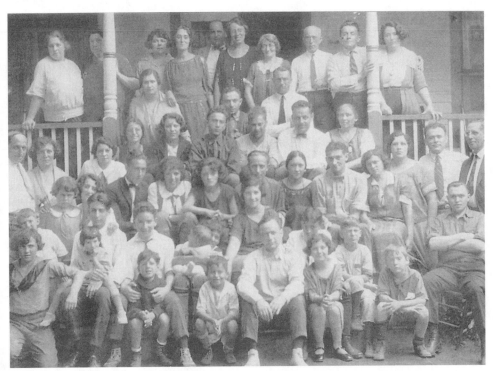

Settlement house group. Joseph and Dora Greenberg on left, third row from the bottom. Clem in center, hands clasped between his legs, ca. 1913–14. *(Courtesy of Martin Greenberg)*

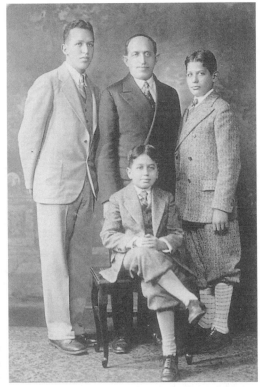

Clem, Joseph Greenberg, Sol, Martin (seated), ca. 1927–28.
(Courtesy of Martin Greenberg)

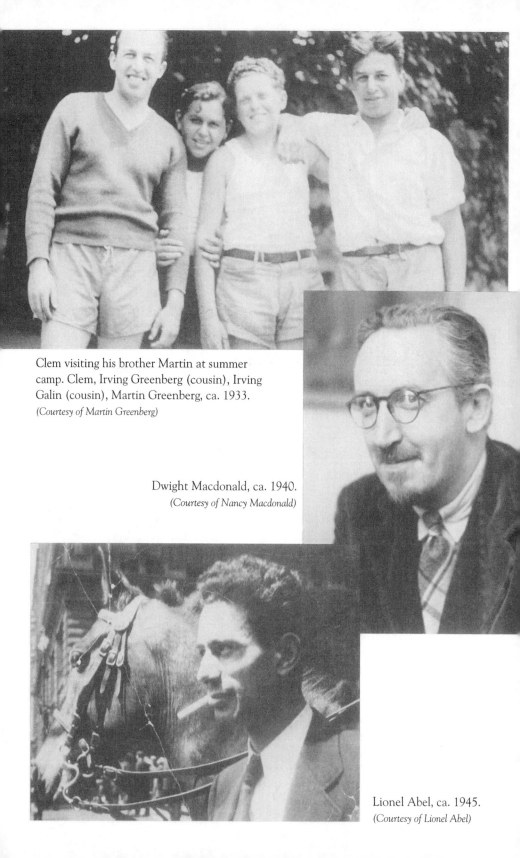

Clem visiting his brother Martin at summer camp. Clem, Irving Greenberg (cousin), Irving Galin (cousin), Martin Greenberg, ca. 1933. *(Courtesy of Martin Greenberg)*

Dwight Macdonald, ca. 1940. *(Courtesy of Nancy Macdonald)*

Lionel Abel, ca. 1945. *(Courtesy of Lionel Abel)*

Lee Krasner and Jackson Pollock, The Springs, East Hampton, ca. 1947.
(Courtesy of the Jeffrey Potter Collection, Pollock-Krasner House and Study Center, East Hampton, New York)

Morris Louis and his wife, Marcella, ca. 1950.
(Courtesy of Marcella Brenner)

Lee Krasner,
Clement Greenberg,
Helen Frankenthaler,
and Jackson Pollock at
Eddie Condon's, New York City,
January 1951. (*Courtesy of
Helen Frankenthaler*)

Clement Greenberg, Helen
Frankenthaler, David Smith,
Jennifer Feeley, Jean Smith,
Jill Feeley, Bolton Landing,
NY, February 1954. (*Courtesy
of Helen Frankenthaler*)

Helen Frankenthaler,
Lee Krasner, Clement
Greenberg, Jackson
Pollock, Helen Feeley
(now Wheelwright), in
front of Feeley home,
Bennington, Vermont,
1952. (*Photograph by Paul
Feeley; courtesy of Helen
Wheelwright*)

Jackson Pollock on the beach, East Hampton, early 1950s. *(Photograph by Roger Wilcox. Courtesy of the Jeffrey Potter Collection, Pollock-Krasner House and the Study Center, East Hampton, New York)*

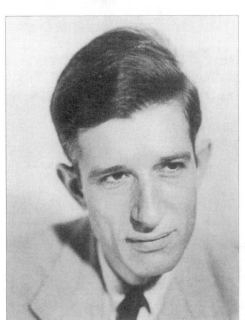

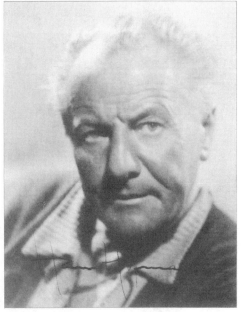

Morris Louis, late 1950s. *(Courtesy of Andre Emmerich Gallery)*

Hans Hofmann, ca. 1950s. *(Albert Peterson Photographers; courtesy of Andre Emmerich Gallery)*

Kenneth Noland, Cornelia Noland
(now Reis), ca. 1950.
(Courtesy of Cornelia Reis)

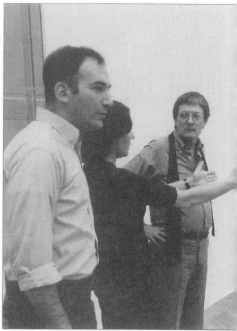

Michael Fried, Susan Waldman,
Ken Noland, 1960s.
(Courtesy of Ken Noland)

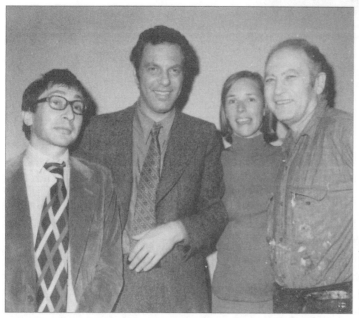

John Kasmin, Lawrence
Rubin, unidentified
woman, and Jules
Olitski, ca. 1968.
(Courtesy of Jules Olitski)

Clement Greenberg, 1964.
(*Courtesy of Cornelia Reis*)

Rosalind E. Krauss, 1969. (*Courtesy of Rosalind E. Krauss*)

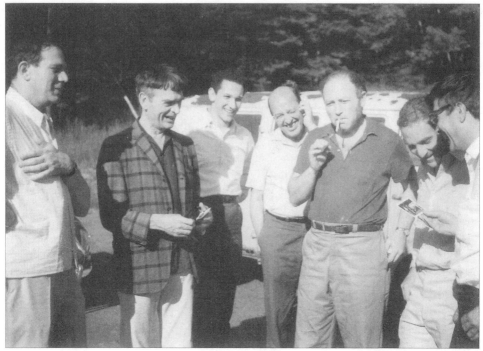

Gene Baro, Paul Feeley, David Mirvish, Clem, Jules Olitski, Tony Caro, Ken Noland, ca. 1964. *(Courtesy of Jules Olitski)*

William Rubin in Jules Olitski's studio, 1960s. *(Courtesy of Jules Olitski)*

Barbara Rose, Frank Stella, 1968. *(Courtesy of Barbara Rose)*

Jules Olitski and William Rubin in Olitski's studio, ca. 1969. *(Courtesy of Jules Olitski)*

Ken Noland, Clement Greenberg in pool at The Gully, Noland's farm in South Shaftsbury, Vermont, late 1960s. *(Courtesy of Ken Noland)*

Andre Emmerich in his gallery, 1960s. *(Courtesy of Andre Emmerich Gallery)*

David Smith in Bolton Landing Studio, wearing welding goggles as he makes decisions about a sculpture in progress, early 1960s. *(Courtesy of Rosalind E. Krauss)*

Sarah, Jenny, Clem Greenberg, and Jules Olitski at Ken Noland's farm, The Gully, South Shaftsbury, Vermont, 1965. *(Photograph by Cora Ward; courtesy of Jules Olitski)*

Larry Rubin, Jules Olitski, unidentified woman, Michael Steiner, and Clem in Bennington studio, 1969. *(Courtesy of Jules Olitski)*

Clem in front of Ken Noland's South Shaftsbury house, 1965. *(Photograph by Cora Ward; courtesy of Jules Olitski)*

Clem looking at a Noland target painting in early 1970s. *(Photograph by Cora Ward; courtesy of Kenworth Moffett)*

Clem, Jules Olitski in Bennington sculpture studio, ca. 1974. *(Photograph by Sara Lukinson. Courtesy of Jules Olitski)*

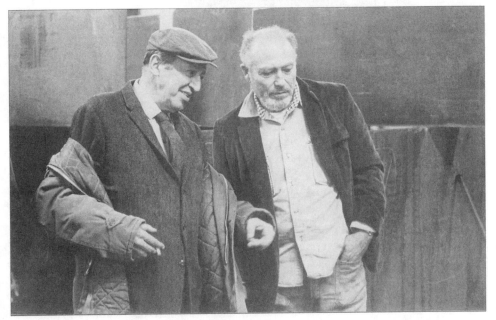

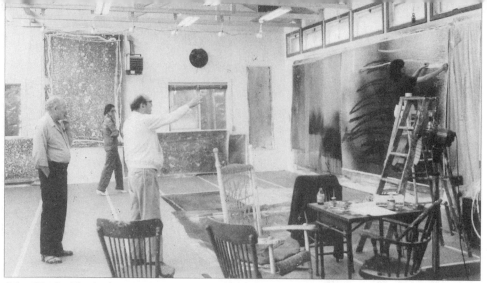

Jules Olitski, Elizabeth von Wentzel, Clem, Christina Olitski (on ladder), in New Hampshire studio, deciding on stretcher marks for one of Jules's paintings, late 1970s. *(Courtesy of Jules Olitski)*

Ken Moffett, Clem, Ken Noland, looking at paintings in Noland's Shaftsbury studio, ca. 1974.
(Photograph by Sara Lukinson; courtesy of Jules Olitski)

Jules Olitski, Clem, Ken Noland in Bennington sculpture studio, ca. 1974.
(Photograph by Sara Lukinson; courtesy of Jules Olitski)

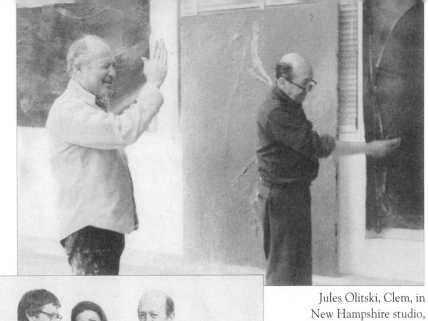

Jules Olitski, Clem, in
New Hampshire studio,
choosing paintings for a
show, ca. 1978. *(Courtesy
of Jules Olitski)*

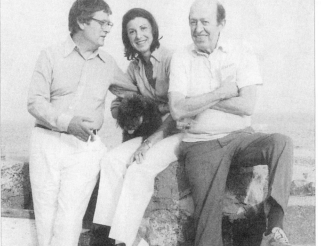

Kenneth Noland, Helen
Frankenthaler, Clement
Greenberg, Stamford, CT
August 1979. *(Photograph by
Cora Kelley Ward. Courtesy of
Helen Frankenthaler)*

Ken Noland, Ken Moffett, Clem, in
Noland's South Shaftsbury studio,
looking at new work, ca. 1974.
*(Photograph by Sara Lukinson;
courtesy of Jules Olitski)*

Untitled, acrylic on paper, by Clement Greenberg, 1978.
(Collection of Lucy Baker)

Clem, Sarah Greenberg, Helen Frankenthaler, unidentified woman (possibly Helen's sister Marge), Jenny Greenberg, Kenneth Noland, in front of Ken's South Shaftsbury house, ca. 1976.
(Courtesy of Ken Noland)

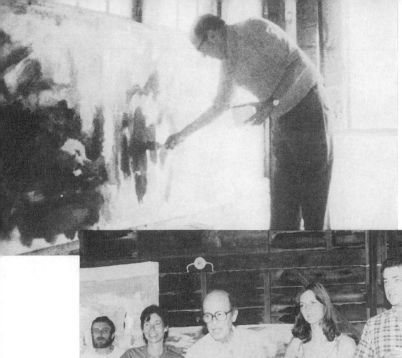

Clement Greenberg working on Friedel Dzubas's painting. Triangle Workshop, 1985. *(Courtesy of Irene Neal)*

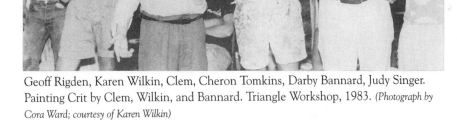

Geoff Rigden, Karen Wilkin, Clem, Cheron Tomkins, Darby Bannard, Judy Singer. Painting Crit by Clem, Wilkin, and Bannard. Triangle Workshop, 1983. *(Photograph by Cora Ward; courtesy of Karen Wilkin)*

Clem, Karen Wilkin, Anthony Caro, in Caro's studio. Triangle Workshop, 1984. *(Courtesy of Karen Wilkin)*

(Sir) Anthony Caro, Stan Smokler, Clem. Crit by Caro and Greenberg, Triangle Workshop, ca. 1985.
(Photograph by Irene Neal)

Mark Tansey, *Triumph of the New York School,* 1984, oil on canvas, 74 x 120 inches. Portrays Pablo Picasso, General of the School of Paris Army, surrendering to Clement Greenberg, General of the New York School Army as Matisse, Pollock, Rosenberg, and others look on.
(Courtesy of Curt Marcus Gallery)

for himself. He presents only the salient points of his emotion." Taking up the cudgels on behalf of the much maligned Barnett Newman, Clem praised the "nerve and truth" exhibited in his first two one-man shows. He criticized those who condemned Newman's art as being concerned only with "the next step" and for confusing the natural feelings of "bewilderment" that always accompany an encounter with a radical new form of expression. On this occasion Clem articulated one of those maxims that became art-world gospel without his name attached:

> Those who so vehemently resent him [Newman] should be given pause . . . by the very fact that they do. A work of art can make you angry only if it threatens your habits of taste (which all important new art inevitably does). . . . If it tries to take you in . . . you react with contempt, not with anger. . . . Barnett Newman . . . took a chance and has suffered for it in terms of recognition. . . . That a majority of the New York "avant-garde" gave his show the reception it did throws suspicion on them—and says nothing about the quality of Newman's art.[20]

Clem's richly nuanced comments packed a great deal into the available space. In the same piece he addressed the psychology of "post Cubist" art, noting that "tautness of feeling, not 'depth,' characterizes what is strongest" in the work. He accounted for the "taking up of slack, [and] . . . the flattening out of convexities and concavities" as reflecting the desire of the postcubist artist to present "only that which he can vouch for with complete certainty." This artist, said Clem, does "not necessarily exclude, but he distrusts more and more of his emotions." Clem praised Hans Hofmann's recent show, commenting that "as a paint handler pure and simple . . . [Hofmann] takes second place to no one alive, not even Matisse." Clem observed that Hofmann, considerably older than the vanguard of which he was part, suffered from an inability to break through to "the truth inside himself." As Clem saw it, Hofmann the talent to "add infinite riches to modern art," but an imposed, rather than felt, tautness marred his recent efforts. Greenberg could be presumptuous—and sometimes wrong—but he worked hard to untangle his own reactions and was couraguous enough to articulate them as clearly as he could. In this rare first-person observation, he noted, "I think Hofmann over-rates art as against pedestrian reality . . . and is therefore too reverential in his relation to it. Humility is owed to the truth inside and outside oneself, but not exactly reverence; one has to have the nerve to impose one's truth on art."[21]

The resentment aroused by "Feeling Is All" overrode positive remarks about Hofmann as well as about Pollock's return to the figure. The de

Kooning camp cohered, at least in part, around opposition to a critic who, they were convinced, prescribed abstraction and proscribed figuration.

When Clem praised Pollock's 1951 show, it was not the figure he focused on. In fact, he insisted his judgment of the paintings was independent of their figurative matter and based solely on the sensations they aroused in him and the intensity with which they were communicated. The formal innovation Pollock devised on this occasion was a response, at one level, to the many critics who had formerly termed his art undisciplined and uncontrolled. Given that planning and artistic control are the sine qua non of high art, this common judgment of his work sorely tried the artist's patience.

Appearances to the contrary, Pollock's art was highly disciplined, and after 1951 no one could doubt it. Artists, like housepainters, normally prime or "size" their surface before applying finish paint. Priming fills in the holes in the cotton weave and seals the fabric. It allows artists to scrape and repaint unsatisfactory passages as they go along, and painters as varied as Courbet, Cézanne, and de Kooning all availed themselves of the privilege. But while control is essential to fine art, it is made manifest in different ways. Abstract expressionists, because they wanted to link the finished artwork to the creative process, prized the appearance of spontaneity and immediacy. They strove for an unworked look. Pollock's unfamiliar art accomplished this so successfully, his critics assumed it was uncontrolled. The black-and-white paintings were Pollock's answer to these judgments. Whatever else they did, these paintings demonstrated a breathtaking degree of control. Their process depended on it.

Using black enamel paint and a glass basting syringe, Pollock drew in space, flooding paint onto raw or unsized cotton duck, which absorbed it like rice paper absorbing ink. The paint "bled and soaked into the canvas," creating an interplay of textures: "matte, where the color soaked through, and glossy, where it accumulated on the cream colored surface."[22] Painter Kenneth Noland named it "one-shot" painting. "Pollock's black enamel was stained directly into raw canvas. The paint was thrown once and once only," Noland explained. In other words, Pollock had to get it right the first time: "The paintings were unmodified."[23]

Pollock assumed that what he had done would be immediately recognized, and it was by Clem and by his artist friends. But the show was sparsely attended, and although the reviews were good, almost nothing sold. One year later, in November 1952, Pollock had his first show at the Sidney Janis Gallery. One week after that Clem and Pollock had an exchange that resulted in an estrangement that lasted close to three years. Clem reviewed neither Pollock's 1952 nor 1954 shows, both of which contained figurative

images (the 1953 exhibition was postponed due to insufficient new work). Some attributed Clem's failure to write to Pollock's return to the figure, and some seemingly chose to interpret it that way although they must have known better.

Pollock's biographers Naifeh and Smith, believed the break was a consequence of the 1952 show. They dated Pollock's decline to that show and cited Clem's reaction as a motivating force, implying that on that occasion he told Pollock that "all artists have their run" and that his "ten-year run was over." Naifeh and Smith then concluded that "Jackson [Pollock] . . . was . . . an artist he [Clem] no longer respected."[24] In 1952, however, Clem never said those words. Nor had he lost respect for Pollock as an artist. In the same letter to Harry Jackson (July 1952) in which he told of taking shots to gain energy, he described a visit to Pollock's studio and his "take" on the new paintings, most of which were included in the November show: "Pollock . . . is on an even keel again and painting better than ever; he's going through a kind of searching but the by-products thrown off in the process would for anyone else represent the fruit of a lifetime's search."[25]

The schism between Clem and Pollock had nothing to do with the latter's 1952 show, despite their proximity in time. Nor did it have anything to do with Pollock's return to the figure. The occasion was the artist's first retrospective exhibition, which took place at Bennington College in Vermont. Clem initiated the show, selected the paintings, and wrote the catalog note. He did not rate all of Pollock's paintings equally, but his note makes plain his unconditional respect for Pollock as an artist.

Bennington did not normally present temporary exhibitions, and the suitable space was small. Clem chose only eight paintings, but two were from the figurative show of 1951. His praise for those eight paintings was precise, explicit, and at a level rarely encountered in the annals of art criticism: "Most of the paintings on view are major works, major in a way that very little American art has been up to now. That is, they determine the main tradition of painting at their point in time."[26]

Paul Feeley, head of the Bennington art department, and his wife, Helen, gave a party after the opening. At that party Pollock insulted Clem, initiating the breach that followed. The painter had been drinking heavily for months. He was tense and moody at the Janis opening and drunk at the dinner hosted by his benefactor, the painter Alfonso Ossorio. A few days later Pollock and his wife, Lee Krasner, together with Clem and Helen, set out for Bennington College in Ossorio's station wagon. The plan was for a leisurely trip with an overnight stay in Bolton Landing at the home of

David Smith and his second wife, now Jean Freas.[27] The Smiths were so broke they had to take out a bank loan to finance a suitable feast, but they were delighted at the prospect of a visit and the welcome was warm.[28]

Clem, Pollock, Frankenthaler, and Smith went immediately to the studio, where they had drinks and spent a long time looking at and talking about Smith's new work. Shortly after they rejoined Freas and Krasner, the latter had a "tantrum," according to Clem, and insisted they leave. With the untouched feast congealing on the sideboard the four piled back in the car and drove to Bennington.[29] Clem attributed Krasner's "tantrum" to the fact that Smith, not Pollock, "was getting the attention." Clem liked to say he never met an alcoholic he did not like, and he had little sympathy for Krasner's fears that Pollock would go on a binge and be a no-show at his Bennington opening. Once in Bennington, however, something apparently changed Clem's mind.

Krasner volunteered to bartend at the Feeleys' party so she could monitor Pollock's intake. But the rail-thin painter, his face a pasty gray color, stood sober and silent throughout the evening. The party was winding down when an unwitting guest offered him a drink, and Greenberg, standing nearby, cautioned him to "lay off." Pollock rounded on the critic contemptuously, calling him a "fool," and belted down the proffered drink. Nothing more was said. In the morning both couples breakfasted with the Feeleys, behaving as if nothing had happened. Pollock, who was returning to Springs, drove Clem and Helen to the station to catch their train to New York. Clem's only public comment came years after the event and was curiously ambiguous: "When he called me a fool, I was furious and I was off him for a couple of years. I didn't say it but Jackson sensed it. . . . Besides, he had become, if not famous, at least notorious, and I suppose the battle had been won."[30]

One week after the Bennington contretemps Frankenthaler painted *Mountains and Sea*, the picture that earned her a place in the history books. Unlike Hartigan and Harry Jackson, she found a way to build on Pollock without looking imitative. Rather than borrow his drip/pour process, she picked up on one-shot painting, the technique invented for his 1951 show.

Thinning oil paint to a watery consistency, Frankenthaler pooled it over a large expanse of horizontally placed, unsized cotton duck, allowing some to soak in before she worked the surface. Using oil paint like watercolor was not original. James Brooks, and others, had done it earlier. It was what Helen did with Pollock's "one-shot" technique, and what Clem later said about its historical significance, that established *Mountains and Sea* as a seminal artwork.

* * *

In December Harold Rosenberg's first major essay on vanguard American art appeared in *Art News*. "The American Action Painters" (December 1952) heralded the public phase of a rivalry whose origins dated back roughly a decade. Rosenberg's ambitious piece provided an intellectual alternative to Greenberg, answering the prayers of that faction of the vanguard that resented and feared his kingmaking power. This group warmly embraced a writer with the guts and cerebral capacity to go head-to-head with "the great poo-bah" and hold his own. "Mostly they liked it because it wasn't Greenberg," wrote Naifeh and Smith. "Finally, someone had challenged Pope Clement; a gate-crasher had confronted the 'bloody concierge' of avant-garde art."[31] Rosenberg threw his hat in the ring just as a sense of possibility swept through the Greenwich Village art world, a sharp sense of being in the right place at the right time.

For artists resentful of Greenberg, "The American Action Painters" seemed to presage a shift in the wind. Rosenberg admired de Kooning and personally disliked Pollock. Artists in the de Kooning camp were his friends. These artists may not have been aware of the bad blood between Greenberg and Rosenberg, but they understood that the latter was on their side.

"The American Action Painters" was a bullet with Clem's name on it. Any ambitious critic wishing to make his mark in the postwar art world had to go up against Greenberg, but the competition between these two ran deeper than that. They met when both were in their twenties and Rosenberg was already a colorful and commanding figure in the New York intellectual world. Clem had read his way through much of the Western canon and was a formidably intelligent, if callow, young man. By his own admission, he "sat at Harold's feet." Intellectually, Rosenberg and Lionel Abel had been to Clem like food to a starving man. At the time he met them, he had two short stories and some translations to his credit, and a wife and infant son he neither lived with nor supported. Harold was a published poet and a regular contributor to the "little" magazines Clem read: *New Masses*, the *Nation*, the first *Partisan Review*. During the Depression, Rosenberg worked as an artist's assistant at the Works Project Administration (WPA) where Lee Krasner was his boss. Rosenberg had met some of the artists who later invented abstract expressionism. Being products of the same zeitgeist, Greenberg and Rosenberg had much in common. But their differences were as great as their similarities. Physically, Harold was the more commanding figure. With his great head and six-foot-four-inch frame he towered over his five-foot-eleven-inch friend. Clem had a certain magnetism in one-on-one encounters, but Harold, "the Lion of Judah,"

dominated whatever gathering he was in. Clem stuttered a bit in those years, speaking in fits and starts. He was painfully self-conscious and either pontificated at length or kept quiet. Harold was a verbal magician capable of mesmerizing an audience of intellectuals, any audience of intellectuals.

In the early days of their friendship, Harold seemed proud of having discovered Clem and enjoyed introducing him to his circle. When Clem expressed an interest in reviewing Brecht's *A Penny for the Poor*, his friends arranged for him to meet Dwight Macdonald, an editor at *PR*. Clem was curious about New York's avant-garde art scene, and the Rosenbergs asked Lee Krasner to take him around. Krasner introduced him to Hans Hofmann's ideas, which started Clem on the train of thought reflected in "Avant-Garde and Kitsch."

In 1938, Rosenberg left New York for Washington, D.C., where he spent four years as the national arts editor of the *American Guides* series, a project funded by the Works Project Administration. His relations with Clem evidently soured at this time. Each gossiped behind the other's back, but no break ensued. In Washington, Harold looked up Clem's college friend Harold Lazarus and called on Toady, Clem's former wife, and Danny, his three-year-old son, who were then living in the city. When Harold came to New York, he often called Clem, sometimes looking for a place to stay. But this became difficult; once Clem met Jean Connolly, it was not convenient to have Harold stay the night.

"Avant-Garde and Kitsch" had been such a hit that Clem soon complained he felt pressured to live up to himself. Intellectuals such as Philip Rahv beat a path to his furnished room. Once inside they met Connolly, the international glamour girl who cooked his meals and shared his bed, and the British literary circle that surrounded her. He and Connolly saw a great deal of Dwight and Nancy Macdonald.

It now appears that early in 1940, when Macdonald first broached the idea to Clem of becoming a *PR* editor, he did the same with Rosenberg, anticipating that he could persuade the current editors to increase their number from five to seven.

Neither Greenberg nor Rosenberg ever commented publicly on the origins of their rivalry. Clem privately suggested that the ill will between them began in the late thirties when he criticized a painting he did not know was Harold's. The following reconstruction was pieced together from disparate sources and fleshed out by Clem's responses when he was presented with the material. From a comment made by William Phillips in his memoir *A Partisan View*, it seems Harold wanted to be a *PR* editor. Describing some of the principal figures around the magazine he and Rahv cofounded, Phillips told how Harold went about securing the position.

When this was mentioned to Clem, he remembered that in late 1939 or early 1940 Harold had talked to him with considerable enthusiasm about becoming an editor at *PR* and what he would do in that position.

As Clem told the story, he listened as Harold talked. He said nothing to indicate that Macdonald had also approached him.

Clem, as we know, demurred when Macdonald first approached him. For months he waffled but finally Macdonald persuaded him. Rahv and Phillips's success fully managed to limit to one the number of new editors. Clem agreed to meet the assembled editors, although he recalled little of his impressions: "I was too screwed up to notice what they were like. I was so self-conscious I couldn't talk." He did recall that the meeting was a formality, that the position was his if he wanted it.[32] In December 1940 Clem became a *PR* editor but no one, it seems, troubled to tell Harold. The next time he came to New York, he heard the news from a casual acquaintance. Livid, Harold blamed Clem and bad-mouthed him to everyone he knew: "Harold started telling stories about me. . . . He made it difficult for me to meet other people. . . . When there was a third person around, he started . . . well, I stopped seeing him."[33]

Harold did not get over it. A year later he shot off a letter to the editor at *PR*, mocking Clem for referring to "himself, his tastes and opinions no less than 10 times in 1¼ pages."[34] Clem's uncharacteristically mild rejoinder—"Mr. Rosenberg seems to read my stuff rather closely"—only highlighted the shift in power.[35]

In his memoir, Phillips told how Harold approached him not once, but several times, to offer his editorial services: "In the forties Harold wanted to be an editor and he tried to persuade me by saying that it [*PR*] was not fulfilling its cultural mission, which it could do only if he were an editor. The assumptions were overbearing, the manner genial. One day I brought these proposals to an end by suggesting that with his editorial vision he could start his own magazine, which would immediately outshine all others."[36]

Today, Rosenberg is considered the archetypal New York intellectual, but as *PR* ascended to unparalleled heights of influence in the New York literary community, and Clem's reputation traced a similar trajectory, Harold was outside the golden circle.

Clem and William Phillips became close friends in the midforties, and their intimacy meant that Clem's ideas sometimes found their way into policy discussions. Harold seemed to blame Clem personally when his overtures to the magazine were rejected, but Clem had had no need to exert himself.

Like everyone else, *PR*'s editors were impressed by Harold's intelligence and writing ability, but they were also a bit put off by him. William Barrett,

an editor in the midforties, recalled entire editorial sessions devoted to lampooning Harold's "bewildering habit . . . even while he dazzled you" of "leaving any subject more complicated and puzzling than when he took it on."[37] Rahv christened Harold a *Luftmensch*, German for one "who blew intellectual soap bubbles but never got down to solid earth."[38] The term stuck and *PR* punmeisters had a field day with *Trance Above the Streets*, the title of Harold's book of poems.

But Harold's relations with the magazine deteriorated further. Rahv was a leader in the Henry James revival and justly proud of the accomplishment. He edited two early anthologies of James's short stories, the first of which appeared in 1944. Flipping through its pages, Harold snidely christened it "the Henry James delicatessen," and the crack got back to Rahv. For several years the latter saw to it that nothing of Harold's appeared in *PR*'s pages.[39]

Time passed. By 1952, *PR* was the brightest star in the literary firmament, the highbrow magazine with the power to confirm or reject a young writer's bid for status in the intellectual world. Clem, a regular contributor to *Partisan Review* and senior editor at *Commentary*, was a powerful voice in that world and a hero for his principled resignation from the *Nation*. He was the most talked about art critic in New York, singled out by Russell Lynes, mentioned in *Harper's*, *Time*, and *Newsweek*.

Meanwhile, Harold had spent the decade writing and editing for *As Is* and several other important but short-lived art publications. He did occasional catalog essays for art he admired. But in the forties "serious" writers did not write about the visual arts, and Harold's major essays were in the areas of literature, philosophy, politics, and culture. Perhaps because his talents were so wide-ranging and his knowledge and interests so broad, he failed to accumulate a substantive body of work in any one area. Although provocative, perceptive, and well written, none of his essays lit a spark. During the years when Clem, building on the entrée Harold so generously provided, ascended to dizzying heights, Harold's promising career never quite took off.[40]

Based on interviews with artists who knew Harold in 1952, Pollock biographers Naifeh and Smith concluded that "nothing galled Rosenberg more . . . than the rise of Clement Greenberg." They cited May Tabak Rosenberg's bitter denunciation of her former friend as a measure of Rosenberg family resentment: "Any time you take a mediocrity with an education, inevitably they want to take charge of the world. They want to tell you how to tie your shoelaces. I never saw a mediocrity with power who was modest."[41] Naifeh and Smith go further: "To May, who adored her husband, it [the situation] was infuriating," but to Harold, "it was deeply mor-

tifying. . . . By the end of the summer [1952] he was determined to topple Greenberg."[42] Echoes of this resolve can be read between the lines of "The American Action Painters."

Harold focused on a crucial aspect of abstract expressionist art that Clem never mentioned. His essay was so impressive that even his former friend was bowled over. "When it first came out, I thought it was so well written; so eloquent," Clem recalled. In some respects both critics had similar views, but the different ways they expressed them accounted for Harold's wider appeal. On one subject, Clem wrote, "Like God, the American artist" constructs a new world out of nothing but his own "instincts, tastes, and intuitions," which are "all he has to go on." Harold said, "The modern painter . . . begins with nothingness. That is the only thing he copies. The rest he invents." Clem responded to the scale, color, and feeling tone of vanguard art. He linked the confidence exuded by the new American art to the optimism of what he called "high" capitalism. Harold focused on process and the differences between the American vanguard and the art of the past. He stressed the fact that some of the artists did not preplan, allowing the finished appearance of the art to evolve during the process of creation: "The painter no longer approached his easel with an image in his mind, he went up to it with material in his hand to do something to that other piece of material in front of him. The image would be the result of this encounter." Harold related the American avant-garde to existentialism, the sexy French import that was all the rage in intellectual circles. His action painter "took to the white expanse of the canvas as Melville's Ishmael took to the sea." Like the heroes of myth and legend, Harold suggested, the action painter journeyed over psychic depths in search of hidden truth.

To subvert Greenberg's authority and establish the American action painter at the forefront of current philosophical thinking, Rosenberg was obliged to sever the umbilical cord connecting American vanguard art to the European tradition. He had to demonstrate that the aesthetic standards that had previously governed art and criticism no longer applied. "If a painting is an action," one painting cannot be superior to another, he wrote. "The second cannot be 'better' or more complete than the first. . . . The critic who goes on judging in terms of schools, styles, forms, as if the painter were still concerned with producing" a product to be exhibited, "is bound to seem a stranger." In other words, since the end product was immaterial to the action painter, conventional criticism—of the kind Greenberg practiced—was irrelevant: "A painting that is an act is inseparable from the biography of the artist. . . . It follows that anything is relevant to it—psychology, philosophy, history, mythology, hero worship. Anything

but art criticism." Harold's authoritative style and vivid prose were impressive. His ideas had a "raciness" that made them seductive, as Clem later wrote.

Clem addressed art in philosophical and sociocultural terms and wrote for art professionals. He observed that every culture emphasized some human feelings and provided little outlet for others. In his view, the best art found forms that released those untapped feelings. Although modern art exorcised realism, he believed its bedrock function—stirring our deepest and most profound feelings—remained the same. Like T. S. Eliot, Clem believed that the vocabulary of modern art had changed but not its function nor the standards by which it would be measured.

Clem saw the raw, inelegant finish of advanced American art as the most recent example of modernism's ongoing quest to "manhandle" into fine art forms previously considered unacceptable. Harold focused on the abandon with which the "action" painter slapped his paint around and interpreted the unrefined finish as a lack of interest in the end product: "At a certain moment the canvas began to appear to one American painter after another as an arena in which to act—rather than as a space in which to reproduce, redesign, analyze or "express" an object, actual or imagined. *What was to go on the canvas was not a picture but an event*" (emphasis added).

Harold's account of the action painter suggested nothing so much as Hans Namuth's film, in which, shooting from beneath the huge glass "canvas" on which Pollock worked, Namuth recorded the artist's movements as sweeping arcs of honey-thick paint poured from large cans or rhythmically looped from a wand held a foot or more above the surface. Namuth's film was shown at the Settlement House in Manhattan on March 19, 1951. An interesting addendum to the round table discussion that followed was Clem's diary notation that night: "1st time I spoke without nervousness." The film officially premiered at the Museum of Modern Art in June and was widely seen and discussed thereafter.

Today Rosenberg and de Kooning are linked like night and day. But de Kooning's process, like that of his followers, was the antithesis of the one Harold described. Where Pollock at least appeared to be throwing paint around in a wholly spontaneous manner, de Kooning spent as much time thinking as he did painting. He labored over every mark and continually scraped and repainted finished sections. Moreover, his canvas was on an easel, a vertical position. Contemplating an artist entering the "arena" of his canvas to splash paint around in an orgy of self-expression, de Kooning does not come immediately to mind. Moreover, for de Kooning the end product was everything, just as it was for Pollock.

Friedel Dzubas often visited the Dutch painter's East Hampton studio

in the fifties: "I was aware to what degree he [de Kooning] was torturing himself, really, in forever trying to create some sort of absolute answer, an absolute masterpiece."[43] One night at a party, Elaine de Kooning, who was close to Rosenberg, laughingly confirmed Clem's suspicion that Harold was not even thinking about de Kooning when he wrote that essay: "She confided that she knew for a fact that Bill was not even on Harold's list."[44]

Pollock, however, was Greenberg's favorite and a man Harold neither liked nor respected. Both lived in the small community of Springs, on Long Island. Pollock later confessed, somewhat sheepishly, that during a drunken train ride from Manhattan to East Hampton some six or seven months before the essay appeared, he responded to Harold's gibes by invoking the "act is all" argument employed by a defiant Barnett Newman to justify his intention to go on painting even though no one in New York would show his work.[45] Pollock told Rosenberg that it was the "act" of painting that counted, not the end product.[46]

Rosenberg took the ideas of the Greenberg/Pollock camp, with which he was not in sympathy, but which furthered his existentialist thesis, and associated them with the faction whose art he admired. He finessed the whole sleight-of-hand operation by naming no names. Rosenberg advanced a new theory and a new movement in art without identifying the artists involved.[47]

An astute *Art News* editor seemingly recognized the conceptual inconsistency between the word picture Harold drew and the work process of the painters in whose studios he spent time. The first paragraph of "The American Action Painters" consisted of a *Luftmensch*-type disclaimer: "What makes any definition of a movement in art dubious is that it never fits the deepest artists in the movement—certainly not as well as, if successful, it does the others."

Rosenberg was a charter member of the Artists' Club. He had known de Kooning since their WPA days in the thirties. In fact Rosenberg had introduced de Kooning to Greenberg. Krasner was sure that Rosenberg and de Kooning were in cahoots against Pollock and did her best to unite the art crowd against what she saw as, and what became, a Rosenberg/de Kooning alliance. She also begged Clem to hit back, but he was "off" Pollock, and besides, to dignify Harold's essay with a response would give it a weight Clem was not disposed to confer.[48] He assumed that the conceptual weakness of the essay meant it would sink of its own weight. But Harold's piece was talked about everywhere and the term *action painting* stuck.

It was at this point that de Kooning's star ascended. Lionel Abel was walking on Eighth Street, on his way to the Artists' Club one Friday night in the midfifties, when he bumped into Robert Motherwell. Abel asked if

they were headed to the same place, and Motherwell shook his head. "I don't go there anymore. It's de Kooning Party Headquarters."[49] The Cedar Street Tavern had become the party's social annex and Tenth Street, where the artists lived and worked, its parade ground.

The de Kooning faction soon symbolized advanced New York art. Pollock was made to feel uncomfortable at the Club and in Cedar Street, but Greenberg was the enemy. Anti-Greenberg sentiment was the glue that bonded Tenth Street and its inhabitants. "All references to Clem, to Pollock, and to what first brought abstract expression to public attention disappeared. Tenth Street was anti-Clem. His name was dirt there," recalled Hilton Kramer.[50] Years later, however, shortly before her death, Elaine de Kooning told Kramer that she planned to discuss Rosenberg's essay in the memoir on which she was working. "She was totally contemptuous of the whole [action painting] idea," Kramer recalled. "She gave me to understand that she was going to go into the low opinion that most painters had of Rosenberg's essay because the ideas had so little to do with what they were doing. At the same time, though, she was going to say how nobody wanted to stand up in public and say boo about their real opinion because Harold's piece looked like it was serving their interests."[51]

The critical rivalry between these two goliaths entertained the art world for ten long years. In the end they "were daggers drawn," as Clem said.[52] Neither emerged unscathed.

11

Sowing His Seed

Rosenberg, de Kooning, and Thomas B. Hess joined forces. *Art News* became the voice of the vanguard. In time this triumvirate became so formidable that it influenced curators, shaped collections, and affected the short-term course of artists' careers.

Hess, wealthy, urbane, and well educated, was an insider accepted by artists and collectors alike. Rosenberg, quicksilver intellectually, had the panache of a guerrilla fighter, but he and Hess had things in common. Novelist Donald Barthelme (managing editor for *Location*, a short-lived publication Rosenberg and Hess coedited in the early sixties), captured the flavor of their interaction: "I was astounded by the ferocity of their enthusiasms, both positive and negative. The vehicle was always a remarkable wit. . . . I spent the first several years of our friendship listening to Tom and Harold tell these ferocious, man-eating, illuminating jokes, art-jokes and politics-jokes and literature-jokes, usually at lunch."[1]

Today, the de Kooning in the triumvirate is often assumed to have been Bill, but Bill was its beneficiary. Elaine, Bill's shrewd and beautiful painter/wife, was the center of that mighty trio.

Bill was the love of Elaine's life, but the reverse was not necessarily the case. With wit and audacity, she did what she could to hold her marriage together. She and Bill were childless. When Joan Ward was in the hospital having Bill's baby, his only child, Elaine went to visit. When no Joan Ward was listed, she asked for Joan de Kooning. Sweeping into her rival's room, arms overflowing with fresh flowers, Elaine cooed, "Joan, what a lovely thing you've done. Bill and I have always wanted a baby."[2]

A macho, working-class ethic characterized the abstract expressionists. Women were second-class citizens and treated accordingly. When David Smith and his first wife, sculptor Dorothy Dehner, traveled to Manhattan to meet Clem for the first time, "I was sent off to the movies alone," Dehner recalled. It was assumed the critic would have no interest in her or her work. Lee Krasner and Louise Bourgeois suffered similar slights. Clem was close to their husbands and a frequent guest in their homes. He

enjoyed talking to both women, spent a lot of time alone with them, but never asked to see their work. For their different reasons, the women put up with it. In the male struggle for dominance, they served a Veblenian function, although the power they symbolized had nothing to do with material wealth. Men like Greenberg, de Kooning, and Kline were compulsive womanizers, and some, like Smith and Pollock, were abusers.[3]

Pollock and de Kooning admired one another's art and, for the most part, did not compete for women. Naifeh and Smith, in their biography, suggest Pollock had little appetite, which they interpret as conflicted sexual identity; a conclusion that flies in the face of reported firsthand experience. One dealer described her affair with Pollock as so all-consuming that her jealous husband, in a fit of rage, ripped a "gorgeous" and now costly, "1950 drip painting off the wall and tore it to shreds."[4]

De Kooning and Pollock may have behaved civilly toward one another, but de Kooning and Greenberg were like great apes jockeying for the alpha male position. Critic Barbara Rose captured the sexual overtones of their competition: "Clem and Bill de Kooning were always on the verge of a fistfight. One night at the Cedar Tavern, they started swinging at one another, and their friends had to pull them apart. Bill started it. He said, 'I've slept with all your women.' And Clem snarled back, 'Elaine was the only woman you ever had that I thought even looked good.' "

Elaine was an exception to the long-suffering-wife syndrome. She was loyal in her way and on her own terms. But she did not sit home and wring her hands. At a time when few people grasped the issues involved in advanced painting, and when *Art News* was just beginning its ascent, Elaine and Tom Hess, the magazine's executive editor, were lovers. "Elaine was the inside connection explaining things," painter Paul Brach explained. "She brought Tom into our world."[5] William Rubin observed, "Hess and Elaine were very close. They constituted a party and they had the power of *Art News* at their disposal."[6]

Today the heady mix of *Art News*, Hess, Rosenberg, Bill, and Elaine reeks of many things, including conflict of interest. At the time, however, few collectors were interested in American vanguard art, and money was not the issue. The stakes were attention and reputation but on a modest scale. Fame, fortune, or celebrity as we now know them were not even conceivable. The triumvirate was fighting the good fight for American art and for modernism. The magazine's preference for de Kooning over Pollock reflected the opinion of its editors and writers. Young critics, many of them New York School poets or painters—Frank O'Hara, John Ashbery, Larry Rivers—found Rosenberg a more congenial mentor than Greenberg.

In the contest between the competing segments of advanced American

painting, the party that controlled the dialogue commanded the high ground. As Hess's power at *Art News* increased, he continued to write reviews himself and along with poets and other critics recruited painters, such as Larry Rivers and Elaine, to review shows. Writers were never told what to say about a given artist but were naturally selected on the basis of shared taste and ideas. Rosenberg's poetic and impressionistic style of criticism had a potent influence. It became the much-imitated "voice" of fifties art criticism. The triumvirate kick-started a pluralistic group of anti-Greenberg/pro–de Kooning artists into a cohesive corps whose every "gesture" was scrutinized in the pages of *Art News*, which Irving Sandler called the "family" publication.

Critical differences between Greenberg and the triumvirate were real enough. The triumvirate believed that quality was determined by the genius of an individual and expressed in forms relevant to the time and place. If a historical wave—through which the best art communicated—shaped these forms, that was a question for aestheticians, not critics. Greenberg, examining the history of modern art, concluded that cubism was the seminal style of the twentieth century. He saw its flattened space and abstracted images as a response to the vast political, social, and technological upheaval of our time. Scrutinizing the best art of the last hundred years, around which there was a consensus, Clem observed that it was all abstract or tended in that direction. He anticipated that for the short term that tendency would continue. That conviction, coupled with his ability to make his taste prevail, led artists with different inclinations to suspect that, quality aside, he was so invested in his theory that, consciously or otherwise, he would "like" only art that confirmed it. The Tenth Street group, although many painted more or less abstract, usually included representational images distorted to fit the shallow space they preferred.

Often overlooked is the fact that the triumvirate too created a pantheon and established a hierarchy. Newman, for example, was out; Kline, Rivers, and Hartigan were in. Smooth fields of barely inflected color were "unauthentic," while "gesture" painting, presumably revelatory of the artist's feelings, was "authentic." Ironically, "Pope Clem," whose autocratic ranking of "advanced" artists had made him the enemy, was supplanted by a critical viewpoint no less exclusive.

Greenberg tried to stay above the fray, praising artists from both camps. He and Tom Hess might not be one another's first choice for lunch partner, but both relished a good fight, and throughout the fifties, relations between them remained cordial. Clem was on good terms with Elaine, who periodically came to Bank Street or his *Commentary* office for drinks and

gossip. The enmity between Greenberg and Rosenberg, however, was well known. Larry Rivers recalled that after a certain point they never even met socially: "I think they just sort of talked about each other and criticized each other. They were like two very important personages neither of which could stand the idea that maybe the other one was important too."

Clem's position was not enviable. He watched while the vanguard for which he had fought the establishment was co-opted by enemy troops: Rosenberg's ideas were taken by readers of *Art News* as the manifesto of "action painting," the term he'd coined for advanced American art. For Pollock, the pressure of being out front, no longer at ease with his friends, combined with his alcohol consumption to make a deadly combination. By the midfifties, Pollock still painted good pictures but he produced less and his public behavior was often outrageous. Newman continued to paint but no gallery or museum in New York would show his work. Clem bad-mouthed those with whom he disagreed, but he also addressed the critical differences between them in print. He retreated to his room-and-a-half walk-up, where the floors vibrated with the rhythm of the trucks on Hudson Street's cobblestoned surfaces. We picture him teeth bared, eyes narrowed, shuffling barefoot toward his manual typewriter to do conceptual combat.

The literary world was still Clem's center and it was there he situated what became the first of a series of essays on abstraction: why it emerged when it did; what it symbolized for those dead set against it; why the abstract/representational divide was the wrong way to frame the discussion. In line with his usual practice he began by establishing the larger context into which this question fit.

"The Plight of Our Culture" (later revised and renamed "The Plight of Culture")[7] appeared in *Commentary* (June/July 1953). Four years earlier T. S. Eliot had published *Notes Towards a Definition of Culture*, exploring its decline in the West and identifying the factors he deemed responsible. Eliot's book generated a great deal of discussion, although in Greenberg's view this "attention," while "commensurate with its author's fame," was not of the "quality" demanded by "the importance of the problems" addressed.[8]

"The Plight of Our Culture" is another example of the distance that sometimes existed between what Greenberg was said to believe and the complexity of his actual positions. His views on the subject of social hierarchy, for example, reduced to a simple high–low dichotomy in the Greenberg myth, were so advanced that, fifty years later, they seem fresh and relevant. Today, "Greenberg" symbolizes a conservative and elitist philosophy in which high represents the elitist values associated with a leisure class and low represents everything else. In this scheme, "low" culture

threatens to destroy the high civilization on which the West for so long prided itself. This was Eliot's position. In "Plight," Clem termed those ideas "silly" and the thinking behind them "callow." Eliot's problem, Clem said, stemmed from the fact that he ranked "aesthetic" concerns above all others. Eliot's skewed, though influential, analysis, wrote Greenberg, had prevented "the discussion of modern culture from advancing . . . beyond the point at which Spengler left it."[9]

Eliot dismissed the Industrial Revolution on the grounds that "technological advance [was] powerless to affect the formal or 'organic' basis of culture." He called for the return of a leisure class. But, as Greenberg pointed out, profound structural changes were already reshaping Western culture as a consequence of the economic realities industrialism introduced. In the past, Clem observed, "the culture of the highest level usually received the greatest social and economic support," i.e., the largest share of the economic pie and the most attention. Today, "the greatest economic support is given to the bottom level," whose sheer numbers and urban concentration mean that the most money is funneled toward their tastes and pleasures; and "the greatest social support [goes] to the middle," although the upper tier continues to carr[y] the main history of culture and exert the most influence on other levels." While the problems Eliot addressed were real enough, argued Greenberg, his solutions were out of touch with reality:

> It is a fact that the source of the gravest threat the present technological revolution offers to the continuity and stability of high culture is a vastly accelerated rate of upward social—more accurately, material and economic—mobility. The traditional facilities of urban culture cannot accommodate themselves to a steadily growing *population* . . . of newcomers to comfort and leisure, without suffering deterioration. To the very extent that industrialism promotes social welfare, it attacks traditional culture, at least this has been the case so far.[10]

But Greenberg believed it was too late to turn back the clock. Western society, he observed, remains in the midst "of a technological 'mutation' on an order and scale such as mankind has . . . experienced" only once or twice in its history:

> The rich themselves are no longer free of the domination of work; for just as they have lost their monopoly on physical comfort, so the poor have lost theirs on hard work. Now that prestige goes more and more to achievement rather than to social status, the rich them-

selves begin to resent old-fashioned, undistracted leisure as idleness, as something . . . demoralizing. . . . The difficulty of carrying on a leisure-oriented tradition of culture in a work-oriented society is enough of itself to keep the present crisis in our culture unresolved.[11]

If technological progress is irreversible, then industrialism is here to stay, and under industrialism the kind of high civilization Eliot has in mind—the kind known for the past four thousand years—cannot survive, much less be restored. If high civilization as such is not to disappear, a new type of it will have to be developed that satisfies the conditions set by industrialism.[12]

In "Avant-Garde and Kitsch" Clem had anticipated that Marxism would define the new paradigm, but fourteen years later he was frank enough to say the future toward which we moved was so different from anything previously known, that he could not conceive the form it would take: "Am I suggesting something whose outcome could no longer be called culture, since it would no longer depend on leisure? I am suggesting something whose outcome I cannot imagine."[13]

Abstraction, like middlebrow culture, emerged as a consequence of industrialism. The culture Eliot wanted to resurrect had been restructured; it was no more. Clem saw himself as the messenger, not the perpetrator. All things being equal, he later said, he too preferred representational to nonrepresentational art and looked forward to a period of equilibrium that would again enable it to flourish. Meanwhile, although abstraction did not satisfy all of our desires, the best of it upheld cultural standards and prevented art from descending into a stale academicism whose inability to do that would be far worse.

Clem's next essay was part of a symposium called "Is the French Avant-Garde Overrated?" (*Art Digest*, September 1953). The implied subject was why the handful of existing American collectors with a taste for abstract art preferred the French to the American variety.[14] Clem suggested that French prestige was one factor in attracting American collectors, but suggested that advanced American abstraction, meaning abstract expressionism, was also more difficult than the French version. Its raw, crude finish insulted our expectations, which had been conditioned by art that "spoke" to what was now a nonexistent audience. French art carried forward the refined, elegant surface traditionally associated with fine art. Its "buttery," "enriched" paint satisfied our expectations. As Greenberg explained, it "disciplined" the rawness cultivated by the Americans but that was not necessarily to its

credit: "Every fresh and productive impulse since Manet, and perhaps before, has repudiated received notions of finish and unity, and manhandled into art what until then seemed too intractable, too raw and accidental, to be brought within the scope of aesthetic purpose."

In conclusion he enunciated the characteristics that, in his opinion, defined the best abstract art at that moment: "Whether it is enamel reflecting light, or thinned paint soaked into unsized and unprimed canvas . . . there is no insulating finish . . . the surface *breathes*. . . . The canvas is treated less as a receptacle than as an open field whose unity must be permitted to emerge without being forced or imposed in prescribed terms."[15]

In January 1954, Clem published "Master Léger" (*Partisan Review*), indirectly confronting the assertion that it was figurative painting, per se, to which he objected. Celebrating the French painter's "tubular, nude forms, limpid in color . . . with their massive contours stilling the clamor around them," Clem termed Léger a "major fountainhead of contemporary style," on a par "with Matisse, Picasso, and Mondrian . . . the very greatest painters of the century."[16]

In May, Clem delivered the Ryerson Lecture at Yale (published six months later as "Abstract and Representational" [*Art Digest*, November 1, 1954]). Turning the charges hurled at him back at abstraction's detractors, he exposed the underlying attitude they reflected: the belief that abstraction was "a symptom of cultural, and even moral, decay" and that "the representational as such" was "superior to the nonrepresentational as such" in principle. Challenging the conviction that "inclusive" art, by definition, had more to offer, he wrote: "More and less in art do not depend on how many varieties of significance are present, but on the intensity and depth of such significances, be they few or many, as are present. Because *The Divine Comedy* has an allegorical and anagogical meaning, as well as a literal one, does not make it a more effective work of literature than the *Iliad*, in which we discern no more than a literal meaning."[17]

In the past, art was often assumed to exist in some ideal realm, complete in itself. Clem believed that without an appreciative audience art was like the tree falling in the forest. For all practical purposes, it made no sound. He believed art's highest purpose was to agitate the human spirit at an experiential level too profound for words and that the artist of genius was in tune with universal truths about his era. In our time, these artists, more often than not, had been abstract: "Experience, and experience alone, tells me that representational painting and sculpture have rarely achieved more than minor quality in recent years. . . . Not that most of recent abstract art was major; on the contrary, most of it is bad; but this still does not prevent the best of it from being the best art of our time."[18]

* * *

It was the forties redux for Greenberg. The artists he praised—Barnett Newman, Adolph Gottlieb, Mark Rothko, Clyfford Still, Hans Hofmann— were so far out that, for the second time, he stood alone. This time the establishment that opposed him included members of the original vanguard. In New York Clem's ideas were regarded with suspicion and hostility, treated as pawns in the taste wars.

Ironically, in February of that same year (1954), Pollock finally had a show (Sidney Janis Gallery) that won critical hosannas from most reviewers. Abandoning his famous drip and pour technique, the artist had returned to the brush, where his technical prowess and remarkable control were plainly visible. Emily Genauer, who had previously described Pollock's paintings as "empty and pretentious wall decorations," now exulted that this was a "real step forward: really painted not dripped!" James Fitzsimmons praised the show in *Arts and Architecture*. Stuart Preston, in the *New York Times*, lauded what he called a "happy advance over the impersonality of much of his early work." Hess, in *Art News*, rejoiced at the return to a more conventional style of painting. Collectors who had never before evidenced interest in Pollock's work sought him out, and sales increased. Clem admired three paintings in the show but detected a "wobble" in others. Again he was out of sync.

From a distance, Clem's every move sometimes seems the result of a brilliant strategic maneuver. In reality, however, his talent was less for planning than for discerning, and acting on, the possibilities that presented themselves. A case in point was his cultivation of a strong connection with some Washington, D.C., artists at a time when his ideas were out of favor in New York. In legend, Clem saw Frankenthaler's *Mountains and Sea* and mentally designated two D.C. artists, Ken Noland and Morris Louis, to carry forward her realization of a way to build on Pollock. Not long thereafter, in this version, Louis had the "flatness" epiphany famously satirized by Tom Wolfe in *The Painted Word*: "A forty-one-year-old Washington, D.C., artist named Morris Louis came to New York . . . to try to get a line on what was going on . . . and he had some long talks with Greenberg, and the whole experience changed his life." To the tune of "That Old Black Magic Got Me in Its Spell," Wolfe played passages from Greenberg's essays in Louis's head: " '*That thick, fuliginous flatness got me in its spell . . . That constructed, re-created flatness that you weave so well.*' " The "spark flew," wrote Wolfe, "and Louis saw the future with great clarity."[19]

Wolfe's tale had just enough truth to make it satire. Clem had not yet met Morris Louis and he had made no effort to show Helen's painting to

Ken Noland. It was chance that brought both painters to Helen's studio some six months later.

Noland had been Clem's student at Black Mountain College during the summer of 1950. Clem thought he showed promise and told him to keep in touch, and Noland did. In April 1953, in New York to check out the galleries, Noland called and accompanied Clem and Helen to a party at Harry Jackson's studio. The following day Morris Louis, Noland's teaching colleague at the Washington Workshop Center for the Arts, arrived with Leon and Ida Berkowitz, director and codirector of the Workshop. Noland wanted Louis to meet Clem. He called and Clem obligingly invited the whole group to join some others for drinks at his Bank Street apartment that afternoon. Helen was busy, but when the talk turned to art, Clem asked if they would like to have a look at something new. His diary entry for April 4, 1953, reads: "At 6PM Louis & Noland, along with Chas. Egan, George McNeil, Franz Kline, Leon and Ida Berkowitz & Margaret Brown [identity unknown] and I visited Helen Frankenthaler's studio [on the West Side near Twenty-third Street], where some of us stayed until 11."[20]

Mountains and Sea had been exhibited at Tibor de Nagy the previous January. "Very few people who had seen the picture seemed to respond," Helen recalled. "To most people it just looked like blots of soaked, smeared marks."[21] The New Yorkers in the group that night were equally unimpressed. But Noland remembered that he and Louis were "galvanized" by the possibilities they saw in her loose, flowing color and open structure: "The painting was big, loose, open, the color spread out, stained in so it would impregnate the weave. We went back to Washington high. . . . The idea was to get free of old ways."[22]

Clem believed that a relationship existed between the character of the artist and the quality of the art produced. Something about Louis's character struck him at that first meeting. Sam Kootz had been trying to persuade Clem to organize an emerging-talent show for his gallery, and Clem had been putting him off because he did not have enough people he wanted to show. He recalled that he had a hunch about Louis, and the next time Kootz asked, agreed to do the show.[23] It was another nine months, however, before he saw Louis's paintings, which, along with those of Noland, and Noland's wife, Cornelia, were included in the exhibition.

All three then worked in a gestural, abstract-expressionist mode. Cornelia soon gave up her professional ambitions, but it was another four or five years before Noland or Louis arrived at the buoyant, fluid color and distinctive stained surface that became their signature. Clem was in Washington only once or twice a year, but he loved to talk, and his enthusiasm

was contagious. His conversation with these artists had far-reaching consequences.

Today, Clembashers like to say the paintings Louis, Noland, and others he championed in the sixties should rightfully bear Clem's name, that the artists did what he told them to do. But if Clem could have made those pictures, he would have. He certainly tried. Throughout the forties and fifties he painted every chance he got. He painted with Fairfield Porter in the early forties and on trips with Helen. He painted with David Smith at Bolton Landing, and in Noland's studio. In the sixties he was part of a weekly painting group that met at artist Susie Crile's apartment.

Clem was central to the flowering that took place in Washington, but not in the way his detractors suggest. He spent time looking at the work of Louis, Noland, and two men who were nominally Noland's students, but also his friends: Howard Mehring and Tom Downing. As was his habit on studio visits, Clem commented on what he liked or disliked, identified passages that he thought "worked" or directions that might be worth pursuing. He did not invent forms, figure out how to unify the picture, or determine its content. But he was inspirational. He propagated ideas and instilled confidence. In the forties, when Clem wrote that "the fate of American art does not depend on the encouragement bestowed or withheld by 57th Street and the Museum of Modern Art," he gave heart to an isolated band of avant-garde artists suffering from deep-seated feelings of inferiority. His confirmation of what they secretly believed was an authoritative ray of hope in those dark days. In Washington, in the fifties, he did something similar.

Clem defined a context that ratcheted the meaning and purpose of art to a very high plane. His conversation usually had philosophical overtones. "There was a great deal of talk about nerve and about breaking the barriers of art," recalled Cornelia Noland, now Cornelia Reis. "It was a bit of a macho thing, Americans versus Europeans. Clem thought the Americans were risking, breaking barriers. That's why he was so up on Pollock, what Pollock was doing was a whole new frontier. So they talked about breaking boundaries. That's how they thought. . . . They all had very grandiose ideas. . . . It wasn't just getting the next show or anything like that . . . it was idealistic. They talked in terms of the history of art much more than artists today do. Artists today worry about more mundane issues, like is my dealer screwing me. In my day, they were much more concerned about really doing something."

The energy and excitement were palpable: "We thought it had to do with American optimism. With the belief Americans still had that everything was possible, that we would always have frontiers, and that we didn't

have to be in bondage to the Europeans. Europe had always been the [art] center and suddenly there was this possibility . . . Clem was a great inspiration. He was great about looking at people's work. He took it seriously and he never said anything he didn't mean. He would never say that he liked something if he didn't or vice versa. You know, if you're visiting a studio and you don't like the work, there are ways and ways of softening the blow. Clem never bothered. He was always right up-front." Reis believed Clem's "studio crits" could make a difference—in terms of his visual perceptiveness and ability to educate taste—for those with the psychological strength to take advantage of his "brutal frankness." "He would tell you why he didn't like something you were doing. He'd say, this is overworked or this is tight. . . . If you respected what he said, it could be very helpful . . . and so you sort of learned to live with that criticism. . . . On the other hand, you could say, 'Screw you, mister,' which people sometimes did. Clem's kind of criticism is hard to take, but ultimately, as an artist begins to earn respect, its very important to have somebody that's that frank. . . . Many times when he looked at Ken's work, he wouldn't like it . . . but after he left, Ken was always invigorated. He always wanted to go into the studio and do more."

Clem's visits were treated as great occasions. Cornelia's father was a prominent congressman but Noland drove a cab to augment his teaching salary, and the young couple mostly did without luxuries. The first time Clem came to dinner she asked what he liked to eat and he said steak. "He was very fussy about what he ate," Cornelia recalled, "which was mainly steak and potatoes. We developed a pattern. During dinner the talk would be about art or theory or art-world gossip. Clem loved to gossip. . . . After dinner he looked at the paintings."[24]

During this period Clem also established close ties with the Bennington College art department. And such was the force of his presence that artists affiliated with both Washington, D.C., and Bennington College speak of the period of his involvement as a "golden age."

Bennington was founded as a progressive liberal arts college for women based on the principles of John Dewey. Its sophisticated student body and intellectual faculty provided a ready audience for Clem's ideas about the place of art in American culture. Unlike literature and poetry, in the fifties modern art was still outside the standard liberal arts curriculum. Few traditional colleges taught its history or analyzed its complex vocabulary within a cultural or philosophical context. Studio courses were beginning to be offered, in response to the demand created by veterans studying on the GI Bill.

Bennington was an ideal laboratory for some of Clem's interests. His contribution to the cultural reevaluation of the visual arts in America has been

little recognized or credited but Bennington was instrumental in this effort. "Clem spun out a kind of mental and intellectual discipline for the visual arts as a legitimate area of American ambition," observed art writer Eugene Goossen, a onetime member of the faculty. "By the late fifties, we [the Bennington art faculty] saw ourselves as involved in a battle against the forces of conservativism and the entrenched powers. . . . No one was thinking about financial reward or success the way we have it now. Success in those days was having a show, getting a little bit of attention. Success was standing against the anger toward abstraction being thrown out by the *New York Times* and the stupidities [about modern art] that were in the public mind."[25]

The college was committed to the idea of learning through doing. It adhered to George Bernard Shaw's idea that historians knew all about "it" but not how to do "it." The point was to involve and educate the whole person rather than just the mind. The Bennington faculty was composed of artists who taught their own specialties—dancers taught dance, painters, painting, W. H. Auden and Stephen Spender taught poetry, Kenneth Burke taught philosophy, Bernard Malamud, literature, Lionel Nowak and Louis Brandt, music. The well-known *New Yorker* critic Stanley Edgar Hyman taught literary criticism. (No one taught art criticism.) Teaching was based on the Oxford system, and weekly tutorials replaced traditional classes. Many on the faculty were known to Clem from *Partisan Review* or *Commentary.* Shared intellectual interests and values, among other things, made Bennington congenial to Clem. Helen introduced him to the college, but his involvement continued after their relationship ended.

Meanwhile, anti-Greenberg, anti-"abstract" points of view gathered powerful support in New York. By the midfifties, the death knell of abstraction was being sounded from every corner. Clem participated in "The New Figurative Painting," a panel discussion at the Artists' Club, moderated by John Myers of the Tibor de Nagy Gallery. The participants included Alfred Barr, the poet/curator Frank O'Hara, Clem, and Hilton Kramer, then at the start of his career. The Museum of Modern Art had recently acquired Larry Rivers's *Washington Crossing the Delaware* (1953), and Barr was much taken with the picture although he had not yet had time to examine it closely and was seemingly unaware of the parodic element involved. Barr's comments were vividly recalled by Kramer: "Barr said that evening, more or less, that abstract art was probably finished and that what he looked for in the next development of American painting was a return to something like history painting."[26]

Clem found much to praise in the representational art of Léger and Matisse and had lavish praise for de Kooning's *Woman* series. He wrote

about, and collected, the work of the little-known American impressionist Arnold Friedman, a painter Greenberg included among "that small number . . . among whom we can name Bonnard and Vuillard, who proved that Impressionism had not lost its historical vitality with Monet."[27] Clem identified the landscape painter John Marin as "one of the best artists to handle a brush in this country."[28] But he remained convinced that the very best art was still abstract or tended in that direction. And he did not trouble to disguise his feelings in the face of arguments he found intellectually unworthy. Larry Rivers recalled that Clem not only disagreed but did it in a provocative manner: "Now, it's possible . . . that Ruskin made a fantastic amount of enemies, and I certainly know that George Bernard Shaw, who wrote art criticism, made a lot of enemies. But Clem made a lot of enemies and he made enemies in such a way that it was hard to undo."[29]

In a squib for *Twentieth Century Authors* (1955), Clem wrote that he gave up the regular practice of art criticism because he had had "a bellyful of reviewing in general." His personal feelings six years later, however, can perhaps be inferred from the statement he went on to make: "Art criticism, I would say, is about the most ungrateful form of 'elevated' writing I know of. It may also be one of the most challenging—if only because so few people have done it well enough to be remembered—but I'm not sure the challenge is worth it."

Alluding, rather gracefully, to New York's lack of appreciation for him, Clem continued, "No one has written about me at any length, though some of my failings were discussed in the reviews of my Miró book [1948]—and I do get referred to, rather unfavorably on the whole, in an occasional article or book."[30]

Breakup, Breakdown, and Literary Backlash: 1955–57

Power shifted in the vanguard world and Clem and Helen's relationship grew strained. In his version, she wanted to get married and he did not. Initially Helen's mother, with whom Clem got along quite well, opposed the union because of the age difference between them. But on her deathbed Mrs. Frankenthaler gave her consent and Clem still held back.[1]

Money may have been a factor. Clem's annual income from *Commentary* was roughly $7,000, a princely sum compared to that of most artists and writers in the avant-garde world. He earned a bit more from writing and from the lectures for which he was beginning to be in demand, but the sums were minuscule. Writers received $3 for a review and a bit more for an article that could take weeks, even months, to prepare.[2] Danny, Clem's son, entered Johns Hopkins University in the fall of 1953.

Helen had an independent income and the leisure to travel. She planned to spend the summer of 1953 in Europe and wanted Clem to accompany her. He, however, had a full-time job at *Commentary* and galleys to correct for his book, *Matisse*. (He received $600 for the completed manuscript.) In the spring of 1954, Helen again made plans to spend the summer abroad, and once more it appeared she would go alone. At the last moment, however, Clem arranged to accompany her, and for two and one-half months they traveled leisurely in Spain, France, Switzerland, and Italy, where they visited the Venice Biennale and saw the de Kooning paintings Clem later praised so highly.

The holiday was not an unqualified success. Two weeks after their return Helen suggested a trial separation. It lasted only four days and Clem did not appear to take it seriously. His diary noted the onset and four days later that he "slept at Helen's," followed by the rhetorical question "Did separation end?" But he spent New Year's Eve alone and on January 19, 1955, took Marjorie Ferguson, with whom he had been in love in the late forties, to John Myers's party for Dwight Dillon Ripley, the Tibor de Nagy

Gallery's silent backer. In March and April relations improved and Clem and Helen again entertained and spent much of their time together, but relations were still somewhat strained.

In May they drove to Bennington College—in Helen's new car—for the opening of the Hans Hofmann retrospective that Clem initiated, and for which he had selected the paintings and written the catalog notes. Three years earlier ("Feeling Is All," 1952), Clem had written that Hofmann possessed enormous potential but had not yet tapped "the truth inside himself." Later, concluding that Hofmann had been "ahead" of him, Clem set the record straight. A gaffe widely celebrated by others stung by the same pen. During the course of that weekend Helen again suggested a separation. They drove back to New York together. She dropped him at his apartment where he had dinner and then went to the movies alone.

Helen was a popular figure among second-generation artists, and the enmity between Clem and her friends created an awkward situation. Moreover, although he remained a highly respected, even feared figure, the second generation, including artists out of favor with Clem, was starting to attract attention from dealers, curators, and some collectors. In fact, Helen's career was taking off. She had been invited to participate in what proved to be the two major shows of 1956: Tom Hess's *U.S. Paintings: Some Recent Directions* and Kyle Morris's *Vanguard 1955*, both at the Stable Gallery. Helen's and Clem's careers were on different trajectories.

Clem admired artists like Newman, Rothko, and Still, but few shared his taste. Rothko and Still were not widely exhibited, and Newman was not exhibited at all. Clem reviewed countless books about art for the *Times* and continued to write essays, but he did not review current exhibitions. As Helen ended their five-year relationship, he was not exactly a has-been but was less influential than in the recent past.

Following the break, the sleeping problems that plagued Clem's adult life worsened. He experimented with all kinds and combinations of prescription and over-the-counter medications, carefully recording each night's menu in his diary. His closest friends—William and Edna Phillips and Sid and Gretchen (Gert) Phillips—often joined him for drinks or dinner during the week, and on weekends he accompanied one or the other of them to the country. He dated other women but nothing seemed to help.

On the afternoon of June 2, after an uneventful day—Ken Noland came to his apartment at nine-thirty in the morning; his father arrived at eleven-thirty to get his signature for a real estate transaction—he walked to the Village and did some shopping before going to his *Commentary* office. Danny arrived at five and they had dinner together. Afterward, Clem became "disoriented."[3] Helen and Clem still spoke. She called that night

and thought the episode worrisome enough to report it to her therapist, who recommended Clem seek help and suggested Dr. Annette Herzman Gill, an orthodox Freudian analyst with a Fifth Avenue office. Clem saw Dr. Gill for the first time on June 6. On the night of the seventh he phoned Helen repeatedly, to "test myself." There was no answer.[4]

The following day he stayed home from work. William Phillips came over, as did one or two others. Clem had a session with Dr. Gill but it went badly: "She decided I was too much for her." Dr. Gill referred him to a psychologist named Ralph Klein, but Clem did not immediately act on the recommendation.

On June 13, William and Edna Phillips invited Clem to dinner. He arrived to find Helen among the guests. The Phillips's idea, apparently, was that Clem and Helen were civilized people and their separation could be handled in a civilized way. Clem did his best. He stayed through dinner and confided to his diary that he was "nice" to Helen. The following day, he saw Ralph Klein for the first time. Klein judged him to be in severe crisis and prescribed daily visits.

Thus began a six-year relationship that Clem credited with "changing my life." Ralph Klein was part of a renegade group, followers of the American psychiatrist Harry Stack Sullivan, in Freudian New York. The Sullivanian-trained psychiatrist Jane Pearce and her psychologist husband, Saul Newton, were its center. Pearce's credentials gave the group its legitimacy, but Newton's ideas, far more radical than anything Sullivan taught, shaped its approach to psychotherapy. For that reason Clem referred to the group, not as Sullivanians, but as Newtonians.

Freud traced the roots of psychic disorder to interruptions in psychosexual development occurring in early childhood. Sullivan traced them to dependency problems endemic to the nuclear family. Freudians put their patients on couches and practiced free association to unlock repressed memories. Sullivanians sat their patients upright and concentrated on the doctor/patient relationship and developing dependency issues.

Newtonians saw the nuclear family as a kind of Kafkaesque cell whose life-strangling bonds could be escaped only by implementing severe measures. They prescribed an immediate and absolute severing of all ties with parents, siblings, relatives, even childhood friends. Newton viewed sexually monogamous alliances as breeding grounds for the re-creation of such relationships. To lessen the tie to any one person, patients were encouraged to spread their dependency feelings around. In 1957 Pearce and Newton founded the Sullivan Institute for Research and Psychoanalysis, located on the Upper West Side of Manhattan, but their basic ideas were in place by the time Clem saw Ralph Klein that first time.

Afterward, Clem met Helen for a drink and they had dinner together. Again his diary recorded only that he was "nice" to her. Clem tended to hold feelings other than scorn or anger close to his chest—even in response to art.[5] But two days later, returning from his early-morning "hour" with Klein, he found a tearful Helen waiting in his Bank Street apartment. She told him that no rapprochement was possible.

He seemed numb at first. He went to *Commentary* and in the late afternoon had a drink with Sid and Gert Phillips. Around six, his youngest brother, Martin, then managing editor of *Commentary*, picked him up and together they went to Helen's, where Clem collected his things. At seven Clem had a second session with Dr. Klein, while Martin waited, and then spent the night at his brother's home in Great Neck, Long Island. Martin recalled,

> I saw a lot, or a certain amount, of Clem when I took him to my house because he was having a kind of breakdown. That was around '55. He had a nervous breakdown. I don't know whether it had anything to do with the breakup with Helen. He was out of the office for a while and he was just miserable. His time with me was a concentrated period of breakdown. He was with us two weeks, maybe three weeks, and it was preceded by a time during which I would go with him to the therapist because he was not well enough to go by himself.
>
> He was kind of sleepwalking. He had a "high" quality: very flushed face; his mind seemed overactive. He wasn't manic in behavior but manic in thought. . . . He was better at that time to be with, more human, more open, than he ever was before or since.[6]

Clem's first breakdown, which he attributed to the army and to being trapped in a situation over which he had no control, occurred just as Jean Connolly abandoned him for Lawrence Vail. His response to Helen's rejection was not dissimilar. Clem was helpless with regard to his feelings about Helen and helpless to make her feel the way he wanted her to. Shocked by her power over him, "Newtonian" ideas made a lot of sense.[7] He shunted aside suggestions that his diminishing influence in the art world contributed to the breakdown, explaining that it took a decade for abstract expressionism to be accepted and that he anticipated, from the outset, that the fight to gain recognition for color-field abstraction would take as long.

Clem left Marty's Great Neck home and returned to Bank Street at the end of June. Two days later, still very low, he traveled to Washington, D.C., where he spent several days with Ken and Cornelia Noland. "He'd started some kind of analysis and he kept talking about that and how much better

that made him feel," Cornelia recalled.[8] He hated being alone and filled his time with dinners, museums, and dates. He did his work at *Commentary*, but often slept in Great Neck. He was restless and had trouble concentrating. He spent a week in Vermont with the critic Gene Goossen: "After he broke up with Helen he came up and just sat around in my backyard for a week or so. . . . He was really looking for a restful situation and we just talked."[9]

Few of his colleagues in the literary world were aware of his personal troubles. At *Commentary*, Elliot Cohen was deep in a depression of his own. He and Clem had not been getting along and Clem's absences were probably a relief. Moreover, as managing editor, Martin Greenberg could usually cover for his brother. And when he had to, Clem rose to the occasion.

In the months preceding his split with Helen, he had wrtten two major essays, both of which appeared during the early stages of his breakdown. "The Jewishness of Franz Kafka" (*Commentary*, April 1955) and " 'American-Type' Painting" (*Partisan Review*, spring 1955) both challenged a basic tenet of British literary theory, still the most accepted body of work on modern art criticism. In Clem's judgment, this axiom, which held that "the value of . . . art depend[ed] ultimately on the depth to which it explore[d] moral difficulties,"[10] precluded either Kafka or abstract art from receiving the recognition they deserved.

Kafka's heroes struggled desperately just to resurrect an illusion of order in a world where nothing was as it had been. "To the extent that Kafka's fiction succeeds," Clem wrote, "it refutes the assumption of many of the most serious critics of our day—F. R. Leavis is notably one of them—that the value of a work of literary art depends ultimately on the depth to which it explores moral difficulties." His next sentence, no doubt, reflected his current sentiments: "One feels that what Kafka wanted to convey transcended literature, and that somewhere, inside him, in spite of himself, art had inevitably to seem shallow, or at least too incomplete to be profound, when compared with reality."

Clem bearded Leavis, the lion, in his den. When he drafted the essay in July 1954, provoking a response from the critic he considered one of the greatest in the twentieth century was probably his fondest dream. By the time it appeared, however, the last thing he needed was a highly visible challenge from so formidable an adversary. Leavis's response, in itself, was a compliment. The Cambridge don admired few Americans, but he knew and respected Greenberg's work. Norman Podhoretz was part of the Leavis circle at Cambridge in the early fifties: "Something Clem wrote—probably his piece on Eliot ["The Plight of Our Culture," *Commentary*, June and July 1953]—caught his fancy. . . . And Leavis, who had virtually nothing kind to say about any American," had a certain admiration for Greenberg.[11]

During the most intense phase of his breakdown, Clem was thrust into an exchange of letters that riveted family attention and became the talk of the literary world. In his Kafka essay Clem suggested that Leavis's preference for literature with moral content would lead him to question how well Kafka's writing succeeded as art. Leavis's rejoinder (June 1955), acknowledged the accuracy of that supposition: "The response to which a great work of literary art challenges us entails a valuation of a most radical kind—a valuation of attitudes to life made at the prompting of a new profound sense of the possibilities of living." By way of example he cited this wonderful passage from D. H. Lawrence: "Supposing a bomb were put under the whole scheme of things, what would we be after? What feelings do we want to carry through to the next epoch? What feelings will carry us through? What is the underlying impulse that will provide the motive power for a new state of things, when this democratic-industrial-lovey-dovey-darling-take-me-to-mama state of things is bust?"

Clem replied that art worked cathartically, not educationally: "I would agree that successful art heightens our sense of the possibilities of life, but I would say that it works on that sense as a sense alone, without indicating superior or inferior possibilities as such. Lawrence's assumption, followed to its logical consequence, would make good taste in art a sign of wisdom and of the capacity for wise action, which it manifestly is not."

Stung, Leavis replied:

> One may readily grant that good taste in art (Mr. Greenberg chooses his phrase cannily) is not necessarily a sign of securely attained wisdom and a consequent capacity for wise action; but it remains true that intelligence about (say) Kafka and Lawrence is intelligence about life. When, in determining how we take this, that and the other work of literature, we settle into our essential discriminations of sympathetic response, the perceptions, readjustments and implicit decisions entailed have—if the experience strikes us as new and significant—direct bearings on our future personal living. And this remains true, even if habit is potent and change difficult, and "bearings on" do not at once become "consequences for." Taking a tip from Mr. Greenberg, I might say that his denial of this assumption . . . followed to its logical consequence, would lead to a doctrine of aestheticism and Pure Art Value.

Clem replied that Leavis had him dead to rights about aestheticism and then qualified the term: "I do hold with art for art's sake: that is, nothing else can do for us what art does. . . . Kafka uses allegory more successfully

than it has been used for several centuries in European literature, but we can still be moved by his art without knowing what it 'means.' If it succeeds, it does so, as all art must, by going beyond interpretation or paraphrase. And also by going beyond its prophetic rightness or wrongness."[12]

Normally, Clem would have stopped there. But Leavis had already called him on his tendency to·"merely assert" rather than demonstrate, going so far as to suggest that "Mr. Greenberg doesn't know how the conclusive demonstration would be done." Obliged to go further, Clem was specific in a way he preferred to avoid:

> Essential determinations and discriminations of sympathetic response are excluded in many works that Dr. Leavis would, I feel sure, agree are masterpieces of literature: *Oedipus Rex* and *King Lear* are among them. Morality is built into the mind and works of art have to respect the limitations that morality imposes on fancied action, otherwise the reader's . . . interest cannot be held. . . . But this does not mean that we have to learn from literature in order to enjoy it properly, or that those who do not learn from it are in no position to judge art.
>
> Art, in my view, explains to us what we already feel, but it does not do so discursively or rationally; rather, it acts out an explanation in the sense of working on our feelings at a remove sufficient to protect us from the consequences of the decisions made by our feelings in response to the work of art. Thus it relieves us of the pressure of feeling. I agree with Aristotle that art is catharsis, but the catharsis leaves us no wiser than before.[13]

On one level Clem's seemingly mechanistic view conjures a theory of Freud's in which feelings are likened to an itch or hunger, an excitation longing to be satisfied so as to reestablish a condition of stasis.[14] Psychologically, it probably reflected his current state, so burdened that, far from enriching or deepening life's sense of "possibilities," art's pleasures served only as a temporary release.

" 'American-Type' Painting," published between Clem's essay on Kafka and Leavis's response, is now widely acknowledged to be the definitive statement on abstract expressionism. At the time, it too provoked controversy and challenging letters to the editor. The Museum of Modern Art was then contemplating a traveling exhibition of vanguard art to be shown in various European cities. Such an exhibition, with the prestige of the MOMA behind it, was certain to attract attention. Clem feared that the

museum would select art too weak to sustain the interest it aroused. He feared the long-awaited American moment would be short lived, not because America lacked art with the requisite staying power, but because those who had power lacked discrimination.

Arguing that modern art had historically proceeded by discarding elements deemed essential by the art that preceded it—subject matter, deep space, three-dimensional form, etc.—Clem credited MOMA, the Hofmann school, and the surrealist presence in New York as crucial factors in the avant-garde's successful struggle to free itself from French dominion. He named Gorky, de Kooning, Pollock, Hofmann, Kline, Gottlieb, Motherwell, Newman, Still, and Rothko as major figures whose work possessed the "centrality" and "resonance" that "assured" longevity, concluding that—more an attitude than a school or a style—"American-type" painters[15] were linked by the fact that they emerged together in a certain time and place.

With the exception of Franz Kline, Clem omitted all second-generation artists and lavished praise on color-field abstraction, whose origins and radical composition he had struggled for several years to comprehend. For a second time he legitimized a new art's formal composition by constructing an intellectual foundation and establishing its genealogy. Tracing color-field abstraction to the artistic discoveries of Monet, he provided penetrating analyses of the artists whose work he named, identifying weaknesses as well as strengths, and creating a rank order of current accomplishment. Pollock was hardest hit in the latter respect. Clem praised his 1950 show, treated with disdain by collectors and critics alike, as the peak of his achievement "so far,"[16] but noted that Pollock's most recent effort (February 1954, Janis Gallery), although it attracted uniformly favorable reviews and contained three or four remarkable pictures—*Easter and the Totem, Greyed Rainbow,* and *The Deep* among them—included others that were "forced, pumped, dressed up." Clem concluded that Pollock's ten-year run as an innovator was over: "Pollock found himself straddled between the easel picture and something else hard to define, and in the last two or three years he has pulled back."[17]

Not one to pull his punches, Clem penned a devastating the-king-is-dead, long-live-the-king scenario in which he praised Pollock's past accomplishments but termed Clyfford Still "one of the most important and original painters of our time." Still, Newman, and Rothko, along with the first great generation of abstract expressionists, he suggested, could gain America the long-term recognition it deserved:[18] "The general impression is still that an art of high distinction has as much chance of coming out of this country as great wine. Literature—yes, we know that we have done

some great things in that line; the English and French have told us so. Now they can begin to tell us the same about our painting."[19]

Lee Krasner often said that being publicly dethroned in this way was the blow from which Pollock never recovered, and her view was shared by many of Pollock's friends. Harry Jackson said, "When Clem wrote against him, Jack [Pollock] took it very badly. . . . But any artist would."[20] Mired in his own problems, however, Clem seemed surprised by the Pollocks' reaction: "I hear there's been a ruckus over my piece in *Partisan*," he wrote them in May 1955. "I hope that you two, at least, read the piece carefully; I weighed every word."[21]

Strangely, that summer, the summer of his breakdown, after a near total absence from the Pollocks' lives for close to three years, Clem began inviting himself to Springs as the Pollocks' houseguest. Why did he choose them and why did they acquiesce? Expediency accounts for part, but only part, of what followed.

In August, as everyone knows, therapists head for the sea. Newtonians summered at Barnes Hole in the Hamptons. Clem had been seeing Ralph Klein five times a week since May, and he was not ready for a two-month separation. Friedel Dzubas had a house in Southampton that summer, not far from Barnes Hole, and invited Clem for a weekend. Unknown to him, however, Helen had rented a house nearby. It was all very civilized. The three had drinks together the night he arrived, and the next night he and Friedel attended a dinner party Helen gave. The Pollocks lived in nearby Springs and the day after Helen's dinner, August 6, Clem had a session with Klein, after which he and Friedel drove to Springs and dropped in on the Pollocks, the first time Clem had seen them since publication of " 'American-Type' Painting." Thereafter, when Clem wanted to see Klein, or wanted to be close to his therapist just "in case," he invited himself to the Pollocks: "Now it came to pass that I went into analysis in June 1955. That summer I visited the Pollocks several times. I found out that I preferred going to them than to anybody else."[22]

The Pollock house was a war zone. Pollock was drunk much of the time and verbally abusive toward Lee. Although Clem insisted otherwise, and possibly it never happened in his presence, Pollock was physically abusive as well. "Jackson was in a rage at her from morning till night," Clem recalled. "He had a sharp sense of how to find someone's sore spot and he was out to wreck her."[23]

A year earlier Lee had suffered a prolonged and painful bout of colitis. Clem's analysis connected Pollock's anger to the aftermath of this illness: "Before Lee got sick she was pretty intense; always talking about art. What do we think of this? What do we think of that? When she got over her col-

itis, she came out soft. . . . Now Lee, I'd always had respect for. She was formidable; made of steel. And so competent at everything, except not the business head she was reputed to be. . . . Then when she was soft after her colitis, she didn't give a shit anymore, for a while. It was delightful that she didn't give a shit about what she thought about art. That was all off, she thought about life. . . . Jackson couldn't stand it. I'll go on record here. That's when he began to turn on her. It wasn't so much attacking her as rejecting or something."

Seemingly insensible to the inevitable consequences, Clem put himself in the middle. He took Lee's side. She accepted his support but let it be known around Springs that she was outraged over his essay and was only being hospitable because he might still prove useful to Pollock.[24] Clem, however, saw himself as a savior: "That last summer they were fighting all the time and I'd be there . . . and I'd take Lee's side. And there'd be the two of us fighting Jackson. . . . Well, I thought, 'Why don't you get out?' . . . She had this drunkard on her hands. I don't like calling Jackson a drunkard, but that's what he was. He was the most radical alcoholic I ever met, and I met plenty."[25]

Toward the end of August, Clem suggested to Lee that she see a therapist: "So then I said to her—my analyst was vacationing out at Barnes Hole, near Springs . . . I said to Lee, you know, you need some backing up. Why don't you—he was so okay for me—and so she decided to go and Jackson didn't want to be left out. . . . So Lee went and Ralph Klein referred her to Leonard Segal, who belonged to the same school. . . . And Jackson went and Ralph decided to hold on to him. And so Jack began to see Ralph."[26]

Pollock responded to Clem's presence, and his alliance with Lee, with an unspoken resentment to which Clem appeared oblivious. Pollock no longer worked regularly, but Clem apparently found plenty to say about whatever he did. Porter McCray, MOMA's curator of international exhibitions, recalled two weekends when he and Clem were both guests of the Pollocks: "I mostly listened to Clem. . . . Clem was, and he did this with other artists, sort of telling Jack what to do. He was fascinated by what Jackson was doing, but he always had a bit to add to it."[27]

In the forties, Pollock, who liked to say that where art was concerned, he did not "think," he "knew," had had high praise for Clem's "take." That was when he told his neighbor, Jeffrey Potter, "That guy can feel." During the summer of 1955, Pollock had other things to say. Harry Jackson saw a fair amount of him at that time: "Pollock would be furious about Clem telling him what to do and curse him out—but not usually to his face. He'd just walk away or get vulgar with him. And then Clem would be hurt: hurt

that Pollock did not just follow him blind. . . . They fought a lot from a distance—maybe more from a distance than when they were together. Pollock would say insulting things about Clem. He'd say, 'That goddamned dumb bastard; dumb son of a bitch. What the fuck does he know about art? He wouldn't know a goddamn work of art if it kicked him in the goddamn ass.' And Clem would hear about it and he would say, 'Well, Jack's off on the wrong hook.' "[28]

Lee told many people that she was the only barrier between Clem and physical annihilation that summer. But Pollock found other ways to retaliate. The lavish praise for his 1954 show had attracted a handful of young collectors, some of whom regarded the artist as a mythic figure, a hero carving his own path through the wilderness of modern life.

B. H. Friedman, a twenty-eight-year-old executive in the family real estate business, was involved in "my own search for freedom," which he defined as an effort to express himself creatively by collecting or writing about art. Pollock, the painter widely said to have liberated painting from traditional conventions, attracted his attention: "I was in a position of educating myself about art. I had never had an art course at college. I was meeting people and writing a few articles here and there." In "The New Baroque" (*Art Digest*, 1954), Friedman identified Pollock as the "Rubens of our time,"[29] and Ben Heller, a collector/dealer who bought his first Pollock in the midfifties, offered to introduce him to the artist. "I talked to Pollock, probably very precipitously that spring, about wouldn't he like to have a biography done," Friedman recalled. "He said no. He said let the work just stand on its own and all that."[30] Shortly after " 'American-Type' Painting" appeared, Friedman had a call from *Art in America* "asking if I'd do a profile of Pollock, at his suggestion."

Inarticulate but perceptive, Pollock was skillful at psychological warfare. Years later Friedman innocently explained, "Clem was around [Springs] quite a bit that summer. We were just casual acquaintances and he didn't seem terribly important to me. I had read a lot of his stuff in the *Nation* and in *Partisan Review*, but Clem didn't mean what Pollock meant to me. Also, and this may be my paranoia, I had the feeling that Clem was a bit condescending—since I was educating myself about art and, uh, he was the old pro.

"So I wrote [the Pollock] piece and maybe it was not a significant piece of work, but it appeared in *Art in America*, and that was the first friction I had with Clem. . . . He told me how silly he thought it was."[31]

Thereafter, when Clem was coming for the weekend, Pollock often invited the Friedmans. Paul Brach and Miriam Schapiro had a summer house nearby. They frequently spent evenings with the Pollocks. When

Clem was present, Brach and Schapiro were very conscious that "Pollock tried to belittle Clem."[32] But Clem either did not notice or chose to ignore it.

Despite Pollock's hostility and the availability of other places to stay, Clem returned to Fireplace Road again and again. Did it give him comfort to be with people in worse shape than he? Did Lee's deference or Pollock's passive hostility give Clem a sense of power at a time when his personal life was out of control? Was he so desperate that he cared only about being close to Klein and was unconscious of what was going on around him?

The finale of the Clem/Helen affair was high drama. In late September, Clem was again staying with the Pollocks in Springs. By then, although he wrote very little, he had resumed his editorial duties at *Commentary*. On weekends, however, he either preferred the Pollocks' company or wanted to be close to Barnes Hole, where Klein was still on holiday. On the twenty-sixth, Clem and Pollock drove into Manhattan with Conrad Marca-Relli for Krasner's opening at the Stable Gallery. Afterward the B. H. Friedmans gave a party at their Sutton Place apartment, its walls chockablock with paintings by modern masters.[33] "Clem was there as was Helen, whom I'd known since she was twelve or thirteen," recalled Friedman. "Helen came with Chandler Brossard, who was a kind of hippy writer and carried a switchblade knife. The next thing I knew, Clem and Chandler Brossard were swinging at each other and rolling around in my hall." Later, Friedel Dzubas, Helen, and Clem had dinner together, and later still, Helen and Clem had a drink alone. She was friendly, solicitous, but her feelings were unchanged.

Ten days later, Clem helped Paul Feeley install his show at the Tibor de Nagy Gallery. Feeley had been close to Helen at Bennington, and the bonds between them remained strong. After the opening, Helen gave a party for him at the home of painter Jennifer Cosgriff. Among the guests were Clem; Janice (Jenny) Elaine Van Horne, a tall, leggy graduate of the Bennington class of '55; Howard Sackler, a handsome young playwright; painter Larry Rivers; and John Myers, at whose gallery Helen and Feeley both showed.

Amiable and full of charm, Myers loved creating situations—especially between his young women artists and their male friends—and then watching as events unfolded. With a mixture of horror and delight, Grace Hartigan, another in the Tibor stable, recalled her own experiences: "John was a terrible mischief maker. He loved the women when they were having passionate love affairs. . . . But what he loved most was making trouble. He'd do anything he could to break up their relationships. I just knew my marriage couldn't last with John Myers around, so when I got engaged, I left

him and went with Martha Jackson. . . . It was crazy but it was fun. I even knew it was fun while I was in it. I just didn't realize it was going to be over. I thought it would go on forever."[34]

The party was in high gear when Myers "in his casual, malicious way," observed Larry Rivers, "sidled up to bald, big-nosed Clem and started raving about the youth and beauty of Helen's new paramour."[35] The next morning, as was his custom, Myers checked in with Hartigan for a daily gossip session. "Are you ready?" he began. "You will never guess what happened . . . I went to this party for Paul Feeley last night. Clem was there and I went up to him and I said, 'Clem, isn't it wonderful that Helen has this new boyfriend,' and Clem hauled off and hit me right in the eye. And I was so lucky. As I was falling, I grabbed some steak tartare and clapped it to my eye and I don't even have a black eye today."[36]

After slugging Myers, Clem hit Helen, knocked her down, and went for Sackler, who floored him.[37] This contretemps has lived for decades in abstract expressionist folklore, sometimes evolving, as it traveled from city to city, to serve the purposes of the teller. Ten years later, in Washington, D.C., for example, Helen's handsome young lover had metamorphosed from Sackler to painter Tom Downing, who spread the word that the quality of his art had nothing to do with why Clem dropped him. He was dropped because Helen found his youthful good looks irresistible.[38]

The fight, witnessed by Janice Van Horne, soon to be the second Mrs. Clement Greenberg, assumed legendary status in the Greenberg household. A version with a common ending was volunteered independently by Jenny, Clem, and their daughter, Sarah. According to Jenny, Clem proposed to Helen the day after the party, and she, naturally, refused him: "It was very romantic. At that party after Paul Feeley's opening, Clem and Helen were having a fight. He slugged her and then there was a big row. After that he was finished with her and felt free to call me."[39]

If anything, real life was even more fanciful. The day after the party (October 5), Clem went to Helen's apartment where he may well have apologized and proposed marriage.[40] The story that circulated around the Bennington campus was that after he left, Helen Frankenthaler confided his proposal to Helen Feeley—the Feeleys were staying with Helen while in New York for Paul's opening—and asked her advice. Helen Feeley advised Frankenthaler to stick with Sackler, or so it was said. The next day Clem went again to Frankenthaler's apartment[41] where she, allegedly, told him her decision. He became violent and she locked herself in the bathroom. When Clem tried to break the door down, Helen Feeley called Ralph Klein and pleaded with him to come and stop Clem from killing Helen Frankenthaler.[42]

On October 7, Clem sent a telegram to Helen and again presented himself at her apartment. She was out but he spent some time talking to the Feeleys. He even "cried for Helen" after learning how much she suffered. Later that evening Clem had a drink at Jack Dempsey's Bar with Jenny Van Horne.[43] Over the next two days he sent five more wires to Frankenthaler but all went unanswered. Legend has it that when Clem learned Helen Feeley had advised Frankenthaler to stick with Sackler, Paul Feeley's surging career abruptly tapered off. Clem, supposedly, never forgave him for the advice his wife gave Frankenthaler.

Meanwhile, Clem brooded and slept poorly, but wooed and won the youthful Jenny. On November 28 they attended Pollock's opening at Janis where, for the first time, even the artist's friends were taken aback. "There was a lot of feeling that the work was falling apart," said Budd Hopkins. "I think everyone shared my feeling that Pollock was physically, psychologically, personally in terrible shape and that the art as art was in terrible shape too."[44] Grace Hartigan remembered Clem walking around, shaking his head, while Pollock stood off to the side, looking devastated.

Two days later Jenny and Clem traveled to Pittsburgh together for the opening of the prestigious Carnegie International Exhibition. Pollock had a painting in the show and was present for the opening.[45] The two men met in front of Pollock's painting and the artist asked the critic what he thought. Clem said that it was okay but that the one next to it—by a little-known German artist—was better.

Jenny gradually replaced Helen in Clem's affections, but his animosity toward Sackler remained. In late December, Eleanor Ward, of the Stable Gallery, gave a buffet supper and book party for the writer Seldon Rodman, an old friend of Clem's. He and Jenny attended, as did Sackler. The two went at it with their fists a second time.

Clem's friends found themselves forced to choose sides. William Phillips had been Clem's closest friend and most loyal supporter for ten years. They saw eye to eye on many things and even painted together during the forties. Phillips was one of the few in the literary world who enjoyed the art Clem wrote about. When Rahv or others thought about ousting Clem as *Partisan Review*'s art critic, it was Phillips who blocked their path.[46] After Clem and Helen split, however, the Phillipses accepted a party invitation from Frankenthaler. Clem ended his relationship with them and with *Partisan Review*. William tried to repair the breach, to explain that he had not taken sides, but Clem was implacable. In his memoir, *A Partisan View*, Phillips wrote, "It is painful for me to write about my relations with Clem, as everyone called him, because I found myself quite suddenly . . . in a maze of psychological misunderstandings that I still do not entirely comprehend.

. . . He became enraged at me. . . . Though he was known to be domineering, he accused me of trying to dominate him, and of having been disloyal."[47] They saw one another on occasion, but their friendship was never again what it had been. Several years later Frankenthaler married Robert Motherwell. She and Clem made up, and throughout the sixties, as his reputation soared, she continued to seek his advice prior to exhibitions, and the Motherwells often entertained the Greenbergs.

On May 4, 1956, Clem married Jenny in a civil ceremony. He recalled that his father and her mother were the only attendants and that Joseph Greenberg hosted a wedding lunch at the Vanderbilt Hotel. He and Jenny spent the afternoon at Radio City Music Hall. That evening, Sidney Phillips, publisher of Dial Press, and his wife Gretchen gave a party to which some sixty people came, including Gloria Swanson and "Roz" Russell—"they knew who I was," Clem bragged. The Pollocks declined to attend the wedding reception and sent only a small gouache on cardboard as a gift. Clem's relationship with Pollock, however, was one he could not end.

During the winter of 1955–56, Pollock traveled to Manhattan once a week to see Ralph Klein. Afterward he frequently appeared, roaring drunk, at the Cedar Street Tavern where a crowd had usually gathered in anticipation of the "performance." "Jackson would come in as though he were an outlaw brandishing two pistols," recalled Mercedes Matter. "He just had to provoke someone," commented Conrad Marca-Relli. "Every night Jackson was there," said painter Herman Cherry, "it was a contest of cojónes."[48] Naifeh and Smith reported a grisly tableau with self-destructive overtones: "More than once, after breaking a tableful of glasses and china, Pollock would sit conspicuously in a corner booth and play with the sharp fragments, casually making designs as his fingers dripped blood onto the tabletop."[49] Pollock rarely picked up a brush during those months, but he did pick up a beautiful Liz Taylor look-alike named Ruth Kligman.[50]

The summer of 1956 Clem and Jenny shared a house in Springs with Friedel Dzubas and two of Jenny's Bennington friends. Ruth Kligman had ensconced herself within easy driving distance of the Pollocks' house—also in Springs—and Pollock cruelly taunted Lee by flaunting his nubile young lover in Jungle Pete's, the local pub, and nearby bars and restaurants. At the Pollock home, the situation was explosive, but Clem fearlessly put himself in the middle again. He frequently had dinner with them or dropped by in the evening for a drink or to watch TV.

Pollock's behavior with Kligman grew increasingly provocative. Early in July the two spent a night together in his studio, their giggling clearly audible to Lee in the nearby house. She was so distraught that Clem prevailed on her to go away for a while until things calmed down. A week later, Lee

left on her first trip to Europe. The plane had barely departed when Pollock moved Kligman into their home.

Clem invited Pollock and Kligman to dinner and proceeded to grill the artist, in front of the assembled company, about his intentions toward his wife.[51] Pollock revenged himself the following weekend by inviting Clem, Jenny, Kligman, B. H. Friedman, his wife, Abigail, and painter James Brooks and his wife, Charlotte, to his studio. "I got into an argument with Clem," Friedman recalled. "There was a squarish painting—about four feet by four feet—it was a little bit like that horizontal frieze called *Springtime*. . . . I said I thought it was less significant than the ones where the blots and lines themselves were the color and form. There was a lot of talk about that. Clem thought it was a wonderful painting."[52]

Pollock was known to be incredibly generous. Half the population of Springs owned Pollocks. That night, it being Friedman's birthday, Pollock invited him to go into the studio and choose a drawing from the portfolio. To the best of Friedman's recollection, Pollock gave the painting Clem admired to Kligman. This, while the critic who had been his staunchest ally for close to a decade, and to whom he had never given a major painting, stood silently by. Thirty-five years later, Clem blamed himself: "The gouache he gave me for a wedding present, it was too small. I should have given it back but I wasn't analyzed enough yet."[53]

Krasner had not been gone two weeks before Pollock was again miserable, restless, and agitated, treating Kligman as badly as he had treated Krasner. One night Clem and Jenny were there for dinner. Pollock flew into a rage for no apparent reason and ordered them to leave. Clem vowed never to go back. Pollock began abusing Kligman physically; she fled to Manhattan with the promise that she would return soon, but did not return until August 11.

That evening there was to be a concert at The Creeks, Alfonso Ossorio's estate. In the morning Pollock called Clem and, as if nothing had happened between them, complained that Kligman was coming for the weekend and bringing a friend. Clem recalled that Pollock rambled on about the cost of the concert tickets and his resentment at having to buy three of them, complaints Clem described as uncharacteristic. Years later, thinking back on that conversation, he castigated himself for not following his instincts and going over there.

Pollock was drunk when he met Kligman and her friend, Edith Metzger, at the train station that morning. When drunk, which was most of the time, Pollock drove like a man with a death wish. The more those with him begged him to slow down, the faster he went. From Kligman's later description he behaved boorishly all day, doing nothing to entertain his

guests, even refusing to take them to the beach. By evening the two women were eager to leave that house. Looking forward to the concert, they dressed with care. Pollock drove even faster than usual. Kligman knew enough to keep her mouth shut, but Metzger screamed at every curve and pleaded with him to stop the car and let her get out. His only response was to threaten to turn around and return to the house if she did not stop. Finally, they arrived at The Creeks, but instead of proceeding through the gates, Pollock pulled off the road and announced he had changed his mind and they were going home. First, though, he would take a nap. The women obediently sat in the car and waited. When he awoke, Kligman, not looking forward to an evening on Fireplace Road, coaxed and pleaded with him to go to the concert. He finally agreed but seemed sick and dazed. Hoping food would sober him up, Kligman suggested they first get something to eat. Once outside the restaurant, Pollock had another mood swing. Gunning the motor, he raced along Fireplace Road in the direction of Springs. Metzger screamed in terror, and the more she screamed the faster he drove. They approached a familiar curve in the road, a place where the surface changed from concrete to asphalt. Pollock knew it well and had slowed for it many times. This time he floored the pedal and the car barreled into the curve. The big Oldsmobile convertible, top down, spun out of control. It left the road, climbed a small sapling, and flipped, front over back. Pollock and Kligman, riding in front, were thrown from the car. So fast had they been moving that he hurtled some fifty feet through the air and smashed headfirst into an oak tree, some ten feet off the ground. Kligman landed in the brush, badly hurt but alive. Sitting in back, Edith Metzger clung to the shoulder strap with all her strength and was crushed to death in the wreckage.[54]

A neighbor, recognizing the car, called Ossorio's and left a message with the maid. Ossorio pushed through the crowd to find Clem, who was holding court on the terrace. Hearing the news, the critic hurled his glass into the bushes and, according to Carole Braider, a friend of Krasner's who was standing close by, cursed his own fate: "That goddamn Pollock, he's always fucked me up."[55] What happened next remained vivid in Clem's mind. He and Ossorio went to the scene of the accident to make the necessary arrangements:

> And so it devolved upon me to call Paris and tell Lee, who was staying with Paul Jenkins and his then wife, Esther. It was by then three o'clock in the morning our time and I called. Paul answered the phone and I said that Jack had gotten himself killed. And then in the background I heard hysterical laughter and it was Lee. She sensed

what was going on, and some people laugh when they get crazy. . . . Lee flew back the next day. I forget whether the funeral was two days later or the next day. And then there was a question. Somebody had to talk at the services, and Lee wanted me and that was a compliment. Okay? And I said how about Barney Newman or else Tony Smith, and she said, 'No, you.' And there was that terrible laugh again.

Pollock's death was reported on the front page of the *New York Times*. The funeral was held on August 15. De Kooning was on Martha's Vineyard when he received the news. He rented a plane and he, Joan Ward, Herman Cherry, and Reuben Kadish flew to Springs. Clem, who could usually be relied on to defend whatever Pollock did, refused to eulogize him and Lee asked no one else. The only speaker was a preacher who had never met the man. There were few things in Clem's life that he chose to explain or justify, but his refusal to speak at Pollock's funeral was one of them. As he told the story, he felt he was being set up:

> I went to bed that night [after Lee asked him to eulogize Jackson] and I agonized because I had the worst case of stage-fright. I was angry at Jackson for killing himself and even more for killing this girl. And the next morning I got up and called Lee and said, "No, I can't, I can't . . ."
>
> What I felt about not talking was—you know in primitive tribes when the hero dies, they sacrifice someone on his funeral pyre. I was to get up there and be the sacrificial victim. What was I gonna say about Jackson? That he was a son of a bitch for getting this girl killed? . . . I'd have to cover up and lie . . . I couldn't have said that. No. I had to mention the girl and it would have been improper to do that.[56]

Lee did not hold his refusal against him, or so he said. He and Jenny were as supportive to her as they knew how to be. Jenny, with some other women, removed all traces of Kligman and Metzger from the house before Lee returned, and Clem stayed with her overnight so she would not be alone.

Clem described the early years of his marriage to Jenny as among the happiest in his life. He liked to say his fortunes changed for the better immediately after the ceremony. It did not happen quite that way. At the time of his marriage, Clem had a higher profile in the literary than the art world. He dined with Alec Waugh, Murray Kempton, and Kenneth Burke, among

others. He and Jenny were out most nights and lived well. Less than a year later, however, his long association with *Commentary* came to an end.

The problem was not with his work. By all accounts Clem was very good at his job. Writers might resent his lack of "kindness." He made no attempt to reassure them as to their talent or intelligence and never pretended to like something more than he did. All agreed, however, that he was a very good editor, adept at tightening a piece, comprehending the nuanced meaning the author intended to convey and finding just the right word to express it. Greenberg might return a manuscript for more work, but he never tried to influence the writer's position on issues. Irving Howe, who did not hide his personal resentment of Clem, admired him as an editor: "Clem was a terrific editor. He had a very keen sense of language. He was just terribly good at it. You can see that in his writing: very disciplined, very controlled. . . . As an editor he didn't interfere much. . . . He didn't try to tell me what to say." Clem earned respect from those he worked with but he never won any popularity contests.

Clem had what psychologists call authority problems. He never found it easy to work for anyone else, and Elliot Cohen, the founding editor of *Commentary*, was no exception. Cohen was a brilliant but difficult man. He had strong editorial opinions but could not write himself. He often did with writers what Clem was said to do to artists. He told them what to say and how to say it.

Clem was Cohen's number two during the critical early days when basic decisions about *Commentary*'s direction were hammered out. His vision was at odds with Cohen's from the beginning, but only in certain respects. Cohen believed that Casey Stengel, Henry James, and Norman Rockwell were equally valid expressions of American culture; that what separated a highbrow from a middlebrow publication was the level at which these subjects were addressed. Clem shared Cohen's enjoyment of movies and baseball but he believed the chief editor was willing to compromise too far on the pitch of discussion. *Partisan Review* was the most influential little magazine of its time, but, as it was written for producers rather than consumers of ideas, its audience never exceeded eight or nine thousand. The American Jewish Committee phased out the *Contemporary Jewish Record* and founded *Commentary* with the idea of appealing to a somewhat broader group. Cohen's ideal readership included, in addition to producers of ideas, curious people who looked to magazines for information and guidance on issues. He was willing to modify the "family's" allusive style to make its discussions more accessible. By definition, however, this involved more explanation, a narrowing of references, a slightly lowered plane of discussion.

On other substantive issues, Cohen and Greenberg agreed. Each saw

Commentary as a showcase for political and cultural ideas presented by Jewish as well as non-Jewish writers, and for addressing ideas that involved Jewish as well as non-Jewish life. They were too sophisticated to imagine that *Commentary* could alter existing stereotypes. But to the image of the Jew as shyster, shylock, or victim, they wanted to add that of the Jew as writer, thinker, scholar, scientist.

Clem did not resign over the substantive disagreements he had with Cohen but made no effort to conceal his contempt. He became the loyal opposition. *Commentary* eventually rivaled *PR* in intellectual status but Clem continued to denigrate it. Podhoretz, who ultimately replaced Cohen as *Commentary*'s editor in chief, worked briefly at the magazine in 1953: "In one of my first meetings with Clement Greenberg he startled me out of my wits by referring contemptuously to *Commentary*, of which he himself had been an editor from the very beginning, as a middlebrow magazine. Quite apart from my puzzlement over what he thought such a statement implied about him and his relation to the magazine, I was bewildered by this application of the term to so intellectually stylish, so (to me) obviously highbrow a phenomenon. But coming from the man who had written that famous essay on 'Avant-Garde and Kitsch' and who in addition had discovered Jackson Pollock [sic], the charge had to be taken seriously."[57]

Clem skillfully re-created at *Commentary* the position he occupied within his parental family. He was the number one son, competitive with father and siblings. Despite Ralph Klein's teachings, Clem never fully severed relations with his family and felt free to call on them for help when he needed it, but he was distant, disdainful, and superior in his attitude toward them. The late Sherry Abel, Lionel's wife, came to *Commentary* in 1950. Lionel remembered her descriptions of office politics: "Whenever they would have these editorial meetings, Clem never participated in them. . . . He just would sit apart from the others, scowling and acting superior. He didn't want to have anything to do with their nonsense. And he made them all feel bad. He was their senior intellectual but he just wouldn't participate in the magazine with the others. He stayed on but he disapproved and never let anyone forget it. He put a different value on what he thought than on what others thought."[58]

By the midfifties, the original *Commentary* staff had gone its separate ways. Irving Kristol resigned early in the decade to become editor of *Encounter*, where he became enmeshed in the scandal that resulted when one of its main sources of support was revealed to be the CIA. Nathan Glazer joined Anchor Books, the publishing house that initiated the quality-paperback revolution. In 1955, the year Clem had his breakdown, Robert Warshow dropped dead of a heart attack at age thirty-seven, and

Elliot Cohen sank into a depression. Day after day he sat in his office, "utterly paralyzed," unable to do anything but stare listlessly at his desk.[59]

Clem, in the midst of his breakup with Helen, had little compassion for Cohen's suffering. He treated Cohen's immobility as a sign of bad character. He also moved into the power vacuum. In early 1955, Hilton Kramer needed a job. Clem urged him to apply for an editorial position at *Commentary* and arranged an interview with Cohen, who was still editor in chief. Kramer had the impression that "the brothers were jointly running the show."[60] Or as Podhoretz later put it, "Marty was running it and Clem was telling him what to do."[61]

Cohen was ultimately hospitalized, an event preceded by a "spat" with Clem (the latter's word for a dispute resulting in only one survivor). On this occasion Cohen attributed Clem's animosity toward him to the fact that he, rather than Clem, had been made chief editor. But Clem hotly denied this accusation, insisting that at the time *Contemporary Jewish Record* was merged with *Commentary,* he told the American Jewish Committee that he did not want the top job: "I wouldn't have found that fulfilling, to use a nice buzzword. I wouldn't dream of editing *Commentary.* Elliot Cohen, when we had our final spat, said, 'Well, maybe you should have been editor,' but he was only trying to motivate me [for thinking so badly of him]. *Commentary* was a nice job. That's all. I never wanted to be editor." He continued, however, to run the show. One week later, amidst much secrecy—mental illness was still considered a morally regrettable lapse—Cohen was sent to the Payne Whitney Clinic, where he remained for two years.

There was much talk among the staff, after Cohen's departure, about Clem's behavior toward him. "Clem and Elliot Cohen had a very, very bad relationship," Podhoretz, who returned to *Commentary* in 1955 shortly after Cohen's departure, explained. "Clem had a lot of contempt for Elliot. I don't know if it started out that way. When Elliot broke down, Clem had no sympathy." It got so bad that the story going around "was that their analysts were going to meet for a duel in Central Park so they could settle the whole thing."[62]

Martin was acting editor in Cohen's absence. In *Making It,* Podhoretz referred to the brothers collectively as "The Boss," portraying a monolithic creature whose insatiable appetite for control made his life a misery.

After two years Cohen's health improved, and by 1957 rumor had it that he would soon be back in the office. On January 3, however, Marty and Podhoretz had what Clem noted in his diary as an "altercation." "The Boss," Podhoretz later wrote, had been heaping scorn and derision on his every utterance for two long years. Despite the expectation of Cohen's

imminent return, Podhoretz could stand it no longer. Rather than simply resigning, however, he went to the American Jewish Committee (AJC) and, in his words, "ratted" on Clem. "The Boss, I said, was running the magazine in a spirit altogether alien to the way in which it had been run by Cohen; worse, if Cohen ever came back The Boss was planning to make life so miserable for him that the return would last just long enough to induce a relapse and set the stage for a coup."[63]

The AJC refused to accept Podhoretz's resignation. An investigation was conducted. "After six weeks of enough intrigue to have launched the Russian Revolution itself, a hearing was held, complete with secret testimony from the entire staff and from every former editor who could be rounded up and persuaded to offer an opinion."[64] It was a rout. Marty was allowed to stay on, although in a lesser capacity. Clem was judged a "bad influence . . . bad for office morale" and fired. Years later Martin insisted that he alone ran the magazine, that he had no idea why Clem was forced out and did not much care: "The whole thing at *Commentary* was very unpleasant. I don't know why Clem was fired. It's funny. I never had any great curiosity about that."[65]

After seventeen years as a prominent member of one of the most remarkable intellectual cadres to grace America's shores, Clem cut all ties to the group against which he had measured and defined himself since the start of his career, the group that had been his "center." Later, he would dismiss the episode as being of minor importance in his life. But it was potent enough, or embarrassing enough, for him to delete all reference to it from his diary. Martin's January 3 "altercation" with Podhoretz was recorded, as was Clem's trip to Great Neck two days later to discuss the situation. After that, for close to a year, openings, sleeping-pill combinations, the names of those with whom he had drinks or dinner, were scrupulously recorded but no mention was ever made of Podhoretz's action, the Committee's investigation, or his firing. No indication as to the day, or even the month, when he cleaned out his office and said good-bye to the *Commentary* staff. The entire episode is wiped out. A December entry indicates he is "reading *Commentary* manuscripts," which suggests he was asked to contine editing on a freelance basis.

Ruminating about these events thirty years later, Clem had a defensive tone. He made no accusations and no apologies with regard to his firing: "Norman Podhoretz told the Committee that Elliot said he wouldn't come back as long as I was there. I was pretty hard on Elliot in the last days, so they fired me." Clem put a benign spin on an undoubtedly painful episode: "I was seeing Ralph Klein at that time. He had been hinting I should leave *Commentary*, that I was not happy there. I'd been married a year and Jenny

got scared, but somehow or other our standard of living went up immediately. Like the day after."

In Clem's version, Podhoretz was a bit player in the drama and the Committee well-meaning, but vaguely benighted: "Jenny and I were in Europe in the spring of '59 and I got this cable [from Martin] saying Elliot had committed suicide. . . . [The Committee] sent Elliot back to the trenches where he'd been mortally wounded anyhow. He shouldn't have been sent back to *Commentary*. He read about these kids getting smothered with plastic bags. He put a plastic bag around his head and smothered himself down there on Eighty-fourth Street. How do you bring someone like that back onto the field where they first got in trouble?"

Although Clem never said it in so many words, he and Cohen were the giants, the contenders, the ones whose measure fate would take. And by its partiality—the status he achieved in the sixties—fate identified him as the greater man.

Clem had done freelance editing for *Criterion,* a magazine published by his friend Sidney Phillips, while still at *Commentary.* He now became more involved and began attending editorial meetings. He embarked on yet another series of remarkable essays: "The Later Monet" (*Commentary,* March 1957), "New York Painting Only Yesterday" (*Art News,* summer 1957), "Picasso at Seventy-Five" (*Arts Magazine,* October 1957), "Milton Avery" (*Arts Magazine,* December 1957), "Sculpture in Our Time" (*Arts Magazine,* June 1958), and perhaps his most influential essay, "The Pasted-Paper Revolution" (*Art News,* September 1958). He signed a contract with Beacon Press for *Art and Culture,* the volume of selected essays published in 1961. He juried art shows, traveled to Toronto to lecture and visit studios, participated in countless panels, and lectured occasionally at museums, but his earnings were meager. In 1956, *Arts* magazine paid $50 for fifteen hundred words. He was invited by the Utica Museum to lecture on Hans Hofmann. The honorarium was $100: "I wanted one hundred and fifty dollars. No go."[66]

Although Clem's separation pay was generous, money grew tight. Close friends such as Sidney Phillips rallied round and Clem even saw William Phillips on occasion. But his circumstances were greatly reduced. He was forced to borrow from his father, from acquaintances, from a high school friend he had not seen in ten years, even ten bucks from his therapist. The nadir was the day Jenny, unbeknownst to him, pawned a prized possession, a bracelet left her by her grandmother. Clem discovered there were buyers for some of the art he had collected and sold a Franz Wols gouache for $350 to redeem it. Later, to keep them going and keep Jenny's spirits up, he

sold two Baziotes temperas for a total of $725.[67] He was offered a teaching position at Bennington College and at first accepted but then refused it.[68]

Through it all he kept moving. He continued to make gallery rounds and was consulted by curators and dealers. He wrote catalog blurbs for dealer friends and organized a Hans Hofmann exhibition—paintings from 1943 to 1946—for the Kootz Gallery. His efforts barely supported them. He and Jenny went to the Five Spot occasionally to hear jazz and attended poetry readings in the Village, but the pressure took its toll. He started to sleep later and drink more, had a brief encounter with writer Jean Stafford—she later wrote saying she regretted they had not met when the timing was right for both—and serious "spats" with Danny, with his brother Marty, and with Jenny.[69] On March 12, 1958, Clem's young wife, terrified by the instability in their lives, had a "crying jag" that lasted until 2 A.M.[70] Questioned as to whether Krauss's "Changing the Work of David Smith" marked the onset of his daytime alcohol consumption, Clem responded with predictable bravado: "Before I got fired from *Commentary* I drank at night, but then I discovered I liked drinking in the day too. So?"[71] Some days he liked it so much he achieved "euphoria" by midafternoon.[72] The "center" Clem lost when he turned his back on the literary/intellectual world would prove far more debilitating than the temporary drop in his income.

Through it all, writing retained its capacity to thrill him. A diary entry for January 14, 1958, noted, "Up at noon. Worked on 'Newness of Color.' Beginning to tremble at 4 PM as the new, briefer design of whole came into view."[73]

13

The Chance of a Lifetime: 1958–60

When Pollock died in 1956, the market response was like nothing that had ever before happened to an American artist. Pollock's 1954 show was the only one in his lifetime to win widespread critical acclaim. After his death, however, he entered the national psyche, "a kind of demiurgic genius, one who led art . . . into a new realm of spontaneity," Clem later wrote. "Pollock became a byword . . . known to Jack Paar as well as Alfred Barr."[1]

By the midfifties, a small market for American abstract expressionist art had developed. In 1953, Sidney Janis sold *Blue Poles* to Dr. Fred Olson for $6,000, and in 1955, Ben Heller bought *One* (1950) for $8,000, a sum that surpassed the annual income of most Americans and was the most ever paid for a work by a contemporary American. Alfred Barr, whose favor normally conferred value on modern artworks, approached Janis that same year about acquiring Pollock's *Autumn Rhythm* (1950) for the Museum of Modern Art. He was so appalled by the $8,000 figure that he backed off and the sale was never consummated. The artist died less than a year later and Barr again approached Janis about the painting, but the price was now $30,000. "Barr was too shocked to answer my letter," Janis recalled.[2] Shortly afterward, the trustees of the Metropolitan Museum of Art voted to acquire *Autumn Rhythm*, and that sale put Pollock in a class by himself. Astute collectors acted swiftly. Ben Heller acquired *Blue Poles* for the princely sum of $32,000, more than five times the amount paid four years earlier. (Fifteen years later he sold it to the National Gallery of Australia for over $2 million. And this, Clem said, "for a painting Jackson considered a failure.") The rise was so steep it affected vanguard art across the board. Pollock's funeral was barely over when Janis sold for $10,000 a de Kooning he had been unable to move a month earlier for half that amount.[3] It was the second generation, however, that profited most. Barr had been slow to recognize first-generation abstract expressionists, but as early as 1950 the MOMA did a

series of three-man shows for second-generation artists. In 1956, the year Pollock died, the museum officially sanctioned the younger group by including Franz Kline, Ernest Briggs, Sam Francis, Grace Hartigan, and Larry Rivers in its *12 Americans* show. Blanchette Rockefeller bought Grace Hartigan's *Essex Market* for $1,200 and Franz Kline's *Accent Grave* for $1,350, unheard-of prices for little-known American arts. *Art News* had promoted the second generation for several years. Dore Ashton, at *Art Digest*, and later at the *New York Times*, became a supportive voice on behalf of painters such as Philip Guston, Joan Mitchell, and Hartigan. It was the Museum of Modern Art, however, with its unique prestige, that legitimized the second generation outside the United States. In 1957, MOMA chose the Americans to be included in the Fourth Bienal in São Paulo, Brazil. One section was devoted to Pollock, the other included Hartigan and Rivers among others. In 1958 the museum organized *The New American Painting*, an exhibition of abstract expressionist work that traveled to Basel, Milan, Berlin, Brussels, Paris, and London. That show reverberated in studios throughout Europe. It marked the onset of American preeminence. Clem was out of work and out of synch with New York taste. His only involvement took place on March 10 when, at the invitation of Porter McCray, he viewed the assembled pictures at the Santini Brothers Warehouse at 449 West Forty-ninth Street, before they were shipped. He had not changed his mind about the second generation. In his view, the great American style of the forties had, in their hands, become a "manner," which was not a bad thing in itself, as he later wrote: "Badness becomes endemic to a manner only when it [the manner] hardens into mannerism. This is just what happened . . . in the mid-1950s, in de Kooning's art, in Guston's, in the post 1954 art of Kline, and in that of their many imitators."[4]

In 1957, the year the center fell out of Greenberg's life, Leo Castelli opened his first New York gallery. In January 1958 he showed Jasper Johns. The repercussions of that show hit the art world like the blast of a meteor colliding with earth. Hilton Kramer remembered it well: "When Alfred Barr went to the first Jasper Johns exhibition and bought three pictures for MOMA's permanent collection . . . I don't believe there were three Rothkos in the museum collection. . . . It was like a gunshot. It commanded everybody's attention."[5] Collectors like Ben Heller and Emily Tremaine responded, as did Robert Scull, "the rough hewn owner of . . . Scull's Angels . . . a fleet of New York taxicabs,"[6] the advance guard of a new class of collector. In the months to come, Castelli showed Rauschenberg and then introduced pop art. Clem looked at Johns with interest, but pop art, judged by his standards, barely deserved the designation art. His view did not carry much weight, however. Clem's preference was neither

for Johns nor the Tenth Street action painters that dominated the New York scene. Clem broke with Betty Parsons at that time because she refused to show Morris Louis or Kenneth Noland.

When American art entered the Promised Land, Clem was wandering in the desert. In 1958 the Museum of Modern Art's traveling exhibition completed its tour of Europe and returned in triumph to its country of origin. A year later, in November 1959, the prestigious British publication *Times Literary Supplement (TLS)* dedicated a special issue to "The American Imagination: Its Strength and Scope": "The current style of painting known as abstract expressionism radiates the world over from Manhattan Island, more specifically from West Fifty-third Street, where the Museum of Modern Art stands as the Parthenon on this particular acropolis."[7] Moreover, said the *TLS*, "It is true to say that the flowering of the American imagination has been the chief event in the area of living art since the end of the First World War."[8]

Despite Jenny's fears, the drop in their standard of living, and the current art trend, Clem was optimistic about his future. His optimism was reinforced when Roy Neuberger, the astute Wall Street trader who later founded the Neuberger Museum in Purchase, New York, invited him to lunch. Neuberger's passion for art was so intense he later attributed his Wall Street career to the need to support his habit.[9] He bought his first Pollock in 1950 (a 1949 all-over drip painting from the period celebrated by *Life*). In February 1958, he presumably consulted Clem about plans involving Pollock. Afterward, the jubilant critic bought perfume and flowers for Jenny.[10]

Clem tried to keep busy and to keep his spirits up. He did regular gallery rounds but rarely saw anything that surprised or pleased him. In March, he chanced on some paintings by Jules Olitski, the man he would thirty years later declare our "best living painter." The paintings looked "Frenchy" (overrefined) and he "didn't want to go for them." But his involuntary response said otherwise. He signed the register and Olitski got in touch.

In April, Clem received a signal academic honor, an invitation to conduct the 1958–59 Christian Gauss Seminar in Criticism at Princeton University. The seminar, comprising six lectures, was traditionally a platform for literary rather than visual art criticism and the invitation acknowledged Clem's contribution in both areas. This professional acclaim, plus the stipend that accompanied it, could not have arrived at a more propitious time.[11]

In May 1958 Lawrence Alloway, a young English writer/curator interested in the new American painting, was visiting New York. Clem spent

several evenings with him. That same month he met Roland Barthes. In June Clem's diary noted: "3 years since I went off rocker." On one level, Rosenberg's star was high in the firmament and Greenberg's all but invisible. But when the art world accepted Pollock, Greenberg's prescience could not be ignored. His money problems remained serious—he was again forced to sell paintings from his collection—and his personal relations continued to reflect the strain. He had such a serious fight with Danny that his son physically attacked him. Two days later his diary records another scene with Danny and an argument with his brother Marty, who apparently took Danny's side.[12]

In August, a happier harbinger of the future arrived in the person of Michael Fried, destined to become an influential critic and the most stellar of Clem's young followers. Fried was then a junior at Princeton University where his two closest friends were painters Frank Stella and Walter Darby Bannard. All three were fascinated by modern art and hungry for anything that could help them understand why art had changed as suddenly and radically as it had or why Picasso and Braque, for example, invented collage. These questions were not addressed by their professors, and in a search of the recent literature they found that Clem was the only one saying anything useful. "We looked a lot at paintings and we talked a lot about paintings," Fried remembered. "We were aware of what was happening [aware that Greenberg's ideas were not getting a hearing]."[13] They knew little of Clem's history or reputation and had read only a few of his essays. His most important piece on the subject, "The Pasted-Paper Revolution" (*Art News*, September 1958), had not yet been published, and *Art and Culture* was three years down the road. Fed up with *Art News*, Fried and his friends thought Greenberg their personal discovery.

Fried wrote Clem "a kind of fan letter" identifying himself as a Princeton undergraduate interested in a career in art criticism and asked for a meeting: "Clem wrote back, gave me his unlisted number, and said I should call and come for a drink."

First encounters with Greenberg had a way of becoming memorable events. Fried's experience was no exception. The critic was at his typewriter revising an essay for *Art and Culture* when the young man and his blond girlfriend arrived: "We talked for a while and then . . . he asked, 'What do you think of Ted Roszak's sculpture?' And I said, 'I really think that's just bullshit.' And he got excited and he said to Jenny, 'Ah, he can see through tit. He can see through tit.' So from that moment on we were in a kind of contact. And he was very friendly."[14] Clem was delighted to have attracted so intelligent, thoughtful, and well-read an admirer and made no effort to conceal his pleasure. Before Fried left, Clem gave him a

letter of introduction to Hilton Kramer, editor of *Arts* magazine. That was the start of Fried's career as an art critic.

The following month—September 20—Clem had a meeting whose consequences influenced the direction of abstract art for more than a decade. That morning, a black, chauffeur-driven car pulled up in front of Clem's apartment building at 90 Bank Street. Inside were Ben Sonnenberg, the art collector who revolutionized the public relations industry; Robert Dowling, a financial genius famous for swimming twice around Manhattan Island; and a Mr. Knight. All three represented institutions prepared to back a new venture in contemporary art. The four drove uptown to the offices of Spencer Samuels, director of French & Co. Galleries, an old and distinguished Madison Avenue establishment specializing in art and antiquities.

"French," as Clem called it, had observed the growing European interest in avant-garde American art and concluded the time was right to open a contemporary branch. To that end it leased the penthouse of the Parke-Bernet building across from the Carlyle Hotel on Madison Avenue, invited sculptor/architect Tony Smith to design the space, and arranged a meeting with the critic who had brought Jackson Pollock to public attention. During the meeting Greenberg talked persuasively about the aesthetically moribund state of "action" painting and his interest in making a case for a second group of abstract artists who, ignored by the New York art establishment, were now producing major art. He talked about quality installations, color catalogs, and artistic control. He emphasized the need for an ongoing search for emerging talent, outside as well as inside the United States. Samuels was interested but could not agree to all of Clem's terms, and the latter declined to commit himself.[15]

It would take several months, and a guarantee of artistic control, before he signed a contract, but at the end of the two-hour meeting, Clem was flying. Jenny Greenberg joined the men for lunch at the St. Regis Hotel, after which, still in Sonnenberg's car, Clem conducted a short tour of Fifty-seventh Street galleries. That night, with David Smith and Ken Noland, he celebrated at three separate parties and the Five Spot before polishing the evening off at the Cedar Street Tavern. The sun was rising over Greenwich Village by the time he climbed into bed.

Fifty years later, it is still said that Clem became a dealer when he signed with French & Co. and that financial reward was his primary motivation. Clem was not unaware of the conflicts faced by a critic assuming a fiduciary relationship with a commercial gallery. His contract stated specifically that he was an artistic consultant, not an employee. He received no commission on sales, no share of profits, and had no obligation to work with

clients. He asked for $100 per week, the amount he had been paid by *Commentary*, and that plus expenses was what he got.[16] The money made a great difference in his life, but given the status of the artists he insisted on showcasing, the charge that profit was his primary motive is absurd.

Technically exhibitions were selected in consultation with Samuels and his assistant, Yolande Le Witten, but de facto control was Clem's, and he used his position to make the kind of curatorial statement he had so often berated the Museum of Modern Art for avoiding—a statement in which the curator, like Eliot's critic, accepts responsibility for shaping rather than pandering to taste. During his brief tenure at French, Clem showed only eight artists, most of whom he had known and encouraged for years, although none was popular with collectors: Barnett Newman, Morris Louis, Jules Olitski, David Smith, Kenneth Noland, Friedel Dzubas, Adolph Gottlieb, and Wolfgang Hollegha, a Viennese artist Clem "discovered" in 1959. There were others—Hans Hofmann, Harry Jackson, Jackson Pollock, Clyfford Still—he would liked to have included, but they were unavailable.

The opportunity provided by French & Co. was so important to Clem that he allowed the planning of exhibitions to interfere with his preparations for the Gauss Seminar, about which he appeared somewhat embarrassed.[17] Clem never allowed those lectures to be published and declined to make the manuscripts available for this book.[18]

His shows at French represented the culmination of years of serious thought about a new and radical style of American abstract painting that although today it seems tame and unobjectionable was then, even to other vanguard artists, as extreme and off-putting as abstract expressionism had looked in the forties. Clem's learning process, recorded step-by-step over the eight-year period during which he wrote "Cézanne and the Unity of Modern Art," "Cézanne: Gateway to Contemporary Painting," " 'American-Type' Painting," "Impress of Impressionism: Review of *Impressionism* by Jean Leymarie," and "The Later Monet," reveals much about the careful preparation, and inspired analysis, that made him so potent an intellectual force.

Clem praised cubism as the seminal style of the twentieth century because its complex "architecture," the combination of faceted forms, shallow space, and color gradations, supplied a structure on which artists as diverse as Miró and Pollock could build. One of the great accomplishments of Renaissance painting was the monumental unity achieved by means of line and shading, by contrasts of light and dark. The goal of modern art was to re-create that unity by means that included neither deep space nor recognizable imagery.

Clem deduced that part of the reason Newman and Rothko appeared so extreme was that they relied not on a cubist-based structure but on one that derived from impressionism. In other words they looked to Monet, who had been out of favor with the avant-garde since Cézanne concluded that impressionism lacked formal structure, lacked the unity without which great art could not exist.

With his remarkable ability to get inside a painting, Clem showed how Cézanne devoted his career to bringing old-master structure to the natural color and shallow depth that felt "right" to the impressionists. And how Picasso and Braque picked up where Cézanne left off.

But, Clem deduced, what Newman and Still instinctively recognized, was that Cézanne and the cubists misjudged the originators of modern art. The impressionists did not lack structure. They "achieved an appropriate and satisfying unity," Clem wrote ("Cézanne and the Unity of Modern Art," *Partisan Review*, May-June 1951), but of a different kind.[19]

In "The Later Monet" he explained, "What the avant-garde [Cézanne and the cubists] originally missed [in Impressionism] . . . was traditional dark-and-light, 'dramatic' structure, but there is nothing in experience that says that chromatic, 'symphonic' structure . . . cannot supply its place. Sixty years of van Gogh, Gauguin, Seurat, Cézanne, Fauvism and Cubism have had to pass to enable us to realize this. And a second revolution has had to take place in modern art . . . [to show that] the first seed planted [was] the most radical of all."[20]

In theoretical matters Clem was thorough. In 1960, shortly after French closed, he wrote "The Early Flemish Masters" (*Arts Magazine*, December 1960), taking issue with Roger Fry's analysis of the same subject. Using the Flemings as a springboard for an historical analysis of pictorial unity, he concluded that "detached," "disembodied," "floating" color, the "kind of color closest to that in the best and most advanced of very recent easel painting in America," could achieve a "pictorial unity" as "monumental" as any other kind.[21]

Clem provided color-field abstraction with a respectable provenance dating from fifteenth-century landscape painting through the impressionism of Claude Monet and laid to rest the charges that color-field was an extremist style lacking all connection to the past.

Clem was often accused of starting with theory and choosing artists for a priori reasons, but because the art he responded to was so revolutionary, it was usually the other way around. He encountered Miró and Pollock before he thought about the malleable architecture of cubism. His experience of the art of Newman, Still, and Rothko lead to his work on impressionism and Monet.

Clem's curatorial aspirations at French were never fully realized. He wanted to demonstrate the progression from a Renaissance-style unity to a unity achieved by means of color and to use Pollock's "all-over" compositions as the crossover point.

Greenberg prepared his theoretical ground with care, but interpersonally, he was less prudent. His desire for a Pollock show loosed passions on a grand scale.

Clem had known Lee Krasner since the late thirties. She introduced him to the teaching of Hans Hofmann, whose ideas about Matisse and cubism were so important to his own thinking. Greenberg and Krasner saw eye-to-eye on art issues. Her recognition of Pollock's greatness attracted her to him, and Clem's recognition of that greatness kept their friendship alive.

Lee was an extraordinary woman, and Greenberg respected her sensibility: "Without her, Jackson wouldn't have made it the way he did. She did everything. I still admire Lee, she had a great eye." Lee was one of the few people Clem found daunting: "That's what I admired. . . . She had force of character. An integrity of character. That's what intimidated me. That's what happened with her analyst Leonard Segal. He became dependent on her. . . . He'd get in a state or something and he'd come over to sit with her. . . . And I could see how you could succumb to Lee with her strength and her [pause] . . . presence. I learned a lot from her too . . . from her strict, strict eye. She was good at looking at art. It was Lee's eye I valued. . . . She was so uncompromising, so tough. I learned from that."

Krasner continued to paint after her marriage, but she put Pollock's career first. His work hung on the walls of their Fireplace Road home in Springs, he had the spacious studio, and it was his art people came to see.

From 1947 to the end of 1952, Clem visited Springs at least twice a year. He looked at Pollock's work, offered suggestions and encouragement. He helped select and name paintings for upcoming shows—a job the artist disliked. In all of these things Lee was intimately involved. Clem and Pollock preferred talking art when Lee was present, and she was often the spokesperson for her and Pollock's ideas.[22] But Clem never talked about Lee's art or went upstairs to her tiny studio to see what she was doing. Later he was somewhat apologetic about his disrespectful behavior: "It was just another one of my mistakes. She wasn't that good but she was a good painter. I remember at the MOMA retrospective [1983] there was only one really good picture. An incandescent, smallish one."

Galling as this must have been, Lee was sufficiently ambitious for her husband that she put up with it while Pollock was alive and accepted Clem's support in their bitter fights during the last year of his life. As her marriage foundered, however, Lee began to devote more time to her own

work, and after Pollock's death she turned her considerable talents, contacts, and art-world know-how toward furthering her own career.

She and Clem remained friends. His diary recorded frequent phone calls, drinks, and dinners with her. Lee was the sole executor of Pollock's estate. She determined which paintings were for sale, when, to whom, and for how much. She made all decisions concerning exhibitions. And often, judging from the frequency of their contact, she consulted Clem prior to making these decisions. Lee handled Pollock's estate so astutely that one art-world insider, looking back on the postwar period, concluded there had been three great dealers: Pierre Matisse, Leo Castelli, and Lee Krasner.

In December 1958, shortly after signing with French, Clem invited Lee to a drinks party and, when the occasion presented itself, told her about French and broached the subject of a Pollock show. Lee was receptive but asked for time to think over what kind of show it should be. In March, one week after Newman's opening—the first at French—Lee invited Clem to dinner at her East Seventy-second Street apartment and told him he could have a Pollock show but only in exchange for becoming, or appearing to become, her champion. The following story is from Clem:

> When I became an adviser to French & Co.—1959 this was—Lee and I were still friends. She invited me, Jenny, and Porter McCray from MOMA to dinner at the expensive East Side apartment she was renting. She wanted me to tell French to put on a show of Jackson's black-and-white pictures from before 1951. In 1951, Jackson did a whole series of black and whites that had been exhibited [at Betty Parsons]. These [that Lee was talking about] were done antecedent to the ones at Parsons. And I said, "Sure, that'd be great." And then she said, "And then a show for me." And I said—I was being so pure and I was showing off to myself, which I've done in the past—and I said, "No, it looks too much like a tie-in. I'll do a show for you but not for Pollock." This in front of Porter and Jenny. So then Jenny and I had it out in front of Porter, and Jenny persuaded me. Finally I said, "Okay, I'm being too pure. A show for both of you. I'll tell French."[23]

Clem saw Lee or talked to her by phone at least five times between that evening and his departure for Europe in early May on a new talent search for French & Co. Lee joined the Greenberg family, Spencer Samuels, Yolande Le Witten, Grace Borgenicht, Sid and Gert Phillips, the Gottliebs, the Newmans, and Friedel Dzubas at the boat to see Clem and Jenny off. Relations were warm and cordial.

The fourteen-week trip garnered only one artist—Wolfgang Hollegha

from Vienna—but it laid the foundation for the international support system of artists, dealers, curators, and collectors that eventually helped "put over" the color-field abstraction Clem admired.

In London he met Anthony Caro, then a figurative sculptor, and visited his studio. Caro later described that day and the dramatic turnaround in his work that grew out of the encounter: "Greenberg was totally involved [in my sculptural conversion]. He more or less told me my art wasn't up to the mark. He came to see me in my London studio. He spent all day with me talking about art, and at the end of the day he had said a lot things that I had not heard before. . . . I had wanted him to see my work because I had never had a really good criticism of it, a really clear eye looking at it. A lot of what he said hit home, but he also left me with a great deal of hope. I had come to the end of a certain way of working; I didn't know where to go. He offered me some sort of pointer."

Much has been said about Clem's going into artists' studios and telling them how to paint, but what he did could be a bit more useful than that, and Caro put it into words: "He clarified things for me, and thanks to him I began to learn to trust my feelings in art. . . . Greenberg is terrific in the studio. He is very direct and he cuts right through to the meaning . . . insofar as whether the art is true and felt, or whether the artist is performing or using his art dishonestly. Whether the artist is discovering something and can go on developing it, even if at the time he is not fully aware of what he has done."[24]

On that same trip Clem renewed his acquaintance with writer/curator Lawrence Alloway and Victor Waddington, of the well-known London gallery. Waddington introduced Clem to his son Leslie and the two became good friends. In London Clem met the influential dealer John Kasmin, and in Paris he met the Rubin brothers: William, a collector and professor of art history at Sarah Lawrence, and Lawrence, then associated with Galerie Neufville in Paris but already planning Galerie Lawrence, his own establishment.

Clem and William (or Bill, as he was usually called) met at a lunch in Paris and began talking. Afterward they adjourned to the Louvre, where the conversation continued throughout the afternoon. When Galerie Lawrence opened, the brothers established Park International Corporation through which they jointly conducted its business. During the sixties William often accompanied Clem to artists' studios or to the Santini Brothers Warehouse to select works to be shown or circulated by the Paris gallery.

Clem visited studios and museums in Germany and talked to the dealers and curators who, a few years later, helped make his New York apartment "the UN of the art world."

Some ten days after returning to New York, Clem and Jenny drove to Provincetown and spent a week swimming, going to parties, and visiting with the Hofmanns and Motherwells. On their way back to the city they attended a party given by Alfonso Ossorio, in East Hampton, and the following day moved to Lee Krasner's. Clem recalled, "When we came back [from Europe], we went out to see Lee socially and with a view to her show. Lee had a friend over, a rich lady, and she was going on about Patsy Southgate. . . . So after this woman left, and the moment the door shut, what came first I don't know because I'd gone to Lee's studio [while the women talked]. First Lee got mad at Jenny because Jenny had something critical to say about the lady who was there, and then she asked had I seen her pictures and I had and I didn't like them."

Clem apparently said something noncommittal and they had drinks and cooked steaks on the grill. Lee returned to the subject of her paintings. Clem's description of what followed was sufficiently self-centered to take one's breath away: "Lee was not a good painter. She was so accomplished but it was hollow. So then I had to tell her. And Lee wasn't large souled, she wasn't magnanimous. . . . I didn't refuse her the show. I said, 'We're gonna show you anyhow.' "[25]

In other words, she might successfully blackmail him for a show of support, but she would pay for it in pounds of flesh. Was his action premeditated? Did her work change between the time he offered her a show and his visit to her studio? Did he mean to keep his opinion to himself but, infuriated by the way she spoke to Jenny, used it to punish her?

It seems impossible that Clem did not know exactly what he was doing, but the extent of his self-absorption has the perverse effect of making his psychological obtuseness almost convincing: "Then Jenny said to me, 'Let's go. Let's go.' And I—with my newly found analytic views—said, 'No, we can't leave angry. We'll sweat this out. Don't leave angry. We're friends and all that.' And so, somehow we got through dinner and I got up the next morning and Lee's face was swollen. You know there are people, and I've noticed this before, who when they sleep on their rage, when they get up, their faces are swollen."

Insisting that Lee had not cried herself to sleep or cried all night, he continued, "I don't think she cried. It didn't look like that. And she drove us to the train station. And Jenny, who is much more self-possessed than I am, wasn't particularly bothered, but I was. We got out of the car at the station and I said some pious thing like 'We're still friends' and so forth. But no, she was angry, angry, angry, with her swollen face. And so we told her, 'Don't wait for the train with us.' . . . Lee was coarse ethically, analysis and

all. She was crude as so many people are. Maybe sensitive in other ways, but this was mortal, absolute. Still, I admire her."[26]

"Did you ever hear the story about what happened with Lee's show at French & Co.?" asked the dealer Robert Miller. "Clem offered her a show and then insisted she make changes in her paintings, so she canceled the exhibition."[27]

Lee told her story all over the city. She told Eugene Thaw, president of the Art Dealers Association, and Betsy Miller, Robert Miller's wife, and everyone in her circle. In Lee's version there was no mention of a show for Pollock. Clem wanted her but had demanded changes in finished paintings and she would not stoop so low. Spencer Samuels, however, who had dinner with Clem and Lee in East Hampton the day before Clem visited Lee's studio,[28] confirmed that separate shows for Krasner and Pollock were on the books for the fall of 1959 but were simultaneously canceled. Lee proved an implacable enemy. As Pollock's reputation grew, she did everything in her power to separate his name from Greenberg's.

Meanwhile, at French, although not obliged to work with clients, Clem gave of himself unstintingly, spending countless hours at the gallery and at the Santini Brothers Warehouse choosing paintings for upcoming shows and socializing with collectors. There were often drinks or lunches for the near constant flow of visiting luminaries and the combination of his critical record and his power to organize exhibitions put Clem in great demand. He was inundated with invitations to speak, lecture, and give interviews, and his shows at French were beginning to attract buyers as well as viewers. By 1960, the work of Smith and Gottlieb had begun to sell. Gifford Phillips and Patrick Lannon were early Smith collectors, and as Clem liked to point out, they did not buy on time like traditional collectors: "They paid cash and French was impressed, but it was too late."[29] By the end of 1959 French decided to close their modern gallery.

The reason Clem gave for this decision was lack of sales. While 1959 had been a banner year for the de Kooning/Kline school, sales at French were minuscule. It is hard to believe, however, that people with the experience and know-how of Samuels and the men backing him expected to put over a radical new style of art in a year's time. In retrospect it seems clear that French & Co. was the first victim of the Krasner/Greenberg imbroglio.

Krasner had ended her business relationship with Janis not long after Pollock's death and, at the time French approached Clem, had not chosen another dealer. Presumably, French agreed to Clem's terms—aesthetic control and a roster of artists for whom no known market existed—because

they wanted Pollock, America's most celebrated artist, and believed Clem could deliver him. They gambled that Pollock could carry the venture until the artists Clem currently backed achieved success.

French's first show was in March 1959. In September Clem's encounter with Krasner ended all hope that French would represent Pollock. By the end of the year the decision to honor previous commitments and "call it quits" had been taken.[30]

Clem and color-field painting enjoyed extraordinary success in the early sixties, but it is fair to say that French did more for Clem and the artists he championed than vice versa. Clem had a fiduciary relationship with the gallery, but he used that relationship as a means toward ends that had nothing to do with immediate financial return.

Clem's career from the midfifties to the midsixties included periods of intense hands-on involvement with art and artists and other periods in which he concentrated on his writing. During the fourteen months of Clem's involvement with French, he published only one essay, a long piece for the *Saturday Evening Post* entitled "The Case for Abstract Art" (August 1959). In 1960, the year French closed, he published three important articles. Together with the shows he organized, these made his case for color-field abstraction.

In the first two, he made clear his belief that gesture painting's continued popularity was the only prime threat to America's chances for maintaining a long-term presence on the world art stage. "Modernist Painting," the essay Sidney Tillim called Clem's "summa," was written for the United States Information Agency (USIA) as part of the Voice of America's Forum Lecture Series. It was read over the air in May 1960 to an audience estimated at over 5 million people.[31] Reducing Greenbergian modernism to its purest essence, Clem emphasized modern art's continuity with the past and took an indirect shot at Rosenberg and other "journalist" critics suffering from a "millennial complex" who saw "each new phase of Modernist art" as the start of "a whole new epoch."[32]

That same month, "Louis and Noland" appeared in *Art International*. Clem began attracting followers among graduate students and younger critics. William Rubin was not the first to write about the current scene from a Greenbergian perspective—Jerrold Lanes's "Reflections on Post Cubist Painting" was "a virtual pastiche of Greenberg's ideas and writing style"[33]—but it was Rubin to whom Clem responded. In a previous issue of *Art International* Rubin had written about the present situation in New York, singling out Helen Frankenthaler, Jasper Johns, Ellsworth Kelly, Raymond Parker, Jack Youngerman, Morris Louis, and Kenneth Noland as

important younger artists. In "Louis and Noland" Clem took issue with some of his choices. Separating the New Yorkers on Rubin's list from the Washingtonians, he wrote, "While agreeing with much that Mr. Rubin said, I still find him a little too kind toward many of the [New York] artists he discussed . . . not one of whom "has succeeded in breaking out of the cycle of virtuosity that began with the de Kooning and Kline school."

Again Clem decried the situation in New York, meaning the power of the triumvirate to dictate taste. He bemoaned a circumstance in which an influential few, by keeping afloat certain "kinds of art that would otherwise have faded into the background," allowed it to "acquire a destructive virulence," that crowded out art that was stronger and more deserving.

Warming to his task, he delivered a rhythmic jeremiad against the "loose-brushed, dry-bristled, scumbled, and lathered surfaces of the de Kooning and Kline school," dismissing its followers in favor of the two Washingtonians whom he identified as "color painters," linked stylistically to Newman and Still although not directly influenced by them. Discussing the formal differences between cubist-based painting and color painting, he articulated the formal problems whose solution led them to create an art so radical it seemed to cut all ties with the past.

Clem explained that unlike de Kooning and his followers, color painters did not think in terms of "shapes." Louis, for example, "began to feel, think, and conceive almost exclusively in terms of open color," a conception that called for a different formal composition. Color painters, Greenberg explained, abandoned cubism, not for intellectual reasons, but from necessity: "Cubism meant shapes, and shapes meant armatures of light and dark. Color meant areas and zones, and the interpenetration of these, which could be achieved better by variations of hue than by variations of value."[34]

Heaping praise on Louis and Noland, he declared the two Washingtonians, along with the California artist Sam Francis, to be the only emerging painters whose work approached the "level" of the original abstract expressionists. Pulling out all the stops, he analyzed what made the paintings of each man work and, lest we forget what we wanted from art, characterized theirs as "fertile," "upsetting," and "profound."

Clem's support for Washington artists and his many visits to that city— once or twice a year from 1950 through 1962—led to his being wined and dined by Washington hostesses interested in contemporary art. He met and became friends with James Truitt, assistant to the publisher of the *Washington Post*, and his wife, Anne, a sculptor whose work Clem later saw and championed. He met Phil Graham, the *Post*'s publisher, and the Truitts' close friend, and his wife, Katharine, who succeeded him. As was his

wont, Clem invested modern art with such excitement and importance that his feelings about it proved contagious.

In the fall of 1961 James Truitt wrote a full-page piece for the *Post* in which he celebrated the fact that America's capital city had become its cultural capital as well. His evidence was the prominent New York critic Clement Greenberg's recent coronation of them in a major essay titled "Louis and Noland."

The elegant and charming Frank Getlein, former art critic for the *New Republic,* had recently become the critic for the *Post*'s rival, the *Washington Star.* Getlein preferred representational to abstract art and had once referred to forties abstract expressionism as "*Schmierkunst,*" an onomatopoetic German word meaning just what it sounds like. Getlein did not care much for the stained-color paintings made in Washington, D.C. Taking issue with what he termed "the fatuous pretensions" of the *Post* piece, Getlein compared Truitt's description of Greenberg as a disinterested authority to a "putative estimate of the Kennedy Administration by Pierre Salinger [its press secretary]." In other words, Clem's fiduciary relationship to French & Co., the New York gallery that purveyed stained-color painting to the public, rendered him a dealer, an interested participant as opposed to a disinterested observer.[35] Clem enlisted high-priced legal counsel and the *Star* printed a retraction.[36]

Clem never lived down his fiduciary association with French & Co. The specifics of the controversy over his market involvement will be fully explored further on, for now, the point to be made is how criticism of his "market involvement," like criticism of his "formalism," sometimes cloaked objections to his character or personality.

Asked why he wrote about Greenberg's market involvement and not about Rosenberg's, for example, Getlein acknowledged that he knew Harold had done everything Clem had: accepted, even asked for, paintings from artists (May Rosenberg's practice of telling people what gift Harold would appreciate when inviting them to his annual birthday party was well known)[37] and served as a paid adviser to Graham Gallery. Getlein then told the following story: In the late fifties, before coming to Washington, he had been the art critic for the *Milwaukee Journal.* He had friends at the University of Wisconsin in Madison and spent a fair amount of time on the campus. There, through the "grapevine," he heard gossip about "Greenberg's sexual marathon at Bennington." Laughingly, Getlein suggested that the real reason he had written about Clem's market involvement and not about Harold's was that he found the idea of a fifty-year-old man "cavorting" with "undergraduate children" repugnant.[38]

In the forties and fifties, the few critics who lived in the artists' world and

supported the vanguard often served as paid or unpaid advisers to the handful of dealers willing to showcase the art. When Grace Borgenicht opened her gallery in 1951, Clem urged her to show Pollock, de Kooning, Kline, and Gottlieb. That same year he and Meyer Schapiro organized *New Talent* for the Kootz Gallery. Miriam Schapiro recalled that she showed at Emmerich because "Dore Ashton recommended me." Ashton was an unpaid adviser to Andre Emmerich, and Harold Rosenberg, as we know, was a paid adviser to Graham Modern.[39] Irving Sandler, a critic closer to Rosenberg than to Greenberg, discussed the situation:

> All critics had or were involved with conflicts of interest. None of us could support ourselves on criticism. You know, you were paid three dollars for a review. You did twenty reviews a month and you got sixty dollars. You made seventy-five dollars for an article that you could work weeks, even months, on. When you added it all together, if you made as much as twenty dollars a week from your writing, you were doing fine. Well, a lot of us could just about squeeze by on that but not for very long. We all did shows for museums and galleries; we taught, we consulted. . . . Unless you were rich like Tom Hess was, you had to scramble around. But the one thing you didn't do, you didn't do what critics today do, you weren't a gun for hire. You didn't write for any gallery that paid you.[40]

In other words, critical involvement with a commercial enterprise was acceptable so long as the critic supported art he or she genuinely admired. The morality of the day dictated that you wrote about or championed only art you were willing to stake your reputation on. To be paid for that effort was acceptable. To be a "gun for hire" was not. When artists who were passed over by Clem wished to denigrate him, they, like painter Herman Cherry, often sneered that "he wrote about them [Louis, Noland, and others] and made them famous and they gave him paintings. And then he sold the paintings." Most, like Cherry, knew very well that Clem had encouraged Noland and Louis, among others, long before they became famous.

Shortly after the episode with Getlein, which remained all but unknown in New York, an incident occurred that makes clear Clem's recognition of how damaging the market-involvement charge could be. Hilton Kramer recalled:

> In the fall of '61, I wrote two pieces about the new Carnegie International Exhibition. I said that it was the first major international exhibition of contemporary art that reflected the influence, or per-

haps I said the taste or the ideas, of Clement Greenberg. And that these ideas, seen in this context, would naturally have an effect on the art market. . . . By the time the article was published, I was in Europe . . . and I got a letter from Clem saying that if I persisted in following this line of thought in things I wrote about him, he would sue me for slander. This seemed to me one of the most bizarre things imaginable. I mean I thought of him as a friend. . . . When I did come back, in the spring of that year, I discovered to my horror that Clem and Jenny had spent the entire winter denouncing me to all our mutual friends, saying that I'd stabbed him in the back and betrayed him after they befriended me and so forth. And we didn't speak for ten years, except on the occasion of my marriage when we met by chance in a gallery and he congratulated me. Then one night, at the Sutton Place apartment of a very rich man named David Daniels, who had an extraordinary collection of Degas drawings . . . I was standing in the library . . . and Clem walked in and started chatting as if we had interrupted a conversation an hour before.[41]

As discussed earlier, French & Co. did not reap the rewards of the arrangement with Clem, but the platform they provided propelled him and color-field abstraction to prominence. Clem was never an ivory-tower critic content to deal only with abstractions. He needed the art to get his critical juices flowing, and he liked being on the barricades. The struggle—for ideas, reputation, taste—was what got him out of bed in the morning. Still, the fifties had changed him. Never a trusting man, he had grown harder and more cynical. How determined he was to prevail can be deduced by the punishment meted out to those "against" him.

Clem's reputation for vindictiveness began during the French connection. Dore Ashton, then writing art criticism for the *New York Times,* was less than impressed with Newman's show and less than enthusiastic about the Louis show that followed. Ashton described a personal experience that illustrates how punitive Clem could be. She believed he intentionally destroyed—or at least undermined—the career of someone about whom she cared deeply as retribution for her failure to support the art he championed:

> I have to tell you . . . if you wrote critically of an artist Clem supported, he took it very personally. Clem told me several times, "Your husband [Adja Yunkers] is a much better artist than most of those you write about." So I said, "Clem, if you think so, why don't you write about him?" But he never did. A dealer in Boston wanted to show my husband's work [but suddenly changed his mind]. After my

husband died [they were by then divorced], I found out that the
dealer consulted Clem and I found a Xerox of Clem's response among
Adja's papers. Clem told the dealer that Adja was a very important
artist but he doubted very much that he was going to be acknowl-
edged. Now why did he do that?

When I was on the *Times* [critic for the *New York Times*], Clem put
on the Newman show [at French & Co.] and I had the chutzpah
to say Newman wasn't an important artist. . . . I was also less than
glowing in my review of Morris Louis. Clem was very angry with me.
I wasn't questioning the painters as far as he was concerned. He made
them. Clem tended to want to make acolytes and I'm a born anar-
chist . . . but I have to tell you, I kept a very low profile [after that].[42]

Clem's disregard for the toes he chose to step on was nothing short of
reckless. In 1957 Leo Castelli opened his gallery and in January 1958 did
that famous Jasper Johns show. Alfred Barr, then MOMA's director of
Museum Collections, was the man who legitimized second-generation
abstract expressionism and whose enthusiasm for Jasper Johns set off a
feeding frenzy among a handful of collectors.

Clem too looked at Johns's early work with interest, but not the pop art
it prefigured. He blamed Barr for conferring MOMA's recognition on this
new direction and diverting art-world attention from work he viewed as
more serious. How strongly he felt can be gleaned from the nasty shot he
took at Barr in a piece he was then revising for *Art and Culture*. In "New
York Painting Only Yesterday" (*Art News*, summer 1957), Clem had
described the idealism and isolation that confronted American abstract
artists in the late thirties and early forties, along with their later triumph.[43]
Taking aim at the powerful figure who had done much for modernism but
not for abstraction, he noted dryly that "Alfred Barr was at that time bet-
ting on a return to 'nature.' "[44] Revising the essay in 1960, Clem inserted a
parenthesis so that the sentence now read: "Alfred Barr (that inveterate
champion of minor art) was at that time betting on . . ."[45] That parenthesis
goes a long way toward explaining why, throughout the sixties, Greenberg-
championed painters had exhibitions in the great museums of the world
but not at the Museum of Modern Art in New York.

Like most of us, Clem had many facets to his personality. He thought
different things at different times about the same person. But it was the
most provocative of his thoughts that he disseminated. An interesting
addendum to the Barr story illuminates Clem's inclination to be a provoca-
teur and to make himself the issue.

William Rubin, director emeritus of the Department of Painting and

Sculpture at MOMA and a longtime friend of Clem's, told this story: "Clem was heartily disliked at MOMA and you can see why. You don't have to have been an idolater of Alfred Barr to find this [the "inveterate champion" remark] monstrous. When I called Clem on that particular issue, he said, 'Well, I hate to say it, I even hate him, but I have to admit Barr is a great man.' "[46] Now if it had been the latter remark Clem circulated, the attitude toward him might have been very different.

$$14$$

Daggers Drawn:
The Battle of the Titans

Opposed by MOMA and most New York critics, Greenberg devoted the better part of the fifties—as he had the forties—to beating the drums for a handful of radical artists whose work he was essentially alone in considering a significant advance in the history of art. Like their forerunners, in the early sixties these artists, too, achieved recognition—first in Europe and then in the United States. As the art market we know today began to take off Greenberg was two for two. Like the phoenix, he sprang from the ashes of defeat to soar higher than he ever had, higher than any of his contemporaries, and higher, arguably, than any other critic in the short history of the discipline.

Louis and Noland were essentially Greenberg's discoveries. Both showed in New York prior to French & Co.—Noland at Tibor de Nagy and Louis at the Martha Jackson Gallery—but to no great acclaim. Jenny Greenberg noted with some pungency, "Clem had been written off even in the fifties. By the time the abstract expressionists were recognized, they'd been taken over by other people and Clem was on to something else. . . . People would come up to Clem and ask who's next after Pollock, and he'd say Louis. [Except for Patrick Lannon, who bought the early veil paintings,] they'd just laugh." But in the early sixties, as suddenly as if in a fairy tale, everything changed.

Clem met Lawrence Alloway in New York in 1958 and renewed the acquaintance in London the following year. Alloway, a great admirer of American abstract expressionism, asked what was happening, and Clem talked about stained color-field painting and showed him slides. By 1960, Alloway was assistant director of London's Institute of Contemporary Art (ICA). Finding himself with an unexpected opening in the exhibition schedule, Alloway wrote Clem asking if "French" could provide "Louis paintings on such short notice?"[1] David Gibbs, the unaffiliated British dealer to whom Lee Krasner consigned the Pollock estate, had purchased

five Louis paintings (with an eye toward resale) shortly before French closed. At Clem's request, those paintings were made available to the ICA. That same year, Lawrence Rubin arranged a show for Noland at the Galleria dell'Ariete in Milan and the following year showed Noland at Galerie Lawrence in Paris.

Jenny was pregnant. At 90 Bank Street the space was so tight that Clem's art collection hung in the living rooms and bedrooms of his friends. One month after his stint ended at French, and despite the fact that he would soon be unemployed, the couple left the apartment he had lived in for nearly twenty years and moved uptown, to a corner apartment on the seventeenth floor of 275 Central Part West. Soon, the long unbroken walls that later graced the pages of *Vogue* were crammed with the art he loved.

In March 1961, Noland had his first show at the Andre Emmerich Gallery in New York. In April, Clem received advance copies of *Art and Culture: Critical Essays.* His book was slow to attract critical attention. Unlike Rosenberg's *The Tradition of the New,* published a year earlier, Clem's book neither stirred discussion nor garnered critical kudos. Greenberg's thirty-seven essays were understated, layered, dense, accessible only to those willing to work for the prize. Moreover, the book neither chronicled the forties and fifties nor presented a complete account of its author's critical development, a fact forthrightly noted in the preface: "This book is not intended as a completely faithful record of my activity as a critic. Not only has much been altered, but much more has been left out than put in. I would not deny being one of those critics who educate themselves in public, but I see no reason why all the haste and waste involved in my self-education should be preserved in a book."[2]

No one knew quite how to take *Art and Culture.* Hess reviewed it for *Art News* and Robert Goldwater for *Partisan Review.* Neither was overly enthusiastic. So restrained was the response that Hilton Kramer, who did not often share Clem's taste and was not then on speaking terms with him, felt obliged to comment: "Mr. Clement Greenberg's *Art and Culture,* although published more than a year ago, has not elicited the kind of discussion one had expected of so important a work. The odd silence that has greeted this book, a silence interrupted only once or twice by reviews that recognized its stature without attempting to assess its implications may be traceable in part to the author's withdrawal from the regular practice of criticism. . . . This is an unlucky fate for a writer who has certainly brought the finest mind to the regular practice of art criticism in our time."[3]

While reviewers responded to *Art and Culture* with no great enthusiasm, the book, coming just as his talent for picking winners was demon-

strated for a second time, had an impact. Curator H. Harvard Arnason organized *The American Abstract Expressionists and Imagists* show (October 13, 1961–January 1, 1962) to coincide with the Solomon R. Guggenheim Museum's celebration of its new Frank Lloyd Wright–designed building on upper Fifth Avenue. Arnason knew Clem and shared his taste to some extent. In 1960 he organized a show for Morris Louis at Bennington College. Arnason had originally conceived his Guggenheim show as an exploration of abstract expressionism, but ended by focusing on what he called its "Imagist wing": "Paintings composed of simple forms and flat colors, e.g., Newman, Rothko, Ray Parker."[4]

Abstract expressionism, first and second generation, had had a long and impressive run. By the time the *TLS* extolled American painting, the latter's distinctive brush mark, what Clem called the "Tenth Street touch," was ubiquitous in New York and, by 1961, was imitated throughout the Western world. In New York, however, some of the most significant backers of gesture, or action, painting, namely Alfred Barr and MOMA, were expressing concern. At a panel discussion at the Artists' Club in the late fifties, in which Barr, Rosenberg, and Hess participated, Barr asked a series of questions raising the subject of stagnation.[5] In 1959 the MOMA all but omitted gesture painting from its influential *Sixteen Americans* show—concentrating instead on antigestural art in the form of assemblage, junk sculpture, and the hard-edge abstraction of painters like Ellsworth Kelly and Frank Stella.[6] In *Art News*, however, Hess praised the "atmosphere of individual freedom" that prevailed among the group and denied "the existence of an establishment, a style, or an aesthetic against which a young artist should, or even could, react."[7] In 1961, acknowledging what Sandler later called the "aesthetic incest"—and Clem earlier called "borrowing"—that permeated the groups' production, Hess defended the practice: "By stealing frequently from each other, painters [quickly force an idea] to all possible mutations," which can then be used or discarded by anyone. "This orients the individual to his basic talent, because he knows that alone remains his."[8]

Arnason's show set off a battle between the proponents of second-generation abstract expressionism and color-field abstraction, a battle that culminated in a symbolic fight to the death between Greenberg and Rosenberg. Meanwhile, in the larger art world, the struggle was still between figuration and abstraction. John Canaday became art editor of the *New York Times* in 1959. Canaday was opposed to abstraction in general but his most serious censure was reserved for what he called the "frauds, freaks, charlatans, and worse" of abstract expressionism."[9] Forty-nine artists signed a let-

ter of protest that the *Times* duly printed, and the controversy attracted an outpouring of letters from the public, which supported Canaday by a twelve-to-one margin.[10]

But among the vanguard Arnason's emphasis on "imagist" art and his inclusion of Louis and Noland were widely understood as an affirmation of Greenberg's ideas and Greenberg's taste. Moreover, Greenberg was invited to give the opening lecture. Clem made no attempt to contain his sense of triumph. His lecture, provocatively titled "After Abstract Expressionism," was delivered on October 29, 1961, to an overflow crowd. In slightly revised form it appeared in *Art International* (October 1962).

Two younger critics, Max Kozloff and Annette Michaelson, were among the first to respond. For Kozloff, Clem's assumption that the art he favored reflected the "attuned eye" of the time, and the easy way he "dictated" the direction sixties art "should" take, prompted the younger critic to write a ten-page letter to *Art International*, mounting a full-scale methodological attack on Greenberg's authoritarian "hardness of line" and the "quasi-religious tone" of his "aesthetic."[11] Kozloff never changed his mind. He later designated him the evil dictator, the Ceausescu of art criticism.[12]

Politically, Arnason's exhibition signaled the end of action painting's long reign and the ascendance of antigestural abstraction. It signaled the decline of the de Kooning/Kline influence, the Artists' Club, and the Tenth Street phenomenon. Although the decade-long struggle between Clem and the triumvirate is rarely referred to in histories of the period, the final episode was enshrined in art-world mythology in the form of a fistfight between Clem and Willem de Kooning that took place roughly one month after Clem's Guggenheim lecture.

Clem rarely pulled his punches and, like his mother, he used truth—or what he saw as truth—like a blunt instrument. Despite the written praise he bestowed on de Kooning between 1950 and 1955, in the discussion period following his Guggenheim talk, he responded to a question from the audience by commenting that, in his view, de Kooning before 1950 was better than de Kooning after.

On December 1, the Cedar Street Tavern being closed for repairs, Clem and de Kooning both met friends for lunch at Dillon's, the substitute bar nearby. The following version of this famous fight comes from Clem, who was at pains to clarify the de Kooning version included in Lionel Abel's *The Intellectual Follies*:

> I had a scuffle with de Kooning in Dillon's bar on University Place, twenty-five, maybe thirty years ago. And then de Kooning, who was a fabulist, gave Lionel Abel his version of the story. . . . In that version,

I came up to Bill at Dillon's and said, "What's the idea of telling people I swiped your ideas from you?" Fancy that, me steal his ideas! Bill did have an active mind though. He was sharper and meaner than the other artists. Well, maybe not meaner, and he did have an active mind. But ideas?

People always tell stories to their own advantage so . . . as Bill told the story to Lionel, after he said that, he felt that I was about to hit him, so he hit me first and then we were separated. And that was the story.

In the actuality what happened was that I was with Jim Fitzsimmons and Kenneth Noland, and Bill came in with a couple—new people to me—and they went to sit in a booth. We were at a table. He left his companions and came over to me and said, "I heard you were talking at the Guggenheim and said that I'd had it, that I was finished." Well, yeah. I had said that. Sure. I meant it too. And I still think that he was finished. He hasn't done a good picture since 1950 or '49. Anyway, Bill sat down with us. . . . He just left his companions sitting alone in the booth. That was Bill. He was a barbarian like his wife, Elaine . . . no manners. Supposedly manners went out in the sixties, but at the Cedar Street Tavern they went out long before that.

Well, I was misguided enough to trade words, to bandy words with Bill. Then some of the painters gathered round to watch this spectacle. I wasn't analyzed enough yet to say—I sort of liked it. Instead of saying, "Oh, we're not performing. Would you please sit down," I let them stay there. I don't want to go into what he said next—it was so awful—about Tom Hess.

After some prompting:

He said Tom [Hess] was riding on his back. Then he said, "Well, Pollock said you were riding on his." I didn't believe him. Pollock never said that. As drunk as he could be, I don't think he said that.

Then I said, my voice going to a falsetto, "So what did I get out of it? So what did I get out of it, you son of a bitch?" And he took his elbow and poked me. It didn't hurt. He got up and punched me lightly while he was standing. So I got up to go after him and then we were separated. There was a scuffle in the separation because the kids—the louts who had been watching—all took his side. He was the hero down there. It took Ken Noland to intervene, to pull somebody off me. Then the next thing—they'd rushed Bill to the back of the bar. And then he was allowed to come back and he said, "I'm not scared of

you. I'm not scared of you." I had a reputation for pugilism because of the thing with Manny Farber.

Clem's 1961 "take" on de Kooning, incidentally, was one with which many in the art world later came to agree, albeit in less dogmatic terms. "Clem always liked early de Kooning, and now there is a broad consensus that de Kooning after the early fifties was not as good as de Kooning before," commented William Rubin.[13]

Meanwhile, with the closing of French & Co., money was again tight for Clem and Jenny, while the artists he championed were richer than he or they had thought possible. In October, the night before Louis's second show opened at the Andre Emmerich Gallery, Noland took Greenberg and Louis to dinner at La Côte Basque. After the opening, Louis and Clem dined alone at the Oak Room in the Plaza Hotel. Clem would later say that one of three main things necessary for a critic's success is artists who live to a ripe old age. Pollock's decline and death had been a blow to the critic and in the spring of 1961, Morris Louis was diagnosed with lung cancer.

In a curious way Clem seemed to retain the position he had at French & Co. vis-à-vis three artists—Louis, Noland, and Olitski—whose reputations took off after their French & Co. shows. They continued to see him as their most trusted adviser and to value his counsel in terms of their art and their careers. Unemployed, Clem poured his prodigious energies into furthering the cause of what he called postpainterly abstraction. From his experience in the fifties he had learned the power a relatively small group can exert if they are united and have a respected publication behind them. He tried to secure an editorial position at Art News, which had recently been purchased by the Washington Post Company. In August 1962, he talked to James Truitt, the magazine's new publisher. Truitt loved the idea, but when Alfred Frankfurter, Art News's former publisher and still a powerful editor, heard about the plan, he smelled a takeover bid and fought Clem off.[14]

In November, Clem wrote James Fitzsimmons offering his editorial services to Art International. Fitzsimmons couched his response in enthusiastic and admiring terms, insisting he would never consider Clem as a mere member of his editorial staff but would welcome him as coeditor of the publication. Unfortunately, the magazine was in such poor financial health he could do nothing at the moment. The idea was put on temporary hold, where it remained, although Fitzsimmons was helpful in other ways.[15] Art International paid $75 for ten double-spaced pages of copy in those days, but Clem received double that amount.[16]

That December, Clem and Jenny's first daughter was stillborn at Doctor's Hospital in Manhattan; "gone anencephalic," Clem said. Jenny's mother, Vera Van Horne, was with Clem at the hospital when the news came. The baby was cremated on the twenty-second, and both parents took it hard. Jenny entered therapy with a Newtonian analyst recommended by Ralph Klein, and Clem drowned his sorrows in activity.

He was in considerable demand as a speaker, and important collectors such as Muriel and Alfred Newman of Chicago and Frederick Weissman of Los Angeles were beginning to consult him before making major purchases. In 1962 he gave his first seminar at Bennington College and embarked on the near constant travel schedule he maintained through much of the decade. His influence was growing but it was not yet what it would be. In October 1963 he proposed a piece on American painting after pop art to *Art in America*. In November it was rejected by editor Jean Lipman. In December his application for a Ford Foundation fellowship was rejected.

Clem was still smarting from his forced departure from *Commentary*. When his editorial feelers were rebuffed, he seems to have decided that he would never again have a formal position in either the literary or the art world. Indeed, he warned Bill Rubin[17] and Maurice Tuchman against institutional connections. Although his comments were couched in terms of Alfred Barr's experience at the hands of an ungrateful MOMA, an autobiographical element can be inferred. Tuchman recalled that before he left New York, Clem told him he was making a mistake: "He really tried to discourage me from taking the [curatorial] job at the Los Angeles County Museum of Art. He discouraged me from working for a museum. He said you give all you can to an institution, and they just throw you away like tissue paper. He had very much in mind the experience of Alfred Barr at MOMA, where they did almost exactly that, and Clem was indignant."[18]

Harold Rosenberg's *The Tradition of the New* was published in 1959. In 1961, just as Clem and color-field painting were beginning their ascent, Mary McCarthy reviewed it for *Partisan Review*. Harold's book had received many glowing reports, but McCarthy focused on the logical incongruity at the heart of the critic's best-known essay, "The American Action Painters," first published in 1952. Conceding the existential possibility that painters who cared only about the "act" or "event" of painting and not about the finished product actually existed, she expressed puzzlement as to why their presumably valueless efforts should be sent out into the world to be shown and admired as art.[19]

Rosenberg's response, "Critic Within the Act" (*Encounter*, June 1961),

deployed a brilliant but logically impenetrable smoke screen from behind which he dismissed McCarthy's objections as irrelevant, "a problem for the picture more than for events."[20]

Clem had waited nearly a decade to respond to "The American Action Painters." Nine months after Harold's riposte to McCarthy, he joined the fray. He had silently watched Rosenberg's meteoric rise, but even in his eighties he was not philosophical about it: "Harold started it [the competition between them]. He was after me for lots of reasons. We were daggers drawn at the end. I wrote first, but then he got bigger, so now they say Rosenberg and Greenberg instead of alphabetically."[21]

"How Art Writing Earns Its Bad Name" appeared first in the short-lived *Second Coming* magazine (March 1962) and, nine months later, in a longer, revised version in *Encounter* (December 1962). Rosenberg's "The American Action Painters" was his prime example. What followed was the intellectual equivalent of a shoot-out at the OK Corral.

Acknowledging the aptness of the name of action painting, Clem homed in on its seductive appeal: "The very flavor of the words 'action painting' had something racy and demotic about them—like the name of a new dance step—that befitted an altogether new and very American way of making art." Couching his comments in deliberately offensive language, Clem termed "The American Action Painters" a prime example of the kind of art writing to which he took exception: a style replete with fine-sounding phrases whose ambiguity succeeded in fudging substantive issues: "What made it ["The American Action Painters"] wonderful was that nobody stopped to ask what 'action painting' could possibly be if it was not supposed to be art." Objecting to critics who conceived of an avant-garde artist as if "he had come out of nowhere and owed practically nothing to anything before," an artist for whom "the painted 'picture,' having been painted, became an indifferent matter"; and one for whom "everything lay in the doing, nothing in the making," Clem picked up on Mary McCarthy's point, noting that Mr. Rosenberg did not trouble to explain "why the painted leftovers . . . should be exhibited . . . and looked at and even acquired by others."

Clem told how Harold transposed certain notions from Heidegger's and Sartre's existentialism to fashion a thesis that denigrated so-called extremist art. He argued that Harold's language was so imprecise, however, that even the artists he was presumably talking about were unable to articulate his position with certainty. Clem cited the example of Lawrence Alloway, in 1952 a young British writer at the start of his career—one of the few who admired "American-type" painting. Alloway then knew nothing of Greenberg but read *Art News* with some regularity. In 1951 he had seen Robert

Goodnough's "Pollock Paints a Picture," illustrated with Hans Namuth's still photographs.

Clem told how Mr. Alloway, lacking the "necessary perspective," missed the fact that in New York Mr. Rosenberg's essay was read as praise for the de Kooning faction of "American-type" painting, and that his attack on "unauthentic" artist who made "wallpaper" rather than art was interpreted as a reference to Pollock. Clem told how Alloway, with little direct experience of American art, supposed Pollock, the best known of the group, to be Harold's archetypal action painter and the essay a literal description of the process employed by a group Alloway identified as "Pollock & Co." In this distorted form, wrote Greenberg, Mr. Alloway "propagated Mr. Rosenberg's notions with such conviction and verve, and with such confidence," that they "became current overnight in England" and soon, "with the prestige" he conferred upon them, were "exported to the Continent," where these notions were taken to be the manifesto (European modernists routinely issued manifestos) of a group Alloway called "Pollock & Co." In this guise "The American Action Painters" influenced European artists who tried to re-create the process he described and the thinking of European critics.

Asking rhetorically what one could possibly say about the cohesiveness and clarity of a writer whose most famous piece was first read as "a veiled blow at extremist art" and later as its manifesto, Clem attributed Rosenberg's ambivalence to a lack of comprehension, an inability to "see" the new art: "It was the first look of the new American painting, and only the first look, that led Harold Rosenberg to take it for a mystification."

Broadening his tirade, Clem turned his fire on the British critic Sir Herbert Read, the Frenchman M. Tapi'e, and Robert Goldwater, his former friend (whose critique of *Art and Culture* still rankled), at whom he leveled a particularly lethal assault: "The same [inability to see] is true, moreover, of an academic avant-garde critic like Robert Goldwater (what with the speeding up of history, camp followers are no longer as patient as they used to be), whose essay on Mark Rothko, which is part of the catalogue for the Rothko retrospective now touring Europe, says hardly anything about its subject which is not equally relevant to Velázquez or Takenobu."

For Rosenberg's "literary discoveries" to seem to anyone to throw light on anything, Clem thundered, could be "explained only by the supposition that the blind actually prefer being led by the blind," which, he continued, "would also help explain Sir Herbert Read's present success as an authority on art."[22] Ridiculing the high-flying rhetoric and lack of historical perspective demonstrated by these critics, Clem branded the lot of them "inveterate futurists, votaries of false dawns, sufferers from the millennial

complex—and to that extent comedians like Mr. Rosenberg, who, back in 1952, greeted the beginning of the end of painting as art." All three accepted his challenge, but none, understandably, with a fury that matched Rosenberg's.

Like spectators at a tennis match, for three long years the monolithic art-head turned, first this way and then that way, transfixed by the bloody and public spectacle unfolding before its eyes. Maurice Tuchman recalled, "We were all very conscious of it. It made life interesting. . . . I didn't know anyone in any circle in the late fifties/early sixties who didn't regard this as the primary topic of entertainment. . . . It's what people talked about. Together Greenberg and Rosenberg constituted a real polarity in the art world, the likes of which haven't been seen since then."[23]

During the shoot-out, political jousts between the two appeared in *Encounter.* Rosenberg's art essays were printed in *Art in America* and Clem's in *Art International.*[24] Clem's precision, his deliberate naming of names, were in sharp contrast to the style of art writing he said was giving his discipline a "bad name." Clem's hard-hitting attack touched a nerve. Irving Sandler recalled that "much of the rhetoric we were using in the fifties tended to be very romantic, very existentialist. We needed something much more formal. We needed to back that rhetoric up with some formal analysis, and the pressure there came from Clem. From 1960, maybe 1961, to as late as 1967 or perhaps later, much as we argued with Clem's ideas . . . you had to take them into account, or even more, use them, because unless we did grapple with what he was saying, our ideas simply wouldn't stand up in the marketplace of ideas."[25]

The lecture that led to Clem's famous fight with de Kooning was published in October 1962, one month prior to the *Encounter* version of "How Art Writing Earns Its Bad Name." In that context, the public declaration of the demise of abstract expressionism, or the mannered form of it into which action painting had devolved, was read as an assault, not on Rosenberg's style of art writing but on his critical acumen. "After Abstract Expressionism" explored the origins of painterly abstraction to discover the intentions of Pollock, Baziotes, Hofmann, Gorky, and de Kooning as they turned away from the clean-shaven forms of conventional cubist abstraction.

Harold's name was never mentioned in the latter piece, but coming close on the heels of "Art Writing," Clem's assumption that he alone spoke for the "attuned eye" of the sixties led an infuriated Rosenberg to go straight for the jugular.

"The Premises of Action Painting," *Encounter* (May 1963), snidely referred to "Clement Greenberg, an advisor on masterpieces, current and future," an "old salesman" who passed himself off as an "expert," "purvey-

ing goods to the bewildered." Just as Harold never lived down his inability to "see" art, the market involvement charges he hurled at Clem for his association with French & Co. stuck to him for the rest of his life. Clem was quick to point out, though not in print, Harold's own experience in that area.

A year later Harold followed with "After Next, What?" (*Art in America*), a mocking reference to the historical progressivism implied by the title "After Abstract Expressionism." This time, he too refrained from using names but referred caustically to critics who view art history as a linear progression of styles: "Anything can be 'traced back' to anything, especially by one who has elected himself First Cause," wrote Rosenberg. But the war was over, as Harold acknowledged. Referring to Clem as a power-hungry dictator who had succeeded in gulling the public, Harold denounced the "Vanguard Audience" for its worship of "the new" and assailed false "prophets" who demonstrated their accuracy by "consigning to the critical rubbish heap any art that fail[ed] to take" the path they predicted. He decried the tyrannical desires of critics who tie "prediction to valuation" and "valuation to the assertion of power" and warned that "Hitler and Stalin were excellent forecasters of esthetic trends, so long as they were there to enforce them."[26]

It was an awesome display between two brilliant, merciless, larger-than-life opponents. They didn't kill one another off, but the wounds each sustained were permanent. Harold became the art critic for the *New Yorker*, a powerful voice among the sophisticated art-interested public. But even his friends, who admired his intellect and his ability to illuminate the points at which art intersected with other areas of culture, admitted that he never had an eye: "Clem was respected because he really could see art," Sandler commented. "No question in anybody's mind that Clem could see. Many of us, even friends and admirers of Rosenberg like myself, didn't respect or trust Harold's eye. His ideas could be wonderful, he was a great raconteur, a brilliant intellectual, but his ideas were never geared to the work of art. Clem's were. Clem's people [the critics attracted to him] were."[27] It was Harold's second chance to watch as, for better or worse, Clem transcended the role of critic to become an art power.

In 1962, Louis and Noland were included in the Carnegie International Exhibition of Contemporary Art, in the Carnegie Museum in Pittsburgh, Pennsylvania. That same year, they were among the Americans—Robert Rauschenberg won first prize—to represent the United States at the XXXII International Biennial Exhibition of Art in Venice. Louis had died a few months earlier and it was widely believed that had he been alive, he, not Rauschenberg, would have been the winner. "There was no question

Louis would have won had he been alive, but the prize was for a living artist," Andre Emmerich, Louis's dealer, said emphatically.

In 1963, Barnett Newman, who had not had a New York show for nine years before Clem gave him the opening exhibition at French & Co., was one of five Americans chosen to represent the United States at the São Paulo Bienal in Brazil. That same year there was a Louis retrospective at the Guggenheim. In 1965, Noland had a one-person show at the Jewish Museum. Noland was then so widely known and discussed that John Myers included him on his list of the four or five New York artists whose positions were "unassailable."

Clem prevailed in his struggle against action painting, but the victory was short lived. Vibrant and instantaneously popular, pop art became chic almost overnight. In 1962 Clem wrote: "Twenty years ago who expected that the United States would shortly produce painters strong enough, and independent enough, to challenge the leadership of Paris? . . . For a long while after it had actually happened you refused to believe it. You were convinced only when confirmation arrived from, of all places, Paris itself."[28] Two years after that pop art was on the six o'clock news. John Myers's scathing 1964 description captured the rapidity of the change in those two years: "At the Cedar Tavern one hears how splendid Mrs. Jackson Pollock looked televised, or what a lousy makeup job they did on [curator] Henry Geldzahler. . . . We watch mesmerized, as [painter] Al Leslie paints himself [on TV] . . . while diffidently confiding to his audience that his true goal is domestic serenity and a bit of financial security.

"Everyone asks the same questions: 'What happened?' Many painters in their forties and fifties wear a look—as grey as evening—which is a combination of surprise and incomprehension."[29]

Meanwhile, graduate students studying art history who were fed up with Rosenberg's efforts to "make rhetoric do the work of analysis," as Hilton Kramer put it,[30] began turning up at Clem's occasional lectures. And the same way "Art Writing" attracted fledgling critics, "After Abstract Expressionism" attracted out-of-town curators. In 1962, not long after his lecture at the Guggenheim, Clem attended a party at the Motherwells' where he met James Elliott, chief curator of the Los Angeles County Museum of Art (LACMA). They "hit it off," and 275 Central Park West became a regular stop on Elliott's New York itinerary. Soon, Elliott invited Clem to curate an exhibition of art after abstract expressionism for LACMA. His catalog essay comprised round one in his fight with pop art.

Post Painterly Abstraction (PPA) opened in Los Angeles in April 1964 and traveled to the Walker Art Center in Minneapolis and from there to the Art

Gallery of Toronto. Clem concentrated exclusively on antigestural abstract painting but made the exhibition as inclusive as he could within those limitations. He showed thirty-one painters. In addition to those whose careers he had helped launch at French & Co. were artists from New York, Washington, D.C., Vermont, and California: Walter Darby Bannard, George Bireline, Jack Bush, Gene Davis, Richard Diebenkorn, Tom Downing, Friedel Dzubas, Paul Feeley, John Ferren, Sam Francis, Helen Frankenthaler, Al Jenson, Ellsworth Kelly, Nicolas Krushenik, Alexander Lieberman, Arthur McKay, Howard Mehring, Raymond Parker, Ludwig Sanders, David Simpson, and Frank Stella, among them.

Clem believed color-field, imagist, or what he called postpainterly abstraction was the only style to have produced major art since the mid-fifties. Explaining why pop had been omitted from a show that claimed to be an exploration of art after abstract expressionism, he wrote, "Underneath all the emblems of far-outness . . . Pop . . . doesn't challenge taste" on anything more than a "superficial level." It fails to provide "new" experience, i.e., to release feelings otherwise untapped in our materialistic culture. Pop might be an "authentically new episode in the evolution of fashion," wrote Clem, or even in "the history of taste," but it was not "an authentically new episode in the evolution of contemporary art."[31] Pop was "Novelty Art," fun merchandise for novelty shops. It offered middlebrows a painless way to associate themselves with "culture," but was not a style capable of producing great art.[32] Clem initially responded to pop, not as an indicator of sociocultural direction, but as nonart, a temporary detour. "The good always prevails in the end," he told sculptor Michael Steiner.[33]

Post Painterly Abstraction was among the most controversial exhibitions of the decade. John Coplans's review for *Artforum* (summer 1964) reflected the attitude of many. Coplans accused Clem of trying to dictate what art should be, "of structuring the exhibition to assert a personal notion of style . . . to reveal what in his opinion the ambitious art after Abstract Expressionism ought to look like and what means it ought to employ to gain this look."

Echoing Rosenberg's allusion to Greenberg's autocratic inclinations, Coplans said the show reflected not the best or the most satisfying art of 1964, but the direction its organizer wanted to impose on art.

Clem relished being in the thick of things, especially controversy, and the museum too counted the cries and whispers as a sign that the dialogue had been focused on an issue that needed to be addressed. Maurice Tuchman was then a curator at LACMA: "The episode that made Clem close to us, to me and to the museum, was the show we did called *Post Painterly Abstraction*. That was Clem's main foray into guest-curating a very impor-

tant show . . . and he loved that. I think he loved that role. He loved being a tastemaker and he liked seeing people spend money, and he liked shepherding careers and getting people in the right institutions."[34]

Clem influenced—changed would not be overstating it—the way American art criticism was written. His ideas and his approach dominated the first half of the sixties. Even those who did not share his taste responded to his call for a more rigorous criticism that stayed close, not to abstract ideas gleaned from some historical or philosophical discourse, but to the art itself. His ideas entered the mainstream. They captured the attention of ambitious young artists eager to avoid the limbo of invisibility reserved for those too intractable to absorb the reality that surrounded them. "In the 1960s and early 1970s," wrote Robert Hughes, "more museum time and space was devoted to color-field painting than to any other American art movement or style."[35] Clem's ideas assumed the mysterious omnipotence that Tom Wolfe satirized in *The Painted Word:* "Theories? They were more than theories, they were mental constructs. No, more than that even . . . veritable edifices behind the eyeballs they were . . . castles in the cortex . . . mezuzahs on the pyramids of Betz . . . crystalline . . . comparable in their bizarre refinements to medieval Scholasticism."[36]

By the midsixties, art students all over America could recite by rote how Pollock's art broke painting's dependence on tactile, sculptural space and eased the way for others to go beyond the cubist grid toward the flat, all-over, atmospheric space of color-field painting.[37] "The business of flatness became quite an issue; an obsession one might say," Wolfe continued. "The question of what an artist could or could not do without violating the principle of Flatness—'the integrity of the picture plane,' as it became known—inspired such subtle distinctions, such exquisitely miniaturized hypothesis, such stereotactic microelectrode needle-implant hostilities, such brilliant if ever-decreasing tighter-turning spirals of logic . . . that it compares admirably with the most famous of all questions that remain from the debates of the Scholastics: 'How many angels can dance on the head of a pin?' "[38]

Accepting Greenberg's ideas might not make you famous, but such was the power invested in them that artists felt God would strike them dead if they broke one. Al Held was a painter who took such a chance. His origins were not so different from Greenberg's. Held was the left-wing son of Jewish immigrants and an accomplished cafeteria debater. Big, burly, articulate, and forceful, he could give and take with the best of them.

Held studied in Paris in 1950 and 1951. He thought of himself as a "formalist," but it was the formalism of Wölfflin and Roger Fry at whose altar he worshiped, which is to say a formalism stripped of the historical progres-

sivism Greenberg imposed. In Held's view the whole dictum about flatness and the integrity of the picture plane was "ridiculous," but he recalled with what fear and trembling he contemplated risking all for his conviction. Held not only banished color from his abstract paintings, but, heaven forfend, he broke the integrity of the picture plane. Held is well known in the history of postwar American abstraction, but he never ascended to the ranks of the heroes. There was no question in his mind that Greenberg was the obstacle in his path. He described what it was like for an abstract painter outside Clem's protection: "Many times I felt he was out to kill me—not me personally because I don't think he thought that much about me—but his presence and his influence made life for an abstract painter like me extremely difficult. A lot of my friends and peers simply fell by the wayside. His dogmatism . . . left no room for anything but his kind of narrow vision. And make no mistake, Clem had influence. Clem controlled the dialogue. . . . At that time—across the board—the most intelligent people in the art world took the integrity of the picture plane and flatness as faith. Even figurative artists accepted it. In my world it was gospel."[39]

15

The Second Coming: 1961–65

With the flawless timing that was the hallmark of his career, Clem's departure from *Commentary* coincided with a realization that launched the freewheeling art market that reached its apogee in the eighties when millions were happily paid for drawings that, not many years earlier, people had declined to steal. The American vanguard attracted European attention just as American collectors developed an appetite for impressionism and cubism. These same collectors suddenly perceived that over the last hundred years, much of the art ridiculed when it was first introduced had gone on to be praised and valued.

Artists poured into New York. Galleries multiplied with breathtaking speed. The sheer quantity of new art was dizzying. Circumstances cried out for an authority with a proven track record to sort the good from the bad and structure the process of selection

The rise in Pollock's prices, the publication of *Art and Culture,* and the international attention showered on Louis, Noland, and nongestural abstraction catapulted Clem into a league all his own. Although he routinely denied it, by the midsixties he had transcended the status of art critic and become an art power: "Clem's comments were taken like the word from on high; graven in stone. Clem was construed to have artistic infallibility," said the dealer Andre Emmerich. "I know. I was the beneficiary as were the artists I showed."[1] When Russell Lynes identified Clem as a quintessential highbrow, he described the chief duties of that rarefied species, one of which was the determination of par. For a large and influential segment of the art market, Clem established value, defined "quality." His taste affected the acquisitions and exhibitions policies of major museums and the collections of private individuals. His influence, however, while concrete, was also intangible.

Clem had no institutional platform comparable to that of Alfred Barr, for example, from which to mount exhibitions and educate viewers. His

power was conferred on him by the dealers, curators, and collectors who respected his "eye" and shared his "take."

Its development is probably more visible with hindsight than it was at the time. Not only did Clem lack an institutional platform, a title, an office to which he repaired each morning; he did not even command a regular paycheck. Clem and Jenny's only child, Sarah, was born in April 1963. Her birth coincided with this tumultuous and exciting period in her father's career. Recalling that period, however, Jenny Greenberg's memory was of an unemployed, "housebound" husband: "I was going out more, which was good. Clem was a totally devoted father. I sort of timed it on purpose. I was just beginning my theater interest when Sarah was born. [Jenny began her theater studies in the early sixties.] I sort of left her and Clem together. . . . She was not afflicted with two housebound parents."[2]

The origin of what became known as the Greenberg network was so gradual it was all but imperceptible. Membership was voluntary, unorganized, and in constant flux. In 1959, Clem traveled to Europe on behalf of French & Co. He made contacts among artists, curators, dealers, and collectors on behalf of the gallery. At each meeting, he found something fresh and substantive to say about the crucial role of modern art in Western culture and the special significance of postpainterly abstraction. In 1961, after French closed, *Art and Culture* demonstrated his prescience with regard to forties abstract expressionism. By then the success of Newman, Louis, and Noland had validated his judgment for a second time. Clem was bombarded with invitations to lecture, participate in panel discussions, jury shows. He loved to travel, see new sights, and search for new talent. He had an abiding interest in educating taste and increasing the audience for art he found deserving. The year French closed he lectured at the Art Institute of St. Louis and went from there to Oklahoma City, where he spent an entire day jurying slides for a local show. He traveled to Raleigh, North Carolina, to speak at the School of Design and took a detour to Georgia to see the Okefenokee Swamp park. From the Chicago Art Institute, where he lectured, he went to Buffalo, New York, for the dedication of the Knox Wing of the Albright-Knox Art Gallery, then took a cab to Niagara Falls and a bus to Toronto to visit the studios of artists he had met on earlier trips. He spoke at both well-known and obscure institutions. In 1963 he organized *Three American Painters: Louis, Noland, Olitski* for the Norman MacKenzie Art Gallery in Regina, the provincial capital of Saskatchewan, Canada. He was curious to see everything wherever he went, and this passion was one of his most appealing characteristics.

He usually spoke at museums, where his audiences consisted of the curatorial staff, trustees, friends, and members. Often there was a recep-

tion in his honor and drinks and dinner parties, at which he held forth. Actually, this accomplishment was no mean feat for a man with little talent as a speaker, poor social skills, and no knack for small talk. He learned to use the assets he did have to advantage, however, on the lecture circuit and in the parlor.

Clem radiated intellectual authority and moral conviction, a package leavened with a refreshing lack of pretense—or seeming lack of pretense. There was nothing smooth about him. Neither was his appearance prepossessing. But he could personalize his relationship with an audience. His lack of polish came across as a mark of authenticity; his warts-and-all demeanor conveyed a vulnerability with which many could identify. Sheer brainpower and an extraordinary ability to focus were prime assets. In panel discussions, for example, he easily grasped all sides of an issue and controlled the direction in which the conversation proceeded before his colleagues knew what had happened. But it was in the give-and-take of the question-and-answer period where he shone brightest. He was unfailingly gracious, radiated good cheer, and his early training among the PR crowd had made him quick on his feet. He could parry with the best. When controversy surfaced, as it frequently did, audiences often took sides. Some would be vehement in their support for his position and others equally vehement in their opposition. The former, however, often became converts, consulting him before they made purchases.

Wherever he went, he collected names (including correct spellings) and addresses. Clem was one of the last great correspondents. As the decade progressed, his terse, typed postcards, every second word abbreviated, became prized mementos in art communities the world over. In New York he made himself accessible to visitors. He invited people to phone when visiting the city—and in the sixties everyone in the art world sooner or later did—and many were invited for drinks. A steady stream of luminaries flowed through his living room, meeting one another, sharing information, making contacts. Clem was information central. In 1962, British writer/curators Alan Bowness and Sir Lawrence Gowing, in New York to select paintings for an American show at the Tate Gallery, came by to have a word with him.[3] Not long thereafter came David Collington of London's Courtald Institute; Dr. Ewald Rathke from Frankfurt; curators Henry Hopkins, Douglas McAgy, Charles Parkhurst, Peter Selz, William Seitz, Pierre Schneider, and Sam Hunter; Harvard scholar Sidney Freedberg; mega-collector Norton Simon; Pontius Hulton, later director of the Pompidou Center in Paris; Bernard Smith of Sydney, Australia; John Walker, director of the National Gallery of Art, Washington, D.C.;

Phillipe de Montebello, currently director of New York's Metropolitan Museum of Art; Martin Friedman of the Cleveland Museum of Art; and many, many more.

Clem was shrewd, informed, perceptive, and willing to be helpful. He could also be charming and good company. Although he was usually considered its archenemy, popular culture and the youth and energy it represented invigorated him. He loved to dance and knew the latest steps. He pursued pleasure as avidly as work; actually, he made little distinction between the two. He was a hawk on Vietnam but in sympathy with the social revolution and knew the words to many popular songs. One of his favorites was the Chad and Jeremy recording of "A World Without Love": "I don't care what they say, I won't live in a world without love," he would croon.[4]

Most nights, he had people for drinks, after which most went on for dinner and some to a dive called the Dome on St. Mark's Place. Barbara Rose encountered him there one night in the sixties: "I was sitting there with Frank [Stella] and the Avedisians. Bill Rubin walked in with Clem. Bill Rubin looked horrified and he said, 'Clem, let's get out of here.' Clem says, 'Ah, no, Bill. You gotta keep up.' 'Why do you have to keep up, Clem?' asked Bill. And Clem drawled in his raspy voice, ''Cause keepin' up is more fun than not keepin' up.' And then he asked me to do the frug and he was really good at it."

By the midsixties Clem's influence was widely visible. Asked to recommend someone to do David Smith's catalogue raisonné, Clem suggested Rosalind Krauss, with consequences we already know about. He recommended Kenworth Moffett for a National Endowment for the Arts grant just when Moffett's financial situation was most precarious. Moffett went on to become curator of contemporary art at Boston's Museum of Fine Arts. Clem suggested the Canadian writer Andrew Hudson to the *Washington Post* when the paper was looking for an art critic.[5]

Jane Harrison had been the London correspondent for *Arts* magazine. In 1963, Harrison came to the United States, bringing with her a letter of introduction to Clem from Leslie Waddington. Harrison came from one of those British families in which the young women were expected to pick up everything they needed to know about art, culture, and politics at the family dinner table. She was a good writer and eventually earned a considerable following for her criticism. Harrison, however, had neither a college degree nor advanced training in art history. After one year as part of Clem's circle, she recalled, "So much was coming my way that I felt I'd like to go to Harvard, that there was a lot I needed to learn. Although I'd left school at

the age of fifteen and had no degree, they [Harvard] said that if I promised to get a Ph.D., they'd take me into their graduate program."[6]

Clem had been proved right a second time and he relished his success, but it brought him little in the way of ease or contentment. During these years his art-world conduct began to reflect the influences of the Newtonian therapy he entered in 1955 and to which he remained committed. Clem was in therapy with Ralph Klein for six years. He married Jenny in 1956 and counted their first years together as among the happiest in his life.

In 1961, after their first daughter was stillborn, Jenny too began seeing a Newtonian therapist. Dependency feelings being the paramount problem for those of us raised in nuclear families, the Newtonians instituted remarkable schemes to interfere with the development of relationships conducive to their development. Newtonians encouraged their patients to terminate all contact with parents, siblings, relatives, and former friends.[7] To facilitate this break, they provided form letters for those who could not bring themselves to compose their own. Clem thought Martin, his youngest brother, was their father's "favorite." Once Clem entered Newtonian therapy, his and Martin's relationship essentially came to an end. "I remember Clem as an absence," Martin revealed. "He . . . held himself away. . . . The absence of personal relations with Clem has always been a disappointment in my life."[8]

Newtonians dealt with marriage, the relationship to which dependency feelings originating in childhood most frequently were transferred, by means of a technique we might call musical beds. Therapists urged patients to avoid focusing on one person by spreading their sexual favors around. "Saul Newton didn't like that I had a girlfriend," recalled sculptor Michael Steiner. "He didn't think it was a healthy thing. He thought I should have many girlfriends. I went in one day and Saul said to me, 'Have you seen Phyllis?'" Steiner continued, "I said yes and he started yelling at me that I shouldn't."[9]

The idea of a therapist interfering with a long-term satisfying relationship is hard to imagine, especially in the AIDS-infected world of the nineties. But in Manhattan in the fifties and sixties, sexual prodigality seemed avant-garde, daring, and an indicator of mental health.

By the late fifties Clem was an active advocate for these ideas, sufficiently intrigued to share them with his wife. This was the period when he gained a reputation for philandering with Bennington students. Bennington's ambience suited Clem intellectually and personally. The late Lawrence Alloway taught at the college for one year during the sixties. His wife, painter Sylvia Sleigh, described what Bennington was like when they arrived and why they left: "I'm something of a prig. . . . I find it disgusting

when professors run after young girls and the girls run after the professors. But I don't really blame the girls because, after all, the professors are supposed to give them a good example. One of the things that I think was a very great mistake at Bennington was they had this thing called counseling. . . . The girls would have weekly sessions with their professors, and of course the consequence was that they all fell in love. . . . When we got there, the girls were invited to faculty parties but not the wives. . . . Lawrence and I were probably the only two people on the art faculty that stayed married."[10]

Clem, however, found this manner of avoiding dependency feelings so felicitous he shared the benefits with his friends. In New York he gave parties to which he invited well-known artists and writers of his acquaintance and young women from Bennington, many of whom he had gotten to "know" when invited to critique student shows. Hilton Kramer knew nothing about Newtonian therapy or Clem's involvement with it, but he reported a puzzling phenomenon he had observed: "Clem did have a tendency in those days, with his younger male friends—and maybe his older ones too for that matter—of wanting to intervene in their personal lives. He liked picking out girlfriends for his male friends. He gave parties, and when you went to those parties, there were always very attractive young girls, many of them from Bennington. And, as it happened, I had an attachment at the time so it didn't interest me most of the time, but I knew without anyone ever telling me that it was not done that you bring a girlfriend with you to those parties."[11]

Jenny too became a convert to certain therapy ideals. Years later, her conversation was still sprinkled with the language ritualistically invoked by therapy enthusiasts. Asked if Clem was sensitive to her feelings, she gave the "correct" response: "Clem kept a very tight record of what he was feeling. . . . He didn't think about other people. He thought about himself. That's the healthy way to be. Sensitivity to one's self is what counts. Clem didn't try to figure out what anyone else was feeling."

Kenneth and Cornelia Noland separated. By the early sixties Ken lived at the Chelsea Hotel in New York City. His girlfriend was Mary Meyer, an attractive and well-connected Washingtonian, who was later killed while jogging on the towpath along Washington's C & O canal, allegedly because of her connection to John F. Kennedy. Ken, Mary, and Clem saw each other almost daily. Noland wanted to set up a painting studio outside New York. Clem suggested he checkout the area around Bennington, Vermont, and the year before Sarah was born—the year Clem gave the first of his two seminars in aesthetics at the college—Noland bought The Gully, a

farm formerly owned by Robert Frost in South Shaftsbury, near the college, where he was offered a teaching position. Noland could now afford to paint full-time, however, and recommended Jules Olitski for the job. In 1963, Ken and Clem together persuaded Olitski to accept the faculty position, and he too established his studio near the college. David Smith lived in nearby Bolton Landing, New York. He organized and equipped a welding shop on the Bennington campus, and Clem and Ken invited Anthony Caro to come for a visit. In 1964, Caro joined the Bennington faculty and, with Smith's help, learned to weld in that studio. Soon the Greenberg aesthetic was so identified with the college that among art-world insiders hostile to Clem, Bennington was known as Clemsville.

Greenberg visited occasionally. This was the period when his Manhattan living room was chronically inhabited by art insiders walking to and fro, talking of Louis and Noland. Collectors, curators, and critics from this country, Great Britain, and Europe came and went, along with American artists. Clem was the sun around which this galactic system spiraled. The innermost ring was composed of artists. The following alphabetical list includes those with whom his name was associated between 1960 and 1970. He did not rank them all equally and was much more involved with some than with others. Many, though not all, were color-field painters who showed at the Andre Emmerich Gallery: Walter Darby Bannard, Jack Bush, Dan Christensen, Ron Davis, Friedel Dzubas, Hans Hofmann, Morris Louis, Robert Motherwell, Kenneth Noland, Jules Olitski, Larry Poons, Frank Stella, and Larry Zox. Among the sculptors were Anthony Caro, Tim Scott, David Smith, Michael Steiner, and Anne Truitt.

By the midsixties Clem's relations with Barnett Newman and Adolph Gottlieb were no longer as close as they had been. Richard Diebenkorn figured in his diaries during the first half of the decade and Clem wrote favorably about his work in "After Abstract Expressionism" (1962), but he never became Diebenkorn's champion. Stella is not considered a Greenberg artist, but Clem included him in Post Painterly Abstraction, and Stella and his wife, Barbara Rose, were part of Clem's circle through those years.[12]

The second ring of the spiral comprised the core of the brilliant young art historians attracted by Clem's ideas about art and criticism. Michael Fried, who returned to the United States in 1962, was the pivotal figure. Soon after his return, Fried entered the Harvard Ph.D. program in art history, which, like the literature department, emphasized formal analysis as the basic approach to aesthetic determinations of value. Clem's ideas, championed by Fried, attracted Rosalind Krauss, Kenworth Moffett, Kermit Champa, and Charles Millard, along with Fried's former Princeton classmates, Walter Darby Bannard, Frank Stella, and Stella's wife, Barbara

Rose, just beginning her career as a critic. Many of these young historians rose quickly to positions of prominence, some as critics who, in their writings, frequently referred and deferred to their mentor.

The curators in his circle also respected Clem's ideas and liked the artists he liked, although their own tastes were usually more catholic. William Rubin became chairman of the Department of Painting and Sculpture at the Museum of Modern Art in 1966. Rubin was Clem's frequent companion from 1960 until the early midseventies, when their relationship abruptly ended. They had dinner together several nights a week, attended parties in one another's home, and often socialized with the same crowd on weekends. They visited studios together, often jointly selecting paintings for exhibition at Lawrence Rubin's European gallery.

At MOMA, Rubin exhibited many artists Greenberg did not admire along with some he did. Rubin wrote *Dada and Surrealism*, art styles Clem considered outside the mainstream. Clem agreed to edit the manuscript, however, and many of the extensive changes he suggested, Rubin incorporated.

John Elderfield, an Englishman, was part of Clem's circle in the early sixties and then again in the early seventies. He became a curator at MOMA. E. A. Carmean introduced postpainterly abstraction to Houston, Texas. Carmean was curator at the Museum of Fine Arts, Houston, in the sixties, and in 1974 became curator of twentieth-century art at the National Gallery of Art, Washington, D.C. In the late sixties, Henry Geldzahler was curator of contemporary art at the Metropolitan Museum of Art. Geldzahler took a lot of heat for his association with Greenberg when his influential exhibition *New York Painting and Sculpture: 1940–1970* was pilloried in the press for its heavy concentration of Greenberg-approved artists.

Emily Rauh, director, first of the Fogg Museum in Cambridge, Massachusetts, and then of the St. Louis Art Museum, admired Greenberg and the painters in the network. Kenworth Moffett became curator of contemporary art at the Museum of Fine Arts, Boston, and Charles Millard, a curator at the Hirshhorn Museum and Sculpture Garden, Washington, D.C. Clem knew Joseph Hirshhorn, for whom the museum was named, and Abram Lerner, its first director, sometimes consulted him as did many others.

Among collectors seeking Clem's advice were Patrick Lannon, of the Lannon Foundation in Santa Monica, California; Eugene Schwartz; Lewis and Judith Cabot of Boston (now Mrs. John C. Bullitt of Princeton, New Jersey); Virginia and Bagley Wright of Seattle; Gifford and Joanne Phillips, and Caroline and Robert Rowan of Los Angeles, the latter a founder of the forward-looking Pasadena Museum (now the Norton Simon Museum); Muriel and Alfred Newman of Chicago, the Schoenbergs of St. Louis; the

Gosmans of Detroit; Lois and Georges de Menil of New York and Paris; Frederick Weissman (whose collection is in the Weissman Museum) in Beverly Hills; and Vincent Melzac of Washington, D.C., to mention only a few of the Americans. Titled Englishmen such as Sheridan Dufferin, the Marquess of Dufferin and Ava, and his wife, the former Selina Guiness, entertained Clem at the Guiness estate in Ulster and saw him often in New York.[13] These people did not buy only Greenberg-recommended artists, but they often consulted Clem before making acquisitions.

Clem established business, and sometimes social, ties with influential New York dealers such as Andre Emmerich, Robert Elkon, Sam Kootz, Xavier Fourcade of Knoedler's, Frank Lloyd of Marlborough, Emmanuel J. Rousuch, vice president of Wildenstein and Co., and William E. O'Reilly of Salander-O'Reilly Galleries. Outside of Manhattan Clem had close ties with Nicholas Wilder and Everett Ellin of Los Angeles; Victor and Leslie Waddington and John Kasmin, of Kasmin Ltd., in London; Bogislav and Elizabeth von Wentzel, of Gallery Wentzel in Cologne; David Mirvish of Canada; Lawrence Rubin; and more. Soon this interlocking web of friends and acquaintances achieved critical mass. News of a secret army willing and eager to do Clem's bidding began to be whispered in hushed tones at openings and parties.

Having no official position, Clem's influence was behind-the-scenes and difficult to trace. No one knew for certain who or how many were involved. As time passed, however, with the help of this network, Clem had the power to take an unknown artist and make him the object of international attention. He had done this earlier on his own, first for Pollock and Smith, and then for Noland and Louis. But in each case it took ten years. Together the network could shorten the time period considerably. In 1959, in Toronto, Clem met Jack Bush. Clem thought his work showed promise, he and Bush got along, and a studio dialogue began. In 1962, Bush had a show at the Robert Elkon Gallery in New York and not long afterward at the Waddington Galleries in London. His New York opening was reviewed by Barbara Rose for *Art News* and by Michael Fried for *Art International*. Similarly, Ron Davis, a West Coast artist, met Greenberg in New York. Michael Fried did a major piece on his work for *Artforum*, and Davis, as he recalled, enjoyed his fifteen minutes of fame. When he fell from favor—for reasons never specified—the consequences were just as dramatic. According to the artist, it was as if a "light went out."[14] Abstract artists in New York, excluded from this golden circle, felt bitter, envious, even shamed.

Outsiders described the network as a disciplined army at Clem's command. His objective, it was said, was nothing less than control over the

levers of tastemaking power throughout the Western world. The reality was looser, less organized, and extremely fluid. Who met whom was based on probability rather than planning. Clem traveled a great deal. People came to New York when he was in the city or called when he was on the road. Clem had no formal relation to any institution. His influence was based on respect for his eye and his ideas, and on his talent for creating win/win situations. He never exercised complete control. Friedel Dzubas and Walter Darby Bannard were both close to him but neither achieved the level of success that Louis and Noland did. Clem turned against Frank Stella and never championed Ellsworth Kelly, both of whom were, and are, considered major figures.

Hess and Rosenberg commanded the art dialogue of the fifties from the pages of *Art News*. In the midsixties Greenberg did the same by means of *Art International* and *Artforum*. The first was a Swiss-based publication, printed in three languages, with a small but worldwide following. James Fitzsimmons, Clem's longtime drinking buddy, may have shied away from the prospect of having him as coeditor, but their tastes were similar. Fitzsimmons routinely printed letters opposed to Greenberg's position, but between 1959 and 1966 Greenberg-favored artists usually graced the magazine's monthly covers and critics sympathetic to the Greenberg position reviewed shows by important abstract artists.[15]

Artforum was started by three San Franciscans: Irving Blum, John Coplans, and Philip Lieder. When the contemporary art scene in that city failed to take off, they moved the magazine first to Los Angeles and, in 1966, to New York City. Lieder, the editor in chief, was close to Frank Stella and Mike Fried. Soon Fried, Darby Bannard, Barbara Rose, Roz Krauss, Jane Harrison, Ken Moffett, and the rest of Fried's crowd at Harvard were writing for *Artforum*. Barbara Rose observed, "*Artforum*, in the midsixties, was a publication dedicated to the propagation of Clement Greenberg's ideas."[16]

Max Kozloff had been *Art Forum*'s New York editor when the magazine was headquartered in Los Angeles. Kozloff, as we know, saw Clem as a dictator. He watched with horror as his magazine moved into the Greenberg camp: "There was a point where I would attend meetings at *Artforum* and the rap, the Greenberg line—about which were the most important artists—was in the air. Phil Lieder would talk about the legacy of Pollock as the one who had been appointed by the master [Clem], and the way things fell out from there. What the 'master' said, the editor picked up and built into a structure of infallible truth."[17]

"What made *Artforum* so powerful," Maurice Tuchman recalled, "was

not only that collectors were reading it, but that curators had to pay attention to it because of the sheer professionalism of the group. Clem argued very well, he was very frank, and he carried terrific weight, personally as well as intellectually, and as a writer. And then having this legion of followers . . ."

Soon, this small but able army of writers comprised the most widely read critics in the vanguard world. And given their shared taste, their effect on the market was substantial. Tuchman recalled the clout *Artforum* exerted: "Collectors, if they didn't read every article in *Artforum*, they certainly counted the paragraphs and bought accordingly. The influence of *Artforum* was more profound than that of the *New York Times*, which always influenced sales considerably. Any positive piece in the *NYT* guaranteed a sold-out show, but it didn't affect tastemaking and it didn't affect the building of 'serious' collections the way the magazines did. And foremost among the magazines was *Artforum* with this very small, fecund network of Greenberg-influenced writers all referring and deferring to Clem in print. That's the epoch that Rosenberg talked about as 'the herd of independent minds.' " Today critics don't occupy quite the same position. From 1960 to 1968, Tuchman continued, "Critics ruled the roost in terms of American pictorial life. Critics were the tastemakers . . . critics were the batters going up to the plate. They sent everyone around the bases."[18]

Collectors and curators who did not have direct access to New York City depended on magazines for news about what was happening. Desperate to find an authority able to separate what had lasting value from the latest flash in the pan, many took to heart Clem's distinction between "true" collectors and those attracted to art for secondary reasons. Any philistine with money could buy art, said Clem, but true collectors had taste, discrimination, and an "eye." They built their collections slowly, acquiring only first-rate examples by "serious" artists with a demonstrable place in the legitimate line of succession. This philosophy was widely adopted by those who knew nothing of Clem. For those who did, his every word was examined for clues to direction.

Part of the extreme animosity Clem aroused can be traced to the size of this market and the extent to which he influenced it. While larger than it had ever been in the past, the art market was small in comparison to what it would become. But Clem could affect the careers of artists and the prospects of their dealers simply by saying nothing about them. The sins for which he was most hated, in fact, were those of omission. He had supported no more than a handful of first-generation abstract expressionists, and a similar number of color-field artists. Those who were overlooked

questioned his eye, his objectivity, his ego. He was said to strike a Faustian bargain with those he favored.

By 1965 abstract painters and sculptors, locked out of the art discussion, realized they would have to take matters into their own hands. In *Studio International* the minimalist sculptor Donald Judd blamed Greenberg and the writers he dubbed "Greenbergers" (Paul Brach called them the "kosher nostra"). Judd suggested that by ignoring artists Clem did not favor or not reviewing the shows of those about whom he changed his mind they did Greenberg's "dirty work" for him. The "Greenberger" appellation soon spread to include artists as well as writers said to be in his sway.

From the inside, the view was different. The attacks on Clem were perceived as the same kind of envy and petty spleen to which he had been subjected since the late forties. To outsiders the network looked like a vast, well-organized machine in the service of the master. Those involved saw themselves as individuals functioning according to their own tastes and interests. In fact, both perceptions were accurate. The network was more of a cenacle than a group. Close connections sometimes formed, as between Ken Noland, Jules Olitski, and Anthony Caro, or Clem, Ken Moffett, and Lewis and Judith Cabot, or Noland, Caro, and Michael Fried. Clem knew and stayed in touch with a great many people, but they were not all friends of one another. Regulars had a social or professional acquaintance with the others and a one-on-one connection to Clem. He never had the power to compel obedience, but the shared tastes and objectives of his followers made them an effective force. But Central Park West was headquarters and Clem a casual but skilled host, with a talent for putting the right people together. There was plenty of liquor and usually some food. Information was naturally shared, and, more often than not, one thing led to another.

James Elliott left the Los Angeles County Museum of Art (LACMA), but through Tuchman, who described himself as closer to Meyer Schapiro's way of thinking than to Clem's, the latter's LACMA connection was maintained. Tuchman was working on Smith's first *Cubi* show—it became *David Smith—A Memorial Exhibition* after the artist's accidental death. When the show opened, he went to talk to Clem, one the executors of Smith's estate. "Clem was great with me about Smith," Tuchman recalled. "I wanted the museum to buy a sculpture and Clem gave me my choice of all the *Cubis*. I remember going to visit him on a Saturday. It was very generous of him to spend that time helping me choose a work, and I didn't think for a second that he was getting anything [financial] out of it. I think he really was very taken with Smith's work. We went over pictures. The

piece I wanted was called *Walking Man*. Frank Lloyd at Marlborough [working in cooperation with Clem] gave the museum amazing terms: we could pay out the forty thousand dollars any way we chose over a period of six years." LACMA became the first museum to own a *Cubi*. Later, Tuchman did a Louis show at LACMA, and a sculpture show that included artists Clem praised.

Clem was in his element. On any given day he might accompany William or Larry Rubin to Santini, as he did in the fall of 1964, to select three paintings by Morris Louis for a show at the Stedelijk Museum of Art in Amsterdam. Later that day he taped a discussion with painters Ray Parker and Robert Motherwell for New York's Channel 13, and still later helped Ken Noland hang his show at the Andre Emmerich Gallery. The following night he attended the opening and the dancing party that followed at Barbara Rose and Frank Stella's loft.

In a famous letter thanking Walt Whitman for sending him an advance copy of *Leaves of Grass,* Ralph Waldo Emerson praised the poet for having "the best merits," namely those "of fortifying and encouraging" other poets. Clem fortified and encouraged his chosen few. He was not equally close to all of the artists he admired. Caro, for instance, was British and maintained his distance; Olitski was moody and reclusive. But once Clem committed himself to the work, he committed himself personally as well.

Clem was often said to diminish—even castrate—the artists in his circle by depriving them of their autonomy, but they described his presence as empowering, at least initially. Clem knew the players—the dealers, curators, and collectors—and his opinion carried weight with them. He knew how the system worked, and once he decided an artist was worthy, no detail was too small to warrant his attention. He liked being consulted about marital problems, health problems, and the care and feeding of dealers and collectors. His correspondence included countless letters from artists and others, asking his advice on business but also on personal matters.

For artists unfamiliar with the commercial world his counsel could be invaluable. In a 1961 letter to Clem, painter Jack Bush—whose studio collectors frequently left empty-handed—recounted what happened when he forced himself to follow Clem's advice: "I showed only seven paintings and refused to let him see more." The collector left in a huff but returned and bought two of the seven.

When Bush was ready for a New York show, he moved to Manhattan and set up a studio at the Chelsea Hotel on Clem's advice. Clem instructed him not to meet potential dealers until he had thirty paintings, enough for two exhibitions, but to show no more than three paintings at any one time.

Three, said Clem, left them hungry. Five gave them an opportunity to make comparisons and judgments.[19]

Clem had a strategy for everything from installations to how artists should price their work. His experience had taught him about the lasting damage a bad installation can do to an artist's career, and he counseled those close to him to maintain control in this crucial area. Another of Clem's postulates was the necessity to support one another. Some artists were better than others when it came to installations, and those skilled in that area made a point of responding when another asked for help. When the need arose, Clem willingly functioned as the eight-hundred-pound gorilla backing them up.

The pricing strategy Clem favored reflected his Marxist origins. "One of Clem's basic precepts," Michael Fried recalled, "was that you never priced your art up to what the market could bear. That was one of the basic differences between him and David Smith. Smith always wanted to make them pay through the nose. Clem always felt that what you want to do is sell a lot, get the money, plow it back into your art. You got a bigger studio, hired a second assistant. You priced the individual piece low and kept things moving."[20]

American art defined the mainstream and Greenberger artists were king of the heap—or one of two main heaps. Bennington was a major production center, and Clem's visits, for which critics and curators who were part of the network often arranged to be present, were big occasions. There were dinner parties, dancing parties, and poker games in his honor. But the focus was art. "Everyone went around to Ken's studio, Jules's studio, Tony's studio," recalled Moffett, "and usually to those of [faculty members] Isaac Witkin, Peter Stroud, Pat Adams, and Vincent Longo." Pat Adams described what it was like: "We had a lot of fun together. Clem was the great defender of the experience of art and my whole effort has been to open up the avisual, so I loved having him around. . . . I invited him up prior to several senior exhibitions, and he would lead the criticism."[21] After David Smith's death in 1965, Clem often combined visits to Bolton Landing with trips to Bennington, where he usually stayed at The Gully where Noland had built a splendid studio and swimming pool. This was the sixties, the decade of assassinations, Vietnam, and the social revolution Clem liked to sing about. Ken Noland had an LSD doctor with a beard who drove a red Porsche and made house calls. Painter/professor Pat Adams had a ringside seat:[22] "The power for the artists must have felt enormous. The money was flowing. There was a lot of what was called 'flash.' Flash had to do with women and money and making it. . . . There was a fever.

There were parties. We danced a lot . . . and we really did drink. There were always two or three cocktails and then wine with dinner and whiskey after dinner. People worked very hard and played very hard. [At Bennington] studios operated around the clock."[23]

Curator Kenworth Moffett recalled it as a magical period: "It was almost like a mystical experience, you know? You go beyond yourself, you're ahead of yourself. You're flying. . . . We'd all get together for an opening or a party. 'Ken's hot,' someone says. Then we go to his studio. We all look and one painting is better than the next and then we say, 'Oh, let's see that again. Oh, yeah!' Then we'd go and eat and talk about what we saw, and then we'd come back and look again. And we'd go all night doing that. . . . It was thrilling, just thrilling. You were there with the greatest artist and the newest stuff as it was being made before your very eyes."

Over and over, the artists involved with this scene described their feelings about Clem in the most personal terms. Anthony Caro, who moved away from him in the seventies, still felt great loyalty: "Clem was like a father to me." Noland put it simply, "He was my best friend." Clem was a facilitator. He was a catalyst for each individual on whom he put his finger. "It's a lonely business being an artist. Clem kept you company . . . lively, intelligent, exhilarating company," said a woman sculptor in the group.[24] "Clem was like the sun. We all felt the heat." In that light, Pollock, Smith, Caro, Louis, Noland, and Olitski produced some of their best work.

In Greenbergian terms the pinnacle to which art aspired was the communication of "new" experience. This occurred when artists found new forms capable of eliciting sensations relevant to that time and place. His response when looking at the art was less arcane. Asked by an admirer how he knew when he was in the presence of great art, he said, "It makes me feel like I'm dancing six feet off the ground."[25]

16

Imperial Clem

The sixties, the only decade Greenberg claimed to enjoy, were the years of Imperial Clem. New art styles originated in America, often led by artists he championed. The American Congress, long suspicious of left-leaning vanguard artists, relented slightly and the State Department, touting the public relations advantages, officially sponsored *Two Decades of American Art*, which opened in Tokyo on September 12, 1966. At the invitation of State, Clement Greenberg accompanied the show as a kind of cultural ambassador. He was met at the airport by Donald Albright, the embassy's cultural attaché, who accompanied him in a chauffeur-driven limousine to the five-star Hotel Okura. The MOMA's Donald Strauss traveled to Tokyo for the occasion, as did Jasper Johns, James Rosenquist, Ad Reinhardt, and Louise Nevelson. For two months Greenberg traveled the country, lecturing about the new American art, talking to artists, giving workshops, visiting studios, and educating himself about Japanese art. In Tokyo he visited museums and lunched on oysters at Pruniers in the Old Imperial Hotel, often accompanied by sculptor Anne Truitt, then living in Japan with her family.[1] After being "debriefed" by Asian experts on the sixth floor of the Department of State, Clem was asked to accompany the show the following year when it traveled to India. Again he was transported in chauffeur-driven government cars, and again he spread the gospel according to Greenberg. Derek Guthrie, cofounding editor of the *New Art Examiner*, was in New Delhi when Clem arrived to conduct his famous lecture and workshop. Guthrie listened as, moving around the open-air museum in which the show had been installed, the famous critic paused before a de Kooning: "See the way de Kooning handles planes in space. . . . This is a quintessentially cubist handling, going back to Braque and Picasso. The only problem is that cubism died around 1912 when it became synthetic—so de Kooning is really continuing a dead tradition."[2]

American art became chic. Civilized countries vied with one another for the opportunity to demonstrate their cultural sophistication to the leading critic of the day. Clem was invited by the Art Council of Ireland to

lecture, tour the country, visit studios, and review *Rosc* (Gaelic for "the poetry of vision"), the first in what was planned as a quadrennial, Dublin-based, international exhibition of contemporary art.[3] In May 1968 he lectured in Australia and New Zealand and the following year in South Africa and later in West Africa. And wherever he went he spread the principles of Greenbergian modernism and the names of the artists who were making an historical contribution.[4]

Clem had thought long and hard about contemporary art. He had reputation, authority, and he was persuasive. For a long time after his visits "Clem says" reverberated throughout the land. Artists and critics hung on his every word and were quick to repeat what he said. In 1969, the Australian critic Donald Brook wrote "Clement Greenberg's Power Lecture," a sarcastic piece about the aftermath of his visit: "Greenberg . . . now stands revealed to us as all things to all men. Scarcely an Australian critic has failed to remark, often and always with approval: 'As Clement Greenberg says . . .' or 'has reminded us . . .' or 'has pointed out . . .'"[5]

Clem's opinions carried such weight that British and Canadian painters actually pooled their meager resources to fly Clem to London and Toronto respectively, to critique their work. So long lasting was his influence that in the mideighties, when Dore Ashton was invited to teach a special two-week course at the University of Alberta in Canada, she was shocked, and irritated, by the esteem in which he was held. "Clem had gone up there and staked out his territory," she reminisced. "I knew that before I went, but I never knew to what extent. Here was a whole community of Clem clones. He had been in their studios and they quoted him. . . . There was this whole provincial community at his feet."

In the meantime a vast, almost insatiable art-buying public materialized in the United States, not only on the east and west coasts but in the middle and the far Southwest. Dealers from the heartland were eager to get in on the action, collectors were hungry for information on what to buy. Everyone looked to New York and acted accordingly.

On a lecture tour in the late sixties Rosalind Krauss was taken to see private as well as public collections in St. Louis, Indianapolis, and other medium-size cities in the American heartland—cities not hitherto thought of as burgeoning art centers. What she saw astonished her: "The collections were all look-alikes. They all had a Noland and an Olitski and a Louis and a Warhol and a Lichtenstein and a Poons. . . . I went to all these places and I became aware that there was a sort of explosion of art collectors and art centers throughout the country. And they all had essentially the same collection. [Four of every six paintings were by Greenberg-

approved artists.]" Krauss was just then breaking from Clem, and it struck her that he was like a giant spider in the middle of a huge commercial web.[6]

The art market took off in the sixties when American corporations, suddenly aware that each new phase of modern art was first ridiculed and then valued, suddenly saw advanced American art as a growth stock. It took off so quickly and unexpectedly that neither laws nor longstanding traditions existed to regulate it. The urbane veneer of uptown dealers soon obscured a kind of free-for-all, as everyone competed for a piece of the same small pie. The countless gray areas that emerged were smoothly traversed by such cultivated practitioners as Leo Castelli, Andre Emmerich, Sidney Janis, and Frank Lloyd. Despite the vast web over which he presided, however, Clem saw himself as Mr. Clean, the disinterested observer whose motivation was beyond question. He freely involved himself wherever art he championed was concerned and he was rarely circumspect.

Morris Louis died of lung cancer in 1962. Louis's widow, Marcella Bernstein (Louis was the artist's professional name), the sole executor of his estate, found herself confronted with a situation for which no model existed.

Louis's life was his art. When other children wanted to drive fire trucks, he wanted to be a painter. During the thirties and early forties he lived in New York and tried unsuccessfully to interest dealers and critics in his work. Poverty and despair finally drove him from the city and he returned to his parents' home in Baltimore, Maryland, where he met and married his next-door neighbor Marcella, an educator by training.

Marcella was the family breadwinner. Louis devoted himself to his art. Eventually they bought an unattached house on a quiet, tree-shaded street in the upper northwest quadrant of Washington, D.C. Louis built himself a storage space in the basement and made a small, roughly twelve-foot square, sunroom off the kitchen into his studio. The problem Marcella confronted after his death stemmed from the limited space in that studio.

By the midfifties, Louis's paintings had outgrown his studio. He had to work in sections, unrolling and painting one segment, allowing it to dry, and rolling it again before he could proceed to the next. The finished painting was too large to be seen in its entirety in the studio. To see it whole he had to spread the rolled canvas on the living room floor. Louis's practice was to complete the visual image and then stack the rolled canvas in his basement, postponing final instructions as to direction—top/bottom—and size—the amount of white border surrounding the image—until such time as the painting was to be stretched and exhibited. Louis died in 1962 only months before his paintings were included in the Venice Biennale for the first time. In other words, he died just as his career took

off.[7] So few of his artworks had been exhibited or sold prior to that time that I. S. (Lefty) Weissbrodt, lawyer for the estate, estimated its total value at $164,000 and the IRS never questioned the figure.

Marcella found four hundred paintings stacked in her basement. While Louis had indicated intended stretching marks on many of those canvases prior to his death, he had not done so in all cases. As to those paintings that had not been marked for stretching, Weissbrodt explained the problem: "Without stretch marks these paintings could not be shown. They were not finished works." In other words, the painted images were complete, but in some cases the amount of white border had not been determined, and, therefore, they could not be stretched and exhibited.

Clem was the first critic to recognize Louis's talent. He met the artist in 1953 and included him in *Emerging Talent*, the show he organized for the Kootz Gallery in 1954. From then on Clem visited Louis's studio once or twice a year for the remainder of the artist's life. Louis valued Clem's judgment. When choosing paintings for a show, he often consulted him. Louis was the least obdurate of the artists Clem championed and today it is sometimes said that Clem told him what to paint and how to paint it. But in the early sixties William Rubin, not yet a member of the MOMA curatorial staff, often accompanied Clem on visits to Louis's studio. He insisted this gossip was absurd: "Morris would unroll a picture for us to look at in the living room. I would say something. Clem would say something. And Morris would make the final decision." Following Louis's death, however, the question of how to handle the unmarked paintings had to be addressed.

Marcella knew Louis would want those paintings shown. She invited Weissbrodt, William Rubin, Andre Emmerich, and Clem to Louis's studio to advise her on the handling of the estate. Among the decisions to be made was whether the unmarked paintings should be marked for stretching. The group's unanimous opinion was that the pictures deserved to be shown and that Clem was the only person with the expertise to do the job. "Clem was the only man in the country who knew the work well enough to be able to determine where the marks should go," Weissbrodt explained. It was decided that, so far as possible, the entire group would be present when stretching decisions were made, but that final authority was Clem's. No one was overjoyed, but Rubin recalled that given the beauty of the paintings, all felt Clem was "better than nothing."[8]

Marcella asked Clem to serve as consultant to the estate on all artistic matters. The initial task was arduous. Clem spent two long weekends in Washington just sorting the paintings: one pile for museums only; another for

important private collections; another for lesser collections; and so on. Only one painting at a time could fit in the living room. Each of the four hundred had to be carried up from the basement, unrolled on the living-room floor, examined, assigned to a pile, and removed by the preparators to make room for the next. Some of the unmarked paintings were marked for stretching on the spot, but others were stored at the Santini Brothers Warehouse in New York and marked only when they were to be exhibited. Over the nine years of Clem's involvement with the estate, his diaries include countless references to entire days spent at the Santini Brothers Warehouse going through the Louis paintings with curators or dealers organizing shows and entire days in the presence of Marcella, Weissbrodt, and often Emmerich and one of the Rubin brothers, determining stretcher marks. All offered suggestions, but "Clem was the expert," Weissbrodt noted. "His opinion carried great weight."[9]

Perhaps because Clem did not stand to gain financially—or then again, perhaps it was because he tended to think that if he did it, it was the right thing to do—he was the least discreet. Lawrence Alloway organized a Louis retrospective at the Guggenheim Museum in 1963. He had talked about the show with the artist, as well as with Clem, prior to Louis's death in September 1962. Afterward, Alloway combed through the paintings with Clem before selecting the ones he wanted. Prior to the final installation, he invited Clem to view the show. Assuming that the stretcher marks had all been made by Louis, he was shocked when the critic—seeing the paintings together for the first time—suggested some slight changes.[10]

Clem would not have shied away from such suggestions had the artist been alive and, right or wrong, he had no compunctions about doing the same thing after his death. But articles soon appeared containing what Clem called "misinterpretations" and "misconceptions" about Louis's work process and about Clem's involvement. In October 1962, a month after Louis's death, Daniel Robbins, of the Guggenheim Museum, writing in *Art News*, implied that a master puppeteer pulled the strings where decisions about Louis's art were concerned. Clem initially made no response but two years later, when Lucy Lippard wrote that Louis had disdained formal relationships "to the extent that he refused to decide the final dimensions of his canvases" and adhered to "principles of non-composition" that depended "heavily on accident,"[11] Clem took it upon himself to set the record straight. In a May 1965 letter to the editor of *Art International*, he responded to Lippard and, somewhat provocatively, to Robbins: "It is significant that nowhere in his [*Art News*] article does he [Mr. Robbins] mention just *who*, other than the artist himself, ever decided the final

dimensions of a Louis painting. Certainly, his stretchermakers never did, or his dealers."[12] (Emphasis in original.)

Clem, and the artists to whom he was close, believed Louis would have trusted Clem to mark those that were unmarked by him. They, too, valued Clem's advice in such decisions. At Bennington, the artists were in and out of one another's studios. They all made suggestions about one another's work and accorded Clem the same privilege. Louis cut his canvas to roughly the size a finished painting would be, but the painting itself dictated the amount of white border that looked best. Noland and Olitski spread an uncut roll of unprimed cotton duck over the studio floor or wrapped it around the four walls. Using squeegee mops or other unconventional techniques for applying paint, Noland, Olitski, and later Larry Poons and others, covered an entire roll in a single, nonstop session. The advantage was the feeling of immediacy communicated to the viewer. The squeegee combined with unlimited surface meant "you could just think it and do it," Noland explained.

The rhythm might peak or fall off several times during these long sessions, and the completed roll always included some moments of higher achievement and some when the energy fell off. Where painters in the past established borders before they began, color-field painters made that decision last. The final step in this process was "cropping," cutting from the roll the sections they chose to preserve, and discarding the rest. These paintings were not finished when the last stroke of pigment was applied but only after the stretcher marks were made. It was an untraditional technique but its roots were in the past.

As a technique, cropping dates back at least as far as Manet. It was used by Degas, among others. Pollock sometimes painted two symmetrical images on a single canvas and later separated them. Clem had a talent for spotting the best passages and a feel for framing them—choosing the width of the surrounding border—that showed them to best advantage. Painter Peter Stroud recalled going to Larry Poons's studio one night. Clem had been there not long before and the artist was ecstatic. He told Stroud that Clem was a genius. "I only found twelve good paintings in that roll, but Clem found more than twenty." The artists appreciated Clem's "eye" and often invited him to be present for cropping sessions. Edward Santiago, who worked for Jim Lebrun, the outfit that stretched and built the frames for Noland, Olitski, and others in the group recalled:

> In a lot of instances Mr. Greenberg was responsible in assisting the many artists he worked with in cropping their paintings. He would stand back with the artists, view the paintings, and give his

opinion. . . . Mr. Greenberg didn't make the whole decision. He did it with the artist. . . . I was present mostly with Olitski. Sometimes the cropping decisions were made in New Hampshire [at his studio], and if the stretchers were ready, we'd just put them on. But sometimes it would be done in Manhattan. I was usually present when it was in Manhattan. Unlike other artists, who cut the canvas and had it stretched before they made the painting, these artists would cover the whole roll. After, when Clem was present, they would tack or nail the canvas to a long wall and decide which sections would be paintings and where they [those sections] should stop, and we would place tape to mark the edges, leaving enough canvas left over to go around the stretcher bar.[13]

News that Clem participated in artistic decisions was soon being whispered throughout the art world. The word was that the artists did the physical labor and Clem made the decisions. Ergo, the paintings were his. In interview after interview artists outside his circle said the same thing. Louise Bourgeois, basing her information on the same data used by everyone else, was emphatic: "If Clem got half the cash that Jackson Pollock made, I think he deserved it. They were his pictures really. . . . I'm telling you he painted them. . . . He told Noland and all those people, 'You should do this, you should do that. That's no good. Why don't you do this?' He made the pictures himself. . . . How do I know that? Everybody said it." Today, collaborative efforts between artists and critics are not unknown but in the early sixties even the idea was heretical.

Clem never denied participating in cropping sessions. He even allowed himself to be photographed while doing it. He said he made suggestions but the artists made the final decision. Once Louis's reputation as a painter seemed secure and Clem was no longer involved with the estate, he attempted to clarify his role in the "completion" of Louis's work: "It mattered very much where Louis's canvases were 'cut,' and it continues to matter very much. The responsibility of stretching the many canvases he left unstretched at his death in 1962 fell upon me. I have followed his indications wherever I could find them, and where I could not, I have followed his practice. In either case there was plenty of guidance."[14]

Considering the extent of Clem's influence and the small number of artists he found worthy, a lot of envy and jealousy was directed at the chosen few. A paradigmatic story evolved to demean favored artists while simultaneously explaining that the artist speaking had not been rejected by Clem but had refused the Faustian bargain he demanded in exchange for his support. The story they related was essentially a variation of the one

told by Krasner after the debacle over her French & Co. show. The gist was that they rejected him because his price was too high, and not the other way around. Artists as varied as the late Herman Cherry, Al Held, and Clement Meadmore all described visits Clem made to their studios—he was diligent in that respect—along with their interpretations of what transpired.

In Meadmore's version, the critic walked around, examined each of the large metal sculptures or the more numerous small maquettes on display, and commented, "Why don't you put holes in the metal rectangles to show that the form is hollow?" As Meadmore told the story, this was an idea he had already tried and discarded. He said nothing, though, because he understood Clem's remark as a test. If he went along, demonstrated a willingness to accept "advice," he could be one of the boys. If he did not, he forfeited his chance. Meadmore said that he refused to demean himself or his art by taking suggestions from a critic, and the result was the one he anticipated.

Al Held told a similar tale. Clem walked into Held's studio—a long, narrow loft—and "sixty seconds later handed down his verdict." Ignoring everything the artist had put out for him to look at, he pointed to something in the far corner and announced, "That's good, I like that." Held's interpretation was that if he accepted the implicit suggestion and followed that line of inquiry further, Clem would return. If he then liked what he saw, he would help Held in his career. The emphasis in these stories was always on the artist's willingness to "sell his soul"—accept suggestions made by a critic. Again, Clem was his own worst enemy. In taped video sessions, he turned finished paintings on their side or even upside down, while the artist stood by, his silence communicating unquestioned acceptance of whatever the master did. Some appalled viewers said Clem reduced art's high calling to the status of yard goods trotted out for sale on Seventh Avenue. The English artist-writer Patrick Heron, who had once been a friend, accused him of degrading "criticism to the status of fashion picking."[15]

The artists involved with Clem saw it differently: "The lasting quality of a work of art," Noland explained, "the quality that emerges from contemplation and reflection, reveals the mind, insight, and feelings of the performer, the artist. . . . Clem was like the postman. He was the central meeting place, the intelligence waiting for whatever was coming up."[16]

One might argue, as William Rubin did, that turning the picture over was Clem's way of saying that that particular work was not entirely successful. Rubin's relationship with Clem ended in the early seventies, but the two were close friends in the sixties. Rubin insisted that the stories about Clem were way off the mark.

Clem made suggestions, but the artists made the decisions. . . . I can remember going into Jules's studio with Clem when the paintings were still on the floor, on the roll of canvas. Clem might point to something and say, "I see it there." And Jules might accept that or might not. But the great majority of Jules's pictures he cropped himself. Jules had a loft in the same building I did [in the late sixties], and I saw a lot more of him than Clem did. This story you tell me [about people saying the pictures were really Clem's] is absurd. I bought finished paintings from Jules and from Ken that Clem had never seen. I was in Ken Noland's studio at least seventy times, fifty of them with Clem. Ken's pictures were painted to be a certain size. Once in a while Clem might have said, "I think you have too much white around this canvas," and sometimes Noland agreed or even later decided he had been right, but that Clem made the final aesthetic decision is absurd. . . . Ken Noland struck me as one of the most headstrong individuals I ever met.

In the eighties Clem pronounced Jules Olitski America's best living painter. With that in mind Rubin observed, "Jules Olitski's opinion of himself was at least equal to Clem's. Jules is so filled with his own greatness and brilliance that the image of him as some nonexistent figure being invented by Clem is absurd. The point is, Clem didn't make artists do it. He made suggestions. They accepted them or they didn't. . . . Those artists were hotheads and prima donnas. Talk to their dealers. . . . Artists are scavengers. They'll take anything they can get, provided it's useful."[17]

Rubin, acknowledging Clem's many flaws, speculated that in this instance the long-lasting venom directed at him probably stemmed from the fact that he had deliberately violated a sacred taboo. In the fifties and sixties, despite modernism's many detractors, and despite those who said vanguard art represented a complete break with the past, art and artists were still imbued with a mysterious divinity. As instruments of the muses, their work was sacrosanct. To make a suggestion for improving an artwork was viewed as a desecration. This, of course, had not always been the case. Leonardo, Raphael, and Michelangelo accepted suggestions from their patrons. They may not have agreed with them, but they never questioned the patron's right to make them. And, Rubin observed, the recommendations do not appear to have affected the quality of their art.[18] Rubin recalled a lecture he attended at Columbia University in the late fifties. The well-known British art historian E. H. Gombrich, asked to speak about Renaissance painting, analyzed Raphael's *Madonna of the Chair.* During the discussion period, Meyer Schapiro queried Gombrich as to

whether he thought Raphael's picture would be improved if the arm of the chair on which the Madonna sat were slightly moved. Gombrich was "astonished and horrified," recounted Rubin. His attitude, as common in New York as in London, was that even to ask the question was a sacrilege. Rubin thought Schapiro had a point but could well imagine the story the English historian told when he reached home: "Gombrich was so astonished I'm sure he told his British colleagues, 'This Meyer Schapiro, he thinks he should repaint Raphael's pictures.' "[19]

When Rubin became director of the Department of Painting and Sculpture at MOMA, he continued to make suggestions to the artists he knew well and reported that they sometimes took them and sometimes did not. Michael Fried and Barbara Rose reported doing the same. But only Clem's suggestions were examined in the light of arguments common today in sexual harassment cases: Anytime a person in a powerful position makes a suggestion to one whose career he or she is in a position to affect, pressure is exerted.

Sculptor James Wolfe was never a member of the Greenberg inner circle, but he was ideally situated to comment on Clem's studio behavior. Wolfe had been sculptor Isaac Witkin's assistant at Bennington in 1967 when Clem was a frequent visitor to the studio. In 1969, he became Ken Noland's assistant. By then, Ken owned a building in SoHo where he lived during the winter and had his painting studio. His sculpture studio remained in Vermont where he summered. During the winter Wolfe lived at The Gully, looked after the property, and used Ken's studio. Clem, in and out of Bennington with some regularity, also stayed at The Gully. Wolfe was "inside" without being an insider, more an observer than a participant. "Clem was an art junkie," he recalled. "Going to studios was his obsession as well as his vocation." Soon Clem visited Wolfe's studio as often as he did the rest. Clem "wasn't trying to change content," Wolfe explained, "he was trying to ferret it out, make it more focused. The only problem you'd see with him was that he might be ahead of you. I was just starting to make sculpture then, and Clem would come into my studio whenever he was in Bennington. His comments were more than useful. They were an education. Clem was superb. He had a superb eye and he really cared about art. He might be brutally frank, but it was okay because he was basically sympathetic. Art was his whole life, you see. He was the only one I ever knew with that kind of voracious appetite for it. I don't have it."

Wolfe described Clem's procedure: "He'd come in and focus on aspects of a sculpture—what he thought was right or wrong, what might be too much, be carrying a lot of emotion—or not enough. For example, you

might get a dead spot that you couldn't see and Clem could spot that. . . . But it was always your sculpture. You could take things out and put them back in. You could try what he said. You didn't lose anything. It was different for people when he was only going to be there once. Then his coming in and making statements was hard to deal with. But for me, he came a lot and there was a dialogue."[20] As Wolfe experienced it, Clem's talent was in isolating the section of a piece where there was a problem. His suggestions were provisional. Neither he nor the artist knew in advance if they would work. Moreover, his "take" was subject to change, a fact he never denied. Something that did not "hit" him one day might elicit a different response the next time he saw it. As Clem understood it, his obligation in the studio was to be as honest as possible in reporting his response.

Jules Olitski told this story about one of Clem's last visits to his island studio in New Hampshire: "Usually, when Clem came, I'd put five or six paintings against the studio walls for his review. This time I put just one, the most extreme of the bunch and the one that, while painting it, scared me the most. Clem walked up to the painting, extending his arms as if to push it away. 'I don't know what to make of it,' he said. 'You don't like it?' I asked. 'It's beyond liking,' he said, 'let's see something else,' and he turned away." The first painting was put away and others brought out.

Clem grew increasingly enthusiastic. At the end of the session the paintings were stacked—those he liked best against one wall and those he liked less against another. After a break they looked at them a second time. Much later, they returned with flashlights in the early hours of the morning to look once more. The next afternoon they began the "weeding out" process. At one point, Jules brought the first painting out again. " 'That's it! That's it!' Clem bellowed. . . . 'Why were you hiding it?' " Told that this was the one at which he had thrown up his arms the day before, Clem grinned: "My eye's fresher today. So? I was wrong."[21]

The common goal was to achieve the best art possible. If Clem made a suggestion that "worked," improved a picture, everybody was happy. If not, it was pointless to adopt it. And for a long time—and this was the key to the system's success—general agreement existed as to what "worked." "That group of artists had to stick together," Wolfe observed. "The fact of their being together created a dynamic that wasn't happening most other places. And Clem was a great person to have in the middle making some sort of judgment. He wasn't another artist. He was a critic. The finest critic America had. They all had to respect that. And to fear it too."[22]

Clem came of age, intellectually, among a coterie that prided itself on carving paths through uncharted mental wilderness. Highbrows were supposed

to be out front. It was part of their job description. If Clem's positions had been quickly accepted, he would have worried that he was off on the wrong track.

As the sixties progressed so too did animosity toward Greenberg. Much attention focused on his relationship with Andre Emmerich, the dealer for many of the artists Greenberg championed. The question asked was the one Rosenberg so famously raised when he wrote about "Clement Greenberg, an advisor on masterpieces current and future." Was he disinterested, honestly reporting his responses to the art, or interested, guided by motives that made his judgments untrustworthy? By the mid- to late sixties the Emmerich Gallery handled Noland, Olitski, and Lawrence Poons, as well as Dan Christensen, Friedel Dzubas, Larry Zox, and sculptors Anne Truitt and Anthony Caro, all Greenberg approved artists. Emmerich was also the dealer for the Louis estate and that of Hans Hofmann.

The alliance between Greenberg and Emmerich began soon after Louis and Noland joined the gallery in 1960, shortly after French closed. Clem invited Andre and his wife for drinks with William Rubin (who brought the painters to Emmerich's attention), Rubin's then wife, Karen, and Ken and Cornelia Noland, separated but still friends. Presumably the talk turned to Andre's plans for marketing the two Washingtonians, and Clem doubtless had suggestions. Andre selected and installed both artists' 1961 shows and Clem attended the openings and parties but was not otherwise involved. After Louis's death, and as the market for his work continued to grow, it was incumbent on Emmerich to maintain a cooperative relationship with Greenberg, the artistic consultant for the estate.

Robert Miller ran the day-to-day operations of the Andre Emmerich Gallery during the mid- to late sixties. He explained that the art pie, though larger than it had ever been, was still small and that more and more dealers were scrambling for a piece of it. The Emmerich Gallery, however, was not among them. At Emmerich, the money was rolling in. As Andre said, "Clem's comments were taken like the word from on high."[23] Collectors interested in abstract art trusted him and bought accordingly. "Clem was the critic in residence, the backbone of the operation," Miller recalled. "A lot of time was spent trying to keep him happy."

Emmerich and the artists were the chief financial beneficiaries of Clem's largesse. By the late sixties the artists had achieved recognition, prestige, and money enough to live like collectors. They had winter studios in Florida or California, summer studios in New England, and lofts or town houses in Manhattan; they had assistants to help where help was needed. Emmerich became a wealthy man, his gallery among the most prestigious in New York. And Clem? The question of Clem's reward, and the conflict of

interest it presumably involved, fueled art-world gossip for thirty years. Given Emmerich's success and the belief of those outside Clem's circle that Clem was in it for the money, the painter Herman Cherry and critics Rosalind Krauss and Dore Ashton, among others, assumed that Clem received compensation from Emmerich. Rosalind Krauss, for example, said she could not prove it but believed it was true. Dore Ashton stated flatly, "I believe he was getting a sizable retainer from Andre Emmerich. I also think—we all did—that he was getting a commission on every painting, by one of his painters, sold anywhere in the world." Both Clem and Emmerich, however, stated that there was no financial arrangement between them. Emmerich insists that "Clem Greenberg never received any compensation from me."

Clem had taken considerable abuse over his connection to French & Co. His increased visibility meant he could count on more of the same and his threatened suits against the *Washington Star* and Hilton Kramer indicate that he was highly sensitive to the issue. Moreover, he was technically unemployed with no visible means of support. It was a situation tailor-made for the projection of fantasies. Artists he did not favor and critics whose taste he did not share saw him as a dictator. They were quick to believe the worst. After French & Co., however, it appeared that Clem never again risked his standing as a critic by entering into a financial arrangement with a dealer. When things got tight, he could, and did, sell artworks that had been given him by artists. In January 1962, for example, Alan Stone came to his apartment and purchased a 1946 Pollock, *Mad Moon Woman*, a Baziotes oil, and a gouache. He paid Clem $35,000 in cash.[24]

A curious notation appeared in Clem's diary for June 2 of that year. He indicated that he stopped by the Emmerich Gallery and then returned home by cab with a small David Smith sculpture and drawings by Pollock, Dubuffet, and de Kooning. During the next week Everett Ellin, a Los Angeles dealer, took the Smith, and "Richard Miller came over" with a view toward buying "a" Pollock.[25]

Were these Clem's own pieces that had been stored at the gallery? Were they artworks that had hung in the apartments of friends when he lived on Bank Street and been left for him at the gallery? Clem and Emmerich both claimed no memory of the incident. Emmerich guessed the objects had been dropped off at the gallery for Clem to collect at his convenience.

In the early sixties Joseph Greenberg distributed the deeds from some of his properties, along with the income they produced, among his sons. This plus lecture fees freed Clem from the necessity of a nine-to-five job. By 1965, the year David Smith died, his finances had improved. Clem was in

such demand that he commanded $300 for twenty minutes of his time; $900 for an hour.

Clem and Andre Emmerich had a love-hate relationship. On both sides professional respect was married to personal antipathy. Emmerich was a German Jew, the product of a cultivated environment. Clem could be charming, but Emmerich's old-world elegance and courtly manners were in marked contrast to his own. Emmerich profited financially by remaining on good terms with Clem but there were costs. Clem was in a position to throw his weight around, and he did. An April 9, 1962, entry in his diary reads: "Went to AE [Andre Emmerich Gallery] to help Ken hang his show. Bill R. [Rubin] came later." This neutral-sounding entry concealed the first round of a savage struggle according to Robert Miller, Emmerich's right-hand man in the sixties. Ken's show had already been installed by Emmerich, but the artist was unhappy with the results. Taking advantage of Andre's absence, Clem and Ken reinstalled it. What happened next was unheard of. The show was installed, re-installed, put back, and rehung. Noland recalled that future shows were installed when artist, dealer—and often Clem—were present. Emmerich says that he always allowed artists to take responsibility for installation of their shows.

Robert Miller now has his own gallery on Fifty-seventh Street, but his memories of those days are so extreme, so loaded with personal pathos, they hardly seem credible. "They [Clem and the boys] came close to destroying me in their own forceful mechanism," he recounted, speaking of the psychological torture he endured at Clem's hands and the "two brain tumors" he believed were the result. "The art world [of the sixties] was still very malleable, a little money and a few people could change the whole thing. The public was not knowledgeable and was gullible, which is how one person could exert so great an impact. . . . Clem operated by controlling people's minds. He controlled the minds of artists, curators, and dealers. He set up an international network. Andre was the weakest link, but he was the purveyor of the goods." Miller explained that as the demand for color-field abstraction increased, dealers all over the world had to go through Emmerich. He controlled access to the art. In other words, Emmerich received a commission on every sale by one of those artists anywhere in the world. "In exchange," Miller continued, "the artists gave Clem paintings. . . . It's a Faustian tale. Andre and the artists sold their souls to the devil. After they became rich, they were fearful of losing their place, their position, so they did whatever he [Clem] wanted. Clem used people as pawns in his own game, and he always knew exactly what he was doing. . . . He would tell Andre what Larry Rubin or John Kasmin, the London dealer, or David Mirvish, the Toronto dealer, had

done for him. If Clem was not happy, the artists threatened to go else-where. Clem didn't back individuals. He backed a mass product. . . . He took a merchandising approach to the art he *caused* the artists to create. It destroyed the artists in the end. . . . After they became rich, they were fearful that he'd drop them and they'd lose it all. They couldn't break away." (Emphasis added.)[26]

Miller had a wife, three children, and an expensive lifestyle. He, too, was unable to turn his back on the "money machine," as he called it, and was obliged to kowtow to Clem—accept and show artists Clem wanted whether Miller liked them or not, swallow the scorn and sarcasm habitu-ally meted out to him and to Andre, and stand by while artists he admired were—as he thought—destroyed: "Dan Christensen, for example, had a fascinating series of ideas. But then for more than a decade the squeegee ruled, and the plastic, gold baguette frame was the symbol of the clan." In Miller's view Clem was unrelievedly evil. Miller blamed Clem for every-thing from the commercialization of the art world to the decline of the cul-ture as a whole: "You have to draw the line. You can't only go where the money is. With Clem there is a furious disregard for the ability of art to uplift us."

In its broad outlines, Miller's story is an extreme version of the common art-world perception, but it differed in one important respect. Most in the art world believed Clem was on Emmerich's payroll. If this had been the case, presumably Miller, Emmerich's right-hand man, would have known about it or have at least heard whispers to that effect. Certainly he had no interest in protecting either Emmerich or Greenberg. Miller, however, said flatly that if such a relationship existed, he had never heard anything about it, never suspected it, and doubted it was true. Moreover, it appears that Clem did not receive a commission on sales. Dore Ashton suggested Mar-cella Brenner could put that question to rest. Brenner, however, said no such arrangement existed. She stated, and Weissbrodt, the lawyer for the Louis estate confirmed, that "Clem received no commission on sales." Emmerich subtracted his share, plus expenses, and the rest he sent to Mar-cella, said Weissbrodt.[27] Noland, too, said Clem received no commission on the sale of his paintings.

As Miller indicated, Clem received paintings. So many that he was forced to store the overflow at the Santini Brothers Warehouse and then at a less expensive facility. Beginning in the forties, Clem accepted gifts from artists whose work he admired, a custom common in Europe and widely practiced in this country as well, although certainly an ethically question-able arrangement. Artists often give paintings as thank-you gifts to their friends, to critics who write nice things about them, and to curators who

include them in museum shows. The gift is given after the fact and the presumption is that it is a token of appreciation, not a bribe. When those receiving such gifts need money, they sometimes sell the art. Frank Stella gave his friend Michael Fried a painting from his famous black series. Fried sold it and bought a house with the proceeds. Stella thought that was fine, according to his then wife, Barbara Rose.[28] Helen Frankenthaler had a painting delivered to Dore Ashton after Ashton gave a favorable review to one of her shows, and the critic had no qualms about selling it.[29]

As the prices for art by those Clem admired skyrocketed, the quantity of gifts to him increased. Beginning with Pollock, Clem routinely visited the studios of artists he was close to prior to exhibitions and helped select and sometimes name the paintings to be shown. In the sixties, cropping decisions were routinely made at this time and Clem was actively involved. He commonly received a thank-you gift after these sessions.[30] Sometimes he was invited to choose a painting on the spot. At other times the artist sent him something later, stipulating that if he was not pleased, he could trade for something else.[31] Clem, in effect, retained the right to receive as a gift the best or one of the best paintings from each show. When paintings are given as gifts, the artist forgoes his normal return and the dealer receives no commission. In this way respect for Clem and the value they placed on his contribution were acknowledged. When Clem needed funds, he sold paintings. It was the artists who initiated the practice and controlled it.

Had money been Clem's primary objective, "he could have made a lot," Leo Castelli commented. With his status, many collectors would have leapt at the chance to back him in a commercial venture. Barbara Rose's comment was apt: "Clem could have been the pope. It's interesting that he didn't choose to be." Larry Rubin, another of those who described Clem as being like a father to him, recalled that the critic lived modestly and "never had any money." Rubin sent Clem a case of good Scotch at Christmas and sometimes on his birthday.[32] Some dealers—Samuel Kootz and Frank Lloyd, as well as Rubin—made their vacation homes, complete with staff, available to Clem on occasion. The dealers paid all expenses, including travel, for Clem and his family.[33] Clem asked for—and received—no other compensation. At the time of his death, he had accumulated paintings but little else in the way of worldly goods. He lived comfortably but modestly. He did not amass houses, cars, yachts, or even expensive clothes. Restaurants were one of the few luxuries he allowed himself, and he was contemptuous of those, like his father and brothers, who ordered with an eye to the right side of the menu.[34] He dined at pricey establishments several times a week during the sixties, including the Oak Room at the Plaza, La

Côte Basque, or trendy places such as Elaine's, but he always went with a group and others often picked up the check. He entertained frequently and his liquor and cigarette bills must have been prodigious. But his rent-controlled apartment cost $600 a month. He bought a suit during the early fifties, a tux before his wedding, and a hat at some point in the sixties, but he never cared about being fashionable and his diaries record few other purchases. He loved opera but usually went as someone's guest. Clem had a curiously ambivalent attitude about money. He enjoyed what it could buy, and was never stingy with it, but he was snobbish about how it was acquired. To be paid for one's expertise was acceptable, but to purvey goods, even art, smacked of being a shopkeeper—a status his father found so repugnant he sold his share of the profitable clothing business he and his brother had established in Norfolk, Virginia.

The marketing strategies shared by many of the artists involved with Clem and the mores of his social circle suggest that the critic's socialist origins continued to shape certain of his attitudes. Michael Fried's feelings toward Clem are bitter, at best, but there were some things he admired:

> Clem gave very good advice to artists about the market, and the artists gave him paintings. But he was not a greedy man. That whole generation wasn't into money. They made a lot but that's not what they went into it for. There was a whole different ethos and it was extraordinarily generous. As a young person in that world, you never paid for anything. Whoever was making the most dough picked up the check.
>
> The whole time I was in the art world . . . I never paid for a thing. One of those artists or Clem picked up the check. And Clem was always hosting, providing drinks and some food. So there was this ethos of generosity that absolutely prevailed—but the money didn't basically change your lifestyle. It was a generation without any pretensions, without any bullshit. Very unspoiled by whatever success reached them. That's true of Frank [Stella] too. He may have race-horses and stuff, but he's the same person. In some way Clem presided over this ethos and it was very attractive.[35]

Clem took pride in the fact that artists he admired wanted him to have their work. He bragged to a cousin that he never paid for a single object in his collection.[36] These gifts reflected real respect and gratitude. Those outside Clem's circle claimed that he took unknown artists, accepted their paintings as gifts, then made them famous and cashed in. In other words, he was accused of being a dealer masquerading as a critic. But Clem

encouraged many of these artists for years before the world paid attention, and in a thirty-year period, he claims to have sold no more than thirty artworks.[37] More importantly, the gifts continued to arrive long after his active participation in the art world ended and long after animosity toward him had reached the point where his praise was the kiss of death. Elizabeth Higdon, then an art history professor at Duke, lived with Clem in 1984 and 1985, by which time he was denounced with awesome regularity. At that time, however, Higdon recalled that a steady stream of paintings flowed through his apartment: "At least two a week and sometimes more."[38]

Clem's father died in 1977 and left him roughly $25,000, a bit less than what was given his brothers. "He thought I was better off than they were," Clem explained. Jenny's mother also died during the seventies, leaving her roughly $300,000. For Clem's consulting services to the Louis estate, 1962 to 1971, he received a total of $20,000—$2,000 a year for the first seven years and $3,000 for the last two—plus eight paintings of his own choosing. As an executor for the David Smith estate—1965 to 1973—he received expenses and in 1973 a lump sum payment of $183,200. (At Clem's insistence the three executors agreed to accept half the amount due them to partially offset some investment losses suffered by the estate.)[39]

Married or divorced, Jenny invested their joint monies, and for a time she did fairly well. Higdon recalls Clem saying that, in the mideighties, Jenny's and his shared income was roughly $100,000 a year,[40] although Jenny places that figure at less than a third of that amount. If an unexpected expenditure was required, or if the market declined and with it their income, Clem sold a painting. Much of their accumulated capital was lost not long before his death, however, when the accountant to whom Jenny had entrusted a half-million dollars absconded with the funds. At the time of his death, the art in Clem's collection, together with the value of the books, papers, journals, and correspondence still in his possession, constituted the bulk of his estate.

People saw Clem as grasping or generous depending on where they sat. Some of those who became rich as a consequence of his efforts viewed him as greedy. Those who were poor described him as generous. Sometimes complaints about money screened other feelings. Emmerich and Brenner, for example, both termed him greedy. Marcella Brenner was a professional, but, as she put it, Clem "treated me as little more than a lackey." He never accorded her work the respect it deserved—never asked how she was or expressed an interest in the school under her control. In fact, he became indignant if her work meant she was not immediately available to do his bidding. "Clem projected a regal assumption which then became true," she said, marveling a little at his ability in this respect. "He behaved as if he was

a great man and you, naturally, would defer to him—take him to lunch, pay attention, do his bidding." She believed his attitude was merited professionally, but "when the professional mixed with the personal, he thought it was warranted there too. You were supposed to pay court to him."

In light of how badly their relationship ended, it is well to have Weissbrodt's assessment up front: "I did not like Clem. I didn't exist where he was concerned. He did not value my contribution [with regard to the handling of the Louis estate]. . . . But Clem exemplified real courage. He was willing to take unpopular positions and he had a real talent. It's entirely possible Morris would not have made it had there been no Clement Greenberg. . . . If Clem had not had the vision, nothing would have happened . . . and you can't place a value on that."

Contrary to the image he projected, Clem often had trouble asking for compensation. He either overreacted and was excessively demanding or requested nothing, then took it personally if the amount proffered was less than he felt was deserved. In the case of the Louis estate, he left the matter of compensation entirely to Weissbrodt and Brenner. Although Weissbrodt quickly acknowledged that Clem was the only man in the world who knew the paintings well enough to mark those that were unmarked for stretching once Louis was gone, he advised Marcella to pay him only a modest sum for his consulting services: "Clem could have asked for more, but it would not have been good for Morris's reputation. . . . It might look as if Clem were being paid off for making Morris famous. I knew that was absurd but my job was to protect my client's interests."[41]

Knowing how Clem felt about Louis's paintings, Brenner devised a compromise. Every year that Clem was involved with the estate, he received a letter and a check on the Jewish New Year. The letter included an invitation to select a painting for his private collection. In 1962, prior to Louis's inclusion in the Venice Biennale, his paintings sold for between $2,000 and $3,000. After the Biennale, his price climbed to $10,000. By the end of the decade, it was $50,000 and climbing.[42]

Emmerich and Brenner both felt that it was greedy of Clem not to voluntarily relinquish his annual painting once it became so valuable. Brenner valued Clem's counsel on placing and marketing Louis's work and was reluctant to terminate his services as a consultant, although Weissbrodt advised her to do so. In 1970 she sent Clem a check, as usual, but her letter made no mention of a painting. When Clem called to arrange a time to make his selection, she told him there would be no more paintings. The conversation was followed by a tactless, even insulting letter from Weissbrodt, formally terminating that part of the arrangement. Despite Brenner's entreaties, Clem finished out the year for which he had been paid and

ended the relationship. What is interesting is that he never claimed to have been treated badly. Asked what happened, he said Brenner got fed up and "she pushed me out."

By the end of the eighties, the backlash against Clem and continued allegations about his market involvement had made him sensitive and he refused to acknowledge any connection with Emmerich and treated the suggestion that the dealer may sometimes have consulted him about market strategy or anything else as an accusation. But in the sixties, he often bragged about his relationship with Emmerich. Clem certainly presented himself as Emmerich's adviser. Maurice Tuchman commented: "We would never ask him whether it was fiduciary or not, but I assume that he was paid for it. He would say, 'Andre screws everything up. He does everything wrong.' . . . Clem was always indignant toward Emmerich about something. I assumed that it was because Andre wanted to do things his way. He was the dealer."[43]

Tuchman thought Clem gave better than he got: "Clem did the French & Co. thing in 1959, and he was so up about that. He was really responsible for that year or two-year contract. But with Andre, he thought the guy was just pushing too hard or not pushing hard enough. He always was critical of the strategies. He found Emmerich a bit incompetent. But it was Andre who got to laugh all the way to the bank."[44] William Rubin recalled buying a painting once from Clem and commented that he would have paid more but that Clem was never greedy and did not ask top dollar.[45]

In Clem's version of this story, you recall, he noticed the financial imbalance between him, Emmerich, and the artists only after the fact. Reflecting that neither Emmerich nor the artists had reason to complain about their relations with him, he told Al Held: "One day I woke up and they were all rich and I was still poor."[46]

Max Kozloff's ruminations about Clem as an independent power illuminate the complexity of the issues:

> This was a very primitive time. Obviously there was no hesitation whatsoever in accepting, for services rendered, certain paintings such as those he [Clem] was treating in an exalted fashion in his criticism, criticism which everyone knew to be calling the shots as far as the collecting classes were concerned. So clearly there was a pecuniary interest. Now I'm not for one minute assuming that was his motive, but that was certainly his reward. Today there are a lot of people who do this—young people—who are moving into curating for various private galleries and get commissions. And that's stupefying. . . . With Clem it's really power. Orson Welles said once about

Hollywood that the people in it—the big producers—don't go into it for money. Why? Because there are all sorts of other things that are much more secure and higher paying. They go into it for power. And so the attractions for a critic were certainly not financial even if, in fact, there were little deals that could be cut and means were supplied to live comfortably through the back door. No. [At that time] critics went into it for power. Intellectual power. Power over people's minds. Power over people's opinions. Power over objects.

Was Clem involved in the art market? He was in it up to his ears, but not for the money. Clem wanted intellectual hegemony. He wanted immortality. He wanted his name in the history books.

How successful was Greenberg? If his intention was to capture the levers of tastemaking power in the industrialized world, he obviously failed. Despite his best efforts, art went its own way. In 1969 he told interviewer Lily Leino that art critics had a responsibility to help elevate taste, but they could not control it: "Critics can direct your attention; then you look for yourself. Critics are manipulators of attention, which is not the same thing as molders of taste. . . . You [have to] make your own way through art. . . . Or rather you ought to; if you don't you're missing most of the fun."[47]

Clem was arrogant. He made his own rules and valued his opinions more than those of others. But he brought intellectual rigor and great personal integrity to the job of art criticism. Clem thought pop art lower, or less ambitious, in aesthetic terms than either abstract expressionism or color-field painting. Nevertheless, in his judgement, the ideas pop embodied were sufficiently serious to make him return to his typewriter one last time.

Not long after the French Dadaist Marcel Duchamp's *Nude Descending a Staircase* shocked Americans in the 1913 Armory Show, the artist put his name on store-bought objects—bottle rack, snow shovel, urinal—which he then exhibited as original artworks. This seemingly outrageous act proved to be the tip of a theoretical iceberg. Placed in a museum context, a snow shovel or and even a urinal is looked at differently. It is experienced aesthetically in terms of form, color, and the material properties of its medium (painted metal, shiny porcelain). In this elliptical fashion, Duchamp's "readymades" questioned the act of "making" and the importance of originality as fundamental properties of art.

Distilled through the mind of John Cage, these ideas entered the New York art world in the late fifties. Andy Warhol's *Brillo Boxes* and minimalist sculptures got much of their conceptual edge from the fact that they could

be, and sometimes were, designed by artists but fabricated by workmen in factories. Warhol even called his workplace The Factory.

It is sometimes said that Greenberg made up his mind about modern art in 1940 and never changed it, but this was not entirely accurate. As the French writer Thierry de Duve pointed out,[48] Greenberg's experience of Duchamp's readymades persuaded him that, however unpalatable, the logic of Duchamp's observation had to be worked through and assimilated. Toward this end Greenberg the critic, made a rare foray into the realm of philosophy. In 1971 he offered a series of nine seminars at Bennington College[49] and signed a contract with Beacon Press for a book tentatively titled *Homemade Aesthetics*.[50] Beginning in 1973, he published eight essays, all titled "Seminar," in which he presented some thoughts on the subject: "If anything and everything can be intuited aesthetically," he wrote in "Seminar One," "then anything and everything can be intuited and experienced *artistically*."[51] Greenberg's experience of Duchamp's readymades had demonstrated persuasively that it was logically impossible to draw a line between art and nonart. Three years later he wrote: "The notion of art, put to the test of experience, proves to depend in the showdown, not on skillful making (as the ancients held)" but on an act of distancing. "Art, coinciding with aesthetic experience in general, means simply, and yet not so simply, a twist of attitude toward your own awareness and its objects."[52]

Duchamp concluded that art was whatever the artist said it was, and in this country artists declared, as Rosenberg had done in 1952, that value judgments were no longer relevant. Greenberg allowed that art might be whatever the artist said it was but he disputed the centrality of the observation. The critical distinction had never been between art and nonart, he maintained, but between good and bad art.

Clem rarely wrote about individual artists at this time but his thinking was publicly reflected in a subtle shift of language on the part of his followers. "Quality" replaced "advanced" as the Greenbergian adjective of choice. In "Quality, Style and Olitski," Walter Darby Bannard's 1972 review of a Jules Olitski exhibition,[53] Bannard spelled out, in somewhat simplistic and patronizing terms, the party line on "quality," celebrating Olitski as a prime exemplar.

At war with Greenberg, Phil Lieder, editor of *Artforum*, published Bannard's piece and, immediately following, a response attacking its basic premise from a Duchampian perspective. Sculptor Bruce Boice's *The Quality Problem* reflected the views of minimalist sculptors such as Tony Smith, Robert Morris, and Donald Judd, who felt the term "quality" was being co-opted and redefined to exclude all but Greenberg approved artists.[54] Unable to attack Greenberg directly, they assaulted the legitimacy

of standards in general: "At issue," wrote Boice, "is the relevance of evaluating art work in terms of quality, or in any other terms."[55]

As art he termed "less ambitious" swept New York, Clem withdrew, although his invisible presence continued to hover over the art scene. The Krauss piece that proved him vulnerable appeared in 1974[56] and the blood bath began. By the end of the decade Greenbergian standards and values no longer dominated the multicultural, urban, and highly politicized art world that was evolving.

It had been Clem's hope that Bennington, with its distance from New York, would safeguard "quality" artists from the pressures toward conformity exerted by the city. But, as he had earlier observed, the forces shaping art and artists reflect the larger sociocultural context. These forces, in concert with the backlash against him, affected the lives and careers of many of the curators and critics associated with him, but most profoundly the lives and careers of the artists involved. A sculptor close to Clem commented dryly that if the artists had held their ground the "renaissance" Clem envisioned might have occurred: "It was like the croquet game in *Alice in Wonderland*. If the flamingos [used as mallets by Alice's team] would have cooperated, they could have won the game."

Clemsville:
A Secular Halakah

Some men mellow with age. Not Greenberg. Age could not wither nor recognition stale his infinite contentiousness. Clem rarely forgave and never forgot a sign of disrespect. In 1941, Greenberg and Saul Bellow, who cut their writers' teeth together as part of that famous "family" of New York intellectuals, had a disagreement. Angry letters were exchanged. A half century passed during which they did not speak. Clem was almost eighty, and Bellow not much younger, when a lunch in Clem's honor was given at the Arts Club of Chicago, Bellow's hometown. By then, arguably, they were the two who had risen highest among that legendary crowd.

Spotting his erstwhile sibling at an adjacent table, Clem swiftly rearranged the place cards so his back was turned to the Pulitzer Prize–winning novelist. And Bellow responded in kind. "There was a dish of fruit before me, and I got his attention by throwing grapes at his bald head," he recalled. "When he could no longer ignore me (I am a fair shot with a grape), he turned around and declared, 'I never did like you.' . . . Now Proust or Joyce could have disabled me," observed the famous novelist, "but Clem didn't have the weight to crush me. I went home feeling jolly, very pleased with myself."[1] A study of Greenberg's life, in one sense, is a meditation on the limits of power.

No sooner did color-field abstraction triumph over gesture painting than it was challenged, first by the brash accessibility of pop, and then by the haughty conceptual and anticommercial stance of minimalism. Clem ascended to the Olympus of criticism just as the art values he stood for were attacked and devalued.

In New York, Duchamp's insight as to the absence of a hard line between art and nonart and his corollary that art is whatever the artist says it is seemed to translate into the conviction that all art is equal and critical value judgments are no longer of consequence. As the aesthetic standards to which Greenberg had devoted his professional life were deconstructed,

the part of Clem that had always seen himself as an outsider came to the fore. He circled the wagons, establishing and presiding over what, in retrospect, can be seen as a discrete universe with its own governing structure, code of behavior, and lines of authority. He once wrote that "the formal culture of the Jews took hardly any more cognizance of the non-Jewish human environment than it did of the natural one," turning its back on both "with a shrug that conveyed its despair at reading rational meaning into either."[2] As Duchamp's ideas swept New York Greenbergers appear to have turned in upon themselves with a similar shrug. Clem's secular halakah was conceived as a sacred enclave free from the pressures of conformity exerted by philistine New York. It came to be governed by rules and a code of behavior that combined principles of aesthetic sensibility with those of Newtonian psychotherapy.

Until the second half of the nineteenth century Jewish culture had been a religious culture. For two thousand years, during the diaspora, the Torah held Jews together, secure in their status as God's chosen people. Clem concluded that Jewish immigrants like his parents had enslaved themselves to the meaningless rules of middle-class propriety because of their nostalgic longing for the security of traditional Jewish life.[3]

When Clem spoke of a childhood within the immobilizing confines of the "fence" of the Torah, he referred to the parental rules that circumscribed every act of his childhood. He felt his parents, like those of his peers, had, as a consequence of their experiences as Jews, erected a barrier that shaped the way in through which their children saw the world. He did not internalize his parents' commitment to middle-class values, but their need for structure. He railed against the psychic consequences of his upbringing, but throughout his life, intellectually and emotionally, he sought out underlying principles. "The thing Clem feared most was chaos," observed his friend Elizabeth Higdon. "He could never deal with a lack of order."[4]

Neither pop nor minimalism was concerned with "quality," by which Greenberg meant the ability to nourish the human spirit at its deepest levels. In hindsight, pop and Warhol, like the music of John Cage, the dance of Merce Cunningham, and the sculpted nonsites of Robert Smithson, reflected a shift in the sociocultural winds. Clem initially anticipated that their life span would be short. He told the sculptor Michael Steiner that "good art always wins out in the end." But as the seige continued he showed signs of strain.

William Rubin recalled that by the midsixties "Clem began sipping vodka at ten o'clock in the morning, and by the time you would get there

for a drink before dinner, he would have about two fingers left in the bottle he started that morning."

Clem had been in therapy with Ralph Klein from 1955 to 1961. In 1965, he reentered therapy with Klein. The impact of Newtonian therapy on Clem's private as well as his public life cannot be overestimated: "I was like reborn. It was the most important event in my life. [Before that] I could never take my feelings seriously; my impulses. I was always looking to the world to get my bearings. . . . Ralph Klein turned my life around."[5] It would not overstretch the facts to say that after the late fifties, Clem's comportment in the art world can only be understood in this context.

Newtonians combined mental health with left-wing idealism and the antiestablishment values that swept the country in the sixties. In the name of mental health, they cut their ties to family and childhood friends. Clem clearly embraced these ideas. Prior to therapy he attended family reunions, saw his brothers on occasion, and his father at least once a month. He borrowed his father's car for the motor trips he and Helen liked to take. Post-therapy his relations with his family became so distant that his daughter, Sarah, born in 1963, barely knew her father's side of the family: "When we went to see my father's father, it was very cold and distant. I remember my father would call him 'Pa,' and I'd always be surprised to be reminded that my father had a Pa. There was never anything between them. He lived only eight blocks from us, but I think we only went to see him two or three times. I don't remember seeing my father experience any grief when his father died. . . . I barely know the names of my cousins to this day. But it was the way my parents wanted it. I think a lot of it had to do with . . . the kind of analysis my father was going through."[6]

The avoidance of spousal dependency, like the avoidance of familial dependency, was a basic Newtonian precept. The prescription included a frequent change of bed partners. Clem entered therapy in 1955 and married Jenny in 1956. By the end of the decade he was dating other women and organizing the parties Hilton Kramer described, at which artists and writers of his acquaintance were paired off with young girls from Bennington. By the midsixties, power being the aphrodisiac it is, a crush of young women—artists and critics—hovered around him. Spreading one's dependency feelings was the "healthy," therefore "right," way to live, and Clem made no apologies and no effort to spare Jenny's feelings. When she returned from acting class or rehearsal, if he was at home with Sarah, she might find him listening to records or cozily dancing with some nubile partner even younger than herself.[7] Jenny entered Newtonian therapy in 1961. By the midsixties her dates called for her at home, met Clem, and were introduced to those having drinks with him that evening. Clem could hardly object, but he was

not unconcerned. His diary entry for New Year's Eve, 1964, included nothing but the name of Jenny's escort and the time he arrived. His diaries routinely identified her companions by name and recorded the time she returned home. In 1966, Clem began traveling the world as the State Department's cultural ambassador and was away from home for several months. Jenny began staying out all night. This too Clem recorded along with the hour she returned the following morning and whether or not there was conversation between them.

In 1966 he left Klein and tried a Dr. Botwinick. In 1967 he returned to Klein, who, among other things, made Clem aware that if he did not value what he himself had to offer, no one else was likely to do so. This revelation may seem absurd in relation to a man as arrogant as Clement Greenberg, but his therapists apparently saw self-esteem as one of his "issues." This was about the time Clem woke up one morning and, as he told Al Held, realized Emmerich and the artists were rich and he was still poor. He began taking dramatic steps to demonstrate to the art community at large the high value he placed on his contribution.

Clem played a large part in Pollock's success, but, as we know, when the latter's paintings tripled and quadrupled in value, he was not among those who profited, or not directly. This never happened to him again. In the sixties, out of self-interest as well as gratitude, the artists he helped, helped him. They gave him paintings, and his correspondence suggests that he did not take it well if the gift was not of a quality that indicated proper respect.

Pretherapy, Greenberg accepted the lecture fees he was offered and gave advice casually, happy to fan interest in avant-garde art. Later, as both the market and his reputation grew, he was more demanding. If an important museum invited him to lecture or serve on a panel and refused to meet his price, he agreed to their terms but then used the time to call attention to the institutions' demeaning treatment of critics. Louise Bourgeois was present on one of these occasions: "There was a panel discussion at the Guggenheim. . . . Everybody was supposed to talk for fifteen minutes. Suddenly it was Clem's turn." He said his standard "fee for advice was $900 to $1,000 an hour and he had already spent forty minutes at the Guggenheim and was obliged to pay cab fare to and from the museum. Then he looked straight at the audience," Bourgeois continued. " 'I'm getting one hundred and fifty dollars for . . . my participation in this panel, and I'm very sorry but I cannot talk anymore.' And he stopped talking. The Guggenheim was paying him so little he could say no more. He behaved as if he was very hurt by this failure of the museum to acknowledge his true worth and was suffering as a consequence. It was very dramatic. Psychologically it was so strong, you see. He couldn't talk so he felt left out. He felt left out to such

a point that he put his head down," covering his face with his arm. "And we couldn't get another word."[8]

Washington Post critic Jo Ann Lewis recalled a lecture she attended in the packed auditorium of the National Gallery of Art, Washington, D.C., in the 1980s. Clem was twenty minutes into a lecture on David Smith when he stopped and said, "I'm sorry. My usual speaking fee is [such and such] and the National Gallery is only paying me [such and such], so I can say no more." And he walked off the stage.[9]

In 1968 Clem again terminated his treatment with Klein and began seeing Jane Pearce—three two-hour sessions a week. After roughly a year he switched to Saul Newton, a man Clem admired but one whose assessment of his own importance bordered on the delusional. "In psychology there is Freud, Sullivan, and Newton. In politics there is Marx, Engels, Lenin, and Newton. We are the psychological and political vanguard for the world community," Newton told a colleague.[10]

With Clem as a major referral source, Newton and his followers enjoyed great success. In the sixties they bought three large apartment complexes on the Upper West Side of Manhattan and established a residential treatment center where patients were encouraged to live. Clem referred his friend Sidney Phillips, who moved into the treatment center. Ken Noland entered therapy, as did one of his daughters. She too lived at the center. Noland's then wife, Stephanie, was so pleased with her experience she became a "Sullivanian" therapist. Jules Olitski, Larry Poons, and scores of the Bennington faculty and student body accepted the therapy, as did many in the Syracuse University art department.

Sculptor Michael Steiner commented, "At one point, Larry Poons and I, and Ken Noland, and Jules Olitski, and then our inner circles and then our satellite circles, were all going to psychoanalysis. We all . . . needed it, that's for sure."[11] Peter Stroud taught painting at Bennington. He described the phenomenon: "I mean I could practically go down the faculty of Bennington. They were all involved. They broke off all of their dependency relationships and went to live in the Sullivanian houses for a time where they reformed their lives. . . . At openings, you could always identify the people in Newtonian therapy . . . they wore black and were always crying."[12]

The Sullivan Institute, almost draconian in the control it exerted over patients' lives, became a mecca for the "formalist" faction of the art world. Clem did not plan this, but the Newtonians' rigidly hierarchical system worked to his advantage. Patients were assigned apartments and roommates. The therapists' control extended even to the selection of bed partners. The daughter of a well-known writer, her husband, and young son all

lived in the treatment center at one point. The husband became disenchanted and moved out. Saul Newton termed his decision a sign of "mental incompetence" and denied him access to his son. The father sued for custody and, in a widely publicized court case, testified that his former wife's Newtonian lifestyle did not permit her the freedom to decide what was best for the child: "Everything about her life from where she lives to whom she marries and who fathers her children is dictated by the group's gang of top therapists."[13]

Long after the cultlike practices of the group became big news, Clem defended them. In 1990 he commented,

> Yeah, they're notorious. There was a fuss about them kidnapping children. Grown-up children. People were taking them to court. . . . Ken Noland's second wife, Cornelia, said they'd taken her daughter. In the case of Noland's daughter, taking her was a godsend. One of the analysts took her in. . . . I think they're the best gurus ever judging from friends who have been in other kinds of analysis and seeing what happened to my other best friend Sidney Phillips. It turned his life around all to the good—as it turned my life around.[14]

For Clem, Newtonian therapy provided a rationale that justified and legitimized his inclinations.

Therapy turned Clem's life around, but whether the change was for the better remains questionable. His marriage dissolved, his dissipation increased, and his irascibility soared to ever more remarkable heights. Like the Marxists with whom he was first aligned, Clem divided his world into friends and enemies. There was no middle ground. For the artists in the first category, he was the sun. For others he was a dark shadow over the art world.

By 1964 the core group of artists on whom the sun shone lived and worked in Vermont, near Bennington College, known by outsiders as Clemsville or Clemberg. Jules Olitski and Anthony Caro were on the faculty, Ken Noland and David Smith lived nearby, and Clem was a frequent visitor. Network writers, curators, and dealers visited frequently, and, as painter Pat Adams observed, the scene got very "rich." No other art school in the country could offer students such access to famous artists and the critics and dealers interested in them. The young writers and curators attracted by Clem's ideas were bright, talented, and well educated. They quickly moved into positions of prominence. Greenbergian modernism was reflected in the exhibitions policies of major museums, and Greenbergian formalism per-

meated art schools around the country. At first, the Bennington art faculty responded to the Greenberg presence with pleasure. Painter–faculty member Adams recalled that when Clem did senior "crits," his comments were "enormously" useful. "It was mainly a seeing into that he did," continued Adams, "a kind of attentive looking. He would see what the artist wanted to say and check it against his own take." He taught the students to do that for themselves and for one another.

In addition, for students and faculty alike acceptance by the Greenberg crowd led to opportunities few artist could casually dismiss. Painter-critic Sidney Tillim taught at Bennington in the seventies. An unorthodox figure in the Greenberg circle, he made history paintings. He wrote about and praised abstract, but also figurative, art. "I simply was considered some kind of eccentric," Tillim acknowledged. His talent, brains, and engagement with Clem's ideas nevertheless gained him entrée to the group, which soon visited his studio and "got involved" with his work. "The next thing I knew," recalled Tillim, "I had a big show of these history paintings in Canada along with a monograph . . . written by Terry Fenton [a network member]."[15]

Those excluded from the Greenberg group were understandably resentful. "Clem could be outrageous and make brutal pronouncements, and he knew just what he was doing," recalled Pat Adams, who found herself in that unenviable position. "He let me know that I didn't know anything about anything, in so many words. In my case it had to do with being a woman [and a mother]. There was this clear sense that you couldn't be creating if you were procreating. And there was an enjoyment there [in his power]. . . . He told me once that if he pulled support from somebody what the consequences would be on their career," and he said it with pleasure.[16]

Some artists opted to remain outside, or said they did, to escape the pressures of conformity the group imposed. They spoke of a pecking order. Clem was on top, but Noland and Olitski were chieftains. "You did not become a member of that group just because you were a nice guy. To be part of it," said painter–faculty member Vincent Longo, "you had to buy into the aesthetic principles. . . . They wanted the good young artists to be formalists, so as to demonstrate the truth of Clem's assertions and the correctness of their direction, which at that time was under attack from the minimalists and pop artists. And you had to buy into the lifestyle. . . . I started to get the feeling the artists did Clem's dirty work for him. If Clem disapproved of what somebody was doing, the group cut that person down. They—Noland and Olitski mostly—bad-mouthed Isaac Witkin, Tony Smith, Paul Feeley, Pat Adams. They were king of the heap and they wanted to keep it that way."[17]

The lifestyle, along with the aesthetics, as Longo noted, was part of the package. James Wolfe recalled the bait that led so many to take the Newtonian plunge: "There was pressure, but it was almost like, in a strange way, a perk you got from knowing certain people. If you were accepted, you were let in on this wonderful thing you could do. You had access. We all tried it." At the same time, however, "it became difficult to be part of the [Greenberg] group if the Newtonians weren't comfortable for you. People tended to think something was wrong with you."

Newtonian therapy was expensive and inconvenient. It involved seeing a therapist several times a week and living in the Manhattan treatment center. There was a sliding fee scale: a novice therapist with no prior training was available for $10 an hour; Saul Newton charged $150.[18] If you worked or studied at Bennington or Syracuse, you had to commute. Moreover, the dictatorial constraints imposed by the therapists included a prohibition on consorting intimately with anyone other than Newtonians. To do otherwise was to risk expulsion. For Greenbergers, the pool was further narrowed. Clan members consorted only with one another. Furthermore, committing yourself to the therapy did not guarantee group acceptance, but not doing so made acceptance problematic.

There were exceptions, of course. Powerful curators and museum directors were exempt, as were dealers, and most critics. Ken Moffett was Boston based. He recalled, "Clem tried to get me involved and I verged on it several times, but I was in Boston and there weren't any Sullivanians up there. . . . I was blessedly absolved from that, and as it later turned out, I was glad . . . but at that time it was something everybody did and I thought, 'Why not?' "[19]

Clem never deigned to live in a treatment center, nor did he cede decision-making authority over his life to anyone other than himself. He identified not with the patients but with the therapists. Within the Greenberg group, some of the power Newtonian therapists exerted over their patients was transferred to him. He replaced Saul Newton as the spider at the center of the web. Peter Stroud recalled: "They broke off all of their dependency relationships and went to live in the Sullivanian Houses . . . and then something strange occurred. I mean it was like G for 'God' and G for 'Greenberg.' I don't know how it happened, but it seemed to be a reinforcing situation. The therapy transference seems to have been put not on the therapist but on Clement Greenberg."

John F. Kennedy was elected president in 1960. His administration prided itself on being tough. In the sixties, toughness was in among certain art circles. One night, painter Bob Rivers was at Dillon's bar in Greenwich Village. He saw Willem de Kooning and sculptor Peter Agostino sitting

across a table from one another taking turns slapping each other in the face to see who could take the most punishment.[20] Newtonian therapy put a premium on confrontation. "Members have several sessions a week with their Sullivanian therapists who shout back at patients and often scream obscenities, telling them they are some form of lowlife and have nothing to live for," wrote Phoebe Hoban in New York magazine in the mideighties.

The idea was that patients had to learn to stand up for themselves and what they believed. Social relations among Greenbergers, patterned on this model, might have been character building, but they were not fun. Members vied with one another for who could inflict the most verbal abuse, and who could command the most attention in social situations. Noland once observed somewhat ruefully, "Clem took possession of conversations and situations by force of being interesting. He was always able to divert attention to himself by shifting the conversation to a relevant perspective that was unexpected and engaging."[21] The idea was that if you could not hold your own, you deserved whatever you got. James Wolfe described conversation as a series of challenges that came down to "What did you mean by that?" The chieftains were constantly at odds with one another and everyone else walked on eggs. Sidney Tillim began demanding a scorecard before entering Noland's house, so he would know who was not talking to whom that night.

Like the PR crowd, competition was a defining characteristic among Greenbergers. The artists were all fiercely ambitious. Olitski once commented, "Noland was a great challenge to me. My response was to go up against that challenge, to go up against that vision, to stamp it out. . . . I think that the history of art is, among other things, a history of visual warfare and that a lot of creative energy comes out of that warfare."[22] The idea was that competition kept you sharp. It honed your edge, and for Greenbergers it seemed to be true. At Bennington the artists were in and out of each other's studio and critiqued one another's work.

After they separated, they never "hit" as consistently as they did when they were together. Clem was the discerning eye. His job was to keep the pot boiling. "If you spent time with Clem, you knew who was moving up or down," recalled Wolfe. " 'He's ahead by a nose; uh-oh, he's having a bad day, he's dropping back. Oops!' It was that kind of comparison all the time."

Bennington students—all women—had no difficulty accepting the association of aesthetics and mental health. It fit right into the hierarchical structure of the school. "Students were there to grow, to have their taste improved. . . . People with taste were superior, so it stood to reason that

artists or critics with superior taste would be experts on interpersonal stuff or on what it took to be psychologically elevated," explained Wolfe.[23]

Women in the group, however—students, artists, and critics alike—confronted a situation few fully anticipated. In or out of Newtonian therapy, they were "hit on" as a matter of course, expected to spread their favors among those who wanted them. Clem frankly said he could not understand why the women made such a "fuss" about it.[24] In his role as surrogate therapist, however, he listened to their troubles and they valued his counsel. Jenny, among others, commented that Clem was "very good to talk to about personal things, personal choices."

But he also made demands. Newton, Klein, et al., felt free to intervene in the most intimate affairs of their patients. If a patient got involved in an "unhealthy," i.e., too exclusive, relationship, for example, they had no compunctions about substituting themselves for the partner in question. Male therapists slept with their female patients, even appeared to exercise seigneurial rights over them. Clem apparently saw himself as similarly entitled. One male painter, a charter member of his circle, noted resentfully, "Clem was always competitive with the men where women were concerned. He needed to dominate the men and he did it by claiming access to the women."

Susie Crile, the only woman willing to go on record about her experiences, studied painting at Bennington. Her combination of looks, brains, talent, and background made her stand out even among her privileged fellows. Crile's memories of that period in her life were so painful, however, that it was still difficult to talk about them. She had fallen in love with Jules Olitski while studying painting with him. She entered Newtonian therapy, had an affair with a London dealer close to Clem and with her married professor.

Crile was the envy of her fellow students. An aspiring painter, she was at the center of a powerful and glamorous faction of the art world, a regular at the parties where artists met dealers and curators, where the right kind of spark could lead to a show in a major gallery or even a museum. She was present at, or hosted, some of the small dinners at which the most interesting conversations took place. But, as she told the story, the price was high. She became addicted to the whole heady scene: Clem, alcohol, drugs, life in the fast lane. One Saturday morning in the early seventies, she was driving from Manhattan to Bennington and stopped at Clem's apartment to pick up something left behind when she and Jules had last been there. Clem got her alone in one of the bedrooms and, although Jenny was in the next room, made advances. Pushing her against a wall, he kissed and fondled her, his husky "whiskey voice" urging her to come with him to the Vir-

gin Islands the following week, "as Sarah's companion." So forceful was he that Crile felt she was about to be raped. Too embarrassed to scream, she broke away, drove to Bennington, and poured out the whole story to her lover. Jules minimized the event, and it became clear to her that he would not stand in Clem's way.

Whether students or critics, Newtonians or not, the women in the circle felt pressured to give Clem what he wanted. He could be helpful in advancing their careers. Artists he recommended had no trouble getting shows. He was often asked to recommend writers or scholars for plum positions. On at least one occasion he did not hesitate to withdraw the name of a woman who proved "uncooperative."

Like Crile, these women put up with a great deal of abuse often for nothing more than the excitement involved and the prestige. "Everyone around Clem learned to be very careful," recalled one who had been close to him. "If you did something that displeased him, if you misspoke—made a grammatical error or said something stupid—he would be on you for the rest of the night." On the other hand, "he'd say wonderful things, and because you want the one, you take the other." Clem told Elizabeth Higdon, " 'You've got a wonderful education. There's nobody on earth I'd rather look at art with than you—not Jenny, not Sarah.' This from Clement Greenberg is heady stuff. You put up with a lot for it,"[25] said Higdon, then a professor of art history at Duke University. Pinpointing what made a relationship with him psychologically debilitating, she continued: "He flatters while putting you down. He'll say, 'What are you doing in art history? With your eye and your command of the English language, you could be a critic.' Sounds nice, but it's a way of saying that what you've devoted your life to is a waste of time."[26]

Crile was so demoralized she could not even terminate her relationship with Olitski. Again she turned to Clem as her therapist-confessor. Many years later, the former Bennington student, now a New York artist with an uptown gallery and a pulled-together life, summed up her experiences as a Greenberger with an eloquent shrug: "Let's just put it this way. When I saw news of the Jonestown massacre in the paper, all I could think was, 'There but for the grace of God . . .' "[27]

Clem had a peer relationship with the chieftains. But even they had to exercise a certain caution. He equated agreement with loyalty. Of her relationship with and break from Clem, Rosalind Krauss observed, "It was a discipleship, and part of being a disciple involves agreement." A Washington sculptor recalled, "I always got along with Clem, but then I was careful never to disagree." Clem hurt the feelings of Jules Olitski's daughter, and

when Jules got angry in return, Clem loftily broke off relations, refusing to speak to the artist for more than a year. William Rubin, Clem's friend for a decade, terminated their relationship over this issue: "Clem was . . . a person who structured things in such a way that it was very difficult, if not impossible, to be a friend and not agree with what he thought and felt."[28]

Barbara Rose and Frank Stella were frequent guests at Clem's apartment during the sixties. Rose recalled, "He'd invite us—the kids—up to his apartment, and we'd all sit around in a circle with Jules and with Ken and everybody. Clem would pontificate and then he'd say, 'Don't you agree?' And you'd go round the circle and you had to agree. . . . It was weird, sort of like a Ku Klux Klan meeting. . . . 'Thou shalt have no other gods before me.' That was the commandment."[29]

Actual events were probably less inflexible than Rose painted them. What was, or was not, acceptable behavior seemed to vary from person to person. In the late sixties, Rose and Stella stopped being invited. Rose attributed this to the fact that Frank's work had changed and Clem no longer liked it. She agreed with Clem, as it happened, and she believed that Michael Fried did too. Neither was prepared to denounce Stella, however, which is what Rose thought Clem required them to do.[30] But if that was true for them, it was not true for all. William Rubin continued to admire, collect, and show Stella at MOMA. Clem made disparaging remarks but nothing more. Greenberg was close to Henry Geldzahler, who showed pop art as well as color-field painting at the Metropolitan Museum. "Clem did not object if you liked artists he did not," said Rubin. "What he could not accept was your not liking someone he did."[31]

The remarkable thing was that most of those in the network saw their choices as freely made. Ken Moffett, the curator-critic closest to Clem in many respects, said, "From the outside it looked like we just took what Clem said as gospel, but there was a great deal of freedom. It was liberating in terms of having your own say." But they agreed about the big issues. "We didn't disagree about Warhol, for example," Moffett explained. By the late sixties many of those around Greenberg were powerful in their own right. Fried attributed Clem's sudden animosity toward him to the fact that he was challenging the master in "bed," which is to say the "studio." Noland and Caro valued Fried's help and asked for it.[32]

Whatever his reasons, Clem set about driving away those who had been most important to him. *Artforum*'s role in disseminating Greenberg's ideas, for example, cannot be overstated. Phil Lieder, its chief editor, had been a true believer, as Max Kozloff indicated when he described staff meetings at the magazine in which Lieder parroted the Greenberg line. Clem's relationship with Lieder had always been contentious, but now it became more so.

Clem complained about pieces Lieder published and about those he refused to publish. Control issues between them escalated. Lieder, presumably, given a hard time once too often, published a posthumous piece by Ad Reinhardt referring to the moment when Greenberg turned "critic/dealer at French & Co." Clem's response was immediate: "Dear Phil. When I first met you years ago I had the impression that you were some not quite identifiable form of rodent. I then allowed us to have certain sorts of friendly relations. But this latest exchange teaches me once again how important it is to trust first impressions."[33]

These years also saw the end of Clem's relationship with his son. Danny went to Europe in the late sixties. He was in his midthirties, had tried his hand at writing with little success, and had no clear direction. Through the sixties Clem received frequent requests for substantial sums of money—hundreds of dollars almost weekly. For several years he sent what was requested, but then began gradually reducing the size of the checks until they finally stopped entirely.[34] There was talk of drugs, of a possible jail sentence, of mental hospitals and a diagnosis of schizophrenia. Martin Greenberg recalled that no one in the Greenberg family had heard from Danny in the twenty years prior to Clem's death, and Clem had made no effort to locate him. "He knows where to find me," was his only comment.[35]

On the face of it, Clem's life was full of glitz and glamour. Collectors continued to buy the work of artists he championed. When he traveled he stayed at fine hotels and was lavishly entertained. In New York he and the "boys" moved from party to party in chauffeur-driven limos. But increasingly he and Jenny led separate lives. She rarely joined the group when people came for drinks in the late afternoon and did not often accompany them to dinner afterward. The appearance of a successful marriage and of himself as a beloved husband and father was so important to Clem that he maintained the myth even during the nearly twenty years in which they were separated or divorced. And they did remain connected.

In August 1970, Jenny and Sarah moved out of the Central Park West apartment and into a loft on West Twenty-first Street. Jenny and Clem made separate wills in which each, plus Sarah, was the other's beneficiary. That year they filed a joint tax return and bought a car together. They spoke frequently, and Jenny often left Sarah with Clem during the week.[36] In many respects, he was the responsible parent. He saw his daughter off to school most mornings, picked her up after school, and met with her teachers. Jenny and Sarah continued to accompany him to important events, such as his father's ninetieth birthday party in 1971.

Clem's diary notations become increasingly subdued at this time, even

depressed. His alcohol consumption reached remarkable heights. James Wolfe recalled going out for lunch with Clem during a 1971 visit to Bennington: "He had his two or three martinis, then he went up to Ken's and drank seriously for the rest of the afternoon. That night we went to a party at Olitski's and he drank a fifth of bourbon. Later, I got back to Ken's and Clem was there with some students, and they were dancing and he was still drinking—into brandy by then." Diary notations such as "drinking too much," "brooding," "strange malaise," began to occur with regularity. He smoked pot and hashish regularly, sniffed coke four, sometimes five, even six times a week, sniffed heroin, occasionally alone, often with others. Sedation was his objective, and the drugs and alcohol did the job. He was so debilitated he had to take morning and afternoon naps. The handwriting in his diaries became scrawling, sometimes barely legible. He had numerous short-term affairs, some long-term but intermittent, with women he saw only when visiting a particular city. There were also countless one-night stands. His womanizing became so prodigious that the generic term "Clemette" was coined to identify members of the corps.[37]

His drinking habits were so widely known that curators, inviting him to lecture at their museums, arranged for him to stay at their homes and hid the liquor before he arrived. Clem's aptitude for ferreting it out, however, meant their efforts were usually to no avail. He still read voraciously, wrote on occasion, and maintained an active schedule. He was consulted by dealers and curators about upcoming shows and made aesthetic decisions concerning the David Smith estate. He received interview requests from print and TV journalists in the United States and Canada, from England, Germany, and elsewhere. Many of these he granted on the condition that he edit the manuscript.

Clem always had a mean streak that now became more pronounced. Barbara Rose recalled this incident: "I used to love to have people around, and Frank and I couldn't go out because we didn't have any money and we had this baby. One night—we had an apartment on Union Square—and Clem was over, and a sculptor who became very famous, and Henry Geldzahler, and a lot of other people . . . and Clem started putting down the sculptor and told him what a rotten artist he was. He was really rather irascible and started to attack him more and more. And the guy just quivered and got up and went out of the room. And later I walked back into my baby's room and he [the sculptor] was just sitting there naked on the floor, rocking back and forth, crying."

By the early seventies, Clem tested the limits of his influence on those in his orbit by forcing their complicity in the ritual mortification of one another. As his dissipation deepened, the pit bull tenacity with which

he eviscerated the unfortunate sculptor was turned on the ablest of those around him. It was as if, consciously or otherwise, he saw that it was over for him and set about deliberately driving them away. Weekends in New York assumed the character of Russian roulette. "When there was a big opening or something, we'd all come to New York for two or three days, hang out . . . everybody was kicking around, insulting each other right and left. It was truth or dare . . . and who knew who was gonna be the selected target for the evening," curator Ken Moffett recalled.[38]

According to one who witnessed a great many of these scenes and bore the brunt of some, the drama usually began over drinks at Clem's apartment and reached its denouement in a restaurant during the early hours of the morning. One person was singled out and systematically ground down while the others watched. No one interfered. No one so much as said "Clem, give him a break." Fried and Krauss were both victims of this ritual mortification. Fried stopped writing about contemporary art and Krauss got even.

Just as Saul Newton assumed the prerogative of inflicting punishment—depriving fathers who refused to live by his dictates of access to their own children[39]—so did Clem exploit the threat of humiliation and/or expulsion from the group. "I have a bone to pick with you" became a dread phrase for those who knew what it meant. Clem created a situation to which William Rubin had to object, and severed their connection when he did. Michael Fried was but the first of many to note, "Clem's a true sadist. And yes, of course he knows what he's doing."[40] Barbara Rose put it this way: "Clem . . . was always involved in seeing if he could either absorb a person and turn them into his creature or destroy them."[41] Ken Moffett explained the rationale: "Clem spoke true about his feelings. He would tell you the way he really felt even if it hurt. He enjoyed it. . . . It had the effect of shaking you up and sometimes that's necessary, but that didn't detract from his sadistic glee. He's the first one to say that anything else [anything that pretends otherwise] is conventional bullshit."[42]

In October 1972, Clem and Jenny bought a house together in Norwich, New York, not far from the Finger Lakes. Jenny completed her theater studies and, hoping to establish her own regional theater, moved there and enrolled Sarah in the local public school. The following March Clem visited for several days. Country life apparently appealed to him, although it soon palled for Jenny. By spring 1974 she and Sarah were spending frequent weekends in the city. Jenny had given up her loft when she moved to Norwich, and on these occasions they stayed with Clem on Central Park West. Jenny was made editor in chief of *Madison Avenue,* an advertising trade

magazine, and in June 1974 returned to the apartment with all of her belongings. Clem, agreeably, transferred himself to Norwich to care for the eleven-year-old Sarah. In July, Sarah too returned to Manhattan, but Clem remained in Norwich.[43] In 1977 Clem and Jenny divorced. They continued to share the New York apartment, although she soon moved to Los Angeles while he remained in Norwich until 1988.

Clem continued to lecture and make himself available for consultations. He regularly traveled to Bolton Landing to see to the affairs of the Smith estate, and to Bennington where he usually stayed at Ken Noland's house. Clem knew people on the art faculties of Syracuse and Cornell universities, and there was a fair amount of visiting back and forth. His appetite for art was as voracious as ever. He spent time in artists' studios wherever he went and still helped those to whom he was closest prior to exhibitions. In fact, he was called the Mad Cropper because of his enthusiasm on these occasions. For these artists, Clem remained the arbiter and they competed for his praise.

Perhaps the last, and cruelest, of Clem's games targeted an artist who had been his friend for almost forty years. In the mideighties, Ken Noland was working with paper. Clem loved the loose way the color was put on and suggested that Ken try that in his paintings. Ken resisted. "He was always the most stubborn," recalled Liz Higdon, who often visited studios with Clem during these years. "Ken finally tried it, but Clem didn't like what he'd done, said it wasn't loose enough, and Ken had a temper tantrum," Higdon recalled. Noland went his own way and relations between them cooled.

By the late eighties Olitski's paint was so thick the subject might have been color as matter. In fact, they were sometimes called matter paintings. "To Clem's eye," Noland recalled with some asperity, the way Olitski used "matter" was "absolute."

The art world, by then, was fiercely pluralistic. There were exhibitions for "Greenberg" artists, for pop artists, German neo-Expressionist artists, for Americans such as David Salle and Julian Schnabel and Cindy Sherman. "Appropriation" art, images appropriated (often from earlier art) rather than "created," became the cutting edge. Much of the art was conceptual. Much of the art writing was heavily influenced by poststructuralist discourses from radical feminism to French literary criticism.

When Clem emerged from the shadows to say in public what he had said privately for some time—that he thought Olitski the world's best living painter—no one knew quite how to respond. Olitski's art might seem irrelevant to the dominant concerns of the day, but Greenberg had an impressive record for standing alone and ultimately being proved right.

William Rubin captured the general state of mind when he commented, "Everybody knew better unless it turned out a hundred years from now that Clem was right."[44]

Clem, doubtless, took a perverse pleasure in flouting received opinion one last time, but he would only have done so had he been convinced of the truth of what he said. Still, more than one truth illuminates most situations. Clem's endorsement of Olitski was a conscious slap at Noland. A younger critic who knew both men well observed, "Clem realized early on that he had a particular whammy on Ken. . . . Clem thought that he was like a father to Ken. . . . Now for years and years and years, it's been Olitski. Not that Ken and Jules see each other anymore, but Clem will always say, 'Jules is the best painter in the world.' It's Pollock, Morris [Louis], and Jules. And Clem knows just what he's doing. He knows that he can say that in an interview in Bangladesh and within a week someone's going to call Ken in California, and Ken is going to go ballistic. . . . And then, very often, my phone rings and I pick it up, and Ken, in his hoarse, rusty, whiskey-whisper voice, says, 'He's done it again. He's left me out again. It goes from Jackson to Morris to Jules.' Clem's a true sadist."[45]

Olitski, exquisitely sensitized to Clem's style of verbal precision, perfectly understood the qualified nature of the compliment. Noland might be out, but the door remained open for sculptor Anthony Caro: "Clem didn't say 'greatest artist,' he said 'best living painter.' It's good enough, but there's a difference."[46]

18

The Question of Immortality

Greenberg, the art power, inevitably affected perceptions of Greenberg the critic. From the beginning he was more than just a commentator on the American avant-garde. The plane on which his criticism was conceived helped shape that epic era in which American art defied Europe's long-held perception that the term "American culture" was an oxymoron. Clem's criticism emerged from direct experience with art that engaged him. During much of his lifetime, it was inevitably linked to the work that inspired it. But the backlash he engendered tied the value of his criticism to the fortunes only of those whose reputations he helped make in the sixties and whose decline in the eighties accompanied his own.

Agreement exists as to the quality of artists singled out by him from Manet through Pollock, Still, and Newman. The effort to discredit his contribution usually centers on his taste, his "eye," his support for stained color-field painters such as Louis, Noland, and Olitski, and on those he spurned, such as Frank Stella, Jasper Johns, and Elsworth Kelly, who emerged as major figures of their generation.

To those who attacked what they saw as his preference for abstraction, Greenberg always insisted that it was not his preference, it was the style that had produced the "best" art in the twentieth century. He focused on formal elements because subject matter had disappeared and content was ineffable. In 1971 he wrote, "Modernism defines itself in the long run not as a 'movement,' much less a programme, but rather as a kind of bias or tropism; towards esthetic value, esthetic value as such and as an ultimate. The specificity of Modernism lies in its being so heightened a tropism in this regard."[1]

He was less sanguine about its future prospects, however. "Modernism has been a failing thing in literature these past twenty years and more; it's not yet a failing thing in painting or sculpture, but I can imagine its turning into that in another decade (even in sculpture, which seems to have a

brighter future before it than painting does)."[2] He did not separate himself from the color-field painters who were by then his oldest and closest friends, but in televised visits to artists' studios he allowed himself to be seen turning paintings upside down or on their sides, an indication he thought there was room for improvement.

Greenberg's ideas seemed omnipotent. In America, formalism, the practice of examining paintings or sculptures in terms of their compositional elements, meant Greenbergian formalism, and that in turn was defined by his many critics as a progressively reductive enterprise from which every hint of experiential content had been drained. In 1972, Leo Steinberg defended pop art against Clem's dismissal by mounting a devastating attack on formalism in general, and Greenberg in particular: "Contemporary American formalism owes its strength and enormous influence to the professionalism of its approach. . . . Its theoretical justification was furnished by Clement Greenberg [who] . . . reduces the art of a hundred years to an elegant one-dimensional sweep."[3] This theme was revisited ten years later by Thomas McEvilley when he wrote, "The impossible idea of pure form quickly became an absolute."

Clem, of course, left Manhattan for Norwich and the pleasures of acute dissipation just as the dam burst. Did he see the fate of modernist painting and sculpture following in the footsteps of its literature? Did drug and alcohol addiction make retreat prudent or did prudence in the face of both dictate that he seek oblivion in private. It is difficult to say. His diaries make clear that what he craved most was "nirvana," the blotting out of feeling and thinking as early in the day as practicable. He had extraordinary reserves of energy and brainpower, however, and when necessary still rose to the occasion. He published his Seminar series, and kept his ideas in circulation by means of the steady stream of interviews he granted.[4] It was in Norwich that Hilton Kramer and Robert Hughes found him when Krauss's "Changing the Work of David Smith" appeared in *Art in America* (September 1974), and there he remained when the bloodletting commenced.

In 1950, artists had been in the forefront of his accusers. This time critics and scholars led the charge. Such was his perceived influence that opposition to Greenbergian formalism came to indicate independence of mind. It established one as a serious person. Clembashing became a career-advancing strategy. The problem was that no one quite seemed to know what Greenbergian formalism was. It was defined so many ways by those attacking it, that the term soon functioned as little more than a political epithet indicating that the speaker's or writer's agenda differed from that of the art world's private Führer. Maurice Tuchman described the phenomenon and Clem's probable reaction:

Krauss broke the ice. She showed that the old man was vulnerable.
. . . Suddenly you could make your way in the art world by becoming a
Clem killer . . . and God knows a hundred people were vying for the
spot. . . . When the herd moved against him, it was quite fantastic . . .
really disgusting. . . . Writers were emboldened to strike out against
the aging critic, the archpriest of modernism/formalism. . . . Everyone
was going at him from every angle. . . . It was kind of amusing because
Clem was so pithy and short and his critics would build up these enor-
mous armaments to shoot down this guy with the laser beam. It was
weirdly disproportionate. I didn't feel too badly because it was unend-
ing, unremitting attention, and I knew he was taking it with a certain
amount of enjoyment. Clem always knew things would go out of fash-
ion and come back in fashion. . . . Whenever you take a very strong
position, you only have a short time. If you're on the barricades, the
troops are going to mass against you. What his flaws were didn't mat-
ter. It was going to happen. It's nature.[5]

Time passed. Greenberg's direct impact on current art waned. His influ-
ence was reflected in negative terms but it seemed also to go underground.
Artist-writer Robert Storr described the dilemma confronting ambitious
young critics in the seventies: "He [Greenberg] loomed. . . . He was always
better than his imitators and better than his off-the-cuff opinions, and so
you're dealing with an institution, not just the opinions per se. There was a
kind of language that was permissible and a kind that was not permissible;
the sense that there was a trick question and a mysterious right answer
someplace. . . . So although we were thinking about different things and we
were pretty sure we were right . . . how do you find a language that has the
same authority [his had] without the narrowness [of a formalist
approach]?"[6]

Greenberg's presence remained so potent, Storr continued, that only
"three paths . . . seemed open. The first was to fly directly in the face of his
prohibitions by testing the capacity of painting to accommodate narrative
or textual content [the path taken by many New York artists]. . . . Second
was to consign him . . . to the past and reduce that past to the 1960s, the
period of his greatest excesses and self-indulgences, and by that token
diminish his critical position to the one described by the effects of his
actions as a manipulator of market opinion. The third, and most hazardous,
was to reconstruct the whole of his career the better to deconstruct it."[7]

In person, the "Dr. Faustus" of art criticism was unexpectedly flexible,
readily acknowledging the subjectivity of individual opinions. When he
changed his mind about a published judgment, as we know, he acknowl-

edged it in print. While Clem was often attacked as a critic willing to support only those artists who demonstrated the correctness of his theory, it was having a theory that allowed him to recognize abstract expressionism's potential in the early midforties. The epistemologist Alexandre Koyre observed, "The possession of a theory, even a false one, constitutes enormous progress over the pretheoretical state."[8] It provides an ordering mechanism for making one's way through the unknown. Clem made no bones about his views in this regard. In "The Renaissance of the Little Mag" (PR, 1941), he wrote: "The function of the little magazine [and by extension the critic who writes for it] is to be an agent. In order to act as an agent and stir up good writing [good art] there must be some kind of positive notion, some working hypothesis, a bias in a particular direction, even a prejudice, as to what this good writing [art] of the future will be like. As Kant says, you only find what you look for."[9]

Clem became an art-world institution, and then a symbol, responsible for all that turned bad in the art world. In 1987 critic Kay Larson wrote "The Dictatorship of Clement Greenberg" (Artforum), in which she blamed him for "the death of painting in the late '60s, the ideological paralysis of art in the early '70s," and the misery visited upon us by "the revolt of the 'Post Modernists.' " Larson portrayed a ruthless autocrat whose "prescripts" were so ubiquitous they seemed inescapable: "Artists . . . consciously or otherwise, are still positioning themselves around Greenberg's ideas, which have provided the four corners of art discourse for as long as I (for instance) have been alive, and which for a time assumed the authority of a priori propositions outside of which no thought seemed possible. I doubt that David Salle or Eric Fischl consider themselves in a critical argument with Greenberg, yet they have chosen to 'bring back' figuration by wreathing it in alienation. Salle's work gets its kick from the chill of confrontation with the hobgoblins of the forbidden; Fischl's from the anxiousness of penetration into the same terrain. Neither artist could sustain the tension if those inhibitions were not still in force."[10]

In 1990 Kirk Varnedoe, William Rubin's successor, announced his ascendance to the powerful throne of the Modern with an exhibition entitled High and Low: Modern Art and Popular Culture, challenging the separation Greenberg posited in 1939. Storr, now a MOMA curator and among the most serious and severe of the Greenberg slayers, wrote a catalog essay entitled "No Joy in Mudville: Greenberg's Modernism Then and Now." Portraying Clem as a consummate strategist who continued to control the art conversation, Storr wrote: "Coming and going we cross his way. . . . Although usually silent on contemporary affairs, even now the subject of this retrospective investigation can be heard commenting on and to a large

extent setting the tone of its proceedings. Indeed . . . like the great Oz, he thus continues to impose his will through a theatrical absence intermittently and unpredictably punctuated with new pronouncements and unexpected twists on old arguments."

Clem "imposed his will" only because the art world, and the market that supported it, granted him the power to do so. When the backlash achieved its full momentum, his ideas were oversimplified by many of his critics, reshaped to reflect their prejudices. In every period a tension exists between art that is self-sufficient and art more closely involved with the life of its time, the political and social issues of the day. Clem was the apostle of the former, not because he believed it the style most likely to produce the best art in all times, but because he had concluded that it produced the best art in his time.

He wrote little about content because the way it was communicated in modern art meant there was little one could say about it as a critic. He is often assumed to have disdained the avisual, according it a limited place in his writing. In fact, in his view, content was the engine powering the enterprise: "All contemporary art is on the hunt for a set of ecumenical beliefs more substantial than those with which society—or religion—now supply it. It does no more good to tell literature [art] to call off this hunt than it does to exhort poetry . . . to stop striving for purity. The hunt, as well as the purity, is socially, politically, philosophically, aesthetically—in short, historically compelled."[11] As early as 1939, he wrote: "It's Athene whom we want: formal culture with its infinity of aspects, its luxuriance, its large comprehension."[12] In some respects Greenberg was a sensualist tarted out in positivist clothes. He once indicated a preference for Matisse over Picasso by commenting, "I can taste Matisse's paintings. I never taste Picasso."[13] Clem thought cubism the seminal style of the twentieth century. He believed the formal task modernism set itself was to distill art to its essence by paring away all but absolute essentials, in that way compressing and concentrating the affective content delivered. But here too he betrayed a flexibility with which he is rarely credited. Clem believed Picasso the foremost exemplar of that task, an accomplishment that guaranteed his place in the history books. But he believed Matisse was the "greatest" painter of his time: "The kind of painting he [Matisse] did in the decade after 1917 is not original in a major way; it does not advance the historical front of art. . . . All the same, more than a few of these 'unheroic' pictures are works of matchless perfection. . . . Here pictorial quality, as separate from the factor of historical originality or ambition, is distilled as purely as it ever could be."[14]

Clem lived in a positivist age. Science was God, and objectivity the first commandment. The task of the critic was to discern and identify the best

art being made: best as measured by the "it makes me feel like I'm dancing six feet off the ground" test. That done, it was the critic's job to identify the forms in the paintings or sculptures singled out that served as gateways to the experience.

Clem had discussed content—or the lack thereof—at length in his criticism of the forties and fifties. He never believed that aesthetic judgments could or should be based on form alone, or that objective measures existed by which to measure the value of art: "Scientific method is of no application in the forming of aesthetic judgment, but it can guide in the elimination of all that is extraneous to it."[15]

Greenberg's critics in the seventies had read little that he wrote. *Art and Culture* (1961) preserved only thirty-seven of more than three hundred reviews and essays scattered over a thirty-year period among different, sometimes obscure "little mags." They read "Modernist Painting" (1960), written to be read over the Voice of America, and "After Abstract Expressionism" (1962), and assumed they understood his position. Both of these, however, refined earlier conclusions without restating the arguments on which they were based. As Hilton Kramer noted, they tended "to summarize rather than to elucidate a point of view."

Clem in fact constructed a closely reasoned, essentially airtight theoretical system based on unstated assumptions common among the New York Intellectuals. His observations on pop art are a case in point. Pop, or some of it, initially attracted his interest. Later he saw it as "novelty" art, the harbinger of a trend toward painting or sculpture that might amuse or divert but, and this was unstated, did not seek a sensory language capable of making "direct communication with the nerves," the language T. S. Eliot referred to as a "network of tentacular roots reaching down to the deepest terrors and desires."[16] Phrasing it with some delicacy, Clem said pop represented a "decline" in "ambition."[17]

Today there are esteemed critics who argue that art as we knew it died with Warhol's soup cans in the midsixties and others who conclude that the energy powering the glory days of American postwar art ran out. There is little disagreement that a change occurred, that postsixties art is less virile and more conceptual. Clem is still condemned for "snooting most signs of intelligent life in new art after the sixties," as one obituary put it.[18]

In 1979, critic Donald Kuspit wrote *Clement Greenberg: Art Critic*, the first serious attempt to define Greenbergian modernism. Identifying his subject as the father of American art criticism, Kuspit concluded, among other things, that the virulence of the attacks on him could only be understood as a patricide.

In the eighties, critics bemoaned art's inability to stir the spirit. There

were calls for a transcendent art, a spiritual art, an art, at least, that engaged with the social and political issues of the day. In one of those ironies that characterized much of his professional life, Greenberg's presumed opposition to such an art led to the first consequential engagement with his ideas. The anti-Greenberg pendulum did not reverse its swing, but its momentum slowed.

The British art historian T. J. Clark (then a professor at Harvard, now at the University of California, Berkeley) was a neo-Marxist with a small but dedicated following. He, and those around him, attributed the loss of vitality in eighties art to Greenberg's, and abstraction's, long dominion. They anticipated that only a narrative art that engaged the issues of the day could revitalize it. Clem's apodictic views as to narrative art's inability to elicit that desirable response in modern times had been widely denounced, but, among artists, they continued to exert a cautionary power. For this, and other reasons, Clark & Co. concluded that their first task was to undermine the intellectual cogency of Greenberg's position.

In 1981, a conference titled "Modernism and Modernity: A Question of Culture or Culture Called into Question" was held at the University of British Columbia. Clark read his paper, "More on the Question of the Differences Between Comrade Greenberg and Ourselves," to a large audience, including the comrade addressed. When he finished, Clem stood to clarify a point, a position Clark had wrongly attributed to him. Despite the years of debauchery, he remained a formidable presence. After a somewhat spirited discussion Clark was obliged to concede his error and, in doing so, delivered himself of this chilling rejoinder, an accurate reflection of current views as to the worthiness of the art with which his reputation was inextricably entwined: "That's the problem! You have unfortunately become . . . the spokesman for a kind of devastating, artistic self-satisfaction and laziness."[19]

Shortly thereafter, with Clem's cooperation, a student of Clark's, John O'Brian, began the work of collecting Greenberg's essays. Four volumes— taking us from 1939 to 1969—have so far appeared: two in 1986 and two in 1993 (University of Chicago Press). That project, although still incomplete, initiated a reexamination of Greenberg's criticism, although much work remains to be done.

The acrimony toward Clem was so virulent that to praise him was to direct it at oneself.

In the late sixties, the French art writer Yves-Alain Bois was coeditor of the journal *Macula*. Discontented with the philosophical-literary style of French criticism, he began looking further afield and soon encountered Greenberg's work. With no knowledge of the surrounding context, Bois felt

he had stumbled upon a treasure. "Compared to the vulgarity" of French commentary on Pollock, he wrote, "Greenberg's . . . formal analyses seemed a remarkable departure . . . a sort of ABC of criticism without which nothing serious could be written about that painter."[20] Bois knew Hans Haacke, a well-known conceptual artist living in New York. When next they met, Bois mentioned his discovery of Greenberg's criticism and, as he described it, a "harsh discussion" ensued. Haacke made clear the many reasons why Greenberg was an "extremely discreditable" figure. With this in mind, further research revealed the paradoxical nature of Greenberg's position: "Skimming through the pages of *Artforum* . . . we [Bois and coeditor Jean Clay] discovered that . . . the vast corpus of American criticism of the late sixties and early seventies, so superior to the French," was dominated by a reaction against Greenberg, but that the "terms of this reaction were still entirely ruled by the tenor of his theory."[21] In 1990, Bois published *Painting as Model,* a sophisticated effort to resuscitate formalist criticism as a respectable mode of discourse. In his introduction, he discussed the "blackmail" to which such an endeavor was subject.

In 1993, *Art and Culture* was translated into French by Ann Hindry, and a colloquium on Greenberg's criticism took place at Le Centre Georges Pompidou in Paris.[22] In 1996 Thierry de Duve published *Clement Greenberg: Between the Lines.* Until the French accepted the New York School, Americans treated their own art with derision. It would be ironic if America's foremost critic of modern art suffered a similar fate.

The New York art world treated Clem's death, in 1994, as a nonevent. No museum hosted a memorial service, no avalanche of articles reexamined his contribution to twentieth-century art criticism or attempted to position him among his peers. Few obituaries rehearsed his accomplishments with the comprehension necessary for an adequate review of his position.

Being "warm headed and coldhearted," as Auden said, Clem seems to have anticipated this state of affairs. Writing about the man he called "the greatest of all literary critics," he defined the standards by which he too might well be measured: "When all [of T. S.] Eliot's *gaffes* and the entire extent of his . . . irresponsibility are taken into account, there is still enough left over to take seriously."[23] And again: "Even where he [Eliot] is . . . wrong, he continues to cast light—more light than most other critics do where they are not wrong. This is perhaps the highest compliment that can be paid a critic."[24]

Perhaps his most fitting epitaph as a critic, however, was penned by him in relation to a painter: "Matisse is there . . . as a fixed pole. . . . More than any other predecessor, he establishes a *relevant* and abiding standard of quality."[25]

NOTES

CHAPTER 1: ICARUS IN THE ART WORLD

1. This observation was made earlier by Hilton Kramer in "Garbled Obituary Slights Greenberg's Achievement," *New York Observer,* May 23, 1994.
2. "Clement Greenberg" (1981), reprinted in *The Hydrogen Jukebox: Selected Writings of Peter Scheldahl, 1978–1990,* ed. Malen Wilson (Berkeley: University of California Press), 65.
3. The name was taken from the Brooklyn ironworks where Smith learned to weld.
4. Reprinted in *Art International,* May 1964, 34–37.
5. Telephone interview.
6. This part of the story from Rosalind Krauss.
7. Rosalind Krauss, unpublished interview. Clem insisted he had not said it but wished he had. However, it was probably one of his standard opening gambits because critic Barbara Rose reported that he said the same thing to her.
8. Ibid.
9. Rosalind Krauss quotes in this section, ibid.
10. Story from CG.
11. Dan Budnik, telephone interview.
12. Hilton Kramer, *New York Times,* September 13, 1974, 28. McKee returned neither letters nor phone calls and was not interviewed for this book.
13. Interview.
14. Ira Lowe, unpublished interview with F. Rubenfeld, March 24, 1987. It should be noted that Mr. Lowe's own billing and investing practices with regard to the estate were the subject of a brief submitted by Mr. Richard Bartlett, guardian ad litem for Smith's daughters, to the Hon. Charles S. Ringwood, Warren County Surrogate, Lake George, New York, on January 4, 1973.
15. Elizabeth Frank, "Farewell to Athene: The Collected Greenberg," *Salmagundi,* fall 1988, 246.
16. Story from Smith's daughters, Rebecca and Candida.
17. "Letters" column, *Art in America* 66 (March-April 1978): 5.
18. Ibid.
19. Interview, 1991.

CHAPTER 2: AN INAUSPICIOUS BEGINNING

1. It is unlikely that a five-year-old could lift an ax. He may have used a hatchet, or perhaps Sonia's memory was correct.
2. See Irving Howe's *The World of Our Fathers.*
3. Interview.
4. Story from Dr. Elizabeth Higdon, a close friend of Clem's.
5. Martin Greenberg, interview.
6. My thanks to Edward P. Chase, former senior editor of Scribner, who questioned Clem's description of himself as a "letterman."
7. CG, interview.
8. Story from Martin Greenberg.
9. Story from CG.
10. Martin Greenberg, interview.

CHAPTER 3: METAMORPHOSIS

1. Curiously, a later friend, art historian Elizabeth Higdon, also claimed Lincoln as a relative. CG may have confused them when he told the story, and Ms. Ewing could not be located.
2. *Clement Greenberg: The Collected Essays and Criticism* (CE), John O'Brian, vol. 1, *Perceptions and Judgments, 1939–1944,* chronology, 254.
3. I am indebted for this information to Irving Howe, who came upon it in the 1950s while going through the *New Masses'* files for a book on the Communist Party.
4. *New Masses,* October 1935, 18.
5. Story from Sonia.
6. Ibid.
7. Story from Martin Greenberg.
8. That Stalin orchestrated the results of the Moscow Trials was suspected by some, but hard evidence did not emerge until much later.
9. Saul Bellow, *The Adventures of Augie March* (New York: Modern Library, 1953).

10. Much of this discussion was contributed by Lionel Abel.
11. Hilton Kramer, "Reflections on the History of *Partisan Review,*" *New Criterion,* September 1996. (Review of Edith Kurzweil's A *Partisan Century: Political Writings from Partisan Review,* Columbia University Press.)
12. Interview.
13. William Phillips and Philip Rahv, letter to the *New Masses* 25, no. 4 (October 19, 1937): 21.
14. See *Special Tasks* by Pavel and Anatoli Sudoplatov, with Jerrold and Leona Schecter (Boston: Little, Brown, 1994), 50. An interesting historical note on the "Kirov" accusation surfaced recently indicating that Stalin knowingly misrepresented the facts, going so far as to have the girl and her mother killed to keep the truth from being discovered, and then using the general's death to foment anxiety about Trotsky's traitorous intentions, with which he justified the purges.
15. Alan M. Wald, *The New York Intellectuals: The Rise and Decline of the Anti-Stalinist West from the 1930s to the 1980s* (Chapel Hill and London: University of North Carolina Press, 1987), 97.
16. Story from CG.
17. Ibid.
18. Introduction, CE, vol. 1, xxi. *Kitsch,* the German word for junk or trash, had been used in English once before but was put in circulation by the Greenberg piece.
19. Ibid., xx.
20. Unpublished interview.
21. Ibid.
22. Story from Louise Bourgeois, June 1990. McCarthy was then an editor at *PR,* living with Rahv. She would have seen the postcards Clem sent Dwight Macdonald.
23. Story from CG.
24. CG, interview #9, February 16, 1990.
25. Alice Goldfarb Marquis, *Alfred H. Barr Jr.: Missionary for the Modern* (Chicago: Contemporary Books, 1989), 152.
26. For discussion, see *Pollock and After,* ed. Francis Frascina (New York: Harper and Row, 1985), 154.
27. CE, vol. 1, 6.
28. Ibid., 8.
29. Wald, *New York Intellectuals,* 145–46.
30. Ibid, 219. See also Philip Rahv, *Essays on Literature and Politics,* ed. Arabel J. Porter and Andrew J. Dvosin (Boston: Houghton Mifflin, 1978), 305–9.
31. CG, *Art and Culture* (Boston: Beacon Press, 1961), 3.
32. Daniel Bell, *The Winding Passage* (New York: Basic Books/Harper Colophon Books, 1980), 129.
33. Quoted in William Barrett's *The Truants* (New York: Anchor Books, 1983). See also *New York Times Book Review,* February 17, 1974, 1.
34. David T. Bazelon, *Nothing but a Fine-Tooth Comb: Essays in Social Criticism, 1944–1969* (New York: Simon & Schuster, 1970.
35. "Towards a Newer Laocoön," CE, vol. 1, 34.
36. Ibid., 37–38.
37. Wald, *New York Intellectuals,* 193.
38. CE, vol. 1, 41.
39. Ibid.
40. Story from CG.
41. Norman Podhoretz, *Making It* (New York: Random House, 1967), 40.
42. Ibid., 254. Podhoretz earned the disapprobation of many New Yorkers far outside the *PR* crowd. His memoir, *Making It,* appeared in 1967, but people still lower their voice when they mention it. Podhoretz was never forgiven for, among other things, suggesting the New York Intellectuals were worldly enough to think about their careers or reputations. As sociology, however, the book proves useful, and we turn to it often for this discussion.
43. David Pryce-Jones, *Cyril Connolly: Journal and Memoir* (London: Ticknor & Fields, 1984), 13.
44. Ibid.
45. Story from art historian Elizabeth Higdon, a close friend of Clem's during the eighties, to whom he identified Connolly as Isherwood's "Ruthie."
46. Christopher Isherwood, *Down There on a Visit* (New York: Farrar, Straus, Giroux, 1987).
47. Interview.
48. CE, vol. 1, 47.
49. Ibid., 65–73.
50. CG, *Nation,* October 17, 1942; CE, vol. 1, 115–16.
51. CE, vol. 1, 75. (The volume of poetry was edited by Oscar Williams.)
52. Ibid., 77.
53. CG, review of *Blood of a Stranger, Partisan Review,* November-December 1942; CE, vol. 1, 117.
54. CG, review of *What Are Years?, Nation,* December 13, 1941; CE, vol. 1, 85–86.

CHAPTER 4: THE NEW YORK INTELLECTUALS

1. Story from CG.
2. Ibid.
3. Interview.
4. Ibid.
5. CG's first art review: "Reviews of Exhibitions of Joan Miró, Fernand Léger, and Wassily Kandinsky," *Nation*, April 19, 1941; *CE*, vol. 1, 65.
6. CG, "Review of Four Exhibitions of Abstract Art," *Nation*, May 2, 1942; *CE*, vol. 1, 103–4.
7. *CE*, vol. 1, 104.
8. Ibid, 106.
9. CG, "Review of Exhibitions of Corot, Cézanne, Eilshemius, and Wilfredo Lam," *Nation*, December 12, 1942; *CE*, vol. 1, 129.
10. *CE*, vol. 1, 129.
11. Ibid.
12. Steven Naifeh and Gregory White Smith, *Jackson Pollock: An American Saga* (New York: Clarkson N. Potter, 1989), 397.
13. Interview.
14. *CE*, vol. 1, 148.
15. Story from CG.
16. Clement Greenberg correspondence, Macdonald Papers, Sterling Library Archives, Yale University. I am indebted to Michael Wreszin, author of a biography on Macdonald, for graciously providing me with copies of these letters.
17. *Partisan Review*, spring 1944; *CE*, vol. 1, 190.
18. Naifeh and Smith, *Jackson Pollock*, 168. When the story was discussed with CG, he objected to such terms as *urinate* or *piss* (which he found vulgar). *Pee*, he said, was the only word that would do.
19. Alexander Bloom, *Prodigal Sons* (New York: Oxford University Press, 1986), 128.
20. S. A. Longstaff, "*Partisan Review* and the Second World War," *Salmagundi* 43 (winter 1979): 108–29.
21. *Nation*, October 16, 1943; *CE*, vol. 1, 154.
22. Naifeh and Smith, *Jackson Pollock*, 465.
23. Ibid.
24. *CE*, vol. 1, 165.
25. The comment about being "hit" by the mural made during an interview with FR. Quote from Naifeh and Smith, *Jackson Pollock*, 464.
26. *CE*, vol. 1, 198.
27. Ibid., 203–4.
28. Ibid., 204.
29. "Review of Exhibitions of Robert Motherwell and William Baziotes," *CE*, vol. 1, 239–41.
30. Ibid., 240.
31. Ibid.
32. Unpublished interview, 1991. CG regretted never having said this in print and asked that it be included.
33. CG, "Thurber's Creatures: Review of Men, Women and Dogs by James Thurber," *Nation*, February 26, 1944; *CE*, vol. 1, 184.
34. Ibid.
35. *CE*, vol. 1, 185.
36. Ibid.
37. *Selected Writings of Walter Pater*, ed. Harold Bloom (London: Signet Classic, 1977), back cover.
38. Barrett, *Truants*, 150.
39. CG, "Review of Exhibitions of Mark Tobey and Juan Gris," *Nation*, April 22, 1944; *CE*, vol. 1, 205–6.
40. CG, unsigned "Review of Exhibition by André Masson," *Nation*, March 7, 1942.
41. CG, "The Plight of Culture," *Art and Culture*, 22.
42. CG, "Cézanne," *Art and Culture*, 50.
43. Elizabeth Frank, "Farewell to Athene: The Collected Greenberg," *Salmagundi* 80 (fall 1988): 249.
44. Podhoretz, *Making It*, 110.
45. Ibid.
46. Irving Howe, *A Margin of Hope: An Intellectual Autobiography* (New York: Harcourt Brace Jovanovich, 1982), 119.
47. Ibid., 114.
48. Interview.
49. Anatole Broyard, *Kafka Was the Rage: A Greenwich Village Memoir* (New York: Carol Southern Books, 1993), 110.
50. Podhoretz, *Making It*, 115–16.

51. Ibid., 117.
52. Howe, *Margin of Hope*, 160–61.
53. Interview, February 15, 1990.
54. Quotes from John O'Brian, ed., *Clement Greenberg: The Collected Essays and Criticism*, vol. 1 (Chicago: University of Chicago Press, 1986), xix.
55. Interview with Lionel Abel.
56. Story from CG in response to questions based on the correspondence in Macdonald's papers.
57. Macdonald Papers.
58. Letter dated February 13, 1946, Macdonald Papers. The latter then wrote a letter of apology and Clem responded in kind and the relationship was patched together.
59. Letter dated February 1946, Macdonald Papers.
60. CG, "Surrealist Painting," *Nation*, August 12 and 19, 1944; *Horizon*, January 1945; CE, vol. 1, 229.
61. Review of *European Artists in America*, *Nation*, April 7, 1945; CE, vol. 2, 17.
62. Story from Abel.
63. Barrett, *Truants*, 42.
64. Interview #2.

CHAPTER 5: HIGHBROW AND JEWISHNESS: TWIN POLES OF IDENTITY

1. Quoted in Ronald Hayman's *Sartre: A Biography* (New York: Simon & Schuster, 1987), 22.
2. Anti-Semitism had been on the rise since the 1920s. Until then, there was little effort to keep Jews out of universities: 40 percent of Columbia undergraduates were Jewish in the decade preceding the flapper era, and the percentage was higher still at New York University. But in the thirties, quotas were instituted. The number of second-generation Jewish intellectuals who were undergraduates at Columbia dropped to zero (Bloom, *Prodigal Sons*, 30.)
3. Podhoretz talking about his days at Columbia. Reprinted in Daniel Bell, *The Winding Passage* (New York: Basic Books, 1980), 133.
4. CG, "Under Forty: A Symposium on American Literature and the Younger Generation of American Jews," *Contemporary Jewish Record*, February 1944, 32; CE, vol. 1, 178.
5. Bloom, *Prodigal Sons*, 141.
6. Kurt Lewin, "Self-Hatred Among Jews," *Contemporary Jewish Record*, June 1941. Quoted by Greenberg in "Self-Hatred and Jewish Chauvinism," *Commentary*, November 1950, 426; CE, vol. 3, 45.
7. CG, "Under Forty," 33.
8. Ibid.
9. Reprinted in Howe, *Margin of Hope*, 253.
10. Ibid.
11. Ibid., 141.
12. Irving Howe, "An Exercise in Memory," *The New Republic*, March 11, 1991, 32. Writing recently of that long-ago time, Irving Howe said, "One of the few critics who saw this differently was Clement Greenberg, who kept issuing cogent warnings against 'culture sickness,' the view that vicious acts and ideas should be tolerated when they are advanced" in the work of distinguished writers.
13. Interview.
14. Lionel Trilling, "The Mind of Robert Warshow," *Commentary*, June 1961. CG's response: "Letters" column, October 1961, 344–45.
15. Howe, *Margin of Hope*. For further discussion see Howe, 254–57.
16. Clem's essay was written as the introduction to Schocken Books' first volume of Kafka's stories and essays. It probably predated publication of Sartre's book in English, although, as an editor at *Commentary*, he had no doubt read the manuscript and responded to the argument.
17. Clem worked with Willa and Edwin Muir to translate Kafka's *Parables* (1947) and *The Great Wall of China: Stories and Reflections* (1948).
18. "Introduction to *The Great Wall of China* by Franz Kafka," CE, vol. 2, 99.
19. CE, vol. 2, 18.
20. An inner-circle artist who agreed to be interviewed on the condition that nothing he said be directly attributed to him.
21. "A Martyr to Bohemia," signed K. Hardesh. Hardesh is Yiddish for Greenberg. CE, vol. 2, 98.
22. Barrett, *Truants*, 140.
23. CG, "A Review of an Exhibition of School of Paris Painters," *Nation*, June 29, 1946; CG, *Art and Culture* (slightly revised); CE, vol. 2, 87.
24. CG, "Review of an Exhibition of Paul Gauguin and Arshile Gorky," *Nation*, May 4, 1946; CE, vol. 2, 77.
25. CE, vol. 2, 80.
26. Ibid., 84.
27. Ibid., 88.
28. Ibid., 90.
29. CG, "Review of Gauguin and Gorky"; CE, vol. 2, 80.

30. CE, vol. 2, 87.
31. Furnishings description from Cornelia Reis (at that time married to Ken Noland).
32. Telephone interview.
33. John Bernard Myers, *Tracking the Marvelous* (New York: Random House, 1981), 65–66.
34. Quote re Rothko and Tomlin from conversation with CG. The term *abstract expressionism* was coined in Berlin in 1919; in 1929, Alfred Barr used it to describe Wassily Kandinsky's early abstractions; in 1946, *New Yorker* critic Robert Coates first applied it to the New York painters, although in 1949, it was reinvented by Philip Pavia, who presented it at an early meeting of the Artists' Club (Naifeh and Smith, *Jackson Pollock*, 887).
35. CG, "Review of the Exhibition *Paintings in France,*" Nation, February 22, 1947. See also CE, vol. 2, 131.

Chapter 6: Breaking the Ice

1. CE, vol. 2, 163.
2. For further discussion see Naifeh and Smith, *Jackson Pollock*, 576.
3. CE, vol. 2, 166–67.
4. Ibid., 170.
5. This information emerged during an interview with Hilton Kramer.
6. Story from CG.
7. CG, "New Acquisitions at the MOMA," Nation, Oct. 9, 1943; CE, vol. 1, 154.
8. Ibid.
9. CE, vol. 1, 213, 183.
10. Interview.
11. At a meeting of the *Partisan Review* Advisory Board, in the presence of the entire staff, Sweeney had made a derisive reference to Clem's views on the death of easel painting. Fortunately, Sweeney hated to write, and so William Phillips's concern about a threat to Greenberg's position as regular art critic never materialized. Story in Barrett, *Truants*, 146–47.
12. "A *Life* Round Table on American Art," *Life*, October 11, 1948. Report written by moderator Russell W. Davenport with the collaboration of Winthrop Sargeant. Quote from Aldous Huxley.
13. CE, vol. 2, 79.
14. Ibid., 219, 221.
15. Ibid., 229–30.
16. Ibid., 322.
17. Ibid., 287.
18. Ibid.
19. Ibid.
20. Ibid.
21. Barr, in symposium "The State of American Writing," *Magazine of Art*, March 1949.
22. James Thrall Soby, "Does Our Art Impress Europe?" *Saturday Review*, August 6, 1949, 143. Quoted in Serge Guilbaut, *How New York Stole the Idea of Modern Art* (Chicago: University of Chicago Press, 1983), 193.
23. For further discussion see Naifeh and Smith, *Jackson Pollock*, 593.
24. CG, "The Late Thirties in New York," *Art and Culture*, 231.
25. Quote and story, Naifeh and Smith, *Jackson Pollock*, 598, 600.
26. Ibid., 598.
27. CG, "The Present Prospects of American Painting and Sculpture," *Horizon*, 1947; CE, vol. 2, 163.
28. Russell Lynes, *The Tastemakers* (New York: Grosset & Dunlap, 1949; reprint, Universal Library, 1972), p. 314 in reprint.
29. From "The State of American Writing: A Symposium," *Partisan Review*, August 1948; CE, vol. 2, 257.
30. Podhoretz, *Making It*, 240.
31. Ibid., 241.
32. Podhoretz interview, February 14, 1991.
33. Russell Lynes, "Highbrow, Lowbrow, Middlebrow," *Harper's*, 1948. Reprinted in Lynes, *Tastemakers*, 310.
34. Lynes, *Tastemakers*, 312.
35. Ibid., 313.
36. Ibid., 314.
37. Story from Martin Greenberg.

Chapter 7: More on the Jewish Question

1. *Partisan Review*, November-December, 1946; CE, vol. 2, 107.
2. Howe, *Margin of Hope*, 151.
3. Radio address, April 30, 1942, quoted by Alfred Kazin, *New York Jew.* (New York: Alfred P. Knopf, 1978), 32.

4. Ibid.
5. Reprinted in *Partisan Review* 16, no. 4 (April 1949): 344.
6. Howe, *Margin of Hope*, 152.
7. Charles Osborne, *W. H. Auden: The Life of a Poet* (New York and London: Harcourt Brace Jovanovich, 1979), 231.
8. Howe, *Margin of Hope*, 153–55.
9. "The Question of the Pound Award," *Partisan Review*, May 1949; CE, vol. 2, 304.
10. Ibid.
11. In the eighties Greenberg was accused by the art historian T. J. Clark of believing in the substitution principle. For that discussion see Paul Richter, "Modernism and After," *Vanguard*, May 1981, 23.
12. CE, vol. 2, 304–5.
13. Podhoretz, *Making It*, 132–35.
14. CE, vol. 3, 45.
15. Ibid., 52.
16. Ibid.
17. Podhoretz, *Making It*, 152.
18. CE, vol. 2, 182.
19. Ibid., 58.
20. Interview with CG.
21. Unpublished interview, March 15, 1989.
22. In 1995, the suit was settled out of court "with a kind of apology" from the *Nation* to Clem and the *New Leader*. Del Vayo resigned and Freda Kirchwey stepped down as editor of the *Nation*.
23. Unpublished interview, February 14, 1991.
24. Story from CG.
25. Story from Jenny Greenberg, January 11, 1990.

CHAPTER 8: INFLUENCES ON GREENBERG'S CRITICISM

1. Interview.
2. Barrett, *Truants*, 152.
3. Kant, *Critique of Judgment*, quoted in Harold Osborne, *Aesthetics and Art Theory* (New York: E. P. Dutton, 1970), 186.
4. *Essays in Kant's Aesthetics*, edited and introduced by Ted Cohen and Paul Guyer (Chicago: University of Chicago Press, c. 1982). I am indebted to Lionel Abel for calling this to my attention, unpublished interview, February 3, 1989.
5. See Wald, *Rise and Decline*, 267, for further discussion.
6. Ibid., 45.
7. Terry Eagleton, *Literary Theory* (Minneapolis: University of Minnesota Press, 1983), 31.
8. Ibid., 42.
9. Ibid., 31.
10. Ibid., 51.
11. Ibid., 44.
12. Howe, *Margin of Hope*, 176.
13. Interview, Howe.
14. I am indebted for much of this discussion to Terry Eagleton's *Literary Theory*.
15. From an unpublished speech by CG on the occasion of color painter Morris Louis's 1986–87 show at MOMA. Speech reported by Karen Wilkin.
16. "Hamlet and His Problems" (1919), *Selected Essays of T. S. Eliot* (New York: Harcourt Brace & World, 1932), 122 (1964 edition).
17. Reprinted in Irving Howe, "An Exercise in Memory," *New Republic*, March 11, 1991, 30.
18. Ibid., 31.
19. Leslie Fiedler, "What Can We Do About Fagin?" *Commentary*, May 1949, 412.
20. CG, "T. S. Eliot: A Book Review" (revised version only), *Art and Culture*, 1956, 244. (First published as "T. S. Eliot: The Criticism, the Poetry," *Nation*, December 9, 1950.)
21. Ibid.
22. CG, "Review of the *Whitney Annual* and the Exhibition *Artists for Victory*," *Nation*, January 2, 1943; CE, vol. 1, 134.
23. CG, "Abstract Art," *Nation*, April 15, 1944; CE, vol. 1, 203.
24. "Review of an Exhibition of Morris Graves" (February 17, 1945), CE, vol. 2, 7.
25. See Milton J. Bates, *Wallace Stevens: A Mythology of Self* (Berkeley: University of California Press, 1985), 127–54.
26. "Laocoön," CE, vol. 1, 28.
27. Ibid., 33. This may have been an allusion to Samuel Johnson's comment that Dryden "delighted to tread upon the brink of meaning."
28. *Nation*, April 4, 1948; CE, vol. 2, 228–29.

29. CG, "T. S. Eliot: A Book Review," 244.
30. Ibid., 239–40.
31. *Nation*, May 18, 1946; *CE*, vol. 2, 80.
32. Unpublished interview.
33. CG, "T. S. Eliot: The Criticism, the Poetry," *Nation*, December 9, 1950; *CE*, vol. 3, 69.
34. Journal now in the possession of Dr. Elizabeth Higdon.
35. "Symposium: Is the French Avant-Garde Overrated?" *Art Digest*, September 15, 1953; *CE*, vol. 3, 155–56.
36. *Selected Essays of T. S. Eliot*, 241.
37. *CE*, vol. 1, 133.
38. Ibid., 246.
39. Ibid., 247.
40. CG, *Art and Culture*, 239. In a private interview, Greenberg credited Pollock with coining this use of the verb.
41. Reprinted in *Canadian Arts*, May–June 1963; *CE*, vol. 4, 153.
42. Ibid., 249–50.
43. Quoted in Eagleton, *Literary Theory*, 41.
44. CG's contribution to "Symposium: Is the French Avant-Garde Overrated?"; *CE*, vol. 3, 155–56.
45. CG, "Review of an Exhibition of Ben Shahn," *Nation*, November 1, 1947; *CE*, vol. 2, 173.
46. T. S. Eliot, "Tradition and the Individual Talent," 1921. Reprinted in *Selected Essays of T. S. Eliot*, 13.
47. Ibid., 6.
48. "Laocoön," *CE*, vol. 1, 25.
49. CG, "Can Taste Be Objective?" *Art News*, February 1973, 22–24.
50. Ibid., 23.
51. A. E. Housman, *The Name and Nature of Poetry* (London: Cambridge University Press; and New York: Macmillan, 1933), 45–46.
52. Joseph Campbell, *The Masks of God: Primitive Mythology* (New York: Viking, 1970), 42.
53. Unpublished interview, April 9, 1990.
54. Ibid.
55. CG, interview#6, June 20, 1989.

Chapter 9: He Wouldn't Join a Club That Would Have Him for a Member

1. Curated by Mark Rosenthal.
2. Jeffrey Potter, *To a Violent Grave* (New York: G. P. Putman, 1985), 122.
3. Naifeh and Smith, *Jackson Pollock*, 631.
4. Quote for Harry Jackson. Ibid., 635.
5. Alexander Eliot, *Time*, December 26, 1949.
6. Naifeh and Smith, *Jackson Pollock*, 636.
7. Ibid.
8. April Kingsley, *The Turning Point: The Abstract Expressionists and the Transformation of American Art* (New York: Simon & Schuster, 1992), 15–17.
9. Irving Sandler, *The New York School: The Painters and Sculptors of the Fifties* (New York: Harper & Row, 1978), 11.
10. Story told by Guston's daughter Musa. See Kingsley, *Turning Point*, 70.
11. Thomas Hess, "Reviews and Previews: Barnet [sic] Newmann [sic]," *Art News* 48 (March 1950). Quoted in Sandler, *New York School* 13.
12. Sandler, *New York School*, 13.
13. Unpublished interview.
14. For Greenberg's description of the event see "Letters to the Editors of *Artforum* about Franz Kline," *Artforum*, November 1965; *CE*, vol. 4, 218.
15. Date based on a notation in Clem's diary.
16. Naifeh and Smith, *Jackson Pollock*, 602.
17. CG, "The Federation of Modern Painters and Sculptors and the Museum of Modern Art," *Nation*, February 12, 1944; *CE*, vol. 1, 182–84.
18. Genauer referred only to the painters.
19. Interview.
20. Myers, *Tracking the Marvelous*, 154.
21. Story from Irving Kristol.
22. Naifeh and Smith, *Jackson Pollock*, 604–5.
23. Quote from painter Nicholas Carone, who was with Morandi at the time. Potter, *To a Violent Grave*, 125.
24. September 10, 1950.
25. Published the following year in the *Museum of Modern Art Bulletin* 18 (spring 1951): 5–6.
26. Sandler, *New York School*, 3.

27. CG, "The European View of American Art," *Nation*, November 25, 1950; CE, vol. 3, 61. Sylvester later took that second look and became a supporter of American-type painting and a Greenberg admirer.
28. CE, vol. 3, 61.
29. The painter Hedda Sterne was the only woman present. For further discussion see April Kingsley, *Turning Point*, 360–61.
30. Date taken from Clem's diary.
31. Interview, December 12, 1989.
32. Interview, June 1993.
33. Naifeh and Smith, *Jackson Pollock*, 655.
34. Interview.
35. Interview.
36. Interview.
37. Interview, December 12, 1989.
38. CE, vol. 3, 89.

CHAPTER 10: MAKING ENEMIES AND KEEPING THEM

1. Interview.
2. Story from Myers, *Tracking the Marvelous*, 120.
3. Story from Grace Hartigan.
4. Interview.
5. Unpublished interview.
6. Interview.
7. Interview.
8. Letter made available by Harry Jackson.
9. Interview.
10. John Elderfield, *Helen Frankenthaler* (New York: Abrams, 1989).
11. Max Kozloff, "An Interview with Friedel Dzubas," *Artforum*, September 1965, 51.
12. Interview.
13. Diary notations.
14. Interview with Rose, May 13, 1990.
15. Ibid.
16. Interview.
17. Interview.
18. CE, vol. 3, 99–106.
19. Ibid., 106.
20. CE, vol. 3, 104.
21. CE, vol. 3. 102.
22. Naifeh and Smith, *Jackson Pollock*, 668.
23. Transcript of National Public Radio interviews for *The Washington Color School* show. Provided by Marcella Brenner.
24. Naifeh and Smith, *Jackson Pollock*, 707. The quotes Naifeh and Smith used to buttress their argument came from interviews with them and others years later.
25. Letter made available by Harry Jackson.
26. CE, vol. 3, 119.
27. Story from Clem's diary.
28. Story from Jean Pond, now Jean Freas.
29. Story from Clem, pieced out by events recorded in his diary.
30. Quote from Naifeh and Smith, *Jackson Pollock*, 698. Part of this discussion from the same source, but important differences in the stories are based on interviews with Clem.
31. Naifeh and Smith, *Jackson Pollock*, 713.
32. Story from CG.
33. Interview.
34. Reprinted in CE, vol. 1, xxii.
35. Reprinted in an editor's note, CE, vol. 1, 96.
36. William Phillips, *A Partisan View* (New York: Stein & Day, 1983), 67–68. Whether this was a continuation of the strategy whose anticipated outcome Harold confided to Clem or a second approach made a few years later is unclear. Phillips can no longer recall the precise date. I am indebted for this discussion not only to Mr. Phillips's excellent book but to the interviews he graciously provided.
37. Barrett, *Truants*, 144.
38. Ibid., 59; James Atlas, *Delmore Schwartz: The Life of an American Poet* (New York: Harcourt Brace Jovanovich, 1977), 143.
39. Barrett, *Truants*, 58–59.
40. Naifeh and Smith, *Jackson Pollock*, 703–4.

41. Ibid., 635.
42. Ibid., 701–2.
43. Max Kozloff, "An Interview with Friedel Dzubas," *Artforum*, September 1965, 50.
44. Story from CG.
45. See CG, "How Art Writing Earns Its Bad Name," CE, vol. 4, 138.
46. Story from CG.
47. See Naifeh and Smith, *Jackson Pollock*, 707–14, for detailed discussion.
48. Ibid.
49. Lionel Abel, *Intellectual Follies* (New York: Norton, 1984), 206.
50. Interview.
51. Ibid.
52. Interview.

CHAPTER 11: SOWING HIS SEED

1. Memorial piece, "Thomas B. Hess, 1920–1978," *Art in America*, November/December 1978.
2. Story from Lee Hall.
3. Smith story from his wives, Dorothy Dehner and Jean Pond (now Freas); Pollock information, Naifeh and Smith, *Jackson Pollock*, 786.
4. Interview with the dealer, who prefers to remain anonymous.
5. Interview.
6. Interview.
7. CG, *Art and Culture*,
8. Eliot published his first thoughts on the subject in an essay by the same name in *Partisan Review* (spring 1944). Clem, William Phillips, and the poet R. P. Blackmur responded in the summer issue.
9. CG, "The Plight of Our Culture," CE, vol. 3, 130; *Art and Culture* (substantially revised).
10. CE, vol. 3, 129.
11. CG, *Art and Culture*, 31.
12. Ibid., 28.
13. Ibid., 32.
14. CE, vol. 3, 155–57. The magazine invited three American artists and a critic—Ralston Crawford, Robert Motherwell, Jack Tworkov, and Clement Greenberg—to discuss the subject.
15. CE, vol. 3, 156.
16. Ibid., 164–73.
17. Ibid., 187; *Art and Culture* (substantially revised).
18. CG, "Abstract Representational, and So Forth" (1955), *Art and Culture*, 135.
19. Tom Wolfe, *The Painted Word* (New York: Bantam Books, 1975), 57–58."
20. Text of quote from a postcard sent by Clem to the author on "27 April 87."
21. Interview for PBS program on the Washington Color School. Interview provided by Marcella Brenner, widow of Morris Louis.
22. Interview with Kenneth Noland.
23. Story from CG.
24. Interview with Cornelia Noland (now Reis).
25. Interview.
26. Hilton Kramer interview, February 15, 1990.
27. CG, "Introduction to a Memorial Exhibition of Arnold Friedman," CE, vol. 3, 18.
28. CG, "Review of an Exhibition of John Marin," *Nation*, December 25, 1948; CE, vol. 2, 268.
29. Interview.
30. *Twentieth Century Authors* (written in 1953 and published in 1955).

CHAPTER 12: BREAKUP, BREAKDOWN, AND LITERARY BACKLASH: 1955–57

1. Story from CG.
2. Interview with Irving Sandler.
3. Inferred from diary notations.
4. Story from CG, details from diary.
5. He kept journals, as well as diaries, in which he may have been more forthcoming, but these he did not make available for this book.
6. Interview.
7. Frankenthaler declined to answer questions about her private life, and details of this story come from Clem.
8. Interview.
9. Interview.
10. Letters column, *Commentary*, vols. 19, 20, June and July, 1955, 595–96 and 177–78.
11. Podhoretz, unpublished interview, February 14, 1991.
12. CG, "Kafka's Jewishness," *Art and Culture*, 271.
13. Ibid.

14. My thanks to Jed Rubenfeld for this observation.
15. Term coined by British painter-writer Patrick Heron.
16. I am indebted to Andrew Hudson for calling my attention to a confusing reference in Clem's 1955 version of the essay. Terming Pollock's 1951 show his best, he went on to praise its huge canvases of "monumental perfection." Although the date given was 1951, his words conjured images of glorious abstractions such as *One* and *Lavender Mist*, shown in 1950. When he revised the essay for *Art and Culture*, he corrected the mistake but did not mention it.
17. *Partisan Review*, spring 1955; *Art and Culture*, substantially changed; *CE*, vol. 3, 226.
18. CG, vol. 3, 228.
19. CG, *Art and Culture*, 229.
20. Telephone interview with Harry Jackson.
21. Note to Pollock from CG, May 21, 1955. Printed in Naifeh and Smith, *Jackson Pollock*, 743.
22. CG, interview #9, February 16, 1990.
23. Naifeh and Smith, *Jackson Pollock*, 747.
24. Naifeh and Smith quote Conrad Marca-Relli as saying Lee stifled her outrage with Clem: "Although she detested him personally, Lee was always doing everything to keep Jackson and Clem together, to keep him in Jackson's camp." *Jackson Pollock*, 899.
25. Ibid. Curiously, Clem takes Lee's side in the fight but protects Jackson against the wife-beating charges that Naifeh and Smith document so carefully (pp. 695–96). During interviews for this book, Clem called David Smith a boor and a bore but continued to deny similar accusations leveled by Dorothy Dehner, Smith's first wife, Jean Freas, his second, and Cornelia Noland, Freas's close friend, during their interviews with this author.
26. CG, interview #9, February 16, 1990. Naifeh and Smith report that Clem sent Lee to Jane Pearce, but told this, he insisted it was to Klein, whom his diary indicated he continued to see each time he visited Springs. The Newtonians—Saul Newton, Klein, even Ken Noland's former wife Stephanie—refused to return calls or be interviewed for this book.
27. Interview. Clem had a penchant for "talking too much" on certain occasions, and it is unclear whether he behaved this way in Pollock's studio all the time or only when the presence of others made him self-conscious.
28. Telephone interview with Harry Jackson.
29. Naifeh and Smith, *Jackson Pollock*, 765.
30. Interview.
31. Story from Friedman.
32. Interview with Paul Brach.
33. Naifeh and Smith date Lee's opening in October, but Clem's diary is usually reliable on such matters.
34. Interview.
35. Interview with Rivers.
36. Story from Hartigan.
37. Ibid.
38. Story from Washington dealer John Pierre de Andino and artist/critic James Mahoney, who got it from the late Louise Downing, the painter's second wife.
39. Story form the late Louise Downing.
40. Visit noted in Clem's diary.
41. Clem's diary confirms this part of the story.
42. Story from artist Peter Stroud, who taught art at Bennington College in the sixties and was part of the Greenberg circle in Vermont. No one in the Newtonian circle would agree to be interviewed for this book.
43. Diary notations.
44. Naifeh and Smith, *Jackson Pollock*, 752.
45. Diary.
46. Clem expressed surprise when told of the desire to unseat him and of Phillips's defense, insisting that my account was the first he heard about it.
47. Phillips, *A Partisan View*, 65, 69.
48. Quotes and story from Naifeh and Smith, *Jackson Pollock*, 749.
49. Ibid.
50. Naifeh and Smith go to considerable lengths to demonstrate Pollock's sexual ambivalence and lack of heterosexual interest, and by 1956 that may have been the case. But a dealer, a woman in a position to know, gave the lie to their assessment of his potency as a lover.
51. Ruth Kligman, *Love Affair* (New York: Morrow, 1974).
52. Interview, March 14, 1989.
53. Interview #9. Interestingly, Clem had no trouble doing to Motherwell and Newman what he wasn't analyzed enough to do with Pollock. A letter from Motherwell included in Clem's correspondence at the Archives of American Art, Smithsonian Institution, Washington, D.C., attests to that fact. The Newman story comes from writer/painter Andrew Hudson, in front of whom Clem bragged about making Newman pony up.

54. Details from Naifeh and Smith, *Jackson Pollock*, 789–93.
55. Story from Jeffrey Potter. In his book *To a Violent Grave*, Potter quotes Braider as saying "someone" said this (p. 246). During our interview he said it was Clem.
56. Interview #9.
57. Podhoretz, *Making It*, 129.
58. Interview with Lionel Abel.
59. Podhoretz, *Making It*, 197.
60. Interview with Hilton Kramer.
61. Interview with Podhoretz.
62. Interview.
63. Podhoretz, *Making It*, 229.
64. Ibid., 230.
65. Interview.
66. Interview. The Utica Museum invitation was in 1958.
67. Diary entries, May 1958.
68. CG, April 1993. Diary entries at the time indicate he first saw Feeley in a group with Helen Frankenthaler, then with Goossen, and then went to Bennington to "nix" it.
69. Information in this paragraph from CG's 1957 and 1958 diaries and correspondence in the Archives of American Art.
70. Notation in diary. Story from Clem.
71. Interview.
72. Diary.
73. The piece began in 1957 as "Cézanne II" and, over time, evolved into "Newness of Color." CG worked on it every day for another two weeks after the quoted diary entry, but then "let the whole thing go" and returned to the revisions he was doing for *Art and Culture*.

CHAPTER 13: THE CHANCE OF A LIFETIME: 1958–60

1. *New York Times Magazine*, April 16, 1961; CE, vol. 4, 107.
2. Marquis, *Alfred H. Barr*, 297.
3. Ibid.
4. CG, "After Abstract Expressionism," *Art International*, October 1962; CE, vol. 4, 124.
5. Interview.
6. Calvin Tomkins, *Off the Wall* (New York: Doubleday, 1980; reprint, Penguin, 1981), 143–44, 179, in Penguin edition.
7. "The Realist Predicament: Past and Present Traditions on the National Scene," TLS, November 6, 1959, xxix. Quote reprinted in Sandler, *New York School*, 265.
8. "Wholly American" (an editorial), TLS, November 6, 1959, 643. Reprinted in Sandler, *New York School*, 267. Not everyone was thrilled, of course. Clem believed the second generation too weak to sustain the momentum. Hilton Kramer, never a fan of Rosenberg's or of the de Kooning faction, penned an editorial in *Arts*, fulminating against the British position: "The *Times Literary Supplement* speaks for the cultivated Briton at his snobbish best. It represents itself as standing for responsible literary taste, for scrupulous scholarship in history and the arts and for literary and artistic values of a seriousness which precludes the least vulnerability to passing fads. Many Americans read the TLS as an aesthetic fairy tale in which 'good' (classical learning, French literature and truly interesting historical personalities) always triumphs over 'evil' (boorish American scholarship, contemporary novels and bothersome social issues)." (Editorial, *Arts*, December 1959, 15; reprinted in Sandler, *New York School*, 267.)
9. Phone interview, October 1995.
10. Neuberger did not recall the circumstances of their lunch, and Clem's diary recorded only the date and what he did afterward.
11. Six lectures in all—delivered in December 1958 and January 1959—for which he received $1,500. Greenberg says he was not pleased with his effort and devoted too little time to it. Asked for a transcript, he demurred. No transcript available from the Princeton Library or notes from the Gauss Seminar files.
12. CG's diary.
13. Interview.
14. Phone interview, April 29, 1992.
15. Telephone interview with Spencer Samuels.
16. Story from CG and Spencer Samuels.
17. Diary.
18. No copies were on file at Princeton nor was there any record of discussion or response. Clem was careful about such things, however, and it seems a reasonable guess that the lectures are among his unsorted papers.
19. CG, *Partisan Review*, May–June 1951; CE, vol. 3, 84.
20. *Art News Annual* 26, 1957; CE, vol. 4, 10; *Art and Culture* (substantially revised).

21. Clem was presumably thinking about the Fry essay during his time at French & Co. Modern, which closed in May 1960. In October he traveled to the Detroit Institute of Arts to see *Masterpieces of Flemish Art: Van Eyck to Bosch*, to which he returned three times in two days. A week later he began "The Early Flemish Masters."
22. From CG.
23. Porter McCray recalls the dinner but not the incident. Spencer Samuels, director of French & Co., confirms that shows were scheduled for Jack and Lee and both canceled precipitately the summer of 1959.
24. My thanks to Andrew Hudson for calling this to my attention.
25. Interview #10.
26. Interview #9, February 16, 1990.
27. Interview with FR.
28. CG's diary.
29. Story from CG.
30. The details of the closing came from Clem, but the parts of the story having to do with Pollock are conjecture. Although initially cooperative, Spencer Samuels stopped returning letters or phone calls once the Pollock/Krasner episode was raised.
31. CG, "Modernist Painting," *Arts Yearbook* 4 (1961) (unrevised); CE, vol. 4, 85–93.
32. Ibid., 93.
33. "Louis and Noland," CE, vol. 4, 94–100.
34. CE, vol. 4, 85.
35. Bradford Collins, "Clement Greenberg and the Search for Abstract Expressionism's Successor: A Study in the Manipulation of Avant-Garde Consciousness," *Arts*, May 1987, 38.
36. Interview with Frank Getlein, April 22, 1993, and written statement, July 1994.
37. Story form Clem and Miriam Schapiro.
38. Getlein interview and follow-up correspondence in July 1994.
39. Interview with Paul Brach and Miriam Schapiro. Clem, asked about their statement concerning Rosenberg, confirmed it.
40. Interview, March 13, 1989.
41. Interview.
42. Story told during an unpublished interview. Ashton herself, it should be said, was no stranger to charges of favoritism. While art critic of the *New York Times*, she was accused of favoring the group of artists to which Yunkers, her then husband, belonged.
43. The essay was prompted by an exhibition at the Poindexter Gallery entitled *The 30's: New York Paintings*.
44. CG, "New York Painting Only Yesterday," *Art News*, summer 1957; CE, vol. 4, 20.
45. Ibid. *Art and Culture*, revision titled "The Late Thirties in New York," dated 1960.
46. Interview #2, March 19, 1991.

CHAPTER 14: DAGGERS DRAWN: THE BATTLE OF THE TITANS

1. Greenberg correspondence, Archives of American Art, Washington, D.C.
2. CG, *Art and Culture*.
3. Hilton Kramer, "A Critic on the Side of History," *Arts*, October 1962, 60.
4. Sandler, *New York School*, 271.
5. Ibid., 284.
6. Ibid. For further discussion see chapter 13, "The New Academy."
7. Ibid., 268.
8. Ibid., 284.
9. Ibid., 281.
10. Ibid., 282.
11. Letter to editor, *Art International* 7 (June 1963): 88–92.
12. Unpublished interview.
13. Interview. In the early nineties a large de Kooning exhibition was shown at the National Gallery of Art in Washington, D.C., and at the Metropolitan Museum in New York. Although the intent was to question this premise, for many it confirmed it.
14. Story denied by Greenberg but told by someone close enough to Frankfurter to know.
15. Fitzsimmons postcard to Clem—in response to his proposal—is part of the Greenberg correspondence at the Archives of American Art.
16. A note from Fitzsimmons dated February 11, 1962, refers to the $150 check enclosed and indicates that it is "twice the usual amount" for ten double-spaced pages.
17. Unpublished interview.
18. Interview. Similar story told by William Rubin.
19. Reprinted in Rosenberg's "Notes and Topics: Critic Within the Act," *Encounter*, June 1961, 58.
20. Ibid.
21. CG, tape #9, December 10, 1989.

22. CE, vol. 4, 141.
23. Interview, December 22, 1989.
24. Rosenberg, "Critic Within the Act." *Encounter* caused something of a scandal when a CIA connection was exposed several years later.
25. Interview, March 13, 1989.
26. Harold Rosenberg, "After Next, What?" *Art in America,* April 1964, 65.
27. Interview.
28. "How Art Writing Earned Its Bad Name," CE, vol. 4, 135.
29. John Bernard Myers, "Junkdump Fair Surveyed," *Art and Literature* 3 (autumn-winter 1964): 140, 129.
30. Kramer, "Critic on the Side of History," 60.
31. "Post Painterly Abstraction" was reprinted many times. The first, in *Art International* (summer 1964); CE, vol. 4, 192.
32. CG, "Changer: Anne Truitt," *Vogue,* May 1968; CE, vol. 4, 288.
33. Interview.
34. Interview.
35. Robert Hughes, *American Visions* (New York: Alfred A. Knopf, 1997), 548.
36. Wolfe, *Painted Word,* 43–44.
37. Description based on April 1970 *Artforum* article by Phil Lieder, page 144.
38. Wolfe, *Painted Word,* 50.
39. Interview, February 17, 1991.

CHAPTER 15: THE SECOND COMING: 1961–65

1. Interview, February 13, 1991.
2. Interview.
3. Greenberg correspondence, Archives of American Art.
4. Story from Barbara Rose.
5. Information from Fried, Moffett, as well as correspondence located at the Archives of American Art.
6. Story from Harrison.
7. Story from CG, Jules Olitski, Cornelia Noland, among others.
8. Interview.
9. Interview.
10. Interview.
11. Interview, February 15, 1990.
12. Interview with Rose.
13. Dufferin was a backer of the Waddington Gallery in London.
14. Interview.
15. Bradford C. Collins, "Clement Greenberg and the Search for the Abstract Expressionists' Successor," *Arts,* May 1987, 38–39.
16. Interview.
17. Interview.
18. Interview.
19. Story from Andrew Hudson, to whom Bush passed on Clem's advice.
20. Interview.
21. Interview.
22. Noland and Olitski both describe an enemy camp at Bennington and position Adams among its most vocal members.
23. Interview.
24. Interview with an artist who preferred to remain anonymous.
25. Story from Andrew Hudson.

CHAPTER 16: IMPERIAL CLEM

1. Notations from Clem's diaries.
2. Conversation.
3. CG, "Poetry of Vision," *Artforum,* April 1968; CE vol. 4, 284.
4. Story from Rose.
5. Donald Brook's "Art Criticism: Authority and Argument" appeared in 1969. Clem's lecture "Avant-Garde Attitudes: New Art in the Sixties" was reprinted in *Studio International,* April 1970, 142–45; CE, vol. 4, 292.
6. Rosalind Krauss, interview, April 24, 1989.
7. Telephone interview with Weissbrodt, January 1996.
8. Ibid.
9. Ibid.

10. Interview with painter Sylvia Sleigh, Mrs. Lawrence Alloway, two weeks after his death.
11. Lucy R. Lippard, "New York Letter," *Art International*, February 1965; quoted in Clem's response, "Letter to the Editor of *Art International* about Morris Louis," May 1965; *CE*, vol. 4, 209.
12. CG, "Letter to the Editor of *Art International*"; *CE*, vol. 4, 210.
13. Edward Santiago, telephone interview, May 1, 1990.
14. CG, letter to the editor, *Arts* 47 (December 1972): 94.
15. Patrick Heron, "A Kind of Cultural Imperialism?" *Studio International* 175 (February 1968): 63.
16. Interview.
17. Interview.
18. Interview.
19. Interview.
20. Interview, April 9, 1990.
21. Olitski, *American Art*, summer/fall 1994, 127–28.
22. Interview.
23. Interview.
24. Diary entry, January 1962. Specifics from Alan Stone.
25. Diary entries on June 3 and 4.
26. Interview with FR.
27. Telephone interview with Weissbrodt.
28. Story from Rose and from Fried.
29. Story from Ashton.
30. Interview with Michael Fried.
31. Correspondence in the Archives of American Art includes postcards from David Smith, Jack Bush, and Robert Motherwell containing such offers.
32. Interview with Larry Rubin.
33. Ibid.
34. Story from Martin Greenberg.
35. Interview.
36. Story from Andrew Hudson.
37. The estimate was Clem's but Emmerich confirmed it.
38. Interview.
39. Information from Jean Freas, Smith's second wife, and confirmed by her lawyer Richard J. Bartlett.
40. Information from Elizabeth Higdon.
41. Telephone interview with FR.
42. Figures from Weissbrodt.
43. Interview.
44. Interview.
45. Interview.
46. Interview.
47. The interview appeared in "USIS Feature," United States Information Service, April 1969. It was circulated among newspapers, magazines, and radio stations as part of a series "designed to present the views of prominent Americans on issues and situations of current significance"; reprinted *CE*, vol. 4, 304.
48. Thierry de Duve, *Clement Greenberg: Between the Lines* (Paris: Dis Voir, 1996).
49. Seminar transcripts can be found in Peggy S. Noland's thesis located in the New York University library.
50. Although he carried the manuscript around with him throughout the eighties, the book was never completed.
51. CG, "Seminar One," *Arts Magazine*, vol. 48, November 1973, 44–45. For further discussion see de Duve, *Clement Greenberg*, 89–119.
52. CG, "Seminar Six," *Arts Magazine*, vol. 50, June 1976, 129. In the course of our conversations, Clem recalled reading, or more probably re-reading, the American philosopher Charles S. Peirce and the aesthetics of Susanne Langer at this time. During the series of lectures and private seminars Kenworth Moffett arranged at Wellesley College in 1978, he recalled that Clem often talked to him about the ideas of both in this context.
53. Walter Darby Bannard, "Quality, Style, and Olitski," *Artforum*, October 1972, 65–67.
54. My thanks to Peter Stroud for calling this to my attention.
55. Bruce Boice, "The Quality Problem," *Artforum*, October 1972, 69.
56. Rosalind Krauss, "Changing the Work of David Smith," *Art in America*, September-October 1974, 30–33.

CHAPTER 17: CLEMSVILLE: A SECULAR HALAKAH

1. Letter to FR from SB.
2. CG, "The Jewish Joke: Review of *Royte Pomerantzen,* edited by Immanuel Olsvanger," *Commentary,* December 1947 CE, vol. 2, 183.
3. Interview.
4. Conversation with Elizabeth Higdon.
5. Interview.
6. Interview, February 18, 1989.
7. Diaries.
8. Interview.
9. Story told during a chance meeting at the Whitney Museum in 1989.
10. Phoebe Hoban, "Psychodrama," *New York,* June 19, 1989.
11. Interview.
12. Interview, March 16, 1989.
13. Hoban, "Psychodrama."
14. Interview, 1989.
15. Story from Sidney Tillim.
16. Interview, September 23, 1990.
17. Interview.
18. Newton died in the early nineties at age eighty-five.
19. Interview.
20. Story from painter Steve Conley.
21. CE, vol. 1, 179.
22. Exhibition catalog "Olitski: New Sculpture," interview with Friedrich Bach. Reprinted in "15 Sculptors in Steel Around Bennington: 1963–1978," Andrew Hudson's catalog essay for the show he organized. (Park-McCullough House Association, North Bennington, August 12–October 15, 1978).
23. Interview with James Wolfe. Pat Adams also commented on "Sullivanian therapy . . . as a kind of elitist point of view—'we who have had this experience' " are, by definition, healthier and better people.
24. Interview.
25. Conversation with Elizabeth Higdon.
26. Ibid.
27. Basic story from Crile, whose long, painful involvement with the group was confirmed by Pat Adams. The incident with Clem was acknowledged both by Jules and Clem, although both pooh-poohed it, suggesting Crile had overreacted.
28. All stories or quotes in this paragraph originate with persons involved and were related during interviews.
29. Interview.
30. Interview.
31. Interview.
32. Interview with Michael Fried.
33. Story from a critic who knew both men well and wishes to remain anonymous. The text of the note was repeated from memory.
34. Evident from diary notations.
35. Interview.
36. Interview with Sarah Greenberg.
37. Story from critic Karen Wilkin.
38. Interview.
39. Telephone interview with the writer Richard Elman, a former patient.
40. Interview.
41. Interview.
42. Interview.
43. Information from Clem's diary.
44. Interview.
45. The source prefers to remain anonymous. Aspects of the story confirmed by Stroud, Noland, Moffett, Caro (indirect but reliable), Wilkin, Fried, and others.
46. Interview with Jules Olitski.

CHAPTER 18: THE QUESTION OF IMMORTALITY

1. CG, "Necessity of Formalism," *New Literary History,* vol. 3, 1971, 105. Reprinted *Lugano Review,* October 1972.
2. Ibid., 106.
3. Leo Steinberg, "Reflections on the State of Criticism," *Artforum* 10 (March 1972): 38. The article was an excerpt from the forthcoming book *Other Criteria* (New York: Oxford University Press, 1972).

Notes

4. Information from his diary notations.
5. Unpublished interview.
6. Interview.
7. Book review, *Art Journal*, winter 1987, 323.
8. Alexandre Koyre, *"La Dynamique de Nicolo Tartaglia"* (1957); reprinted in Yves-Alain Bois, *Painting as Model* (Cambridge, Mass.: MIT Press, An *October* Book, vol. 1, 1990), 68.
9. CG, CE, vol. 1, 46.
10. Kay Larson, "The Dictatorship of Clement Greenberg," *Artforum* 25 (summer 1987): 75–79.
11. CG, "Frontiers of Criticism: Review of *Les Sandales d'Empedocle: Essai sur les limites de la littérature* by Claude-Edmonde Magny," *PR*, spring 1946; *CE*, vol. 2, 71.
12. CG, footnote in "The Avant-Garde and Kitsch," *CE*, vol. 1, 19.
13. Comment made by Greenberg in Michael Blackwood's film *Pablo Picasso: The Legacy of a Genius*.
14. CG, "Matisse in 1966," *Boston Museum Bulletin* 64, (1966); *CE*, vol. 4, 220.
15. "T. S. Eliot: The Criticism, the Poetry," *CE*, vol. 3, 67.
16. Quoted by Terry Eagleton, *Literary Theory* (Minneapolis: University of Minnesota Press, 1983), 41.
17. Lecture at the University of South Florida, February 9, 1990.
18. Peter Schjeldahl, *Columns and Catalogues*, May 25, 1994.
19. Paul Richter, "Modernism and After," *Vanguard*, May 1981.
20. Bois, *Painting as Model*, xvi.
21. Ibid., xvii.
22. The international group of participants included Bois, Claire Brunet, Dominique Chateau, Bradford Collins, Arthur C. Danto, Jean-Pierre Criqui, Hubert Damisch, Thierry de Duve, Ann Hindry, Caroline Jones, Rosalind Krauss, Elisabeth Lebovici, John O'Brian, and Jean-Marc Poinsot.
23. CG, "The Plight of Our Culture" (1953), *Art and Culture*, 23.
24. CG, "T. S. Eliot: A Book Review," *Art and Culture*, 240.
25. CG, "Matisse in 1966"; *CE*, vol. 4, 219.

INDEX